Videojournalism
Multimedia

Kenneth Kobré
San Francisco State University

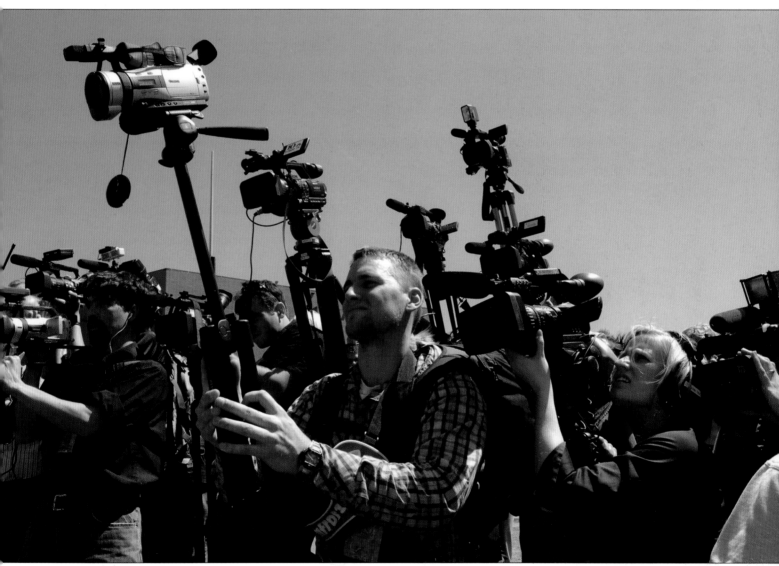

▲ Photographers at a National Press Photographers Association (NPPA) video workshop. (Photo by Donald R. Winslow)

ELSEVIER

Amsterdam • Boston • Heidelberg • London • New York
Oxford • Paris • San Diego • San Francisco • Singapore
Sydney • Tokyo
Focal Press is an imprint of Elsevier

Focal Press

Cover illustration by William Duke (www.williamduke.com)

Focal Press is an imprint of Elsevier
225 Wyman Street, Waltham, MA 02451, USA
The Boulevard, Langford Lane, Kidlington, Oxford, OX5 1GB, UK

Library of Congress Cataloging-in-Publication Data
Application submitted

British Library Cataloguing-in-Publication Data
A catalogue record for this book is available from the British Library.

ISBN: 978-0-240-81465-0

For information on all Focal Press publications
visit our website at www.elsevierdirect.com

11 12 13 14 15 5 4 3 2 1

Printed in China

Working together to grow
libraries in developing countries

www.elsevier.com | www.bookaid.org | www.sabre.org

ELSEVIER BOOK AID
 International Sabre Foundation

Dedication

This book is dedicated to my wife, Betsy Brill.

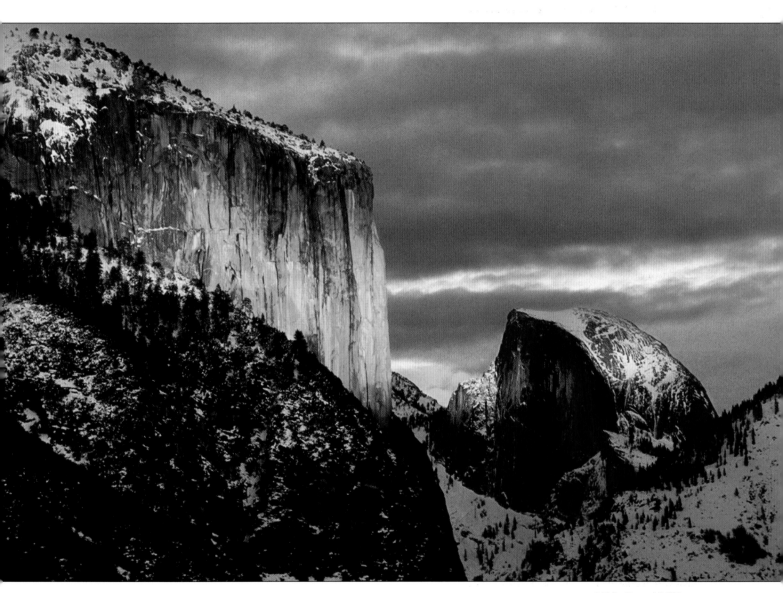

▲ **El Capitan and Half Dome Yosemite National Park, California.** (Photo by Pete Erickson)

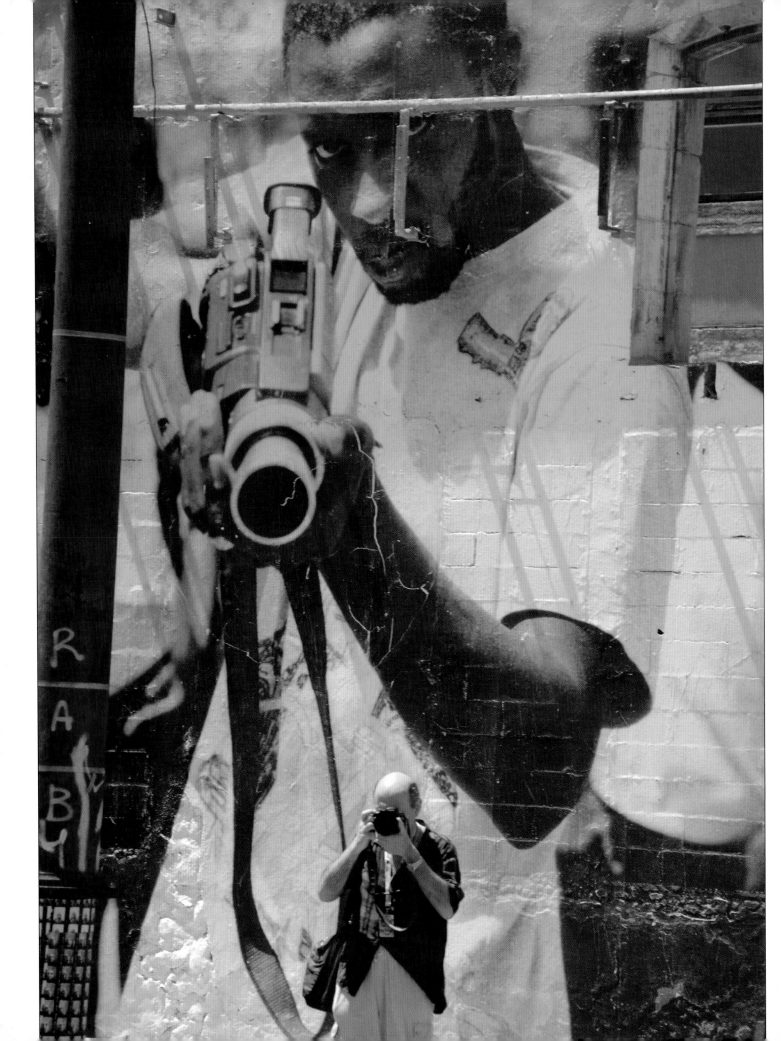

Contents

◄ The photographer stands before a three-story tall poster of a young man holding a video camera like a gun. The poster was part of a project by two French photographers to paper walls with outsized images. (Photo by Ken Kobré)

Preface

Videojournalism is a new field that has grown out of print photojournalism, slideshows that combine sound and pictures, public radio, documentary filmmaking, and the best of television news features. This amalgam of traditions has emerged to serve the Internet's voracious appetite for video stories.

Good videojournalism demands a broad set of technical skills and a real appreciation of how to tell a story. But with practice and knowledge borrowed from these traditions, the skill of videojournalism storytelling can be learned. As a matter of fact, that is expressly what this book is all about.

A VERY SHORT HISTORY

Around the turn of this century, circulation of traditional newspapers and magazines began falling at a speed corresponding to the skyrocketing use of the Internet. At about the same time, audiences for local broadcast television news were finding other sources of information, from cable television to the Web.

As print publishers' cash registers emptied, editors were told their savior would be the Internet. Editors' first reactions were to "shovel" material from their print publications to corresponding websites. Then . . . they hoped for the best. Needless to say, the "shovelware" approach to saving print journalism did not work.

Media consultants next informed editors that what they really needed to spice up their sites was multimedia—sound and pictures. The editors peered from their glass-enclosed offices and noticed the photo department. "Ah," they said collectively. "Hmmmh. Yes. Why not? Photographers can take care of the pictures. Let's send them out with audio recorders."

Overnight, editors reasoned, news sites would be dancing with multimedia stories told in sound and pictures.

And more or less, that is precisely what happened. They got sound. And they got pictures.

Suddenly, every self-respecting news website rushed to have a multimedia component. Still photographers went out the door with their traditional cameras slung over their shoulders and state-of-the-art, high-quality sound recorders in their hands. Editors told the photographers to find stories, shoot them, and record the sound. The photographers were directed to perform these tasks all at the same time. Then, they were told, they should go to the nearest coffee shop, edit the story on a laptop, and upload it to the publication's website. A few news outlets took the time to train photographers on sound recording, but many did not. Metaphorically speaking, the training back then consisted of inviting photographers to dive in and swim while manipulating both a camera and a sound recorder. That was the standard—painfully insufficient—training philosophy.

But, to the surprise of many, photojournalists willingly grabbed those handheld audio recorders as though they were a professional lifeline, and proceeded to learn to use those tools by the collective seat of their pants. With the advent of a simple computer program that facilitates combining images and audio—"Soundslides"—websites

▲ Videojournalists are using all kinds of cameras to shoot multimedia stories. (Photo by Betsy Brill)

across the country and around the world began featuring multimedia slideshows.

These newfangled slideshows were shorter than the hour length of a typical TV documentary or 90-minute cinematic release but longer than the typical one minute and thirty seconds of a television broadcast news story.

Unlike traditional documentary or broadcast news teams—consisting of a producer, an on-camera correspondent, a video camera operator, a sound technician, and sometimes even a lighting specialist—this new multimedia maker was by and large a one-man band, a solo operator, a backpack journalist.

Parallel to their counterparts at print publications, local TV news producers were pressed to save money in the face of declining viewership. They, too, espoused the notion that a lone-wolf journalist could report, voice, shoot, and edit his or her own story—that one person should combine the entire set of what had been unique skills to produce compelling stories.

At newspapers and magazines, the revolution did not stop with multimedia slideshows. Affordable digital video cameras and video editing software for personal computers came on the scene. And as the speed and bandwidth of the Internet grew, the ease with which it could send and play video also increased. Viewers were watching hours of video on YouTube and Vimeo.

So the same editors who had given out handheld recorders now wanted video stories,

too. Why not give photographers—and by now reporters, too—video cameras to tell stories?

Thus, TV stations and an array of publications assigned one person to do the work of many—to be a one-man band, a backpack journalist. Photojournalists, reporters, editors, and almost anyone who could carry a video camera were sent out the door and told to bring back pieces that would capture and hold viewers' attention on the Internet and even for on-air broadcast.

And that willy-nilly explosion of assignments to print and television journalists that required juggling new skills while still mastering them is where things became chancy.

Finding riveting stories, shooting them professionally with a video or hybrid still-video camera, interviewing subjects as expertly as a talk show host, recording clear sound, writing a script filled with pizzazz, and finally, editing the material into a piece worthy of five minutes' attention is not easy or straightforward. In fact, mastering this new form of storytelling and its requisite skills is as challenging to veteran visual reporters as it is to newbies to the field. Yes, more or less everyone can do it. But not everyone can do it well.

Indeed, the term "videojournalist" was invented to describe this jack-of-all-trades journalist who can and will "go it alone." Yet the very concept of videojournalism is so new that the word "videojournalist" is not yet in all dictionaries.

NEW BOOK

I wrote this book with the collaboration of eight contributors—a collaboration that represents the merger of traditions that has given birth to videojournalism. I decided to call the book *Videojournalism: Multimedia Storytelling*

because I sincerely want to assist anyone interested in learning how to master the art and craft of telling real short-form stories with words, sound, and pictures for the Web or television.

This book can be read in the order in which chapters are presented. Or it can be sampled in an order that corresponds to a reader's level of knowledge about the subject. For those who already know how to operate a video camera, the chapters on camera basics and exposure may be superfluous. Readers with a good foundation in media law need not spend much time with the law chapter. Anyone with a full-time job will likely find the chapter on marketing unnecessary. For those just starting out in multimedia storytelling, I dare hope that reading the foundation chapters will point you in a steady direction and perhaps help lead you to a career in the exciting new field of videojournalism and multimedia storytelling.

WEBSITE

Videojournalism: Multimedia Storytelling has its own website and Facebook page. You need go to only one URL to find all the stories mentioned in the book. You also will find "how-to" videos there. Bookmark this page, and you're all set to go: http://www.kobreguide.com/content/videojournalism.

You will see this icon to indicate when to go to the website for information or to view an online story. There you will find the title of the story or reference, the chapter and page number in which it appeared in the book and, when available, an image that corresponds to the one in the book.

To keep up with the latest changes in the field such as new cameras, new books, new stories, or editing software, check the site regularly and follow the KobreGuide on Facebook, www.facebook.com/KobreGuide. ∎

Contributor List

Chapter 1 Regina McCombs, Faculty for *Multimedia and Mobile*, The Poynter Institute

Chapter 2 Josh Meltzer, Photojournalist-in-residence at Western Kentucky University, formerly with *The Roanoke Times*

Chapter 3 Josh Meltzer, Photojournalist-in-residence at Western Kentucky University, formerly with *The Roanoke Times*

Chapter 4 Josh Meltzer, Photojournalist-in-residence at Western Kentucky University, formerly with *The Roanoke Times*

Chapter 11 Jerry Lazar, Editorial director, KobreGuide.com

Chapter 12 Stanley Heist, Lecturer, Philip Merrill College of Journalism, University of Maryland

Chapter 13 Kathy Kieliszewski, Deputy Director of Photo and Video, *Detroit Free Press*

Chapter 14 Donald R. Winslow, Editor, *News Photographer* magazine

Chapter 15 David Weintraub, Instructor, Visual Communications Sequence, School of Journalism and Mass Communications, University of South Carolina

Chapter 16 Mary Thorsby, Independent business writer, Thorsby and Associates ∎

Acknowledgements

For some books, the author goes into a dark room and writes and writes and writes and finally emerges with a manuscript. That was not the case with this one. This manuscript took a village to write. I had the help of eight professional contributors, each handling a different aspect of the videojournalism field; multiple editors who reviewed chapters with their own fine-toothed combs and found many a burr each time; plus a network of professional and academic reviewers who checked and double-checked for technical errors or omissions. Without the help of everyone who contributed, this book would never have exited the writing room and made it to your hands. Whatever mistakes may remain, of course, are mine alone.

▼ Mary Thorsby, a contributor to this book, shoots a test video.
(Photo by Ken Kobré)

MY MENTOR

First, I must thank **John Hewitt**, Professor Emeritus in the Department of Broadcast and Electronic Communication Arts at San Francisco State University, author of *Documentary Filmmaking*, my mentor of 12 years, my collaborator on many projects, my video editor, and my co-producer for "Deadline Every Second: On Assignment with 12 Associated Press Photographers." From my friend John, I have learned most of what I know about videojournalism.

CONTRIBUTORS

This book owes much of its depth and breadth to the eight contributors who each wrote chapters. I am confident their research and writing will stand the test of time.

Stan Heist, executive producer, *Maryland Newsline*, and adjunct professor, University of Maryland

Kathy Kieliszewski, Deputy Director of Photo and Video, *Detroit Free Press*

Jerry Lazar, editorial director, *KobreGuide.com*

Regina McCombs, faculty for Multimedia and Mobile, The Poynter Institute

Josh Meltzer, photojournalist-in-residence at Western Kentucky University, formerly with the *Roanoke Times*

Mary Thorsby, independent business writer, Thorsby and Associates

David Weintraub, instructor, Visual Communications Sequence, School of Journalism and Mass Communications, University of South Carolina

Donald R. Winslow, editor, *News Photographer* magazine

EDITORS

I want to thank the people who read every chapter, every page, and every word with an eye for clarity and consistency.

John Knowlton, founding editor of Business @ Home, currently directing the journalism program at Green River Community College, brought his copy editing skills to bear on the early manuscript.

David Weintraub, a teacher, writer, and editor par excellence, lectures on videojournalism at the University of South Carolina. He knows what to leave in and what to cut. His organizational skills helped give the whole project a coherent look and feel.

Suzanne White, a writer extraordinaire, studied the manuscript carefully, sentence by sentence. She read each sentence aloud to make sure it sounded good for the ear as well as for the eye. She has taught me never to accept a weak word when a more robust one is available.

Betsy Brill, a co-author with me on *Photography* (6th and 7th editions), editor for the past five editions of *Photojournalism: The Professionals' Approach*, and my wife, took the first pass at the technical chapters and tackled the final reading and fine-tuning of the entire book before it shipped to the printer.

Emmanuel Serrière, whose native language is French but who loves spotting typos in English, reviewed the final proofs and found the mistakes the rest of us had missed! Voilà!

ACADEMIC REVIEWERS

Max Negin, Elon University

Michael H. Rand, associate professor and coordinator of the Digital Video Center, Cleveland State University School of Communication

Jeff South, associate professor and director of undergraduate studies, School of Mass Communications, Virginia Commonwealth University

Susan Walker, broadcast journalism professor, Boston University

CHAPTER REVIEWERS/ PROFESSIONALS

Lisa Berglund, senior producer, World Vision, and former director of photography at KNSD-TV, San Diego

MJ Bogatin, media law attorney, Bogatin Corman and Gold

Denise Bostrom, professional screenwriter and screenwriting instructor, City College of San Francisco

John C. P. Goheen, executive producer, Terranova Pictures, and three-time National Press Photographers Association Television News Photographer of the Year

Stan Heist, adjunct professor, Philip Merrill College of Journalism at the University of Maryland College Park, and a former executive producer for the Capital News Service broadcast bureau

Russ Johnson, publisher, the Connected Traveler website, and 25-year radio-television professional

Rodney McMahon, director of photography/camera operator, CBS Television, International Cinematographer's Guild of America

Colin Mulvany, videojournalist, the *Spokane-Review* in Spokane, Washington

Steve Sweitzer, Sweitzer Productions, adjunct professor at Indiana University–Purdue University at Indianapolis, chairman of the National Press Photographers Association's Advanced Storytelling Workshop, and veteran television professional

VIDEOGRAPHERS AND PHOTOGRAPHERS

I also wish to thank all the videographer and photographers who contributed their powerful images to this book. Each of their names is listed under their picture. Their pictures gave this book its visual impact.

OTHER KEY CONTRIBUTORS

Ben Barbante, with whom I have worked for many years on other book projects, again came through with clear and informative line illustrations.

Bill Duke, a master photo illustrator, conceived, propped, shot, and assembled the cover illustration to humorously depict the many skills today's videojournalist must juggle.

Jerry Lazar, editorial director of *KobreGuide.com*, also organized the section of *KobreGuide.com* with all this book's references and featured stories.

Bill Pekala, general manager of Nikon Professional Services, generously loaned me an array of cameras and lenses to test Nikon's video capabilities as well as to shoot many of the book's demonstration photos.

Sibylla Herbrich and **Dave Hall** shot the lighting demonstration pictures.

MY EDITORS AT FOCAL PRESS

Elinor Actipis, my editor at Focal Press/Elsevier, recognized the need for this book and shepherded it through all its publishing stages.

Michele Cronin, editor at Focal Press/Elsevier, exhibited consistent patience with all the changes the book has undergone.

Nancy Kotary, copy editor, snagged final errors that had eluded other eyes, and formatted the typography for consistency.

Paige Larkin, production coordinator, LaurelTech, a division of diacriTech, worked with me patiently to assure text and pictures flowed together logically and aesthetically. ■

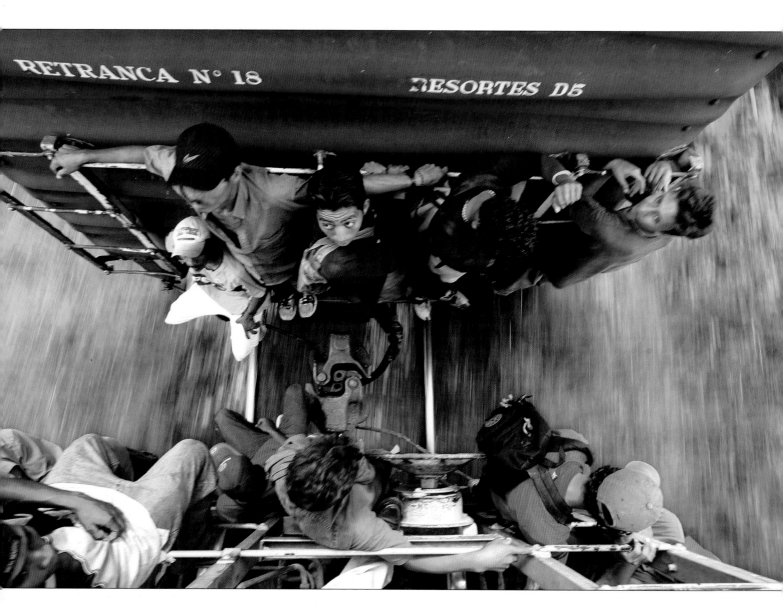

▲ **Train Jumping: A Desperate Journey.** The photographer rode the rails and the reporter provided a voice-over for this harrowing tale of immigrants trying to reach the "promised land." (Photo by Gary Coronado/ *Palm Beach Post*)

Telling Stories

Regina McCombs
Faculty for *Multimedia and Mobile,* The Poynter Institute
Additional material provided by **Stanley Heist, Kathy Kieliszewski, Ken Kobré, Josh Meltzer,
David Weintraub**, and **Suzanne White**

T his chapter is about the many ways to tell a story
and serves as an introduction to videojournalism as
it relates to nonfiction storytelling. Videojournalism
is not reality TV; it is not traditional front-page news articles.
The secret to good videojournalism lies in finding and telling
well-shaped, powerful stories in multimedia presentation. Most
successful stories have a main character.

There are many ways to tell a story. You can do it chrono-
logically—start at the beginning and end at the end. Or, you can
disclose the most important piece of information first, and then

This symbol indi-
cates when to go to
the *Videojournalism* website
for either links to more infor-
mation or to a story cited in
the text. Each reference will
be listed according to chapter
and page number. Links to
stories will include their titles
and, when available, images
corresponding to those in the
book. Bookmark the following
URL, and you're all set to go:
http://www.kobreguide.com/
content/videojournalism.

Or use your smart phone's QR
reader app to scan this code.

reveal the rest of the story, bit by bit. You can tell the story through the eyes of your characters, or from the viewpoint of an outsider. As a videojournalist, you get to decide how you will tell your story—in a way that will compel your audience to stop, look, and listen.

NARRATIVE ARC
You Tell Stories All the Time

You already know how to tell stories. Don't you do it all the time? When your car breaks down on the way to the hospital? Or your girlfriend or boyfriend leaves you? Or simply because your dog eats your homework? Then, quite naturally, you tell the tale to a friend.

How is **your story** different from the story in a novel or a movie? First and foremost, of course, your story is **real**. The events actually happened. They were not figments of your imagination. You did not invent the characters or the plot. Your story is nonfiction.

In this book, we will be dealing solely with true nonfiction stories—with events that actually happened in the past, are taking place right now, or might occur in the future. Herein we deal exclusively with actual events that happen to real people—not to actors, volunteers, or contestants. Again, this book deals only with reality.

▼ **The Reach of War: A deadly search for missing soldiers.** The photographer gives a firsthand report of the patrol in Iraq that he went on and that ended in tragedy. Three soldiers were wounded. One died. The photographer's images and narrative turn this incident into a gripping story. (Michael Kamber, *New York Times*)

Reality TV Versus Real Stories

◄ **Bachelor.** When "reality" show bachelor Jason Mesnick selected as his final choice Molly Malaney, whom he had rejected six weeks earlier, some viewers figured the change of heart was one more example of TV producers meddling with the outcome of supposedly "real" situations.

TV shows like *Big Brother* or *Survivors* are loosely referred to as "reality shows." But is reality TV real? Not quite. Reality TV shows such as *The Apprentice, Fear Factor,* and *The Amazing Race* are highly orchestrated and often partially fictionalized pieces of entertainment. They would not occur without a producer, multiple camera crews, willing participants, and bundles of money. These shows are contrived contests, not real stories. They would never have taken place without the creative energy of a writer, a producer, and a director. The outcome of such shows may be unknown at the beginning. But the setup is cleverly engineered to produce an almost fictional effect.

Real stories, on the other hand—those you see on television news programs such as *60 Minutes* or on the Web at KobreGuide.com—reveal actual people living through the thrills and pitfalls of unadulterated events in their lives without the interference of a script doctor.

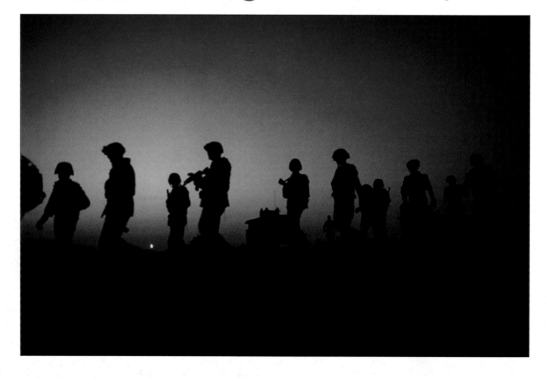

STORYTELLING OR NEWS REPORT

So how are stories you tell your friend different from front-page articles published in the newspaper or news segments broadcast on the six o'clock news with an anchor providing the lead-in?

Traditional News

Traditional news stories required starting with the most important fact—a form of news reporting called the inverted pyramid.

News reports sound like this:

A fire burned 30 homes in San Bruno today.

The San Francisco Giants won the World Series yesterday.

Sometimes news reports are just headlines. Sometimes they have more supporting facts. These reports relate what happened today but don't engage viewers with a character or plot.

Reports rarely introduce you to a subject, follow the subject from one state of emotion to another, see the challenge the person is facing, or reveal how the person resolves the problem. News articles and typical television reports are content to inform viewers. Storytelling, however, not only informs viewers but engages them emotionally.

Personal Story

Let's go back to your original story about the calamity of getting to the hospital despite your malfunctioning car, tragically breaking up with your sweetheart, or losing your homework to your rambunctious dog.

When you tell your interesting story, why doesn't your tale sound like a plain newspaper article or even a report on the evening news? It's because you are telling your story in the form of a narrative, not simply reciting facts with the most important fact at the beginning.

And, of course, your particular story has a sympathetic character—you!

Your story evokes the problems you yourself faced with a car breakdown, a relationship breakup, or mangled homework. "Oh boy, my car broke down on the way to the hospital." You might begin by exposing the problem. Then you might go on to explain what you did about overcoming the problem—how you had to call AAA and get a ride to the hospital in a tow truck; how many phone calls, gifts, cards, and letters it took to make up with your boyfriend or girlfriend; or how reprinting the brilliant 200-page term paper your dog ate almost made you miss the deadline for turning it in.

▼ **Car Accident.** Police officers hold up a white sheet as paramedics remove a victim from a Honda Civic that crashed on Robeson Street in Fayetteville, North Carolina. The victim died in the one-car accident. A standard news story puts the most important facts first. (Andrew Craft, *Fayetteville Observer*)

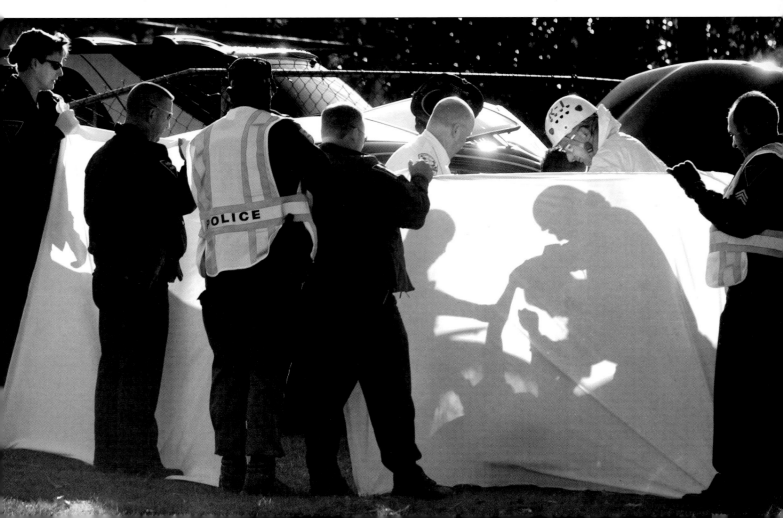

Your tale features a sensitive character (you!) facing an obstacle to overcome. Your adventure has a story arc—a beginning, a middle, and an end. Along that arc, you interject drama, humor, or insight as you reveal how you overcame the obstacle and what finally happened. In sharing your tale, you are—in the classic sense—a storyteller.

The Rise and Fall of Freytag's Pyramid

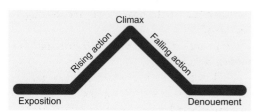

▲ **Freytag's Pyramid.** Classic storytelling structure.

The narrative is a classic storytelling form. Just like a movie, a novel, or even a story you share with your friends, the narrative contains a clear beginning, middle, and end. On this path lie an **exposition, rising action, climax, falling action,** and **dénouement, or resolution**—an arc known historically as **Freytag's Pyramid.**

- **Exposition** provides an introduction to the character(s), the conflict, and the basic setting.
- **Rising action** reveals the complication in more detail.
- **The climax** is the moment of greatest tension in a story, a turning point (for better or worse) in addressing the conflict or complication.
- **Falling action** is what unravels after the climax. In some cases, this may involve continuing suspense, but the story is now heading toward its conclusion.
- Finally, the **dénouement** is where complications are resolved and the story comes to an end.

Freytag's Pyramid, originally developed to analyze ancient Greek and Roman plays as well as those of Shakespeare, applies to documentary-style visual storytelling as well. You need to set up your story—characters, issues, location—in a way that allows events to unfold so that viewers learn more and more about the topic, the ways your characters are affected by it, how they develop a solution (or not), and finally, where they go from there. Just like the cowboy riding off in the sunset at the end of an old Western, at the end of your story, real characters go on with their lives.

► Consider a story about a vote on a proposed gasoline tax increase. Consider two approaches.

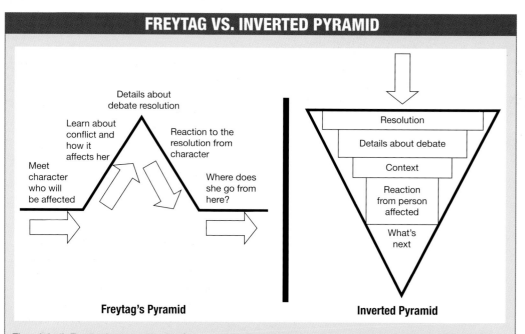

Though both **Freytag's** storytelling approach and the **inverted** pyramid approach communicate the news of the day (the resolution), the narrative approach (on the left) allows the audience to relate to the conflict before getting to the resolution. The inverted pyramid (on the right) gives the important information first but does not provide the audience with an emotional incentive to stick around for the entire story.

NARRATIVE VERSUS NEWS STORY
An Idea Is Not a Story

You may have tons of keen ideas for stories. But don't confuse an idea with a story.

Steve Kelley and Maisie Crow of Maryland's *Howard County Times,* for example, had the idea to document the effects of an incurable genetic disorder whose symptoms include insatiable hunger, low IQ, and behavioral problems. Although the disease is unusual, merely documenting Prader-Willi syndrome would only have yielded, perhaps, a well-done piece for medical students. But such a piece would not have told a story.

Instead of doing a mere report, Kelley and Crow presented the relationship between a teenage boy with the unusual disorder and his father, the boy's caregiver. The effects of the disease are shown in the five-minute multimedia video

▲ **Hungry: Living with Prader-Willi Syndrome.** The story shows not only the disease but also reveals how that disease has affected the father–son relationship. Note how in this video the sound track including the ticking clock adds depth to the story. (Steve Kelley and Maisie Crow, *Howard County Times*)

"Hungry: Living with Prader-Willi Syndrome." The story reveals how father and son deal with the toll the syndrome takes on their relationship, and the strength they find to survive.

Your first goal, then, is to find the story in your bright idea: how to turn an idea—"Living with Prader-Willi Syndrome," for example—into a story. The subject is the disease. The story is the relationship between the dad and the son who is afflicted with the disease. Once you have found the right story, your next goal will be shooting and recording it, writing a narration or script, and assembling the pieces during the

editing process. It is crucial to tell that story in a way that engages viewers emotionally.

Good Storyteller or Bore?

Let's face it. Some people are better narrators than others. Some start a story in the middle and have their audience nodding off within minutes. Others tell a story like it was a recitation of a list of facts. Yet others capture their audience from the opening words of "You won't believe this but when I . . ." to the final words "and then I got out safely."

What makes one storyteller electric and another tedious?

And, by the same token, what makes a short video documentary story that grabs viewers by their eyeballs and doesn't let go until the final credits different from a dull documentary which inspires the viewer to click "next" after 10 seconds?

Good videojournalists do not just report facts. They employ classic storytelling techniques to present accounts about real people. They share their stories in the form of short documentaries, usually shown on the Internet, but also on television, sometimes even in theatres. Videojournalism applies the fictional storyteller's techniques of character development and story arc to relate real-life tales of happiness, achievement, struggle, success, failure, and woe.

The secret lies in finding and telling powerful stories.

Kingsley's Crossing: A Compelling Narrative

Photographer Olivier Jobard of Sipa Press and producers Brian Storm and Eric Maierson of MediaStorm tell the story of Kingsley, a poor young Cameroonian man who is driven to emigrate to Europe to find a better life. Why? Because Kingsley faces poverty and stagnation at home. He is poor and going nowhere. He feels he must emigrate, to go elsewhere, to seek an escape. The blazing complication confronting Kingsley is the fact that he must emigrate illegally. As detailed in the multimedia piece "Kingsley's Crossing," the young man faces one perilous hurdle after another.

Kingsley was a 23-year-old lifeguard from the Cameroon in West Africa. As a lifeguard, he earned just enough to pay for food and the rented two-room house he shared with his

parents and seven siblings. In Europe—the new El Dorado—Kingsley knew that African immigrants could vastly increase their incomes while also providing for their families back home.

Photojournalist Olivier Jobard was vividly aware of the wave of African immigrants desperately seeking better lives and economic opportunities in Europe. To illustrate the conflicts facing these young people, Jobard decided to document one person making the treacherous, illegal journey from Africa to Europe. After paying the smugglers, Jobard and a friend who is a videojournalist made the crossing with Kingsley.

The multimedia presentation of "Kingsley's Crossing" on *MediaStorm.org* combines Olivier Jobard's still images with a videotaped interview

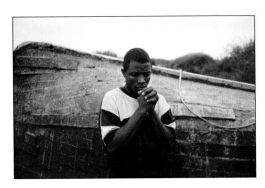

▲ **Kingsley's Crossing.** Kingsley, a 23-year-old Cameroonian, ponders migrating to Europe, where he hopes to have better job prospects and an improved quality of life.

Kingsley: "I was really scared not to fall off from the car because I was sitting just at the side at the edge of the car. And behind me there was guys fighting. 'Get off my leg, my leg, please, my leg.' The more we driving, the more we suffer from heat, sun, and dust."

Kingsley: "The captain successfully crossed the waves. Water was getting in everywhere. Rapidly. People become more and more frightened. Guys were shouting, 'Hey captain, turn back, turn back, turn back!'"

[At this point, a Spanish Coast Guard boat comes near.]

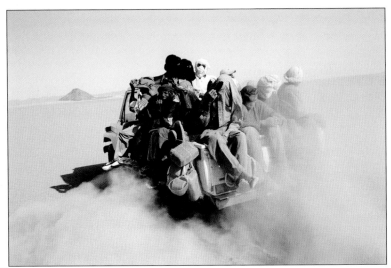

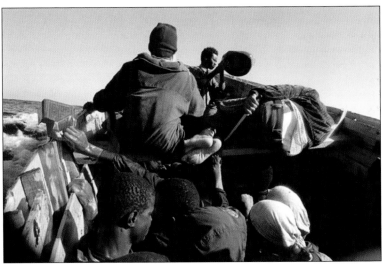

"They [the Spanish Coast Guard] told us nobody should make any move. Our boat might capsize, so they were calling us one after each. We were very, very happy. Now my life is safe."

Kingsley: "I contacted my only friend. We have grown up together. He's married to a French woman living in France. So I phone him and let him know that I've arrived. At the train station I was there waiting for my friend. He arrived behind me, and when he touched me it was a joy. Shouting, rejoicing. It was something marvelous. Later he carried me with his car to his house. Met his wife. We spent all our time talking. That day was really an exciting one. Crossing the ocean, the desert, that was the only way for me to make it out. And I did it." (Photography, Olivier Jobard/Sipa Press; Producers, Brian Storm and Eric Maierson, MediaStorm)

of Kingsley. The face-to-face on-camera interview introduces Kingsley to viewers. With this effective device, people get to hear the young man's story in his own voice. They are therefore engaged emotionally as he describes his desperate journey in his own words.

SHAPING A STORY

This is your challenge: how to shape your story and design the story's structure. Sometimes—but rarely—you'll know how before you even record the story. Most times, however, the story structure develops while you're working in the field. Sometimes it doesn't even develop until editing begins.

Three-Act Play

Many storytellers think of structure as a three-act play.

Act 1. Introduce your characters. Let us meet them; give us a reason to care about them and introduce the key layers of conflict.

Act 2. Reveal the complication. This is usually the longest part of the story. The act reveals how the layered complications intensify—there's no easy fix for the conflict from Act 1—until the final showdown: the crisis.

Act 3. Resolve the conflict/crisis, and finish the story in a satisfying way. This act reveals the choices made in the crisis and how these choices are resolved.

The three-act play design is as old as ancient Greece and as modern as the most recent Hollywood release. Watch movies, TV shows, and even some commercials closely for structure and you will see the three-act construct used over and over again.

In "Hungry: Living with Prader-Willi Syndrome," mentioned earlier, the first act introduces you to the father and son. The second act explains the disease. And the third act shows how the disease brings the father and son closer.

In "Kingsley's Crossing," Kingsley emigrates illegally from Cameroon to escape the country's grinding poverty. In Act 1, you meet Kingsley in Cameroon and come to know a little bit about him and why he is desperate to escape his present circumstances. In Act 2, you follow his harrowing adventures in trying to cross the desert sands and the Mediterranean Sea to reach economic freedom. Finally, in Act 3, you witness the outcome of his trials.

Complication and Resolution

In his book *Writing for Story,* Pulitzer Prize-winning author Jon Franklin says that stories share a common structure but are a bit different than the three-act play. Franklin, who twice won the prestigious Pulitzer award for feature writing, says that stories revolve around a complication and its resolution. Good stories typically contain layers of complications.

Complications can be good or bad. Franklin defines a **complication** as any problem that a person encounters. Being threatened by a bully is a complication. Having a car stolen or being diagnosed with cancer is a complication.

In "Kingsley's Crossing," the central character recounts the complications he faces in his harrowing attempts to escape the grinding poverty of Cameroon and reach Europe illegally. You witness the roadblocks he must overcome as he tries to cross the dessert and the sea.

The story of "Kingsley's Crossing" serves as an example of a three-act play but can also be analyzed using Franklin's complication and resolution concept.

Complications are not all bad, Franklin says. Falling in love is a complication because you may not know whether the other person is in love, too. Winning the lottery means you get to figure out how to spend the money—but still you must pay the taxes.

Significant. Complications that lend themselves to journalism must tap into a problem basic enough and significant enough that most people can relate to it. When a mosquito bites you, you have a complication. But it neither reflects a basic human dilemma nor a significant universal problem. Discovering you have malaria and might die, on the other hand, is a fundamental complication that would be significant to most readers. Kingsley faced potentially deadly complications from every side as he battled his way towards what he thought would bring him a better life in Europe.

Resolution. The second part of a good story involves a **resolution**, which Franklin says in his book "is any change in the character or situation that resolves the complication."

Whether you are cured of malaria or die from the disease, the complication is resolved. For stories with complications and resolutions, Franklin points out that most daily problems don't have resolutions and therefore don't lend themselves to creating terrific stories. After months of struggle, Kingsley's story came to a resolution when he finally reached France and was able to stay.

External and internal conflict. Although Franklin is talking to writers, his central idea is applicable to many other story forms. Let's dissect his central thesis and see how it applies to video. "To be of literary value," he says, "a complication must not only be basic but also significant to the human condition."

So complication—sometimes called "conflict" or "tension"—is an essential story element. Just introducing a character is not enough to tell a compelling story. Adding a complication—an obstacle to the character's progress—enables us to relate to the person facing it.

Kingsley, the central character in the story "Kingsley's Crossing," had to overcome dangerous obstacles including highway robbers, breakdowns in the dessert and leaky boats, in his quest to reach Europe and a better life.

In many hard news stories, the tension is obvious: man against fire; woman fighting discrimination; child triumphing over a bully; police solving a mystery; neighbors battling over property lines; and so on. These all originate as external conflicts. Hence, they are easy to see and relate in a story.

Feature or in-depth stories can be much more subtle, as they may involve internal conflicts or reveal understated complications. Overcoming depression after a divorce, for example, involves an internal change in the person. The challenge to the person is just as big as if they had fought a fire or triumphed over a bully, but the changes take place internally. In any case, we now know that to be worthwhile to any reader or viewer, a story must contain tension.

The "Why" question. How do we identify and use this tension? When searching for tension in a story, it helps to start with one simple question: **why**?

What is motivating the character or characters? Motives frequently reveal tense inner conflicts and help us to answer the **Why** question. Merely showing someone creating a sculpture is not a story. It's a demonstration of a process.

To get to the complication within the sculpting process, we want to ask an artist, "**Why** do you create these sculptures?" Using this tactic, we are likely to uncover some intriguing surprises. The sculptor might have a burning desire to form some image from his dreams or might want to experiment with how a particular shape looks when it is constructed from a unique material.

Peoples' motives may include wanting to please someone else, or they may possess an inner compulsion they feel must be obeyed. Subtle motives such as these constitute complicating factors that help make up a more compelling story.

Protagonist wants change. Stories begin when protagonists want to change their lives, their environments, or something or someone else. Kingsley wanted to change his life. In fact, he had tried to reach Europe on an earlier attempt but failed. Protagonists may know they want to change consciously or unconsciously, but when an event throws their lives out of balance (sometimes called an *inciting incident*) protagonists decide to act. In any story you produce, look for the inciting incident that tips the balance.

So now we can see that a complication is established once the audience can identify a drive, or a pressing need, in a character. The protagonist wants to change.

CHARACTER-DRIVEN STORIES

Although every story does not have to have a main character, most successful stories do. Finding a compelling central character or group of characters can mean the difference between a lifeless story and an outstanding one. The young man with Prader-Willi syndrome is a sympathetic character that lets you feel his pain. Kingsley personalizes the problems of mass emigration.

The main character might simply be someone who has an intriguing tale to tell, or a person with a unique talent, an unusual achievement, or a quirky personality. Or your central character may be someone who can personalize a complex issue such as health care or environmental pollution.

Unique Talent

Here is a story based on a unique talent. In "Collin Rocks," by Boyd Huppert and Jonathan Malat of KARE-TV in Minneapolis, our "hero" is a kid with a unique talent. As the story develops, we find out that he has a medical history and a

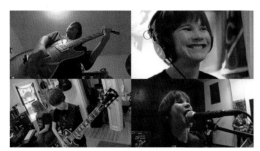

▲ **Collin Rocks.** Collin, the main character in this short video, has a personality that helps to bring the story to **life.** (Boyd Huppert and Jonathan Malat, KARE, Minneapolis)

personality that make him special. He's a character worth knowing. Along the way, we meet a supporting cast, as well—his parents, sister, teachers—each of whom helps develop important elements of Collin's story.

Personalize an Issue

The second possibility for a central character is someone who personally illustrates an important issue or problem. This character becomes Everyman or Everywoman and helps viewers relate to what otherwise might be a dry, tedious, fact-filled story. These characters' individual situations can clearly illustrate such issues as government funding, health insurance, or the complexities of the legal system. By meeting so directly with someone struggling against an unyielding obstacle, viewers can both sympathize and even identify with the person. In this way, the viewer experiences a clearer, more emotional impact of how laws and regulations can really affect a single human being.

For an example of someone personifying a national problem, consider the story of Phan Plork and his wife Tal, Cambodian refugees who had found a home and a good living shrimping off of the Louisiana coast. Their lives changed radically after the BP oil rig exploded and polluted the water for hundreds of miles, shutting down commercial fishing. Now instead of shrimping, Phan's boat and crew had to work soaking up floating crude oil with fabric booms. BP pays Phan a take-it-or-leave-it day rate for his services. That day rate is half what Plork made before the spill.

This *Los Angeles Times* video by Sachi Cunningham profiles the Plorks as they try to make the best of a disastrous situation, giving the viewer a personal look at the effect the spill has had on the fishing community. Tal prays for her husband's safety while Phan and his crew, wearing protective suits and gloves, are seen hauling thick ropes of oil-soaked material from the water—a far cry from prespill days when they handled wiggling shrimp rather than toxic substances. It is obvious that with no experience, the shrimpers are ineffective at gathering oil.

In the video, Plork reminisces about his childhood days in Cambodia where he was starving under the Pol Pot regime. He tells us how much better his life has been in the United States until now. But this oil gathering is dangerous work for a shrimp boat that is likely to founder in the open ocean should a storm come up. "Looks like this is what we're gonna be doin' for a living from now on," he tells his fellow fisherman.

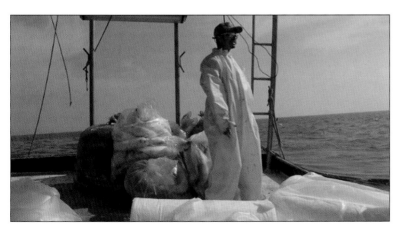

▲ **They Have Struck Oil But They Are Not Rich.** Phan Plork is a commercial fisherman that lost a large part of his income because of the British Petroleum (BP) oil spill in the Golf of Mexico. The core of the video rests on Plork telling his own story.

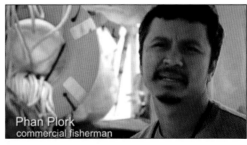

Phan Plork
commercial fisherman

▲ Phan Plork is the central character in a story that humanizes the impact of the British Petroleum oil spill off the Louisiana coast.
(Sachi Cunningham, *Los Angeles Times*)

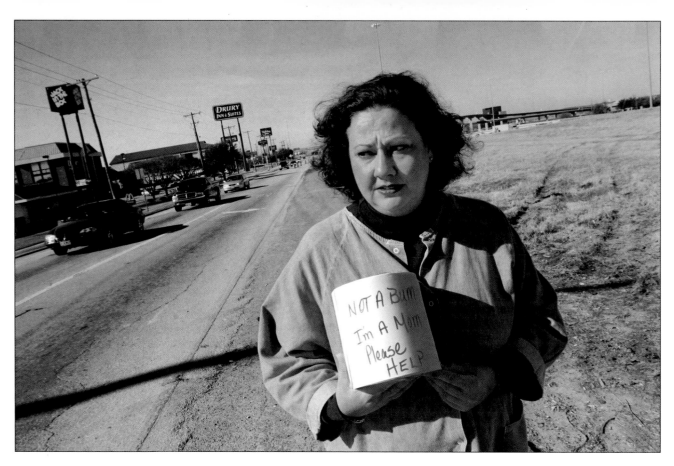

▲ **Denied.** In "Denied," the photographer and videographer tell the story of health care through the experiences of one woman who had to ask for help on the road side to pay her medical bills. (Photo by Ed Kashi)

In "Denied," directed and produced by Julie Winokur and Sheila Wessenberg, the central subject represents Everywoman and Everyman caught in the tangled web of the American health-care industry. Unable to afford escalating insurance premiums, the central character had to stop chemotherapy for breast cancer. She died the day before she would have been eligible for Medicare, the government-supported health care program.

STRONG, NUANCED PERSONALITY

Strong characters often become obvious—they have vivid personalities and the ability to speak clearly and are personally compelling. They should be like a friend everyone wants to hang with. They entertain us, enlighten us, and stay focused on the story they're telling us. Wanting to hear more about someone when meeting him for the first time is a good sign. To spot possible strong characters, when you're in the field on an assignment, looking for people to interview, watch for the person in the crowd who makes eye contact despite the fact that you are toting a camera.

Bethany Swain, a photojournalist at CNN who also produces the network's photographer-driven "In Focus" series, says she asks others to help her find the right subject. "If I am going to interview one person in a group (such as a group of students), I will often ask them, "Who's the most talkative?" or "Is there anyone you think I will enjoy talking to?" Swain's method, she says, nets much better results than asking someone who the most important person is.

Strong characters are often nuanced characters: we get to see their strengths and vulnerabilities. We get to see them begin a journey to "right a wrong," or "change a situation, or save a person's life," but strong characters also go through an arc, in which they will have to face grave doubt, fear, insecurity, and have to dig deep to find out not only what they truly believe, but also reconsider their goals and/or visions.

An Unforgettable Character

David Stephenson of the *Lexington Herald-Leader* found a great character in Ernie Brown, Jr., a snapping-turtle catcher in Kentucky. In

▲ **Ernie Brown, Jr.,** known as the Turtle Man, is trying to make a name for himself for his entertaining style of catching snapping turtles with his bare hands. (Photo by David Stephenson/*Lexington Herald Leader*)

Stephenson's piece "Turtle Man," Brown pops off one-liners in his thick Kentuckian accent and behaves in the most extraordinary ways. He dives into muddy water and pulls up a large snapping turtle with his bare hands, all the while giving an ear-splitting whoop of success. Brown's is a story of the odd and the extreme, which is one reason this character appeals to such a wide audience.

"Ernie is entertaining, and, in fact, he wants to be an entertainer. That is actually a big part of the story," Stephenson says in an interview for this book. "In fact, Ernie tries too hard to be an entertainer, which ends up being funny. He's odd and unusual, but simply put, he makes funny sounds—much beyond his dialect and accent—and he whoops and he hollers."

Stephenson said that many journalists had done stories on the Turtle Man. So he and writer/narrator Amy Wilson decided to take the story a bit deeper. "We wanted to examine more about why Ernie Brown wants to become famous. Basically, he doesn't have what it takes to make it big nationally or internationally. He's really not sophisticated enough. But he does well at the kitschy, campy level, which will probably be fine for him. He'll make money at it, and as he says, 'I'm the poorest famous guy around.'" So Ernie's tale, which on its base level is just funny and fun, was taken to a higher level of storytelling because the creators of the piece went one step further and looked into Ernie's quest to become famous, albeit in his own weird and unique way. Amy Wilson and David Stephenson sought to engage viewers emotionally. And they succeeded.

Though Stephenson often works with a writer who will narrate parts of his stories, he prefers to let his subjects narrate their own stories. He says, "Whenever we can let our subjects have a voice . . . if they have the power to articulate, then all the better."

Strong characters, though, don't often make themselves as obvious as the Turtle Man. You must seek them out by opening your eyes and ears and sometimes holding dozens of mini pre-interviews while scouring your scene for just the substantial character whose presence will place a gentle five-minute hook into your audience's attention span.

Find Subjects to Tell All Sides

If your story centers on a public conflict, remember that one character is hardly ever enough. Each side of an issue needs to be represented by equally well-spoken and authentic voices.

Anticipating the 25th anniversary of what was supposed to have been a strategic bombing intended to clear a building of members of a controversial liberation group, editors at the *Philadelphia Inquirer* set out to produce a comprehensive multimedia package on the tragedy, which ultimately claimed 11 lives (including 5 children) and damaged or demolished 65 surrounding homes. The project includes entire archives of stories and photos related to the liberation group MOVE and its history. Four videos, a photo gallery, an interactive timeline, and extensive articles document and explore the impact of the tragedy through the voices of neighborhood residents, police and fire officers, politicians then and now, and the only surviving adult member of MOVE.

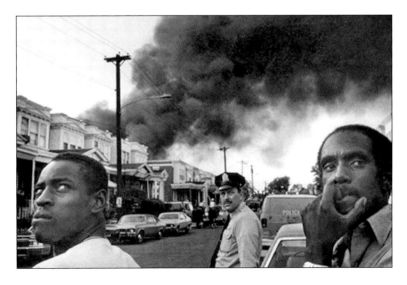

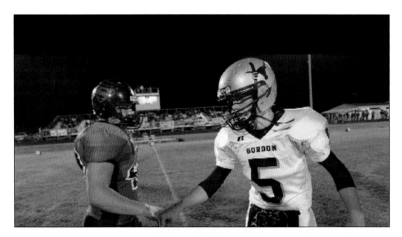

▶ The Texas towns of Gordon and Strawn are only eight miles apart and the high schools play 6-man football because they're so small that they don't have enough boys to field regular 11-man teams.

▶ Residents in both towns are crazy about football and once a year the neighboring teams play each other in a heated rivalry that began 86 years ago. The game is about as important as graduation, one player says. "All that matters is how you play on this night." (Produced by Jay Janner, narrated by Kevin Robbins, *Austin American-Statesman*)

UNIVERSAL THEMES

All humans share certain common experiences, such as birth, death, love, fear, joy, and, for many, a sense of competition. Universal themes might include: what it means to be a hero, looking at evil, defining success. If you are lucky enough to hit on a story that touches on universal themes, chances are your audience's interest will be aroused.

Rivalry

The Texas towns of Gordon and Strawn are only eight miles apart and the high schools play 6-man football because the schools are so small that they don't have enough boys to field regular 11-man teams.

The narrated audio slideshow, "The Schools Are Tiny; The Game Is Huge," produced by Jay Janner of the *Austin American-Statesman*, is a well-crafted combination of stills, natural sound, music, and interviews. It reveals the history of the rivalry in the town and then builds suspense

◀ **The Schools Are Tiny; The Game Is Huge.** The story reveals the history of the rivalry between two small schools in Texas and then builds in anticipation as it follows the teams on the night of their highly anticipated annual showdown.

as it follows the teams on the night of their highly anticipated annual showdown.

Although not everyone has gone to a tiny high school in Texas, most people have experienced some from of rivalry or competition—for a job, for a scholarship, or on the playing field.

As part of AARP's monthly series on triumphant mid-life transitions, "Your Life Calling," NBC's Jane Pauley profiles Robert Rudolph, 53, who left a mortgage-broker career and his 5,000-square-foot Atlanta home to return to his original passion—church music.

Through sit-down and walk-and-talk interviews, along with high-quality b-roll that incorporates images from throughout Rudolph's adult career, Pauley elicits the saga of Rudolph's professional rise, fall, and resurrection.

Rudolph had gotten a master's degree in music. But, following in the footsteps of his businessman father, who valued getting a job that would pay enough to enable early retirement, Rudolph pursued a traditional corporate career. However, when the bottom fell out of the housing market, Rudolph saw an open door. While job hunting (in vain), he returned to his lifelong passion for church music, burning through all his savings and possessions in the process. Finally, a small church offered him a job, which led to another position as a choir director—and sure enough—Rudolph was soon pursuing a new life path.

◀ **Rediscovering a Passion for Music.** Robert Rudolph finally gets to live out his dream as the director of a choir.

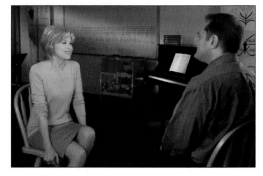

▲ NBC's Jane Pauley interviews Robert Rudolph, 53, who always wanted to be involved in church music.

Identifying universal themes like competition, a dream, birth, death, love, fear, or joy in a particular situation is a way to connect your story to your viewers' lives. (See Chapter 3, "Successful Story Topics.")

A SLICE-OF-LIFE STORY

A slice-of-life story dissects the ordinary life of someone or some place with which the viewer is probably unfamiliar.

Point of View

The slice-of-life story has a point of view. A story of this kind might document how a single mom manages a household while juggling jobs and raising kids. The videographer doesn't just document every moment of the woman's life but selectively captures the scenes that reveal the challenges of single motherhood. A slice-of-life story might document a chef driving his pop-up food van and delivering gourmet meals to hundreds of eager customers. The story could concentrate on the pressures the cook faces every day to meet his demanding clients. A slice-of-life story following an emergency room (ER) nurse on a Saturday night could highlight the contrast between hours of total boredom and the seconds of flat-out stress during an evening in the ER. Even a casual observation of the life of an immigrant gardener might show how he handles the demands and whims of his well-heeled clients. A slice of life of a place might tease out what makes a small French town so French. The video would highlight the aspects that give the town its special character.

Slice of Life Versus a Narrative

In a narrative story, as discussed earlier, the protagonist faces a complication in life and either the person or the situation changes. In a slice-of-life documentary, nothing changes. A conflict is not resolved. No resolution occurs. Instead, observes Denise Bostrom, screenwriting instructor at City College of San Francisco, the viewer gets to see the inner working of another person's life or another place. These people or places serve to make a point the videojournalist wants to emphasize. These kinds of stories can reveal the stress of a single mom, the pressures of a chief, or the "Frenchness" of a French town.

In a story called "Jonnie Footman, New York City's 90-Year-Old Cabbie," videojournalists produced for *MediaStorm* a slice-of-life personality profile of this lively, opinionated cab driver who still navigates the streets of the big city. This memorable character's spunkiness provides a point of view in the video.

In Travis Fox's short video documentary "Portrait of Coney Island," the videojournalist

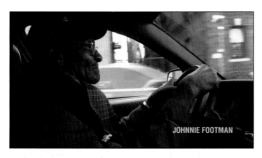

▲ **Johnnie Footman: New York City's 90-Year-Old Cabbie.** At 90, Johnnie Footman is probably the oldest cabbie driver in New York City. Footman's quirky personality, captured as he spouts his opinions on his customers, women and his past, provide the story's point of view. (Photography and video Jan Johannessen and Charlotte Oestervang; audio Scott Anger and Charlotte Oestervang; editing Scott Anger and Megan Lange; produced by Scott Anger and Megan Lange/MediaStorm)

PORTRAIT OF CONEY ISLAND

◄ Sideshow tent. With the purchase of most of Coney Island's six-block area by a commercial developer, Travis Fox's short documentary captures the last of its pre-Disney past. (Travis Fox, *The Washington Post*)

◄ Cyclone Roller Coaster.

◄ Barker with a screwdriver up his nose.

◄ "Shoot the Freak" paintball.

presents a slice-of-life portrayal of this soon-to-be demolished amusement park. Without the aid of any voiceover to explain what the viewer is seeing, he lays out some special aspects of this nostalgic, pre-Disney entertainment spot. Fox's point of view comes across clearly in his subject choice. He has chosen to highlight some of the more bizarre aspects of the boardwalk.

DAY-IN-THE-LIFE

A day-in-the-life story records the activities of someone through a period of time—such as the length of a day. The videojournalist shoots everything in hopes of capturing revealing details. But most people's daily lives are not actual stories. See if you can remember any of the individuals or the stories featured in the many beautiful picture books with the theme "A Day in the Life." You can't? Why? Because the *Day in the Life* books consist of beautiful images, but the individual pictures don't add up to tell a coherent story.

Central Theme, Point of View Lacking

There are other differences, too, between a day-in-the-life and a true story approach. A day-in-the-life video has no central theme or point of view. Someone doesn't necessarily face and/or resolve the conflict and resolution of an external or internal problem even if you follow them from morning to night (as discussed shortly). A day-in-the-life video is merely documentation of what happens over a period of time.

When possible, look for a better story plot than a day in the life of your subject. Day-in-the-life projects make nice coffee table books, where there is little competition for attention, but they do not work as stories told for the Internet.

From Day-in-Life Idea to Themed Story

Seasoned photojournalist Eileen Blass, a staff photographer at *USA Today*, was attending a Western Kentucky University Mountain Workshop on multimedia storytelling when she selected as a story idea a Kentucky family who runs an organic farm. Bob Sacha, a multimedia journalist and Eileen's coach at the workshop, asked her to explain in two minutes or less what the story (not the idea!) was going to be about. She replied that her plan was to make a story about how this farmer had to work a second job as a conservation officer in order to maintain the family farm—basically a day in the life of a man

struggling to maintain his farm. "But I didn't have a focus beyond that," Blass admits.

Her plan, Blass told her workshop mentor, was to hang out for a couple of days and hope that the story would sort itself out. "Without an interview, I really didn't know what the story would be. So for the first day or so, I shot everything in sight—a few hours of tape," Blass recalls.

"I'm actually personally interested in organic farming and healthy eating," she says, "but even I had no real interest in the story so far. For me— and for a general audience—I still wondered why we were going to connect to the story. I knew that a broad audience wasn't going to connect because of healthy eating or organic farming. I needed some other, more universal and emotional draw. Frankly, at that point my story sounded pretty boring," she said in an interview after the workshop.

Blass says she was pretty lost on the first day, so she was shooting everything in sight. She did conduct interviews, trying to make some kind of story pan out of her original idea. But it still didn't have the necessary emotional attraction that Bob Sacha wanted.

Finding a Theme

Says Blass, "All along I've been told that at the end of an interview I should always ask, 'Is there something else I should know?' I did just that with the farmer, and that was the moment when he really told me what was on his mind. He explained that a good friend, an older farmer, had just passed away. As he told me about his friend, he became very emotional and teary-eyed. I certainly didn't expect that," she recalls in an interview for this chapter. "It really took me aback. He cried about his friend who taught him how to make sweet sorghum, and how he planned to preserve that tradition. So at that moment, I knew I had the story."

Her idea to follow the farmer's efforts to maintain the farm while working another job became instead a story about relationships, tradition, loss, and love. These are the types of themes that a broad audience can and will relate to on an emotional level.

Blass's final story, just over two minutes in length, centered on these universal themes—still showing, of course, that the subject is an organic farmer. But as the farmer moved through his day, Blass's story focused on emotional issues, to which an audience can connect.

Concise Description

A handy measure of whether you have a decent story is to try to describe your story in two or three sentences to another person. With a little practice, you should be able to concisely introduce the characters, set up their conflicts, and evoke their challenges.

Eileen Blass might describe her story this way: "This is a story about a young organic farmer dealing with the loss of a dear friend and fellow farmer. To help deal with this loss, he preserves the traditions taught to him by his late friend, and honors him by practicing what he was taught." If you can reduce your tale to a few concise lines and make it worthwhile for someone to listen to, chances are you've got yourself a terrific story.

▼ **Tethered to Tradition.** Brad Lowe feeds his chickens and turkeys on his family's farm, Hillyard Field Organics in Murray, Kentucky.

The video became more than just a day in the life of this farmer because the videographer looked for **universal themes.** (Produced by Eileen Blass)

AUDIENCE MUST CARE

So now you know much more about stories. All kinds of tales of human experience: adventure, escape, loss, rebirth, rivalry, revenge, sorrow—and then some—all of these can be foundations for stories. Of course, even with the most captivating theme, we still need a strong character or characters. We need the audience to care about the characters. It's up to us to assemble the puzzle pieces of sound and pictures into a story that sings. One thing is certain: good stories are not just pretty pictures. ■

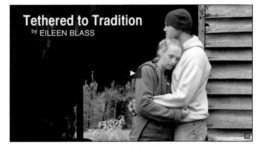

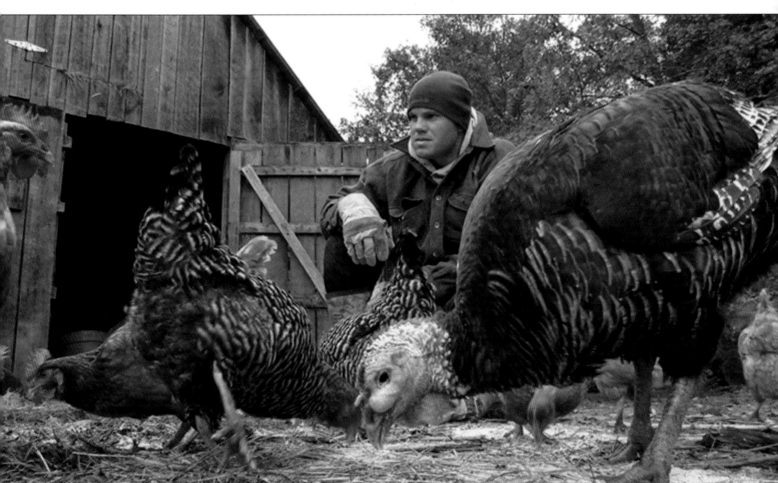

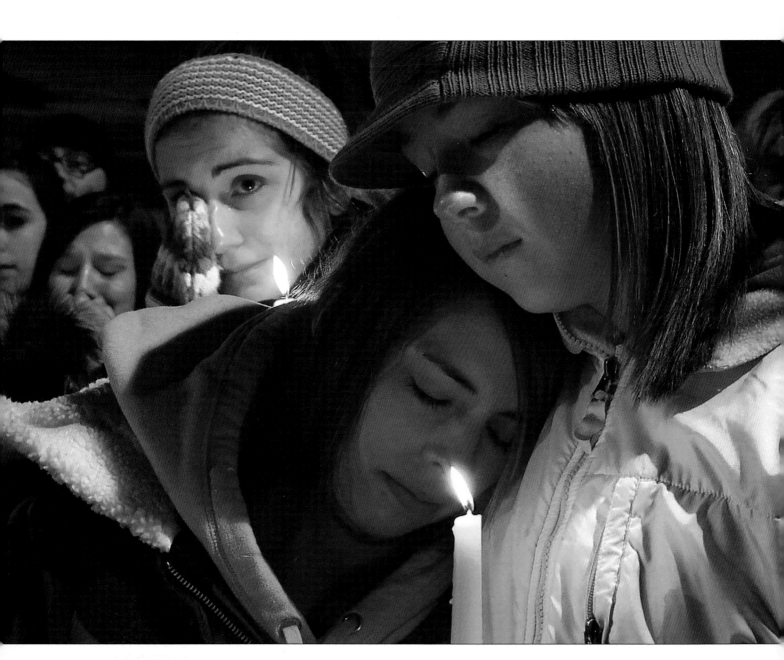

▲ **Vigil for Teen Crash Victim.** A videojournalist has to stay current. The day after a Cheney High School student died in a two-vehicle collision, mourners gathered for a candlelight vigil near the scene of the accident. There was something about the short news brief on his paper's website that caught the producer's eye. (Photo by Colin Mulvany, *Spokesman-Review*)

Finding and Evaluating a Story

Josh Meltzer

Photojournalist-in-residence at Western Kentucky University, formerly with *The Roanoke Times*

N ow that you've learned what makes great storytelling, how do you actually go about finding possible stories and evaluating their potential for your video and multimedia journalism projects? Sometimes a story comes from the videojournalist's own experience. Sometimes it comes from talking with other people. Story leads can grow out of news assignments. Following are some other possible sources for stories.

This symbol indicates when to go to the *Videojournalism* website for either links to more information or to a story cited in the text. Each reference will be listed according to chapter and page number. Links to stories will include their titles and, when available, images corresponding to those in the book. Bookmark the following URL, and you're all set to go: http://www.kobreguide.com/content/videojournalism.

WHERE TO DISCOVER STORY IDEAS

Stories are all around you, but how do you get started? Watch for trends that might include shifts in the public's buying preferences, changes in lifestyles, or a technology revolution in an industry. For example, a news story about a new smart phone might result in a trend story that looks all the ways smart phones have changed how people communicate.

A trend doesn't start in one day; it occurs gradually over time. Gary Coronado, a staffer for the *Palm Beach Post,* read an opinion piece about the trend for Central American immigrants to jump on trains for a free ride to the United States. He filed the clipping and later pitched the story to his editor. His dramatic multimedia story is called "Train Jumping."

Read the Paper or The News Online

"Having worked at the same newspaper for 22 years," says Colin Mulvany, a multimedia producer at the *Spokesman-Review* in Spokane, Washington, "I feel pretty connected to my community. I know what is happening in my town. I know what people are talking about and this helps lead me to good stories.

"Many times at my newspaper, word editors would pitch stories about major community events. My approach is to think less about an event and more about the people at the event. Personalizing a big, sprawling story with compelling characters will make your video stories come alive.

"In order to find multimedia story possibilities, I troll the newspaper's lists of upcoming stories (a.k.a. story budget). The deciding factor on whether to commit to doing a video or audio slideshow versus doing a still photo depends on two things: (1) is there a strong central character in the story and (2) is it visual? One without the other is usually a no-go.

"I'm always searching for that elusive emotional gem. When we package a daily video with a print story, I look for ways to tell the story a little differently than what the print reporter is doing. Instead of thinking broad, I think defined. That can mean focusing on just one or two subjects out of six the reporter might have talked to.

"Nearly all global stories have local impact," says Mulvany. "Nearly every small town has a soldier in the wars in Afghanistan or Iraq. Every rural county has families with unemployed parents due to the struggling economy.

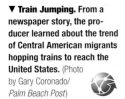

▼ **Train Jumping.** From a newspaper story, the producer learned about the trend of Central American migrants hopping trains to reach the United States. (Photo by Gary Coronado/ *Palm Beach Post*)

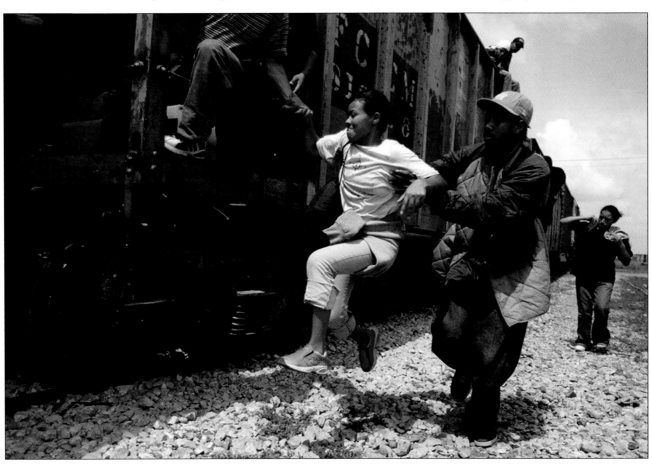

"Reporting and producing stories like these to your local audience will help put global events into better perspective, and when you do so with a strong narrative and powerful characters, you can really draw in your audience and make a powerful connection with them."

Mulvany's advice on finding stories: "Find time every day to read and listen to news and information that you can use for story ideas in your work. Listen to NPR, read national and international publications like the *New York Times* and the *Wall Street Journal.* Watch a variety of television news programs to stay informed. Write down your ideas and follow them up with research."

Craigslist, Classified Ads, and Social Media

Today, online classifieds like Craigslist, and social media outlets like Facebook are exploding in popularity. We all know by now that social media is a handy tool for keeping up with friends and family, but that's not all its only use. It also allows us stay abreast of what's going on locally. Make use of your connections to people who are more in the know than you are. Participate in discussions. Check out those sites daily and maintain your connections by interacting. Social media sites make excellent sources for story ideas and subjects. You may find that an acquaintance is aware of a strawberry festival or a baton twirling contest, a beauty pageant or an important political gathering going on in your town. If you're always at the ready, you can quickly run out and cover it. Use tools like Facebook and Twitter to stay in touch. They might indeed lead you to some unexpectedly terrific stories.

ICU: Los Angeles Connections. Craigslist, the Internet's global classified website, can be a gold mine of story ideas. The *Los Angeles Times* produced an entire series of stories that were found in the "Missed Connections" section of Craigslist. In this section of the site, people describe a situation about how they almost met someone they had encountered. But, for a variety of reasons, they didn't get the opportunity to actually meet that person. The stories about these missed opportunities—called ICU, as in I See You—feature love, lust, loss, and intrigue and span the emotional spectrum from heartfelt to hilarious.

Videojournalist Katy Newton, the project's producer, came up with the idea. "I had a friend who was going to Trader Joe's for weeks at the same time hoping to see a guy again whom she hoped might be the perfect match for her, based on the vegetables he was choosing," Newton explains. "I had never heard of Craigslist's Missed Connections, but when I checked it out the next day, my first reaction was that many listings in that section of Craigslist are real human interest stories. They contain drama, and they're all set up with engaging characters who have a pressing need they feel must be fulfilled."

The fact that all of these stories had built-in compelling narratives was just what Newton was looking for to apply to a regularly running series of online video stories.

After Newton came up with the idea and made a successful pitch to her editors, she began the process of weeding through hundreds of ads a week, getting up early each day to read the posts on Missed Connections. "Just by the way they wrote the ad," Newton says, "I could tell which ones would be good storytellers, and so I would email about a dozen people a day and hear back from a couple and narrow my choice down from there after talking on the phone."

"These narratives that unfold from Missed Connections have perfect built-in arcs," says Katy Newton. For example, one of Newton's stories is about a woman who hits a guy on a bike with her car.

First she sets up a normal day. A woman is driving in to get gas and then—wham!—she hits something or someone with her car. This moment creates speculation in the audience's mind. What or whom did she hit? Then, she inserts an amusing comment. The audience is taken quite by surprise when the woman says, "I thought I might have hit a baby." Then the truth is revealed. The driver has hit a man on a bike. One might expect the man to be angry or sustain a severe injury. The two characters might end up hating one another. Instead, Newton explains, the story has a twist. The guy isn't

▲ ICU: Los Angeles Connections.

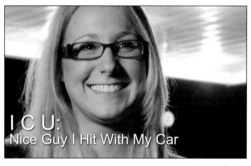

▲ **ICU: Nice Guy I Hit with My Car.** The videojournalist found her subjects by searching the Missed Connections section of Craigslist. (Produced by Katy Newton)

angry with the woman. Instead, he is worried about *her*. This comes as a welcome shock—not only to the woman, but also to the viewer. In a happy instant, the perpetrator, the woman has found the type of guy she has been looking for—someone who values the welfare of others before his own. Who wouldn't want to meet someone like that? Of course, the resolution of the story isn't that the couple lives happily ever after but that the main character finds the type of man she has been dreaming of meeting. The quirky part is that he disappears. Now, the young woman is left to wonder. She has no idea how to contact this man of her dreams again. Hence the original reason for her posting on Craigslist's Missed Connections.

So the story is set up with a need; there is a twist; the need is satisfied; and a problem is resolved. Newton explains that though each of the 52 stories produced in ICU that year were on different subjects, they all more or less followed this same arc.

Looking back, Newton tells us that the series was a success. Her audience wrote in frequently with positive feedback.

Obviously, the success of this series of stories was due to the fact that all people inherently want to connect and find love. Looking for love is a universal theme. So we can all empathize with the subjects' personal tales of missed connections.

Aside from Craigslist, make sure to check out blogs and websites on any and all topics you can think of. At this writing, there are over a 125 million blogs, 500 million Facebook users, and 255 million websites on the Internet. A search on Bing, Google, or Yahoo! on any subject that comes to mind will surely bring up a healthy list of story possibilities. You can research a topic internationally, nationally, or right in your own backyard. Learn from the experts how to hone in on your topics with more efficient searches.

Often you can even check facts for your story with a web search. Or you might be able to find contacts and potential subjects to interview that way. The Cision Survey found 89 percent of journalists turn to blogs for story research, 65 percent go to social networking sites such as Facebook and LinkedIn, 61 percent use Wikipedia, and 52 percent go to microblogging services such as Twitter.

Bulletin Boards

Locating usable stories requires constant observation. Never walk past a bulletin board or utility pole covered in flyers again without at least scanning the notices. There is probably at least one story on every utility pole. Pick up neighborhood flyers and subscribe to email lists from clubs and organizations to find out what's going on. Often you can translate a group's activity into a lead for a genuinely compelling story.

Listen for Offhand Comments

Take your eyes off your smart phone for a sec. Stories can be lurking in the environment through which you move every day. Stay awake and alert at all times in order to be ready for them.

Scott Strazzante, a photojournalist at the *Chicago Tribune*, says that his antennae are always up. "I find that while I'm shooting routine assignments, I'm simultaneously listening to people talking. I'm reading blurbs that are in every little neighborhood publication, forever

▶ **A Team Without a Home.** Scott Strazzante's path to find this story of a soccer team consisting of homeless players is a great example of finding for stories by keeping your ears, eyes, and—most important—your mind **open.** (Scott Strazzante, *Chicago Tribune*)

fishing for ideas. In simple stories that my newspaper thinks are just a brief, I might find a great narrative angle to make a powerful audio slideshow from. I never discount even a passing idea."

For example, Strazzante was sent to a nearby community to make a portrait of a family living in a homeless shelter for a Christmas gift-giving story. The night manager of the shelter gave him a quick half-hour tour and Strazzante made his portraits. "On my way out, the manager said to me, 'Have you ever heard of homeless soccer? There's something called the Homeless Soccer World Cup, and there's no team in Illinois yet, but we're starting one here.' So of course my story lightbulb went off big time," Strazzante says.

Strazzante spent the next several months following the team from the Illinois shelter, shooting photos, recording audio interviews, and capturing ambient sound. He says it was a perfect narrative of a sports story. Would they succeed or would they fail? They trained and sweated and ran their legs off. Of course, there were ups and downs in their season, including many losses and even the death of an assistant coach. But the team members struggled on, all the while dealing with their own personal issues of homelessness.

Cross the Tracks

To hunt down the best stories, do one thing everyday that makes you a little uncomfortable. Go to unfamiliar neighborhoods and attend meetings of groups that are completely new to you. When you go, hand out business cards. Sit down and chat with the folks present. Ask people what's been going on in their lives and communities.

What is important to them now?
What or who would make for an interesting story?
What stories are the news media not covering in their lives?
What are the local controversies?
Who are the characters in the community? The standouts? The misfits? The community leaders?

"A Sunday morning without assignments led me to a small Baptist church that I had never been to," recalls this writer, who was working for the *Roanoke Times* at the time. "While there, I photographed a middle-aged woman who cared for a handful of elderly women during the service. Some of those women were widows, others had husbands with duties at the front of the church, and so the women had to sit alone."

▲ **Age of Uncertainty.** Sylvia Coleman lifts a cup of wine to help Hattie Brown take communion. The photographer suggested a feature story on this woman who assists her fellow church members. But a colleague encouraged him to think more broadly about what this lady did—caring for elderly people in general. (Photo by Josh Meltzer, *Roanoke Times*)

"Sylvia Coleman helped the older women turn to the correct pages in the Bible. She told them when to stand and sit and when to drink their communion wine. Many of the elderly women suffered from Alzheimer's or dementia.

"The next week, while chatting with colleague Beth Macy, I suggested a feature story on this woman who helps her fellow church members. Macy encouraged me to think more broadly about what this lady did, about caring for the elderly. With a few weeks of brainstorming with our editors and experts on aging, we developed a plan for a nine-part series on people who voluntarily care for the elderly. The news peg was that our community in western Virginia was experiencing huge growth in its elderly population. This new demographic raised the question: 'Who will care for this rapidly growing population?'"

The photos and audio gathered at the church that morning never even made it into the final project. But they did become the spark for a series that personally and intimately related to members of the community who come from different backgrounds. The project, called "Age of Uncertainty," was made up of nine video stories, photo galleries, and interactive elements. And, accidentally, it was born out of a random Sunday morning foray to an unfamiliar church across the tracks from this writer's usual haunts.

Localize and Personalize Large Issues of the Day

Think of the biggest stories in the news going on right now. They might be playing out in Washington, D.C., and appearing on national news, or perhaps they are unfolding in the largest immigrant communities. But no matter where they are occurring, chances are they are affecting people who live in your community or town.

The health care reform debate filled the news for endless weeks. Most of the video reports on television focused on town hall meetings and congressional debates, both important events related to the issue. Robert Krulwich produced "Four Stories on Health Care" for National Public Radio Online (the NPR website also features multimedia and video stories) that put faces on the news and presented four unique different viewpoints and situations of real Americans who will be affected by health care reform.

In one story, a locksmith reveals that he has never needed health insurance and doesn't

▲ **A Locksmith's Tale and Other Health Care Stories.** To tell the complicated story of health care for NPR Online, Krulwich and Hoffman zeroed in on the personal tales of a few individuals. (Robert Krulwich and Will Hoffman, NPR Online)

want it. In another story, a man is thankful that he had insurance after a near-death accident at his home.

These unique stories of different individuals do keep the audience centered on the large issues of health care and insurance. But they go further by presenting personal stories that help the audience to better identify with the broader issues. Furthermore, because the audience experiences these stories through single characters, there is a better chance viewers will be engaged and the stories absorbed in their entirety.

Stories About the Past

Telling a complete story about the past using still pictures only, though certainly not impossible, can be a challenge. However, using multimedia complete with interviews, graphics or archival footage makes the job of recounting a tale about the past much more manageable. Writers have always loved to tell narrative stories about the past. But photographers often struggled with what they should photograph when a story had already happened. Now, with unlimited access to the tools of multimedia, the subjects of our videos can take an audience back in time just as writers do for the written word.

Ben Montgomery, Waveney Ann Moore, and photographer Edmund Fountain from the *St. Petersburg Times* produced a story called "For Their Own Good" about the abuse suffered 50 years earlier at the Florida School for Boys. The men tell haunting stories of abuse and punishment and the lingering effects of that trauma.

Portraits of the men and landscapes of the now-abandoned school accompany the powerful video interviews.

Long-Term Projects

In 2003, Chad Stevens, now an assistant professor at University of North Carolina at Chapel Hill, traveled with students from Western Kentucky University for a spring break workshop (the Appalachian Cultural Project) to the Eastern Kentucky town of Whitesburg, deep in the heart of coal mining country. While working there with a few dozen students, he first learned of a mining process called mountaintop removal, in which coal companies blast the tops off mountains to extract coal without having to mine underground. "I had grown up in Kentucky and had never heard of the practice," Stevens says, "but when we went to see it first hand, I was changed forever." Stevens had read

a book called *Lost Mountain.* That book became the source for his master's thesis at Ohio University. Stevens says, "The genesis of the project was to do a visual version of this book with still images only, which would symbolize the transition of a mountain through this drastic process."

That initial spark has now spanned into a seven-year (and counting) project that evolved into a film project that Stevens continues to shoot to this day.

While shooting, Stevens has simultaneously been raising funds intensely. There are many grants available to photographers and filmmakers, some more competitive and lucrative than others. Stevens has won a few and lost others. But, along the way, a few freelance licensing projects have come his way. He never expected these lucky breaks, he says, which have fortunately helped to fund his project.

▲ **A Thousand Little Cuts.** In one of the more extreme acts of civil disobedience on Kayford Mountain, an activist poses as a crucified Jesus on the edge of the Arch Coal mountaintop removal coal mine.

The first nonviolent protest on Coal River Mountain brought attention to the campaign to build a wind farm. Five protesters, including Rory McIlmoil, left, and Matt Noerpel, chain themselves to an excavator on a mountaintop removal preparation site. Chad Stevens, the photographer, has been working on the project for more than seven years. (Photos by Chad Stevens)

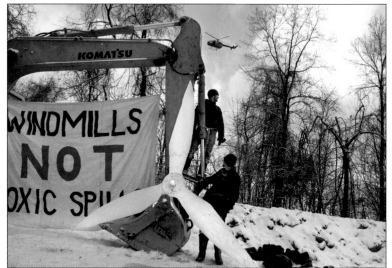

"I've licensed blast footage to a broad spectrum from Al Jazeera to the BBC and most recently Spike Lee's film *If God Is Willing and Da Creek Don't Rise*," he says. "Without foreseeing or even trying, I became the go-to person for mountaintop removal footage."

Though Stevens considers that the risk of taking on a long-term personal project is personally and financially daunting, he feels strongly that "there is something in the universe that helps us when we risk. Risk is usually rewarded in one way or another."

Some of the most important and influential photographic and documentary projects have emerged from personal interests. These kinds of projects are neither easy nor cheap. But if you can find a steady support network for both financial sponsorship and editing assistance,

you can pursue issues that are important to you. Your conviction and enthusiasm for your own personal subjects will often be reflected in a highly successful result.

Keep a Journal

Richard Koci Hernandez, former multimedia journalist at the *San Jose Mercury News,* has volumes of journals that he uses to take notes, record inspirations and thoughts, and make sketches and plans for future and ongoing projects. "If you really study some of the most creative artists and storytellers and writers or musicians, many of them have kept meticulous journals—everyone from Edison to Picasso—all at different levels and in different styles, but it's been critical to their success, and I've found that to be true for me, too," Hernandez says.

"Keep the journal with you all the time," he says. "You've got to be disciplined to write in it regularly. Even while I was working for the *San Jose Mercury News,* I would drive down a street a hundred times and all of a sudden I would see a store or a person and something would hit me on that 101st time for a potential story or a type font that I liked in my next project, and if I hadn't had the means and the notion to jot it down, I would've forgotten it. Now, more than ever, it's important to 'journal' because we're so inundated with info on the Web."

Hernandez says he finds his journals most useful when suffering from a creative block in

▲ **Journal.** Richard Koci Hernandez's journal of ideas that he kept when he worked for the *San Jose Mercury News.*

editing. "I'll just pull out my journals to remind me of ideas and—boom!—problem solved. All this stuff we think we'll remember will inevitably slip through the cracks under the pressures of daily life."

Hernandez also uses the Internet to find inspiration. "In addition to a small physical journal you can use social networking, bookmarks and RSS (real simple syndication) feeds to keep up with and share work that inspires you," he says. "Google Reader is a great way to subscribe to blogs and websites that you want to keep in touch with. I visit my Google reader list most mornings to see what's new when looking for inspiration. Furthermore, use Facebook, Twitter, and multimedia sites like vimeo.com to follow the work of artists and journalists you admire."

STORY-FINDING TIPS FROM REPORTER BETH MACY

When the *Roanoke Times* ace reporter Beth Macy thinks she might be onto a good issue story, she often meets an expert for coffee to feel out the story and to start gathering a list of potential subjects and a plan of action. Macy is always on the prowl for ideas, pulling out her calendar as she browses bulletin boards or has a conversation with a public relations representative from a relevant organization. A friendly meeting in person over coffee or tea will often yield Macy more contacts, names and numbers for a variety of stories than she could ever hoped to have gotten over the phone. "When you're genuinely curious about the world, there isn't a topic that, with the right amount of probing and tweaking, can't make a great story," Macy says.

Macy's story-finding tips:

- **Be nosy.** Sniffing out a good story is like being paid to get a graduate degree in stuff you're interested in.
- **Get out of the office.**
- **Public relations representatives** can actually be great sources, if you prod them enough.
- **Pay attention to your own life.** Do other people experience the things that are going on with you?
- **Reserve judgment.** Don't knock down an idea before you give it a chance to mature a bit.
- **Be alert.** It's the old boyfriend theory. The only time you find a boyfriend is when you're not looking for one.
- **Read** the walls—bulletin boards, ads, and posters for upcoming events.
- **Listen to what your friends** are talking about; eavesdrop on strangers.
- **Collaborate.** Find reporters, photographers, producers, and/or editors you like to work with, can collaborate with and trust.
- **Trust your gut.** If I find myself talking to my husband about someone, or find myself ruminating about something, there just might be a story there.
- **Read** and take copious notes.

FINDING SUBJECTS

The subjects in a story are often dictated by the nature of the piece. Some stories are about a particular person or family, whereas others are about an issue for which you will choose topics that exemplify the issue you are focusing on. The themes that you choose must draw the audience into the story and make them feel a part of it for the entire time. You don't want viewers to feel like mere observers—outsiders looking in. If you can hunt down truly engaging subject matter, you'll have a better chance of creating an excellent piece of work.

Three Necessary Keys Before Selecting a Subject

Pamela Chen, a senior communications coordinator in photography and multimedia at the Open Society Foundations says, "Often, we encounter the story of a person whose life journey encapsulates the metaphor for the bigger picture issue. But in order to produce a multimedia story, we need to know:

- **First,** is this person actively engaged on the issue and doing work that is visually dynamic?
- **Second,** do we have the access necessary to record this action? Is the person willing to show their face and record their voice for the camera?
- **Third,** will they allow someone to follow them around in their daily life for an extended period of time?

"These questions are about action, access, and time. They are all three key to the eventual outcome. If this trio of crucial criteria cannot be met, then we must seek another way to tell the story."

Chat with Your Potential Subject

While preparing to shoot a video story at an event, Evelio Contreras, a video photographer at the *Washington Post*, says he'll often casually chat with people at the event before shooting. This accomplishes two things. First, it allows him to understand the story better, and second, he can hold informal pre-interviews to determine whom he might want to interview for the piece he is about to shoot.

"I never go where I'm expected or assigned to go. I don't want to be where the main story is, but rather I choose to be on the sidelines. The main story is very often over-populated with people who aren't looking for stories but rather sound bites. They are not looking for a dialogue or a conversation.

"I'm looking to have a conversation with someone so that I can hang out with them . . . so that they'll be loose and relaxed and be themselves. I want to be able to hear someone sound as if they actually want to be talking to me."

Contreras says he looks for people who are quirky or have something different about them. If they make a lot of hand gestures, he says, he'll see that as a sign of someone who might be a character in the story. "I'm looking for passion in their eyes."

Contreras tries to establish himself as a documenter up front so that he can start a one-on-one conversation as soon as possible. He says, "I'm not interested in a hodge-podge of voices. I see that as overload to the audience. And it can often be a gimmick. I feel that interaction with one character at a time is more deliberate storytelling. You really have to suss out the tale you want to tell ahead of time."

Searching for Great Characters

Tim Broekema, a professor at Western Kentucky University, says, "You can't sit at your desk and speculate: 'Hmmmh. I wonder where that character might be lurking.' Captivating characters appear to you when you're out in the field asking questions. Allow characters to come and go in and out of your life until you find the just right one. Too many beginning videographers get stuck. They settle for a character they think is 'good enough.' But 'good enough' isn't going to cut it. The chances of finding a great speaker who is also visually pertinent to your topic are few. Characters who grab and hold the viewers' attention are pivotal. So the process of character search is vitally important. Magnetic characters are just plain gifts from God."

Leads from Public Radio International (PRI) and National Public Radio (NPR). In *This American Life*'s "Going Down in History" video story for Public Radio International's (PRI's) website, Ira Glass and his visual reporting team attend a high school portrait day to talk about how a single image taken that day for the yearbook—a photo which really doesn't represent much of anything about you—is the image that becomes your permanent historical record. In this story, Ira Glass shows the audience dozens of high school yearbook portraits. He then selects a half a dozen students to interview about this odd situation.

At the portrait day for class pictures, Glass gets students to open up while reflecting on the idea of the permanent portrait captured their yearbook. The students discuss boyfriends, gossip, and what they regret doing in their past. They are fantastic subjects and they certainly weren't picked at random. They're all great talkers. They aren't shy and they obviously enjoy elaborating on Glass's comments and questions.

Many excellent examples of character-told pieces can be heard on National Public Radio's (NPR) weekly feature *StoryCorps*. *StoryCorps* actually is a nonprofit devoted to recording people's stories of their lives. The group uses a radio booth housed in an Airstream trailer that travels about the country and invites volunteers to interview a friend or chat with a relative or simply to recount a personal story.

For more well produced stories on radio, check out *This American Life* and *Radiolab*.

Look for an Extrovert

On the topic of finding a subject, Darren Durlach from station WBFF-TV in Baltimore observes, "Hopefully a great character is someone who is dynamic, open, and unafraid to say what they think. Viewers generally care more about those extroverted types. Of course everyone we talk to each day is different. But I have learned to use my gut to look for 'real' people. The more sincere they are about what they say, the more their message shines out through the television screen. I just jump right in and ask almost everyone who walks by a question or two off camera to put out feelers or lead me in the right direction. Oh . . . and we always try to avoid making leading characters out of public information officers or stiff people in suits because that usually takes us out of the realm of sincerity."

In Marlo Poras's full-length film "Run Granny Run," the lead character, Doris Haddock, speaks eloquently about her motivations to run for U.S. senator of Vermont in her mid-90s.

She takes the audience through her entire range of emotions throughout the story, and is open, well spoken, and often very funny as she attempts to break many stereotypes of the modern-day politician.

Characters who are the most "interviewable" are not camera-shy. They even like the camera. They speak clearly and with appealing detail about their experiences. Additionally, you

◄ **Run Granny Run.** Doris Haddock, in her mid-90s, a true character, explains her motivations to run for U.S. senator of Vermont.
(Film by Marlo Poras)

will find that the more interviewable people are, the more they will offer when you ask questions. It's almost as if they can sense what you're looking for.

There is a category of people who are overinterviewed. Their message often sounds a bit memorized, like a sound bite. Politicians and public figures often fall into this category. If you're faced with interviewing such a person, plan ahead and ask unusual questions—questions that won't elicit a sound-bite response. Hark back to 90-year-old politician Doris "Granny D" Haddock. That feisty woman politician certainly does not fall into your typical sound-bite category.

EVALUATING THE STORY'S POTENTIAL

All stories, regardless of the medium, should consider the following: strong characters, narrative tension, a take-away point to remember, strong visual impact, emotional engagement, broad appeal, narrow focus, cooperative subjects, and a reasonable deadline. It wouldn't be a bad idea to answer these questions: what does the story say about the human condition? Will it be a visually exciting story? Will the story have broad audience appeal? What emotions does this particular story tap into in order to engage your viewers?

Strong Characters?

Strong characters in your online stories are like the friend that everyone wants to hang out with. They are funny, compelling, and interesting to listen to. They entertain us, enlighten us, and keep the focus on their story.

We have seen all kinds of stories covering the wars in Iraq and Afghanistan, from battlefield action to recovery, families at home, and even analyses of money spent during the war. Craig Walker's Pulitzer Prize–winning story "Ian Fisher: American Soldier," for the *Denver Post*, contains all of these elements, including a strong lead character. In a ten-part video story,

◀ Ian Fisher: American Soldier.

▼ Ian Fisher cradles his injured elbow during processing into the Army at Fort Benning, Georgia. Though he later has a change of heart, he sees a possibility only two days after arriving, to escape enlistment. From his first day in fatigues through his days driving a Humvee in Iraq, military life often doesn't mesh with his expectations. Sometimes the structure of the Army and the demands of training for war clash with the freedom he shared with his outside friends. (Photos by Craig Walker, *The Denver Post*)

▲ Ian braces for his crossed-rifles pin, signifying his completion of training. Drill sergeant Eldridge holds the pin in place and prepares to secure it with a fist. "I hit him square on the chest," Eldridge says. "He had two holes, and blood dripping down from each—'blood rifles.'" A sergeant closes the ceremony: "You are now the guardian of freedom and the American way of life! A warrior!"

◄ As his team prepares to secure a room during a training drill, Ian is the first man in a four-man stack. Echo Company is deep into three days of urban-combat exercises. Drill sergeant Tommy Beauchamp has a lot of experience to share: he served one tour of duty in Afghanistan and two in Iraq.

we follow the path of an average U.S. soldier, Ian Fisher, as he signs up for the military, trains, heads to battle, and returns. The narrative is powerful, with honest interviews with Fisher and his mother and father throughout the piece.

The story arc for Walker's piece is classic. It's chronological and follows Fisher through a major change in his life with twists and turns, ups and downs, and a variety of small setbacks and successes that keep the audience's attention.

Furthermore, this story is playing out in every town and city in America where soldiers have been sent abroad to war, so it helps to explain who these soldiers are and what their individual stories might be, by telling it through the eyes of one soldier.

Walker begins the story as Fisher graduates from high school and follows him for 27 months through his return. And Fisher is a perfect character. Completely open and compelling, he

▲ Ian shows his frustration during a counseling session with Sgt. 1st Class Joshua Weisensel. For the second time, Ian returned late from a weekend home. Now he has turned himself in for a drug problem. In the days to follow, Ian's failure to cooperate puts him in danger of getting kicked out of the Army. Instead, the commander assigns him to a new platoon and drops him in rank. It's a demotion. But it is a fresh start.

▲ Three days after Ian's return from Iraq, he and Devin apply for a marriage license. The couple are married an hour later in a quiet courtroom. Driving away, Ian turns down the music. "Ya know, everyone gets counseled in Iraq that life is not going to be like your fantasy when you get back home," he says. "Well, I'm checking this off my fantasy list."

offers insight into his situation and serves as one representative for the more than 100,000 soldiers serving in Iraq. The narrative has ups and downs and twists and turns that serve to keep an audience hooked, wanting to know what happens to the young unsung hero soldier.

Finally, Ian's story has relevance to current events, is reflective of how Fisher feels about being at war, why he joins and how it is to return. This impactful piece puts a face on a large issue in what is probably the biggest story in this period of American history. It is a personal and intimate look at one of the most important stories of the decade.

Narrative Tension?

Michael Nichols and J. Michael Fay's story "Ivory Wars," featured on MediaStorm, is the story of efforts to protect elephants, often hunted for their ivory tusks, both inside and outside of national parks in Chad. Though the issue of poaching certainly is important on its own, it still needs a narrative thread to which audiences can attach themselves. The filmmakers and producers found a narrative thread within the general report on a national park. They zeroed in on one elephant named Annie whom the researchers collared to track as she moved both in and outside of the park.

Now their story, which is still about the issue of poaching and protection of natural resources, contained a chase that followed both the researchers tracking Annie's every move and the poachers who aim to kill her just as she exits the safety of the Zakouma National Park's boundary. Annie wanders here, and the tension builds. Then she goes there, and the action grows even more compelling as she continues to move throughout the region in search of water. Finally, we learn that Annie has been shot by poachers.

The tension, not knowing what will happen to Annie, is precisely what keeps an audience's attention. The narrative tension that the storytellers create and build upon as the story progresses is the kind of vehicle that carries an audience through a piece.

Cooperative Subject?

One of the obstacles that can make or break a story is whether your subjects are in tune with your need to finish the story. This is one obstacle you must work out early. Your characters may simply see you as a photographer who wants to take a portrait and be done with it. But in fact, you have plans to hang around with them for the long term. You want to do several interviews and organize multiple follow-up visits. Have a conversation with the people you are filming early on in the reporting process so that they fully understand what might be expected of them during their participation.

Similarly, you should have a conversation about the depth to which you want your story to go. This is a delicate area, so you must tread lightly to avoid causing the subjects to think you are intrusive, which could ruin your chances for developing a more in-depth story. The message is: don't scare away your subjects.

▶ Ivory Wars: Last Stand in Zakouma. A story with narrative tension about poaching. (Photos by Michael Nichols)

Sonya Hebert from the *Dallas Morning News* produced a profoundly somber, emotional story about a couple that loses an infant son to a rare birth defect. Hebert gained the trust of the family, who allowed her to remain with them, video camera rolling, while their son actually dies. Photographing the moment of death indicates that a high level of trust has been established with family members.

There exists a delicate balance between scaring your subjects away by having them commit to giving their all from Day 1 and being utterly honest about what kind of commitment you need from them in order to satisfactorily report the story. Bob Sacha, a multimedia producer, photographer, filmmaker, and teacher whom we mentioned earlier, says he likes to be frank pretty early on in the reporting process. "I'll tell my subjects, 'I want to tell your story accurately, so I want to spend as much time here as I can.' I want the experience to be a pleasant and positive one for the people. Basically, it's all about building a good relationship with them. You don't want to be a colossal pain in the neck. But you don't want to waste time and go nowhere either."

Sacha says he frequently has to be persistent to get his subjects to be fully participatory. "When you show up more than once, the people may be impressed by your level of commitment to telling their story well. By the third, fourth or fifth time you visit them, they will be comfortable with and even flattered by your dedication to their story. Such proof of your dedication will often open the final door to the degree of intimacy you've been waiting for."

Dai Sugano, a multimedia journalist at the *San Jose Mercury News*, agrees. "It's all about maintaining a relationship," he says. "When a person sees that you are consistent and committed to the story, they tend be more accepting of your presence. You know you are in a good position when the subject stops asking, 'Why are you taking that picture?' If you have established good rapport, the people may even begin to contact you about upcoming events in their lives. This obviously precludes your having to constantly ask them probing questions.

"There is no magical way for you to know what people are thinking, especially when you first meet them," says Sugano. "It's really not a

▼ T.K. Laux feels for Thomas's heartbeat during one of the many recurring episodes of silence followed by gasps. "We love you, big boy. Please go home," Laux kept saying. "Thank you, Thomas. Please go." "Just let him do it his way," Deidrea said with a sigh. Again, Thomas gasped after ten minutes of silence. "There's nothing we can do."

▲ **"Choosing Thomas"**
Deidrea Laux sits on her bathroom floor holding Thomas before making a plaster mold of his hands and bathing and dressing him for the last time. "I got to feel what it's like to be a mom. It was good, Thomas. Thank you. I needed you," Deidrea said to her baby. The video-journalist was able to capture this very intimate moment in a couple's life. (Photos by Sonya Hebert, *Dallas Morning News*)

bad idea to put in the extra time to fully explain what it takes for you to tell the story well. Don't be afraid to inform them that things might not always go as smoothly as you both hope at the outset.

"When you are making a documentary, you can't really predict what's going to happen next. Things have a way of just happening. And you simply don't have time to ask for permission when they happen—one more reason why it is so important to explain the ground rules early on. If not, later on you could find yourself in a situation where the person you're filming thinks you have crossed a line and are being intrusive or rude. Of course, you can always explain afterward why you needed to photograph the subject in a sensitive moment, but if the person knows ahead of time that you might eventually tread on some delicate territory or other, they will be more likely to allow for those awkward moments without resistance."

Sugano shot and produced a story called "Torn Apart," which chronicles the story of a family of immigrant parents and American-born children who are faced with the parents'

deportation. He followed the family for close to a year. "I photographed many stressful situations, including an occasion where an eldest daughter was emotionally overwhelmed. I took the trouble to later explain to her why I had photographed her crying. That way, she better understood why the picture was so important as it showed the pain she felt over being forcibly separated from her father," Sugano says.

▲ **Torn Apart.** Immigrant parents and American-born children face the possibility of the parents' deportation. This story took the videographer a year to complete. He explained the photographic process to the family before he started so they would accept him over the course of the saga. (Dai Sugano, *San Jose Mercury News*)

He adds, "It is important that the people understand what they are agreeing to when they give you permission to follow their journey. Otherwise, major misunderstandings can occur later, which can completely derail the story. That said, you may not want to go into extravagant detail or push for definitive ground rules in the beginning as when it works well, the process of filming peoples' lives quite naturally evolves as the gradual building of a trusting relationship."

A Take-Away Moment?

Once we have good characters and a sufficient narrative to keep our audience interested, a story should also have a take-away message. Perhaps there is a lesson or moral to the story, or maybe it just teaches us something we didn't know enough about. Maybe it serves to make us laugh or cry, but every story must have a purpose to it that will linger after the viewer absorbs the last picture.

More Than Strong Visual Impact?

The story is the most important part of a video or multimedia project. Without it, you have nothing. That said, we work in a visual medium, and your project should also have strong visual impact. Strong visuals on their own can't carry a multimedia story, but they most certainly will raise the level of its quality.

▲ Take Care. The producer was first attracted by Virginia Gandee's brilliant red hair and dozen tattoos—but then went deeper. Inside Gandee's family's Staten Island trailer, she cares for her grandfather. (Photography and video by Gillian Laub, MediaStorm)

Eric Maierson, a producer for MediaStorm, says that sometimes the initial attraction to a story might be purely visual. "There are people who create interesting visuals," says Maierson, "and that's their thing and there's nothing wrong with that. But if you're a journalist, you need more than just interesting visuals. You must have a story."

A story that Maierson helped produce called "Take Care" was discovered by photographer Gillian Laub, who had noticed the story's main subject, Virginia Gandee, a 22-year-old woman covered in tattoos, waiting for the subway. The initial attraction to her came out of a purely visual interest. But the story that Laub discovered about the tattooed woman was that Gandee was not only a single mother, but she was also the caretaker for her dying grandfather.

"That is what's compelling about the story," says Maierson. "In addition to having great visual potential, a good story must have a narrative that an audience can connect with. Furthermore there is great contradiction in this piece. Gandee is a hard-rocking woman with tattoos, yet she cares for her grandpa," says Maierson. "That contrast shocks the hell out of your audience."

A story that has visual potential refers to the idea that at least part of the story is going to unfold in front of you and you will have enough opportunities to show rather than tell that story to your audience. With this approach, one is thinking like a still photographer. Other times, as in the story "Take Care," you might feel that your subject has a look about him or her that catches your fancy. That initial curiosity might lead you to find a terrific story. As storytellers, we must be perpetually on the lookout for opportunities to record real moments that we can bear witness to with our cameras and microphones.

Every story you do will fall somewhere along a continuum of either great visual potential or strong narrative potential, so logically part of your decision-making process has to be to make a choice about where you want to and are actually able to take the story. Many stories that seem to have little visual or narrative potential on paper can end up becoming great storytelling opportunities. This is due in large part to the thought process of the photographer or storyteller. Think about all of the options you have before writing a story off. There is no one way to tell a story.

Can You Capture Revealing Moments?

While a graduate student at Ohio University, Yanina Manolova produced a series of video stories on women living in the Appalachian region of Ohio—women who struggle with recovery from substance abuse and domestic abuse within their homes. She tracks the women every step of the way, following them through treatment,

visits to prison and even during violent encounters in their own homes.

Simply interviewing the women about what had happened in the past would certainly have been powerful, but Manolova realized that whenever she could *show* rather than *tell* the women's stories, the impact was tenfold. To tell their stories, she needed to actually document what was going on, including the drug use, the domestic violence and even sticky family situations.

▼ **Neverland: A Short Film.** Patricia, 27, smokes crack in Mansfield, Ohio. She graduated from the Rural Women's Recovery Program in the spring of 2009 but relapsed in June of that year. Sexually abused at age 14 by a middle-aged man, her father's best friend, she has been using alcohol and drugs (marijuana, crack, cocaine, oxycodone, and morphine) since. "I got pregnant with my daughter by a drug dealer, and I went for treatment for about nine months while I was pregnant. He is in prison and has never seen his child," Patricia reveals.
(Photography by Yanina Manolova)

▲ Stephanie, 19, cries on her mother's shoulder after graduating from the Rural Women's Recovery Program. Due to drug charges that resulted in the loss of her two children, her probation officer ordered her to attend the substance abuse program. She started using drugs when she was with her ex-boyfriend, Carroll, the father of her daughter. "He beat me all the time, choked me, shouted at me, put a knife to my throat. I felt like shit. That's why I used—so that I could hide my feelings. I started out with lower doses of Vicodin and Percocet, then I went to Oxycontin and heroin," Stephanie says.

◄ Deanna, 33, cries in her temporary housing provided by the Salvation Army Shelter in Newark, Ohio. She has been physically abused by her husband. Deanna lost custody of her son and although she completed a substance abuse treatment program, she could not stop abusing alcohol. She is on the waiting list for another substance abuse treatment program.

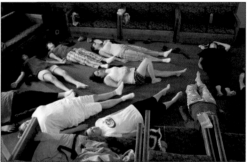

▲ Clients of the Rural Women's Recovery Program practice yoga.

▲ Jessica, 27, talks on the phone with her boyfriend during her relapse after having seven months of sobriety. She was abusing drugs and alcohol. She has survived several abusive relationships and has had five children from three different men and has lost custody of all of them. Jessica went for treatment at the Rural Women's Recovery Program.

▲ Deanna, 33, left, cries following a visit from her husband and son at the Rural Women's Recovery Program, where she has been for two weeks. Her mother was an alcoholic, as are many of her family members. "I would get up and start drinking. Every single day. I will drink until I pass out," Deanna says. Lisa, 44, right, is sad after her boyfriend's visit at the Rural Women's Recovery Program. Another alcohol abuser, she has been part of the program for two weeks. Lisa was sexually abused by her father at age six; her husband, a drug addict, sexually abused her as well, and she has three children by him, all of whom are drug addicts. "After I left their dad, the kids left me. Then I started drinking a lot more," Lisa says. Hannah, 29, far left, talks to her mother, far right, during their family visit. Her alcohol problems began when she was fifteen. As a child, she was abused by her father.

◄ Destiny, 4, poses in her stepfather's car in Mansfield, Ohio. Her biological father was a drug dealer and was recently released from prison. She has never seen him. Her mother, Patricia, went through substance abuse treatment and graduated. She relapsed and went back on the streets again. Destiny lives with her grandparents in Mansfield, Ohio. "Why mommy keeps leaving me? She promised she will never leave me again," Destiny asks.

Emotional Engagement?

You are well advised to use emotion in your story. Does your story explore feelings such as humor, grief, passion, or rage (to name a few)? Though not everyone will think the same things are funny or sad or inspiring, there are certain types of characters and stories to which the majority of people will react strongly.

In Anwar Saab and Tima Khalil's story, "Hammoudi," the audience listens to the very frank voice of 12-year-old Mohammad Hajj Mousa, who lost both legs to a military bomb while living in a Palestinian refugee camp. His blunt and honest discussion of attempted suicide and depression, mixed with his look at his own friendships and family, are topics of mutual interest to a wide audience.

We as an audience have great compassion for this child, and the storytellers, through Mousa, have tugged on a variety of powerful emotions to keep us hooked.

▶ **Hammoudi.**
(Directed by Anwar Saab, produced by Tima Khalil)

Broad Appeal or Niche Audience?

If your story has broad appeal to wide group of people of different ages, ethnic backgrounds, and economic levels, you'll have the best chance of drawing in a large audience. The broader the appeal, the more people from varied backgrounds will have an interest in your work. You can't expect absolutely everyone to be interested; but as part of deciding whether to pursue a topic, you have to examine whether you think a large enough audience will be attracted and engaged in your story.

Are you hoping for wide appeal, or are you producing for a smaller niche audience? If you intend your audience to be small, you may want to include more pertinent details that would appeal to such an audience. If your intention is to reach a more vast audience, you will have to think carefully about the details and depth you put into the project and decide whether the subject will be more universally appealing.

High Click Rate. MediaStorm founder Brian Storm observes, "You want to do one of two things to successfully market your work and get it seen by a large audience. You either want cats spinning on a fan—something short and funny that gets 50 million hits on You Tube—or you want to produce the greatest series ever done on Darfur, for example. What you don't want to be is the noise in the middle."

Part of MediaStorm's success in terms of the numbers of people watching the stories there, Storm says, is due to the viral nature of the site's following. "We want people to see these stories and be so moved that the first thing they do is repost them on Facebook or Twitter. One person can create a huge trail of viral activity. But it won't happen for stories that don't move your audience in some emotional way."

Is Your Focus Narrow Enough?

Don't attend events and merely cover them in a general fashion, stopping by here and there to shoot and interview a little bit of everything. Find a focus first. And stick to it!

In the *Time.com* story "Sudoku Master," producer Jacob Templin covers the Sudoku championships. Rather than feature everything going on at the event—clearly a visually rich environment with plenty of interesting characters—Templin focuses on two players, both former champions and good friends, as they compete in the weekend tournament.

◀ **Sudoku Master.** Templin zeroed in just two players to tell the story of the Sudoku contest. (Produced by Jacob Templin)

Their friendship, partnered with their competition, helps provide a focus on what could have been a banal story about this event. Again, zeroing in on the human interest within a general subject often makes the story sing.

Reasonable Deadline?

Many stories are produced in a few hours on strict deadlines; others take years or even decades to finish. How will your story fit into your schedule? Often, many editors do not understand the gobs of time it takes to both shoot and edit even a short piece. It takes even longer if you're a little green and inexperienced. Shooting low-quality stories is easy and quick. Making great ones is usually not so simple or rapid. So be wise and plan ahead. Calculate in advance how long the entire process will take you.

Director and producer Taggart Siegel shot "The Real Dirt on Farmer John," a full-length documentary, over several decades. He began photographing a college classmate in the 1980s and continued until he felt the story was complete. He documented several major transformations in his lead character's life. He followed him throughout the economic farm crisis of the 1980s. He documented his battles with local residents over his perceived lifestyle. And, finally, he brought to light the man's success at building up a large community-supported agriculture farm that now supports many families in the Chicago area.

Sometimes, as happened to Taggart Siegel, you can't put an end date on a story because you don't know when or how it will finish. As it turns out, this type of long-term story is very compelling to an audience. They watch the lives of the characters unfold in much the same way and at the same cadence the documentary maker did while producing the story.

Of course, we do not all have the luxury of following a subject over many decades. Most of

▲ **The Real Dirt on Farmer John.** The documentary took several decades to create. (Produced by Taggart Siegel)

us live in a world of deadlines. All the more reason to figure out the amount of time you'll need and discuss it with your editor so you both agree on a time frame. Many beginning video storytellers with too little experience in the medium make the mistake of underestimating the time they'll need to finish a story. They end up rushing or racing into the office at the last minute panting and pleading for more time. Remember that turning out high-quality storytelling in these media takes lots of concentrated application and oodles of time. ■

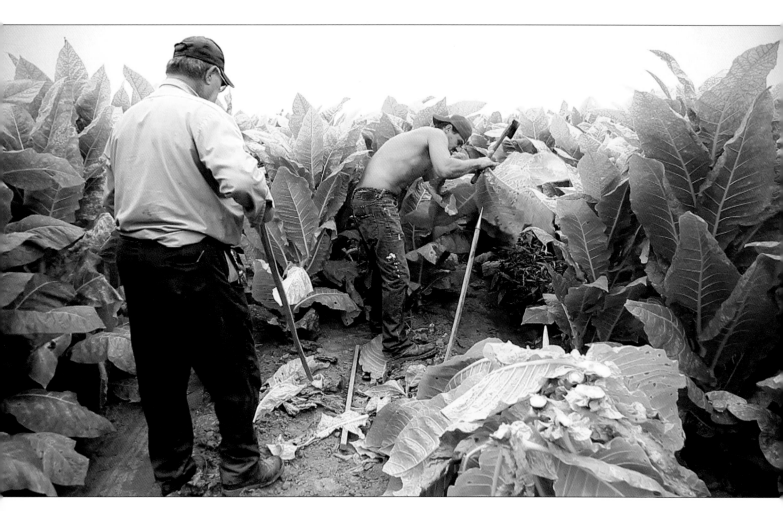

▲ **Alvin Stamper, 26, defends his title as the tobacco cutting champion at the Garrard County Tobacco Cutting Competition. Contests make good topics for multimedia and videos because they have a natural story arc built in.** (Photo by David Stephenson/ZUMA Press)

Successful Story Topics

Josh Meltzer

Photojournalist-in-residence at Western Kentucky University, formerly with *The Roanoke Times*

Not every topic lends itself to a videojournalism story—some are better suited to being told in print or on the radio. So how do you pick a topic that will compel viewers to watch your video?

Ironically, poor people or people touched by war make excellent subjects for compassionate videojournalists and audiences alike. Poverty's sting and the ravages of war touch the hearts and minds of viewers everywhere. People overcoming adversity, handicaps, and other seemingly insurmountable problems also make good material for visual storytelling.

This symbol indicates when to go to the *Videojournalism* website for either links to more information or to a story cited in the text. Each reference will be listed according to chapter and page number. Links to stories will include their titles and, when available, images corresponding to those in the book. Bookmark the following URL, and you're all set to go: http://www.kobreguide.com/ content/videojournalism.

Luckily, life consists of more than the tragedies of poverty and war. The stories that underlie the daily lives around us can make for compelling videojournalism, as well.

CONTESTS, GAMES, AND SPORTS

Competitions have built-in story arcs. They always have a protagonist and a natural timeline from start to the finish. In this respect, it is relatively easy to find the narrative because the conflict is so obvious. The challenge is the game and conflict is inherent in the competition. The outcome is unknown until the winner and loser emerge.

David Stephenson's story "Cutting Through the Competition" follows a tobacco-cutting competition that pits two experienced tobacco farmers against each other in a unique race. The story builds with edgy tension as the two farmers labor shirtless in blazing summer heat, each working madly to cut his respective rows more quickly than the other.

"The tobacco cutting contest was perfect for a narrative," Stephenson says. "There is a beginning, middle and end, already spelled out for us. There is obvious conflict and resolution. We found a character that added grist to the whole story because of a sympathetic twist—if he won, Alvin's' winnings would help pay fees for a child he hoped to adopt. Really, it was a no-brainer in terms of having a competition and character. We almost couldn't go wrong."

Obviously, as seen in the previous example, competitions don't have to feature only traditional sports. In fact, the more unconventional the competition, the more likely it is to draw in viewers. There are TV programs and in fact whole TV channels devoted to covering alternative competitions: hot dog eating contests, lumberjack events, and strongman competitions are fast gaining audience attention.

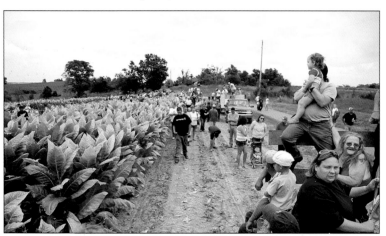

▲ Alvin Stamper, 26, slices tobacco stalks at their base and spears them onto a stake. Stamper's grandfather, left, is his "walker" and helps by providing both stakes and words of encouragement.

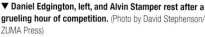

▼ Daniel Edgington, left, and Alvin Stamper rest after a grueling hour of competition. (Photo by David Stephenson/ ZUMA Press)

▲ **Cutting Through the Competition.** Spectators try to peer over the tops of tobacco plants to get a glimpse of the competitors at the Garrard County Tobacco Cutting Competition. During the tobacco harvest at the end of every summer, men gather to compete against each other to see who is the fastest at cutting the crop before it is hung in the barns to cure. From planting to the auction house, tobacco remains one of the most labor-intensive crops, and the hands and backs of laborers have yet to be replaced by machines.

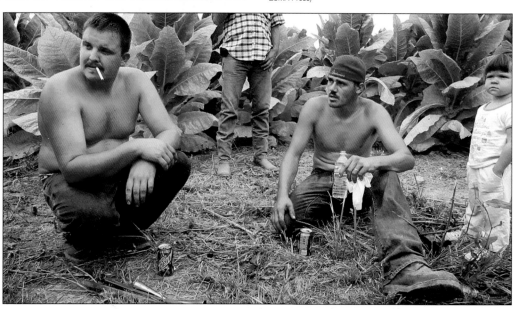

Sports Can Follow a Natural Story Arc

Many times, sports and competition stories will have a second storyline within the obvious narrative. For example, Stephenson's weaves into the tobacco-cutting contest facts about the history of tobacco farming and the decrease in small tobacco farms in Kentucky. "If you can add a subplot to the story," Stephenson says, "all the better."

Western Kentucky University photojournalism students Bethany Mollenkof and Ben Severance produced a story on a fraternity boxing match called "Sigma Chi's Battle of the Greeks." The story, which could have easily been a general story about the event, covering the uppercuts, right- and left-handers and drunken fans, instead featured just two of the boxers, keeping its focus on their fights.

Mollenkof explains, "Ben and I had been to the event in the spring of the previous year. We both thought this should be a multimedia story, but at the time we didn't have the skills. So we filed it in the back of our minds. We had met one of the fighters, Evan Goddard, that previous year. We remembered to contact him when we were ready to do the story. We knew Evan could be just the guy we needed to put a narrative story behind the event."

The two producers understood they needed to focus on a particular match to make a decent narrative arc for the story. "When you're watching the fight, you know there's going to be a winner and a loser. We wanted to follow Evan, the favorite to win, and another fighter who was an underdog," Mollenkof says. "Obviously there is going to be a definite ending to the story. There'll be conflict, action, characters, and resolution. We had all the pieces of the puzzle. We knew if we put them together right, we would produce a compelling narrative."

This piece they made was a classic. It was David and Goliath all over again, good versus evil, new versus old, strong versus weak. "The better the characters are, the better they'll carry the narrative," Mollenkof says. "Luckily, we remembered Evan from the year before. He was intense, driven, and way popular with the girls."

◄ **Prove Yourself.** Evan Goddard (left) speaks with confidence about the upcoming fight. (Photo by Ben Severance, *The Herald*)

Derek Mundt is concerned about his chances in the upcoming fight, where he will face a seasoned opponent. (Photo by Ben Severance, *The Herald*)

◄ **The fight pitted an inexperienced boxer, Derek Mundt, against a much more seasoned one, Evan Goddard.** (Photo by Ben Severance/ Bethany Mollenkof, *The Herald*)

▼ **Members of Pi Kappa Alpha cheer on their fraternity brothers at the annual Sigma Chi Battle of the Greeks boxing event.** (Photo by Bethany Mollenkof, *The Herald*)

► The overhead camera captures the moment the referee declared Goddard the winner. (Photo by Ben Severance/Bethany Mollenkof, *The Herald*)

► Evan Goddard, wearing the title belt, bumps knuckles with Derek Mundt after defeating him in the ring. "At the end, there's a reconciliation. After Evan beats Derek, he says, 'Good job, Derek, you tried, I've been there,' and that was our story," says producer Mollenkof. (Produced by Bethany Mollenkof and Ben Severance)

Severance notes, "Evan represented a prototype of person which exists everywhere, on most college campuses. Derek Mundt, Evan's challenger, was a particular type, as well. Derek was a first-year frat brother, had never fought before, and was unsure of himself. Evan was a cocky, arrogant, and popular jock. Derek was the clear underdog."

So once the team of producers settled on their characters, they began the process of interviewing and shooting. While doing so, they went on searching for just that hidden message that would make the story sing. "We basically knew what we thought about them, but we were constantly trying to peel back layers," Mollenkof tells us. "Once we had talked to Evan, we came to realize that he is who is he because he used to be more like a Derek. When integrated, that revelation gave the story a personal twist and set it apart from the stereotypical fight story level. At the end, there's a moment of reconciliation," Mollenkof says. "After Evan outboxes Derek, he meets him outside of the ring and tells him, 'Good job Derek, you tried. I know. I've been there.' That statement lent the perfect amount of emotion to our story."

The story "Prove Yourself" is indeed a tale about a boxing match. But it is much more a narrative about two characters. They are both vying for the same title, but they are doing so for completely different reasons. This element alone takes a simple boxing match tale and turns it into a much more complex and thought-provoking story for a larger audience. It's about daring to challenge oneself. Straightforward sports stories almost always benefit from a little in-depth reporting and interviewing.

DRAMATIC TRANSFORMATION THROUGH RECOVERY

Rick Loomis, a photographer at the *Los Angeles Times*, produced a story called "Breaking the Chains of Addiction," which tells about a few recovering addicts of various sorts who have come together for rehabilitation at a treatment center. Though they have come from multifarious backgrounds and lifestyles, their goals are the same—recovery.

The rigorous process of recovery from addiction provides a natural narrative. The subjects have a problem, they have a goal, and there is a path to that goal. The outcome is unknown. The suspense of not knowing the outcome is largely what hooks the viewer.

"Each character had hit rock bottom, and each one's rock bottom was different," Loomis explains. "One woman had a DUI and had killed someone. She couldn't find a way out for a long time. The center was using art therapy to help her. Each person was trying to grasp at something. I interviewed about eight people for half an hour each."

Loomis found that recovery in and of itself was a challenge for the characters. Some had physical challenges. Others had mental or psychological challenges. Loomis struggled, wondering what format he would use to tell the story. "Originally, I wanted to do one portrait with one piece of audio interview. But I felt it wasn't going anywhere and wouldn't drive a viewer to want to see it all the way through. Frankly, back then, it didn't even make me want to listen to it. Then

▲ **Breaking the Chains of Addiction.** Beit T'Shuvah, a mid-city Los Angeles synagogue and rehab center catering to a mostly Jewish clientele, leans on spirituality and the Torah to heal addiction. The clients include heroin junkies, alcoholics, sex addicts, and gamblers. (Photo by Rick Loomis, *Los Angeles Times*)

I started cutting the audio down to some choice quotes that were sending chills down my spine," Loomis says.

"I just pursued heroin into the gates of hell."

"Look, if I get high in the next two years, I go back probably for life."

"From the moment my eyes would open, I would start drinking, and I wouldn't stop until I passed out."

"I knew that if I kept using I was going to die."

These are the kinds of arresting quotes that engage an audience and compel people to want to continue to follow a narrative. The quotes are inspiring. They make real what had only been hinted at in the introduction of the piece.

Loomis decided to bookend his story about the rehab center with portraits and short powerful quotes. It's an effective way to introduce the characters and make the audience wonder about each one's story and struggle.

CHANGING A LIFE

Chang Lee of the *New York Times* publishes a regular series called "Second Chance," which profiles people in transformation of some sort in their lives. As he explains in the project summary, the stories are "portraits of journeys to truthful self-existence."

Some of his subjects make a transformation of career or lifestyle. One profiles a woman who chose to change her gender. The piece takes place during the time she is completing sex-change surgery. Like Loomis's story following a recovery process, Lee's stories aim to follow subjects through various kinds of transformations, which create the narrative that keeps an audience hooked throughout the pieces.

DEATH AND DYING

Stories of death are almost always dramatic, and audiences are naturally drawn to them, especially when produced thoughtfully and tastefully. Because death, like birth, is perhaps one of the only universal experiences for all people, audiences are curious to learn about others' experiences with death and dying.

Sonya Hebert's series for the *Dallas Morning News*, "At the Edge of Life," follows families and health care professionals as they learn to use palliative care to help those who are dying.

"When I first got the assignment, I thought, 'Who cares, everyone dies,' but after some research I realized, wow, this story has potential

to be really powerful because everyone experiences it and everyone hurts from it," Hebert says. "There are literally tons of stories out there, and I saw it as my job to help link them into this large project about death and dying." Hebert indeed met the challenge by finding universal themes like love, hope, and despair that were present in the stories. Rather than focus on the specific experiences of each family, she uses the experiences to focus more on the universal themes with which her audience can best connect.

"If you look at good literature," Hebert says, "it works partly because you can relate to the characters. You think, 'Wow, I can imagine that happening to me.' You walk in the characters' shoes, and feel their profound emotion. Human experience translates across historic, economic, social, and other barriers. You especially relate to the

▲ **At the Edge of Life.** Miles Hoffman tenderly embraces his wife, Christina Hoffman, at Baylor University Medical Center in Dallas. Christina Hoffman has Huntington's disease. The Baylor palliative care team is helping Miles find solutions to meeting Christina's needs as the end of her life draws near. Miles continues to struggle with the knowledge that he is no longer able to take care of her. (Sonya Hebert, *Dallas Morning News*)

◄ **Second Chance.** Terry Cummings prepares to go to work in Montclair, New Jersey, before sex reassignment surgery. (Photo by Chang Lee, *New York Times*)

characters' experiences when they touch a nerve in you or are otherwise brought close to home."

This is why finding universal themes in any story you're pursuing is so crucial. You want to appeal to a large audience. Always seek to connect viewers with your characters' real experience. Themes of this type invite people to become immersed in a narrative.

Casey Kauffman produced a story for Al Jazeera International, about a little boy living in Gaza, "Baby Feras," who desperately needed surgery to repair two holes holes in his heart. Though the Israeli hospital was only an hour's drive from his home, in the end he was unable to have surgery in time because of the Israeli blockade.

The story follows the family on a natural narrative as they repeatedly struggle to get the baby into the hospital in Israel, where he can be admitted for emergency treatment only. Finally, after far too long, they are granted permission. But the permission arrives too late. Baby Feras dies while awaiting permission to cross the border. An unknown outcome frequently contributes not only to sparking but also to holding onto an audience's attention.

LOCALIZING A NATIONAL PROBLEM

Brian Kaufman's *Detroit Free Press* story "Carrier of the Economy" presents a micro view of the economic crisis through the eyes, experiences and observations of a postal delivery worker.

▲ **Baby Feras.** A hospital with facilities to treat Baby Feras' heart condition was only an hour's drive away from his parent's home in Gaza, but it might as well have been across an ocean. His families requests for treatment were turned down—only an "emergency" qualified. Unfortunately, the child's condition deteriorated so rapidly that it became an "emergency." His paperwork arrived too late to save him. (Produced by Casey Kaufman, Al Jazeera International)

This postman says that he is witness to the downturn in the economy via the types of mail people receive: bank notices, advertisements for legal services, and certified letters. This story, which has an ordinary person as its main character, is enlivened by compelling videography: clever camera angles, unusual shots, quick-cut editing, and smooth transitions.

HUMANIZING LARGE ISSUES

The problem with many stories about broad issues—be they the failing economy or the rising homicide rate—is that a large audience may find them dull. Many members of the mass-market audience rarely get beyond the big picture news value of a story. The videojournalist's challenge is to stimulate the public by infusing the work not only with human appeal but with clever videography as well.

One morning in his own newspaper, Will Yurman, a staff photographer at the *Rochester Democrat & Chronicle,* read a brief 102-word story about one of about fifty homicides in his city. "It contained the barest of facts. A man was found dead at 7:00 a.m. There were no suspects," Yurman remarks.

A few days later, Yurman was assigned to cover the memorial for the slain man. "So I get to the vigil early, and his sister was there outside the house. I start talking to her and naïvely say, 'I'm shocked at how little we wrote about your brother.' She said 'I'm not surprised, no one cares about a black man from Jamaica.' She didn't say it angrily and wasn't blaming me, or the paper, but was rather saying sort of 'The grass is green, the sky is blue, and no one cares about a dead Jamaican man.'

▶ **Carrier of the Economy.** A postal worker's observations on changing trends in mail delivery encapsulate the condition of the economy. (Produced by Brian Kaufman, *Detroit Free Press*)

"I couldn't let go of what she told me. I drove back thinking, 'We should care.' The facts are that Rochester has a fairly hefty homicide rate. We've averaged 50 per year. People like Ian Crawford deserved to be remembered," Yurman explains. "So," says Yurman, "I conceived this idea to do a project about who these homicide victims were. I didn't want it to be about the crimes, but rather about who they were as people and the effects their deaths had on the family and friends who survived them.

"I pitched it to my editors, who decided it would become a web-only project. So for one year, every time there was a homicide, I reached out to the victim's family. I often went to funerals and vigils. Only four or five families politely declined to participate. The majority was totally open to the idea of participating in the project."

Yurman's story answers the question about why you should care about the homicide statistics of Rochester, New York. After seeing the story, when you read the numbers and statistics, you cannot help but care and feel the chagrin of the characters. The numbers are hard enough to wrap your head and heart around. But then how do you transform that into a human story that shows the humanity behind the numbers?

"I think at the very least," Yurman says, "it makes readers stop and think when they actually see the numbers. Many people's eyes may glaze over when you report the 27th homicide of the year, or low graduation rates, or high rates of poverty. After all, if you live safely out in the suburbs, such statistics only represent more negative news from your local newspaper. Why should I care about those people? Well, when they see my story, they will care about Alpha Lee and how she lost her son because people in the suburbs have sons and brothers they might lose, too. The story appeals on a visceral level to every man and woman, regardless of their social status or geographical location."

◀ **Not Forgotten.** Sandra Porter consoles her niece, Tasha Gano, Shamar's half-sister, at calling hours for Shamar Patterson at the D. M. Williams Funeral Home.

◀ Beverly Dunbar of Rochester says goodbye to Christopher Dunbar at his funeral in the Faith Deliverance Christian Fellowship Center in Rochester.

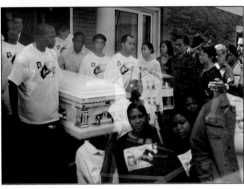

◀ Pall bearers carry the casket from the funeral home for homicide victim Ramon Burgos.

▼ Mourners gather at a candlelight vigil for homicide victim Korey Ellis. (Photos by Will Yurman/*Democrat and Chronicle*)

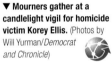

HUMOR

Multimedia and videojournalism are built for humor. Think of the times your friends have sent you a video on YouTube that you laughed at until your sides hurt. In fact, you laughed so hard you couldn't resist forwarding it to a dozen other people.

Powderpuff football is a high school tradition all across the U.S. Girls and boys switch traditional roles for one game. The girls play football and the guys cheerlead. While at the *Roanoke Times,* this writer produced a story called "Powderpuff Cheers: Hidden Valley Boys Dress the Part." The story, centered on the cross-dressing boys, was full of funny one-liners. When referring to his false "breasts", one male student said to a girl, "Balloons as boobs look pretty big and real. But I think rolled-up socks have the feel down right."

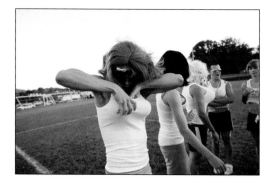

▲ **Powderpuff Cheers.** A senior powderpuff cheerleader checks the location of his balloons before the game. Girls and boys switch traditional roles during a powderpuff football game.

▼ Cheerleader for a day Eric Finch applies some lipstick in the mirror before leaving for the game. Finch and several senior friends acted as cheerleaders for the annual powderpuff game.

▲ Students hold a fellow powderpuff cheerleader during their game. "We're just like sisters," says one of the male cheerleaders.

▶ Cheerleader Eric Finch (left) gets some help adjusting his rolled-up socks in a bra from teammate Jacob Andrews (right) at Andrews's home before heading off to lead cheers for the annual powderpuff football game. (Josh Meltzer, *Roanoke Times*)

Kyle Green of the *Roanoke Times* produced a story on a woman who runs a dog poop collection business. Green's questions led to some funny answers. The subject tells Green, "I don't charge more for small dogs than I do for large dogs because it actually is harder to find small dogs' poo than large dogs'. Here you are searching around the yard hoping you won't step in it, but that is the way you find it. Large dogs, you can't miss it."

The answer to another question produced this insightful response. "I am one of the few people in town . . . that can come home and say, 'You can't believe the crap I put up with today'" followed by this observation on life: "There are only so many hours in the day. How many do you want to spend picking up your dog's poop?"

THE UNUSUAL AMIDST THE ORDINARY

Amidst the plethora of news stories online, our audiences are always looking for something to catch their attention. Many times, it can be the slightly oddball or different slant on a subject that does the trick. Everyone has a story. But not everyone's story is appealing to a large audience. As a videojournalist, it's your job to ferret out captivating people and appealing stories so as to make your work stand out above the masses of other alluring stories crowding the media today.

Todd Heisler from the *New York Times* finds fascinating people in his weekly "One in 8 Million" multimedia series. Each week, he profiles

▲ **Dooty Diva.** Katie Halsted has created a business called "The Dooty Diva." Job description? "Professional pooper scooper." Katie's business involves traveling to customers' homes and removing, well, dog poop. In the photo, Katie walks with her own three dogs. It is stories like Katie's where inherent humor grabs and holds the attention of an audience, shocking them with witty lines and satirical comments. (Photos by Kyle Green/*Roanoke Times*)

and tells the story of one New Yorker. His characters range from an urban taxidermist to a woman who loves sadomasochistic sex. There are veterans, sports fans, flirts, boat dwellers, gang members, detectives, criminals, gardeners, doormen, and mozzarella makers. The photography, all in black and white, is extraordinary, and the pacing is perfect for each story. It allows the audience to connect with one individual who is not a celebrity—just a single New York person (out of a city of eight million) who has something engaging or unusual to show the world. ◼

◀ **Stefanie Rinza: The Animal Rescuer.** *One in 8 Million* tells the stories of New York characters in sound and images. Stefanie Rinza is one of those characters. (Photos by Todd Heisler, *New York Times*)

▲ **Keeping Track.** As they
are shooting a story, some
videojournalists make notes
to remind themselves of
shots they need to complete
a story arc. (Photo by
Josh Meltzer)

Producing a Story

Josh Meltzer

Photojournalist-in-residence at Western Kentucky University, formerly with *The Roanoke Times*

S o you've found what you think will be a good video or multimedia story. You've determined that it at least appears to have some of the necessary components to be a successful story:

- It has a narrative line and potential conflict or tension.

- It has strong characters.

- It contains universal and pertinent themes outside of the story itself.

- It has something to say about the human condition or has direct relevance to significant, meaningful issues.

This symbol indicates when to go to the *Videojournalism* website for either links to more information or to a story cited in the text. Each reference will be listed according to chapter and page number. Links to stories will include their titles and, when available, images corresponding to those in the book. Bookmark the following URL, and you're all set to go: http://www.kobreguide.com/content/videojournalism.

But wait! Not so fast. Do you have an actual plan or outline for the story you're going to tell? Have you any idea who you might need to interview? Do you know what direction the story might be going in?

MAKING A PLAN

Multimedia journalist and teacher Bob Sacha likes to have a clear idea of what he's attempting to accomplish before he heads out to the field. "A certain amount of planning ahead prevents me from shooting wildly," he says, "and it keeps me from gathering too much irrelevant material." He says the story doesn't have to end up following the scenario he initially sets out to cover, but at least his plan gives him a starting point. Moreover, we know that most journalists have limited time to report. So a solid plan is a definite aid to using that time wisely. "I'm always thinking of what the conflict is going to be," he says. "Entering the fray on a prayer is a universally recognized bad idea."

Research is one of the most effective tools you have for maximizing your story's potential. First you need to hatch the idea, then you analyze it and decide whether a story exists. You must be sure the piece will contain sufficient conflict, and finally, you have to develop a hypothesis for what you *think* might happen.

Many videojournalists create a **storyboard** to keep track of all the elements in their story. (See also Chapter 13, "Editing.") Make notes of scenes on sticky notes or index cards. Each note card will represent a scene in your story. The scene sketches don't have to be sophisticated. They are strictly for use by you. So even scribbles and stick figures will do. Lay the individual sketches out in the order you think they might appear in your final video. You can rearrange the cards as you go along and see how to improve the narrative impact of your story. The notes are there to help you tell your story as clearly as possible. These simple note cards will give you clues about missing actions or transitions. If you realize a scene is missing, create a new card and add the scene to your required shot list. This simple index card method ensures that you don't repeat yourself or let your story sprawl too far in one direction or another.

By the way, rather than using note cards and hand drawn stick figures, you can use any of a number of software programs designed to help you produce a storyboard. Some videojournalists find these electronic storyboards easier and faster than the traditional paper-and-pencil method.

You can make the storyboard as detailed as you like. You should include opening and closing shots as well as transitions that take your audience smoothly from one scene to another. Quite naturally, as you shoot your story, you will constantly be changing your original storyboard to make it coincide with the actual scenes you have recorded. It's like a crossword puzzle, except you make the pieces. Depending on what your characters say and do during the shoot, you adjust the order of your pieces. The value of this kind of storyboard is that it allows you to spread out the "big picture" and see, as well as adjust, the shape of your story as reality unfolds.

COMMITMENT STATEMENT

A good story structure depends on, among other things, staying focused on what the story is really about. Viewers, it turns out, can track only one thing at a time. To ensure that the message is getting through to them, maintaining a sharp focus is critical. Longtime TV photojournalist, editor, and teacher Sharon Levy-Freed advises that you create a **commitment statement** (also called a focus statement). She suggests we try thinking about stories as a one-sentence summary with a subject (character), a verb, and an object.

For instance, "Mary Livingston overcomes spousal abuse through prayer" is an example of a commitment statement. The subject is "Mary." The verb is "overcomes." And the object is "spousal abuse." The videojournalist could record Mary talking about spousal abuse, then document any evidence that her husband harmed her, and finally, show the prayer in Mary's life that helps her to confront and overcome the abuse.

So before you can build your story, you need to be clear about its focus. Thinking of the story itself as a full sentence containing only a subject, a verb, and an object will show you how to find the story's structure.

Boil It Down

At the Advanced Storytelling Workshop put on by the National Press Photographers Association, students are instructed to find a story and then write a brief commitment statement. This statement is the heart and soul of the story and will guide them both in the field and during the edit.

Though this book is about short-form stories for the Internet, some television videojournalists also tell stories (not just record the news). Boyd Huppert, of KARE Channel 11 Minneapolis, is one of TV's short-form storytellers.

As one of the workshop leaders, he took participants through a real-life example of honing a focus statement using one of his own KARE-TV stories, a piece about an elderly woman named Clara who learned one day, after a spring storm, that her lifetime home would be threatened either overnight or the next morning by approaching flood waters. As he drove to the town that was awaiting the approaching flood, Huppert's focus statement went through five different stages. His focus evolved from "Sent out to cover flood" to "This flood is impacting individuals" to "Clara is packing up" to "Clara packs up to save her past" to the story's final focus, which was: "Clara struggles as she packs up to save her past."

"A story's focus can be in a character, or an emotion, or a concept," Huppert says. "It's got to be something that ties the otherwise disconnected pieces of a story together. There are a lot of stories that may not have a strong central character. When that happens, you have to replace the strong character by finding a concept that ties everything together."

Understanding the central role that focus plays in storytelling is key. Not understanding how to gain and maintain focus can jeopardize the quality of the final product.

Scott Rensberger, a freelance TV journalist who has traveled the globe and is a faculty member at the National Press Photographers Association storytelling workshop, follows such advice and boils his story idea down to a simple phrase. "If I can say what the story is about in one line and everyone wants to see it—you know it's going to be good. How can you screw up? 'The world's largest machine gun shoot;' 'A dog who thinks he's a postal worker;' or 'A happy couple that has been married 82 years.'" A simple, powerful sentence will help guide you and keep you on track through every step of the storytelling process. You will also find this simple sentence, or commitment statement, approach to be particularly useful during the editing phase.

YOUR PRIMARY CHARACTERS

After you've boiled the concept for your story down to a single sentence, it's time to decide who will tell the story. Who are your primary characters?

Who Can Represent the Story Best?

Months before his story "Uprooted" was produced, Dai Sugano, a multimedia videojournalist at the *San Jose Mercury News*, read an article in his paper about a trailer park's upcoming closure. The city of Sunnyvale, California, was attempting to close the Flicks Mobile Home Park via eminent domain for a large-scale construction project. "When I read it," Sugano says of the news story, "I knew that this was only the beginning of what could be a series of unfolding events. I went to the trailer park one day and knocked on several doors searching for residents who would be open to letting me follow them through their journey."

Knocking on doors is a good way to start, but you can't stop there. Next, choose and then interview the primary characters in your story. This second step is as important as the narrative itself. The trailer park in question had many residents. Some were American families, some immigrants, and some elderly. Sugano molded his story around two central characters—an immigrant family and an elderly single woman.

◀ **Uprooted.** Its owners were closing down and selling the Flicks Mobile Home Park. The photographer went from door to door to find subjects. (Photo by Dai Sugano)

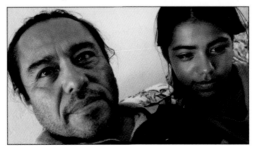

◀ Luis Trujeque and his daughter Minelia live in the Flick's Mobile Home Park in Sunnyvale, California, and face having to move if the park is closed.

► After 26 years of living at the mobile home park, Marilyn Baker will have to move if it closes.

▼ Marilyn Baker pauses while packing up to leave.

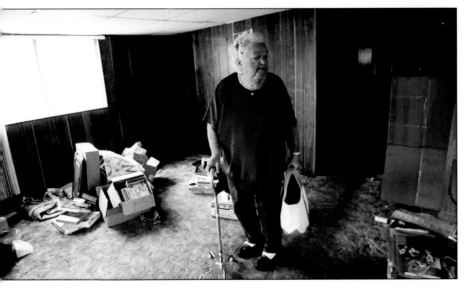

► Marilyn Baker addresses Sunnyvale city leaders about plans to close the mobile home park where she has lived for 26 years. Sugano was looking for two things in his story's characters: that they would be open, have a compelling story and could represent the residents of the community he was covering.
(Photos by Dai Sugano, *San Jose Mercury News*)

Sugano goes on to say, "In terms of the overall story, I needed subjects who represented the various populations that lived in that trailer park. Marilyn, the older woman, represented the seniors who were living there on a fixed income and had limited options. They wanted to finish out their days right where they were. On the other end of the spectrum, Luis and his family represented working families who saw living at the trailer park as a stepping stone to home ownership and the American Dream. Being able to compare and contrast the two different circumstances added both appeal and depth to the story."

Beware the Over-Eager Subject

Sugano cautions that, through experience, he has found that subjects who seem over-eager to tell their stories may have a strong agenda that can overshadow the truth of the story. So it's important that you, the overall storyteller, recognize your characters' motivation for participating in a project.

"If your first contact with your subject seems a little too good," adds Sugano, "then you need to think through the motivations and/or expectations of the person before you proceed. Sometimes a person takes a special shine to you because they mistakenly think you are there *for* them, and not for journalistic reasons. When people think that way, they may eagerly give you access to events they want you to photograph. But they may be concealing elements that they don't want you to witness."

Avoid an Official as the Lead Subject

Sometimes a person in authority volunteers to be your main character. A director of an organization might be willing. Or perhaps he or she will try to steer you toward a particular person they work with. Don't settle for these people as your characters right away. Rather, spend time in your story's environment first. Observe the people and analyze their motives before you settle on your protagonists. You don't want to spend hours, days, weeks, or months following some CEO or district manager around who ultimately doesn't turn out to be good for your story.

Additionally, remember that you're looking for someone who can stay with you all the way through to the end. Many times, journalists ask a lot of their subjects in terms of both time and the quality of their participation. The journalist wants the people he has chosen to be on tap at all times and to be completely open and frank.

"When working in multimedia, it is not only important to find subjects who will allow you the access you need to tell the story visually but you also need people who are able to articulate their part of the story," Sugano says. "The narrative is the key element that guides viewers through the documentary. As each event occurs, we want our characters to feel free to explain their feelings and be able to actually reflect on their experiences.

"From the first day I met her, Marilyn, the older woman who was about to evicted from her trailer, she was very open to talking about her situation. I could sense that she wanted someone to listen to her story. She really did have a compelling story and an open personality. She also indicated a willingness to have me follow her on her journey—yet she wasn't overly eager."

Many folks are not really willing, nor are they able, to lend all of their time or be perfectly candid about everything. "In the end," Sugano says, "choosing any of your characters is a leap of faith. You simply never know if or when the person may grow tired of you. Marilyn, the elderly single woman in the trailer park, was open, but at times, I had to be persistent."

Fair and Unbiased Journalism

Remember, too, that yours is a journalistic piece. It ought to represent more than one viewpoint. Consider ahead of time who will serve as counterpoint subjects and what those opposing viewpoints might be. You must also try to remain utterly fair and rigorously representative of the population or situation you're covering. Sometimes it can be easy to put blinders on and go with one viewpoint because one person is working out so well for your narrative. But do make sure that you step back from time to time and reevaluate your journalistic balance.

Journalistic stories have to present viewpoints from multiple sides of an issue. If you fail to do so your story will lack journalistic integrity. You may have a major point or an agenda to get across with your story. Nevertheless, you do have to give those with opposing viewpoints an opportunity to respond to your premise. Fairness and thoroughness can help you tell the story accurately and completely. In the end, if you manage to maintain balance, your story stands to be even more powerful.

In addition to assuring that your story is fair, you should also provide yourself with the means to fact check what your characters tell you. As the old saying for journalists goes, "If your mother tells you she loves you, check it out." This imperative holds true with video just as with the printed word.

By eliciting a variety of viewpoints, you can often add more powerful emotion to your story. Frequently, this emotion will manifest as humor. Suppose a person remarks on his old dirty clothes. If you ask a partner or good friend on camera if it's true about the clothes, the question may yield an entirely more powerful response, such as, "That guy looks like he walked out of a trash can." This type of exchange can add personality to your story.

In sum, don't be too quick to settle on characters for your story. Time and energy spent pre-interviewing as many candidates as possible and doing research to fully understand the story will save you a lot of headaches later on. When you sit down to storyboard your project, and the pieces and narrative are fitting together perfectly, you will be congratulating yourself for so carefully picking the voices for your piece.

Check with the Experts

Depending on the topic of your story, you might want to interview experts who can confirm a set of data, explain a phenomenon, or make a comment that helps put the story in the big picture. Bob Sacha, who has produced stories on issues as difficult to explain as climate change, often relies on scientists to help explain the topic.

"Mainly, I'm looking for an articulate expert who can tell the scientific story a different way," explains Sacha. "The danger is that many experts have their own professional jargon, so I have to ask them to speak in simple English. I always hope that maybe they can formulate an analogy for a difficult concept so that everyone will understand."

◄ On Thinner Ice. Bob Sacha calls on climatologist Lonnie Thompson as an expert scientist for his story about melting glaciers and global warming. Sacha understands that much of his audience is nonscientific; Thompson must speak in plain English so that his message will come across to a broad audience of laypeople. (Bob Sacha, Asia Center on U.S.-China Relations & MediaStorm)

Sacha says it can be pointless to use even the best experts if their language is too complicated and jargon-laden for his audience. "At some point, the expert must put the points in everyday terms," Sacha says. As an example, in a story for the Asia Society on global climate change, Sacha used the voice of an expert, Lonnie Thompson, a professor of paleoclimatology at Ohio State University. In this story, the expert made the analogy between glaciers melting and a dwindling bank account.

"You can think of a glacier as a bank account—as a water bank account," Thompson says in the story, "that has been built up over thousands of years. In the beginning of the 21st century we are taking more out of that bank account than is being put in. Of course we all know that long-term with any bank account if you do that, it will soon be empty."

"That analogy was a stroke of luck because everybody can understand a shrinking bank account," said Sacha.

Global warming may seem like a complex scientific topic to explain in a video story

intended for a general public, but if your expert can relate to the audience in a way that makes the subject appealing to everyone, then you're in business.

Finally, if you can strike a comfortable balance between experts' knowledge and the experience of people at ground level affected by the phenomenon, then you have a story that your audience can both comprehend and be emotionally moved by. Your goal is to teach your audience and at the same time touch a nerve with them.

HOW TO BEGIN THE STORY

How cleverly you tell the story will determine your story's arc. Though it may seem that this arc really develops after the field reporting is done—and it very well may—you want to be concerned with your narrative plan before you get started and keep it in mind throughout the reporting process.

The Audience Is Watching . . . the Clock

Here's the good news.

According to a survey of Internet video viewers, if your video story is less than 10 seconds long, about 89 percent of viewers will watch your whole video.

The bad news?

There just aren't that many 10-second videos out there. Most journalistic video stories are much longer. If your story is about 30 seconds long, the study shows that about two-thirds of your viewers will finish watching it. Make it 30 seconds longer and fewer than half the

viewers will stay till the end. Because most online video stories are in the 1:30 to 3:00 range, you may only hope that 10 to 20 percent of viewers will watch all of yours. The aim of the game in videojournalism is to create gripping, well-wrought stories that grab a viewer's eyeballs and do not let go until the every last frame.

As video and multimedia storytellers, we are fighting an uphill battle. The wide general audience we keep talking about—your average viewer—is probably checking email, chatting online with a friend, and visiting another two or three websites while your story is loading and playing. Once you have grasped this discouraging fact, you can start to see just how compelling and engaging your stories must be in order to compete with the daily avalanche of online distractions all your potential viewers deal with.

The first 10 to 20 seconds of your story is without a doubt the most important part. Keeping a viewer's eyeballs glued to the screen while your show is playing is, of course, the ultimate challenge. It takes research and planning and a knack for telling a story. But if you have gotten this far and are still interested in trying to create multimedia stories, you are probably a fine candidate for this fascinating profession.

Combine a Powerful Quote and Shocking Action

Study the first 10 to 20 seconds of strong films. Have a look at the 1983 documentary film *Street-wise*, by Martin Bell. In a few short minutes, Bell's audience is focused on the story and its characters. The film begins with a powerful quote. One of the street kids, by the name of Rat, is standing on a bridge. It appears he is getting ready to jump off. "I love to fly," says Rat. "It's just you alone. You have peace and quiet, nothing around you but clear blue sky. No one to hassle you. No one to tell you where to go or what to do." Then he adds, "The only bad part about flying is having to come back down to the fucking world."

As soon as Rat jumps off the bridge into the river, the film cuts to scenes of Seattle in the early 1980s. First a wide view with ships, trains, long views, then it narrows quickly onto the street. We hear street performances and boom box music and then meet the main characters of the film. Another kid is panhandling and says to a passerby, "Spare some change, ma'am, so me and my father can get something to eat?"

This intro of less than two minutes in a feature-length documentary film sets the mood and hooks the audience with a powerful quote

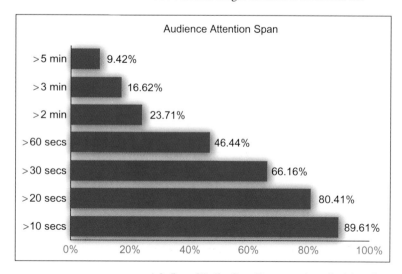

Audience Attention Span

>5 min	9.42%
>3 min	16.62%
>2 min	23.71%
>60 secs	46.44%
>30 secs	66.16%
>20 secs	80.41%
>10 secs	89.61%

0% 20% 40% 60% 80% 100%

▲ **Audience Attention Span.** The average drop-off rate in audience attention span presents a constant challenge for videojournalists. *Source: Tubemogul, a video analytics platform for research.*

◀ **Streetwise.** To grab viewers' attention, the producer opened his documentary on street kids in Seattle with a teenager jumping from a bridge with shocking dialog. (Producer, Martin Bell. Courtesy of Angelika Films)

and a kid's terrifying leap from a bridge, and then a panoramic shot of the setting that quickly establishes a sense of place.

Be **bold**! Think about this. Is there a powerful line from the peak or climax of your story that might be a great way to start? Sometimes it's seductive to hint or foreshadow where your audience will be taken. PBS's *Frontline* tells a story of assisted suicide that follows the saga of an American afflicted with the disease ALS as he decides to end his own life. In the opening scene, he is on a plane taking off for Switzerland, where he will eventually end his suffering. The very beginning is dramatic because he is declaring right at the start of the story that he is going on a trip to end his life. For the moment, the audience can only imagine or wonder why. But that initial statement is a shot square in the solar plexus. Dramatic beginnings that leave unanswered questions are terrific ways to start a story.

▲ **The Suicide Tourist.** To seize the viewer, the producer opens this documentary with Craig Ewert saying he is taking a trip to commit suicide. (Produced by John Zaritsky, *Frontline*)

Don't be afraid to use quotes and symbols. But don't fall into the trap of trying to be too clever with symbolic imagery or obscure quotes that force the viewer to work in order to understand what is going on. Very early on, you need to tell the viewer what the story is about. But you don't want to confuse or alienate an audience with show-off grandiosities.

Hook Them with Humor

Don't shy away from humor. If you can get viewers to laugh up front, they'll assume they may be in for more fun later.

Photographer Katie Falkenburg produced a short story about love and work. She begins with humor to engage her audience. This is a story about Richard and Debbie, a middle-aged couple in love, and how they helped one another find and start a business.

▲ **Labor of Love.** The producer selected a funny line of dialog to start a story about how a couple began their mobile pet-grooming business. (Produced by Katie Falkenberg)

The story begins with a description of how they met and what attracted the two to one another. It opens with Richard singing, "She's my girlfriend, she's my girlfriend, and I love her to the very end."

Debbie's voice comes in speaking, "If I could have George Clooney or Richard, I would pick Richard. I really would." Then Debbie adds with a hint of laughter, "I might have George Clooney's photo, but yeah, [Richard's] definitely a keeper."

By using this touching bit of humor, the story seduces the audience with the whimsical side of the characters and lends a tone of light-heartedness that carries us along throughout the piece. If your characters are funny, let them be funny. Their humor can only enhance your story.

Throw the Viewer into the Story

You want to plunk people right into the action. For instance, get a main character to recount and retell a part of the story so your viewers feels as though they, too, are reliving it right in front of their eyes. In a piece in the *Raleigh News & Observer*, photographer Shawn Rocco and Travis Long report on a wrongfully convicted and imprisoned man who is exonerated and released. The photographer uses this "character retelling the story" technique. In this example, the character is really reliving the story right in front of the viewers. It's quite a compelling method of drawing in viewers.

▲ **Dail: Life Unbarred.** Accused of rape, Dwayne Dail lost half his life to prison before DNA evidence found on the victim's nightgown proved his innocence. In the video, Dail tells his own story.
(Footage: Shawn Rocco, Travis Long, interviews: Mandy Locke, stills: Shawn Rocco, editing: Travis Long, Shawn Rocco)

What the Hell Was That?

Put something out there in audio or visuals (or both) that makes the audience say, "What the hell was that?" Build it slowly and little by little make them wonder. Give only a little smidgen away at a time. If you spill all the beans up front, there is no reason for a viewer to stay with you. Hook them with the bizarre, but keep it relevant. The perfect story won't all happen at once. These techniques take practice, and practice, we already know, makes perfect. Trying different approaches will eventually lead you to the one that works for you.

In a video story by PRI's *This American Life*, which tells the story of a group of young people in North Philadelphia who ride horses, viewers are presented first with a look at the inner city, and then we see horseback riders pass through each frame. There is only music covering these shots, so it sets viewers to wonder, "What the hell was that?" It's an excellent trick when you can pull it off because their very wonderment will make them want to continue. Basically, you want to try to do something that puzzles your viewers and urges them stay with you.

Delayed Lead

Bob Sacha worked with Reuters photographer Lucy Nicholson and visual projects editor Jassim Ahmad during a MediaStorm workshop. The pair wanted to do a story about Times Square in New York City. After discussing five possible story ideas, the two journalists settled on the Naked Cowboy, an icon of Times Square. But Sacha had concerns about the story. Several Naked Cowboy stories had been done, he said; plus, the Naked Cowboy is a celebrity, and celebrities rarely open up the way he likes his subjects to do. Visually, of course, "it would be like shooting fish in a barrel," Sacha said, "but we had no story."

As the three were leaving the first interview with the Naked Cowboy at home, the subject's girlfriend arrived. Nicholson asked her, "What's it like to be the Naked Cowboy's girlfriend?" Sacha says, "She totally opened up, told us all about how they met on the elliptical machines at the gym. It was a boy-meets-girl story," Sacha says. "The lightbulb went on!"

The relationship, of course, ensured the universality of this story. But what set it apart was that the relationship was that of someone public, someone famous. Everybody wants to know what is it like being the Naked Cowboy's girlfriend. Says Sacha, "Imagine what's it like to be in a relationship with a guy in such dazzling

▲ **One Man Band: The Naked Cowboy.** The Naked Cowboy playing in Times Square was a celebrity, but alone he did not make a story.

▼ When the photographer discovered that the Naked Cowboy had a girlfriend, they realized they could give the story a new twist by telling it from two points of view. (Photos by Lucy Nicholson Reuters)

shape with a dazzling ego to match. What makes this naked cowboy so irresistible in Times Square is precisely what makes him so problematical for her." So the Naked Cowboy story is not just about a celebrity, per se. It's about a singular relationship, and a complex one at that!

Once they determined what their story would be about, Sacha and his team quickly made a plan for the opening of the story. "We knew we wanted to hide the fact from the viewer that the subject was the famous Times Square Naked Cowboy. We knew that to start the story we wanted a video of the couple working out together on the elliptical machines at the gym. So our story begins by hearing the story of a regular girl meeting a regular guy at the gym. They chat. She asks him where he plays his guitar. He gives the address. He even hints that everyone knows him. But still, as the story inches forward, we still are not aware of who he really is. Then, BAM! All of a sudden Jack is out of the box and our hero becomes the Naked Cowboy! That's when the two personalities really come alive.

THE END WILL BE REMEMBERED

Viewers tend to remember the beginnings and endings of stories. Make the end as good as the beginning. Be cognizant of how you want to leave your audience. Remember, they have invested precious minutes watching your piece. Don't just end the story without offering some satisfying closure.

If your finale is weak, no one will remember the story. The obvious fallout from a flabby ending is that people probably won't come back for any other stories.

Three Essentials to End the Story

In an essay for the Nieman Foundation for Journalism at Harvard, Bruce DeSilva, an author and former writing coach for the Associated Press, observes, "A good ending absolutely, positively, must do, at a minimum, three things: One, it must tell the reader the **story is over**. It must do that. Two, it also needs to **nail the central point** of the story to the reader's mind. You (the writer) have to leave the reader with the thought you mean him to be taking away from your story. And three, that thought should **resonate**; it really should. You should hear it echoing in your head when you put the paper down, when you turn the page. It shouldn't just end and have a central point. It should stay with you and make you think a little bit."

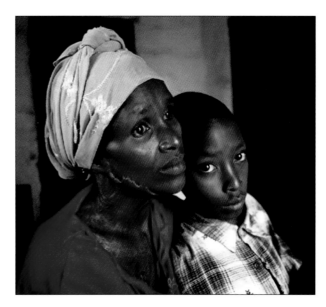

That is my brother.

▲ **Intended Consequences.** The story of Rwandan women who had been raped by men of a different tribe ends with a montage of images of the mothers and of their children. The video closes on a hopeful note with the last child going from a serious face to a smile. (Story by Jonathan Torgovnik; produced by Chad Stevens, MediaStorm)

Although DeSilva is talking about the written story, the same can be said for a video story. In "Intended Consequences" by Jonathan Torgovnik, near the beginning of the story, there is a portrait montage of some African mothers. According to Chad Stevens, the story's producer for MediaStorm, you can see the scars of experiences of these Rwandan women who were raped and then gave birth to children of the Hutu militiamen. The central point of the story asks the question: can these women and these children overcome these scars? This point is reinforced at the end of the story. "The children's fates are unknown," says Stevens. "Will they get any education? Can they overcome the drastic ethnic boundaries? Will they make it to adulthood? Questions remain unresolved. Or maybe because their futures are unknown, there is still room for hope. The story ends with a montage of the children's portraits, echoing the mothers' portraits from the opening. The children's expressions are quite different. Their scars aren't as deep. A smile signals hope." Stevens says this story required the infusion of a sense of hope so that the viewer could envision change and maybe even be motivated to act. This story, like all good stories, resonates. It stays with the viewer after the last image fades from the screen.

▼ **Motel Manor Suburban Homelessness.** The intersection of Interstate 70 and Highway 40, dubbed the "crossroads of the nation," is also where suburbia meets a national problem. Two motels here have become home to St. Charles County's chronically struggling, homeless, fragile families.

Two-year-old Drew Trantham plays in puddles in the parking lot, his playground, outside the Budget Inn in Wentzville. His parents, Cherri and Joe Trantham, and sister Mary, age 1, moved into the hotel after losing their trailer to foreclosure. (Photo by Robert Cohen, *St. Louis Post-Dispatch*)

End the Story with a Punchline

Robert Cohen, a photographer at the *St. Louis Post-Dispatch*, shot and produced a story on the U.S. economy that focused on homeless families living in hotels in a middle-class suburb of St. Louis, Missouri. His story followed families in a paradoxical setting. Many people believed there were no homeless families living there. Using both familiarity and access, Cohen tells their personal stories as a way to put faces on the economic crisis. The story concludes as one father has found work at a local McDonald's restaurant. Though the job certainly isn't the

▲ Joe and Cherri Trantham moved their family of four to the Budget Inn after losing their home. Joe works at a nearby McDonald's. He brings home dinner at the end of his shift.

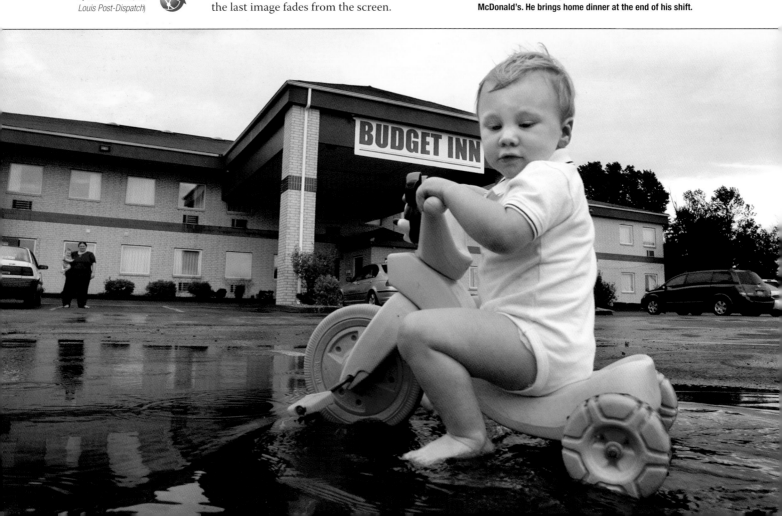

◄ The Budget Inn and Economy Inn are, for many, a place to grab a cheap, no-frills $36 room on a road trip. For others with no place to turn, it's the last-chance inn.

▼ When the family checked into the motel, they registered with no home address.

▲ A school bus transports homeless children between the motels and their schools in Wentzville.

◄ "I'm glad to be back . . . to be able to provide for my family," says Joe Trantham about his new job at McDonald's. Here, he gets ready to go to work with his daughter Mary at his side.

◄ "When you go on vacation and stay in a motel . . . you're able to spend time with your family and not worry about nothing," says Cherri Trantham. "But when you live in a motel, you're like when is this vacation gonna end so you can get to go to your own home."

solution to releasing his family from a tentative life in a hotel to one in their own home, at least it produces a sense of hope.

The final comment in the piece comes from his wife, who explains that for many families, going to a hotel *is* a vacation, where people clean up after you. Cherri just wants their *vacation* to end so they can leave the motel and move into their own home. This poignant ending serves two purposes: first, it connects the audience to a universal and familiar experience—staying in a hotel. But it just as poignantly reminds viewers that for this family, the hotel experience is turned on its head. Second, it says to the audience, "This story isn't over. It continues. And nobody knows how it will end. There is some hope, but there are no promises."

Story endings are critical. In this case, the use of Cherri's poignant quote aptly sums up the feeling, the experience and the moral of the story. It is an excellent way to provide the audience with a sense of closure. ■

▲ **Single Purpose Video Camera.** A well-made video camera is designed with most of the controls you need on the body of the camera within easy reach while **shooting.** (Photo by Ken Kobré)

Camera Basics

If you are used to shooting still pictures, making the transition to video may feel like a big step. Don't be alarmed. Many of the skills you have already acquired about shooting stills—skills such as focus, lens selection, and controlling exposure—will transfer seamlessly to video. There are, however, some skills that are specific to video. You will be obliged to learn about these in order to make full use of this new visual medium.

SELECTING A CAMERA

Cameras today are ubiquitous. An employer might hand you a camera and tell you to go out and shoot a video story. Or you might check out one camera brand and then another from your school. In a pinch, you might even shoot a video using your cell phone.

This symbol indicates when to go to the *Videojournalism* website for either links to more information or to a story cited in the text. Each reference will be listed according to chapter and page number. Links to stories will include their titles and, when available, images corresponding to those in the book. Bookmark the following URL, and you're all set to go: http://www.kobreguide.com/content/videojournalism.

But sooner or later you will probably wind up buying a camera for yourself—one that you can use all the time.

Sizes, prices, and functionality of video cameras and/or cell phones can turn choosing a brand and model into a daunting task. Today's cameras range from pocket-sized point-and-shoots that sell for less than $200, through smart phones and tablet computers, all the way up to full-featured, shoulder-held professional video cameras costing thousands of dollars.

▲ **Smart phone.** Smart phones are becoming better at recording high definition (HD) video. Many are equipped with multi-million pixel sensors that produce sharp pictures and some even sport software to edit the video on the fly and of course send it anywhere in the world with a finger's touch. (Photo by Ken Kobré)

Smart cell phones with complete video capability are growing in popularity. These sophisticated cell phones can shoot high-definition (HD) video as well as record sound. Some even allow you to manually focus one section of the image or another by touching the screen. They often have a built-in light for shooting in dark areas. With these devilishly capable devices, you can edit your video directly on the phone itself. Then you can share it by simply sending it to a friend or posting it on Facebook or some other social network. Or you can upload it to an Internet video site such as YouTube or Vimeo.

A cell phone is small and compact. It's already with you most of the time. For that reason alone, many users find the cell phone preferable to standalone video cameras or single-lens reflex (SLR) cameras that shoot video. Because you can send video directly from your cell phone, many users prefer these devices over similar-sized but dedicated pocket video cameras.

The automatic and manual controls on these high-end cell phones are constantly improving. Soon there will be easy ways to plug external mics and headphones into your cell phone so that you can simultaneously record and monitor your audio. Although they don't quite measure up to the quality of a dedicated video camera, cell phone videos are fast improving. One thing is sure: smart phones are more and more pervasive. The number of homemade videos shot with cell phones on YouTube alone is staggering.

The tablet computer with its video capability is following in the footsteps of smart phones that shoot video. Users are shooting videos with their tablets and immediately showing the footage on the tablet's relatively large screen.

Many cameras, also called camcorders, are designed specifically for shooting video. These cameras are the culmination of 60 years of perfecting equipment for this sole task. These video cameras have grown increasingly smaller. Makers have produced a wide range of models offering a vast array of different features, but the function of camcorders continues to serve primarily for recording moving images and sound for video. Single-purpose video cameras provide an ease of use for capturing high-quality images that make them ideal for documentary shooting.

▲ **Camera for both stills and video.** Small, light hybrid cameras allow shooting both stills and video. The photographer has attached a viewfinder adapter to the camera shown here. (Photo by Ken Kobré)

▲ **Single Lens Reflex Camera + Devices.** Using a DSLR (Digital Single Lens Reflex) as a full functioning video camera can require buying a number of add-on devices. Here the photographer is using an external viewer, shoulder-mount support and portable light. (Photo by Melissa Morley)

Several cameras designed originally to capture still images now shoot video as well. They are what we call hybrids. Hybrids come in at least two flavors. One is the standard Digital Single Lens Reflex (DSLR) camera with interchangeable lenses that can now shoot both stills and video. A second kind of hybrid that is smaller and lighter than a DSLR has interchangeable lenses and still shoots stills and video. With this type of hybrid camera you can't view the image optically, only electronically, on a viewing screen. By eliminating the DSLR mirror, however, the camera designer saved space, bringing the lens closer to the sensor.

This reduced distance means the camera can use smaller, lighter lenses.

A powerful cinematic effect also allows the shooter to achieve sharp subjects and blurry backgrounds. The hybrid cameras have a relatively large sensor chip. That additional sensor size allows the video shooter using a hybrid camera to determine how much of the area in front of and behind the subject will be sharp. The effect is difficult, if not impossible, to achieve with many of the smaller single-purpose, video-only cameras because their sensor chips are smaller.

Switching between shooting stills and shooting video with the hybrid is easy enough. The trouble is that some hybrid cameras lack the ergonomics and functionality of the advanced video cameras. With hybrids, the audio options are quite limited. The audio controls are sometimes buried in menus that are time-consuming to find. Most don't have the capability to allow the user to record directly with professional-level microphones. Focusing is also more difficult with some of the hybrids. In fact, videojournalists often add external focusing aids to help their cameras along because the screen on the back of the camera that shows the video, sometimes called "Live View," is nearly impossible to focus in bright sunlight. The hybrids lack a number of the options found in dedicated video cameras, such as power zooms. As technology improves, however, many of the limitations of the hybrid video camera will surely disappear.

► **A Range of Cameras for Video Shooting.** Here is a subject being shot with three different cameras. From left, a pocket video cam, center, a DSLR hybrid, and a dedicated full-feature video camera. (Photo by Ken Kobré)

"It's good to try out a camera before you buy one," says Lisa Berglund, a former director of photography at KNSD-TV San Diego, California, and the first woman to win the National Press Photographers Photographer of the Year award. Berglund now is a senior producer at World Vision. "That might mean borrowing it, or renting it from a production house, or checking it out at your school. Doing this could save you lots of headache, time, and money in the future. When you actually use it, you will quickly notice a camera's limitations and will find out if the camera quality is suited to your project."

How can you make sense of all the different video choices? In the following subsections, you will find some of the most important elements to pay attention to when choosing a video camera to use as your own.

Picture Quality

Most video cameras shoot clear, sharp images in bright sun or even in deep shade. What really separates the sheep from the goats when it comes to video quality is how the cameras handle very low light like that in a dimly lit room. Though a multitude of factors determine how well a camera shoots in low light, the critical variables are the number and size of the sensor chips that the camera uses to record images.

Some cameras have only one sensor; others have three. In this case, three is better than one. Color will be crisper when it is taken with a camera with three sensors, especially indoors in rooms without much illumination or outdoors at night. The larger each sensor is, the more light it collects. Collecting more light results in brighter, sharper pictures with better colors—especially in low light. A camera with three large sensors produces crisper pictures than one with three small sensors.

Of course, even sensors of equal size are not always equal in quality. Those with higher resolution are more densely packed, with more

Three-chip video cameras delegate each primary color—red, green and blue—to its own sensor chip. These provide vivid, natural colors over a wide range of lighting conditions. These 3-chip models usually feature high resolution as well.

Most small video cameras use just one sensor to capture images. The physical size of the sensor in most home camcorders is between 1/6-inch and 1/3-inch. The sensor in professional video cameras is larger—usually 2/3-inch and greater.

In a **full-frame SLR hybrid** the sensor is almost 1 inch by 1-1/2 inches (24×36 mm) or ten times larger than a 1/4-inch video sensor.

Pocket video cameras are easy to shoot but have tiny sensors and lack manual override controls.

than a million pixels; those with lower resolution have half a million or fewer pixels. In theory, more pixels mean sharper images.

Also, the most basic video cameras make all the exposure decisions for you—but they do not always make the right choices.

When purchasing your own video camera, take all these factors into consideration. Ask advice of pros. Keep lists of brands you see and try. Check off what each one offers. Then, after due analysis, choose the one that's right for your personal and professional needs.

Features and Functionality

The only camera control you'll find on some pocket video cameras consists of a single on/off button. Moving up from there, better-performing cameras include automatic features and also allow for manual controls of brightness, focus, color balance, and a slew of other variables.

Whether you like just pointing and shooting or you are a professional one-man-band and prefer doing everything yourself, the automatic settings on the camera—either located as a menu setting or a dedicated button—will be useful. There will, however, be conditions where more control is necessary. Even if you're new to shooting and don't want to use all the controls, as you become more familiar with the equipment, you're going to find them extremely useful.

All of the following factors affect picture quality. Check to see if your video camera has these manual controls:

- **Exposure:** An adjustable iris, the opening in the lens, lets in more or less light. On still cameras, this opening is called an aperture.
- **Focus:** Your eye focuses naturally, but sometimes your camera needs help.
- **White balance:** Cameras must adjust for the change in color tint from the blue of the sky to the yellow of a desk lamp or the green of a fluorescent tube.
- **Shutter speed:** You rarely need to change the speed at which the shutter opens on a video camera. This is one manual control videojournalists don't often use.
- **Video gain control:** This feature changes the electronic sensitivity of the sensor to brighten the picture in low light.

Recording Media and Playback

Does the camera record to tape, flash memory cards, DVD, or an internal hard drive? Although tape served the industry well for many years, most of today's digital cameras record directly on removable flash memory cards (for example, Compact Flash or Secure Digital), or more expensive proprietary memory cards unique to the manufacturer.

In general, for shooting documentaries, consider a camera that uses the SD card. SD cards are small, cheap, and hold a lot of data. Their size and price allow carrying many cards at a time. Carrying multiple cards will greatly extend your productive time in the field.

Whether you have recorded one scene on a flash memory card or a thousand, you can review your handiwork in the video camera itself. If you have shot on tape, the camera controls work just like a VCR player with "rewind" and "forward" buttons. If your clips are stored on a flash memory card or a hard drive of some sort, you can just select the scene you want and review it immediately. Reviewing your most recent footage while still in the field is crucial because it allows you to identify problems on the spot and immediately strategize on how to solve them.

TIP Avoid cameras that record to an internal hard drive. They require stopping to download when the drive is full, which renders the camera useless during the download phase. Those that burn a DVD while the camera is recording also are poor choices because processing the material from DVD for editing takes far longer than it does with other formats. No sense buying a time drain. Videojournalists are busy people.

Zoom Capability

Many video digital cameras offer two ways to zoom: optical and digital. Optical zooms physically adjust the lens from wide angle to telephoto to bring the image closer. Picture quality remains excellent. On the other hand, digital zooms create the illusion of coming closer by basically cropping out part of the image and enlarging what remains. This cropped image thus has fewer pixels. Digital zooming results in blurry footage. Make sure your camera has optical zoom instead. Avoid the digital zoom like the plague.

▲ **Secure Digital** (SD) card (left) and **Compact Flash** (CF) card for shooting and storing video.

◄ **Digital Zoom.** Many smart phones and pocket videos have a digital, not optical, zoom. Avoid the digital zoom option. This fake zoom produced by electronically rather than optically enlarging the image produces blurry footage. If you feel you really need to zoom digitally, stop. Instead, walk closer to your subject.

Essential Audio Features for a Video or Hybrid Camera

All video cameras can record sound. However, most built-in microphones also collect too much room noise. For this reason, they are rarely effective at isolating human conversation. They often even pick up the noise of the camera as it is being handled.

For video documentaries of any length and for any medium, you need a camera with an audio-in port so you can use at least one or—even better—two good external microphones. Many pros say the ability to add good microphones is even more important than the choice of camera itself.

Equally critical is an audio-out port on the camera for adding headphones in order to monitor the quality of what you are recording.

If a video camera can't accept an external mic or headphones, it's just not up to speed for shooting documentaries. Don't be tempted by low prices. You get what you pay for.

Here's your audio checklist:

- Audio-in ports for adding one or more external microphones
- Audio-out ports for adding headphones to monitor sound
- Both manual and automatic control of sound levels

Finding a Camera that Fits You

Some cameras fit in your hands like soft kid gloves. Others seem clunky and confusing. Where are the camera's controls located? Where are the important buttons and switches located on its body? Are they buried in a series of menu items that you must scroll through on the camera's LCD screen? Check each of these features and think about how they might eventually impact your use of the camera. Use Internet forums to learn about other shooters' opinions. Before buying, download and study the camera's manual. Make your final choice only after thoughtful research.

There are various sites that contain information valuable for researching camera choices. The KobreGuide link will take you to them.

Of course, camera equipment comes secondary to your story. Great storytellers can shoot with an iPhone and tell a powerful story. The power is not hidden somewhere in the equipment. The power still lies in what you do with it.

▼ **Compact Video for Travel.** Many decisions go into selecting a camera for shooting online video including weight, clarity of color, ease of use and, of course, cost.
(Photo by Ken Kobré)

THE GEEKY STUFF
Frame Rate

Video footage looks continuous but is really constructed from a series of individual images or "frames" presented to the eye so quickly that they seem like an uninterrupted stream. In fact, at any rate greater than about 15 frames per second (fps), our brains cannot distinguish individual images. Instead, our brains interpret the rapid series of frames as a stream of visual information. To our eyes it looks like continuous, smooth motion. Most videos are recorded at twice the 15 frames per second rate. They run by our eye at about 30 fps.

Format

Format, or aspect ratio, refers to the proportions of the individual video frame—in other words, the relationship of width to height. When setting up your video camera, you may be asked to select from one of these formats before shooting. It's best to know which one you want before you start shooting.

Standard 4:3. The TV screen for many years was more or less the shape of a slightly oblong box. This relative shape was referred to as four by three format (standard definition, or SD, 4:3). If you could have frozen the picture on the screen and counted the lines in each frame, you would have seen that image was really made of 640 distinct vertical lines and 480 horizontal lines. No matter how big your TV screen, it was the same relative shape, and 640×480 lines formed each frame that flashed by at 30 times a second. This was the SD format. (On some cameras, this format is referred to as DV Normal.)

Wide-screen 16:9. Because TV programming began featuring so many Hollywood movies that had been created for viewing on a wide screen, manufacturers next developed televisions that were wider and introduced a new format they called 16:9. The picture quality wasn't really much better—the line count had been increased only a little—but the screen itself was wider and could play the movies without cutting off the sides of the picture or putting a black band on the top and bottom of the screen, a technique known as letterboxing. (Some cameras call this format DV Wide.)

High definition. Then, along came high definition—HD. Any new television is HD, and most of the better video cameras sold today shoot HD. The size of the picture is in the wider

◄ Aspect Ratio. Aspect ratio is the ratio of width to height for an image or screen. The North American NTSC television standard uses the nearly square 4:3 (1.33:1) ratio. High-definition television (HDTV) uses the wider 16:9 ratio (1.78:1) to better display widescreen material like HD broadcasts and DVDs.

16:9 format but consists of many more lines of information—1280×720 or even 1920×1080—resulting in a much sharper the image.

Progressive versus interlaced. Video can be shot and displayed as either "progressive" or "interlaced." A progressive video, as indicated by a "p" after the capture rate (30p), shows a complete frame, one at a time, on your television screen or computer monitor. An interlaced video, as indicated by an "i" after the frame rate (60i), shows only half of the frame at a time, with the second half appearing 1/60th of a second later. As with frame rate, your brain is fooled into seeing the two interlaced half-images as one whole image. In high definition, there are two common choices: 720p, with progressive images (720 lines high and 1280 lines wide) and 1080i, with interlaced images (1080 lines high and 1920 lines wide).

Setting Up Your Camera

So what does all this geek-talk about 4:3, 16:9, HD, interlaced, progressive, and so on mean to the videojournalist? Well. The menus on video cameras require you to decide which format to use. You are likely to be offered four or more choices:

- Standard definition—4:3
- Wide-screen—16:9
- High-definition progressive—720p
- High-definition interlaced—1080i

Select high definition (HD) when available if you expect your video to be seen on either a computer or a television screen. HD footage looks fine on an older television also; standard widescreen 16:9 will not be as sharp on an HD television.

But which of the HD formats—interlaced or progressive? Pros debate this. Some claim that 720p is a better choice for shooting sports and grabbing still photos. Others say that interlaced results in more of a film-like look.

If your camera offers different format choices, try running your own tests to see which option best fits your needs. Take time to experiment with both HD formats. Then you will be able to make an informed choice.

STARTING AND STOPPING THE VIDEO CAMERA

For anyone accustomed to taking still pictures, the most difficult habit to overcome when shifting to video is the tendency to push the video camera's start button and use it as if it were the shutter release on a still camera. Pushing the

button turns on the camera. But pushing it again puts the camera on standby. So if the camera is already running, hitting the button at the peak moment *stops* the recording and leaves nothing, nada, zip. And you are left standing there as the critical moment plays itself out unrecorded. Once you've mastered this twist of logistics, you'll probably find the video controls relatively straightforward. Most video cameras have a "record" indicator visible in the viewfinder or on the LCD screen. Get in the habit of checking this onscreen indicator to make sure the camera is actually recording before the subject starts speaking or the dog does his trick or the baby performs his Michael Jackson imitation.

CARRY EXTRA BATTERIES AND MEMORY CARDS

Battery and Memory Card
Never leave home without extra charged batteries and flash memory cards. Left to right, SD card and a 180-minute video battery. No matter how short you think your shoot will be, you never know when you will need the extra recording capacity. You can never have enough.

STAYING FOCUSED

The optics in today's lenses produce laser-sharp, clearly focused video pictures under almost any conditions. Even low-end cameras with fixed-focus lenses capture sharp pictures as long as the subject is three feet or farther away. Higher-end cameras offer a choice of automatic, manual focus, or a number of options in between.

How to Use Autofocus

In most circumstances, you just put the camera on autofocus and shoot, but you do have to continue monitoring the screen or viewfinder to make sure that the camera is producing the results you want.

The camera will usually focus on the subject in the center of the frame and nearest to the lens. As you reframe from one subject to another, the lens will gradually readjust and sharpen the newly framed image.

With sufficient light, the camera adjusts focus quickly. When tracking someone, for example, the camera can maintain sharp focus as the person moves toward or away from the camera.

▼ **Autofocus.** As the woman approaches the camera, autofocus keeps her face in focus. The autofocus option also works well when the subject moves away from the camera. (Photo by Ken Kobré)

▲ **Focus.** On many video cameras, you can focus manually or automatically. Pros prefer manual, but automatic works well in most fast-moving situations. (Photo by Ken Kobré)

Maintaining sharp focus on a subject coming toward the camera can be difficult with manual focus. Use autofocus for fashion shows, sports, street altercations, or other fast-moving situations when you will not have time to follow focus manually. Autofocus is remarkably good and often better and easier than manual focus, but certainly not perfect in all situations. However, for the one-man-band faced with simultaneously controlling exposure, sound levels, framing, and interviewing, autofocus makes it possible to more or less manage all the various elements and produce sharp footage as well.

Face Detection Recognition

Some autofocus cameras employ **face recognition** software that literally recognizes, hones in, and focuses the lens on a human face. This function is great if you want, say, a porcelain vase collector in focus and not the Chinese teapot in front of her. One advantage of face recognition when shooting video is that once a face has been detected, the camera follows that person through all movements in the scene, from side to side, up and down, and off-center. Of course, the face recognition software does not know which subject in the scene is central to your story and which is just an unimportant interloper.

When Autofocus Fails

Autofocus can be fooled. Under certain circumstances, autofocus does not perform well. That's why it is not a panacea for all situations. In these circumstances, seasoned videojournalists use a combination of autofocus and manual focus.

Staying Sharp with Manual Focus

John Goheen, a 12-time Emmy winner, has shot for 30 years. He has never used autofocus. He manually focuses every shot, as do many longtime professional television shooters.

Here are the steps pros like Goheen use to achieve sharp results with manual focus for an interview before starting to shoot:

1. Turn on the camera.
2. Locate the focus control.
3. Set the focus to manual (M).
4. Either look through the camera's viewfinder or watch the image on the LCD screen. Pros tend to use the viewfinder, claiming that the image is sharper and more precise for critical focusing than on the LCD screen. That claim may be changing as LCD screen resolution improves.
5. Zoom in on the face.
6. Focus on the subject's eye, adjust focus until the eyelashes are perfectly sharp.
7. Zoom out to achieve the composition and framing you want.
8. Begin shooting.

AUTOFOCUS MISTAKES	MANUALLY FOCUSED

Focusing through a glass spotted with water droplets, the camera will lock on the drops and leave the subject behind the glass out of focus.

Focusing through vertical stripes like a fence or bars on a prison cell, the camera will focus on the bars and not on what is behind.

In low light, the camera will not always focus properly, nor will the face detection function accurately.

With some autofocus cameras, the camera will not detect that the main subject is off-center, and focus on whatever it finds in the middle of the picture. (Photos by Ken Kobré)

TIP Some video cameras allow you to adjust the eyepiece to your particular vision. The adjustable part of the eyepiece is known as the **viewfinder diopter**. Even if you have nearly 20/20 vision, always adjust the viewfinder diopter (if available on your camera) to suit your individual prescription. Rotating the diopter does not change the focus of the lens. It personalizes the optics of the viewfinder for your unique vision. If you usually wear glasses, adjusting the diopter may eliminate the need to wear them while shooting. When shooting with an unfamiliar camera, be careful to adjust the diopter of the new viewfinder before anything else. Adjusting the diopter beforehand is critical when focusing manually.

High-End Focusing Aids

Because nothing kills audience interest in your video quicker than blurry images, camera manufacturers have come up with ways to aid focusing in difficult situations.

Edge detection. Some sophisticated cameras have an electronic edge detection program (sometimes called **Edge Detection Focus Detail** or **EDF DTL**). This option emphasizes the outlines of the images in the viewfinder or on the LCD screen (not in the final footage) in order to make manual focusing easier.

▲ **Focusing Options.** Some video cameras offer several alternatives for auto and manual focus, as well as the capability to switch between the two quickly. The buttons in this photo include **FOCUS ASSIST** (enlarges the image in the viewfinder for more critical focusing); **FOCUS A** (Automatic); **M** (Manual); ∞ (goes immediately to infinity, focusing at the farthest point available); **PUSH AUTO** (with the camera still on manual, the lens will switch to auto as long as you continue to push this button).

Focus assist. High-end cameras offer a **focus assist** switch that magnifies images in the viewfinder and on the LCD screen for the sole purpose of helping focus manually—without changing the actual image being recorded.

Momentary autofocus. If, while recording, you suddenly realize the subject is not sharp, push

the **momentary autofocus** button. This feature switches the camera to autofocus, and the subject will pop into sharp focus—even though the camera remains on manual focus. Releasing the momentary autofocus button returns the camera to manual adjustment. This is a good technique for capturing a moving item, animal, or person when you don't have time to adjust the focus by hand.

Infinity button. There's also a "rescue" button on some cameras. It's for suddenly changing focus from something near to something far away. The **infinity** button pops the lens to its farthest focus point with a one-button push. Say, for example, you're photographing a baggage handler at the airport. Suddenly you see a jumbo jet ascending on a take-off. The plane will have disappeared by the time you correctly focus by hand. By hitting the infinity button, you can immediately catch footage of the distant plane.

WHY MANUAL FOCUS FOR INTERVIEWS?

Almost all pros switch to manual focus for recording interviews. Though the interview setup is static, with the camera on a tripod and the subject sitting in a chair a fixed distance from the camera, the camera on autofocus constantly rechecks itself automatically to verify sharpness. A slight rock forward or backward by the interviewee sets off the automatic search for a new focus point and results in the annoying effect of the image going from sharp to blurry and then back to sharp again. Using manual focus, the videographer sets the distance, so a slight movement by the subject won't change the sharpness of the picture.

DEPTH OF FIELD

In still cameras, the adjustable opening in the lens that lets in light is called an **aperture**. With video cameras, the same opening is called an **iris**. If you are not already familiar with these terms and their uses, they can be confusing. Adjusting the iris on your video camera not only allows you to get the correct exposure, but it also provides creative control of how your shots look and how viewers respond. As with still cameras, the diameter of the iris is described as changes in f-stops, also called f-numbers. A larger f-stop number (f/16, say) allows less light into the camera than a smaller f-stop number. For example, f/2 opens the iris wide and allows in more light than f/16.

Adjusting the size of the camera's iris alters the "zone of sharpness." Closing the iris to its smallest size (Frame 1, f/16) produces the greatest depth of field. The statues lined up before and after the sunglasses (the point of focus) are sharp.

Opening the iris to its widest limit (Frame 2, f/2) produces a shallow depth of field, with only the point of focus, the sunglasses, remaining completely sharp.

Other factors will also affect depth of field. For instance, depending on whether you are physically closer to a subject or are using a telephoto lens to get a closer image of it, you will have less apparent depth of field.

In many circumstances, you will be better off shooting with the least depth of field in order to visually isolate your subject from a busy background.

To keep the subject sharp but the foreground and background blurry (shallow depth of field):

- Use the longest focal length possible (telephoto).
- Come as near as possible to your subject.
- Use the widest iris (aperture) possible (such as f/2).

Creative Use of Depth of Field

The human eye naturally gravitates toward the part of a scene that is sharply focused—and glosses over what is blurry. Within the image frame, cinematographers and videographers use the eye's instinctive reaction to control viewers' attention.

▲ **Sharp Front to Back.** Sometimes you want everything in a scene to look sharp. This requires the **maximum** amount of **depth of field.** To achieve deep **depth of field,** as in this photo, the photographer focused on the farthest haystack, just before the green grass started. The photographer then closed the iris to its smallest opening (f/16). This setting kept the nearest haystack as well as the farthest conical towers in the distance in sharp relief. (Photo by Ken Kobré)

The reason for this seemingly backward system for f-stops is that f/16 really represents the fraction 1/16. Likewise, f/2 really represents the fraction 1/2. One-half (1/2) is bigger than one-sixteenth (1/16), so that is why the iris at f/2 lets in more light than the iris at f/16. Over the years, the industry convention has dropped the fraction and retained just the bottom number: f/2 and f/16.

Depth of Field Explained

Depth of field is a technical term that actually means the "zone of sharpness" in an image—the area that is sharp in front of or behind the point on which you focused. The demonstration photos above illustrate how adjusting the iris controls depth of field. Although a lens can focus on just one point at a time—the sunglasses in these pictures, for instance—the area in the pictures in front of and behind the sunglasses can also appear to be sharp, or it can be blurry, depending on depth of field.

◄ **Controlling Attention with Depth of Field.** Here the focus is on the grasshopper. The iris is at its widest setting (f/2). The photographer wanted **minimum depth of field** in order to show only the insect and the subject's hand in sharp relief. The person holding the grasshopper is completely out of focus, thereby assuring that the insect gets all the viewers' attention. (Photo by Ken Kobré)

DEPTH OF FIELD FOR DIFFERENT TYPES OF CAMERAS

Wonder why a Hollywood film looks so different from a video documentary? It's quite simple, really. If all other factors are equal, the size of the camera's sensor determines the area of sharpness. The sensor in most small video cameras is a lot smaller than the sensor in large Hollywood cameras.

HOW DEPTH OF FIELD DIFFERS FOR DIFFERENT TYPES OF CAMERAS

In this illustration, all cameras are 5 feet from the subject, and all cameras are taking the same shot. The iris/ opening on each is f/2.8. The white number on each camera shows the actual focal length of its lens (so each camera frames the subject the same way). The green bar indicates the distance that will be in sharp relief for each scene.

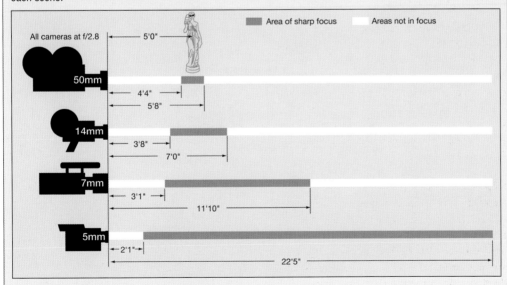

1 35mm movie camera used in Hollywood
2 16mm movie camera (or a 2/3-inch broadcast camera)
3 1/3-inch professional DV or mini-DV camera (Canon XL1, Sony VX2000)
4 Consumer 1/4-inch mini-DV camera (Canon GL1, TRV900)

TIP

The extreme **depth of field** of most video lenses poses some extreme technical problems. The slightest speck of dust or dirt on a lens shows up in final footage as a recurring spot visible in every frame. Avoid the problem before it occurs—and recurs.

• Install an ultraviolet (UV) protective filter on the front of the lens.

• Cover the lens with a lens cap when the camera is not in use.

• Clean the filter and the lens with a soft cloth to eliminate foreign objects.

• Use a lens hood at all times to avoid lens flare (see p. 96).

LENS
Selecting the Right Lens Length

Many video cameras allow the user to shift from a telephoto to a wide-angle shot simply by zooming the lens in or out. Changing the lens' focal length allows directing attention to one detail or including a wider perspective.

Most video cameras have a rocker switch or moveable collar on the lens itself that allows the user to smoothly change the lens from wide-angle to telephoto or vice versa. Some cameras even offer control over the speed of the motorized zoom.

SLR cameras and other hybrids with a video option have the advantage of an enormous assortment of lenses to use—from a fish eye all the way to a 600mm telephoto and beyond. Using the entire assortment of lenses available for SLR or other hybrid cameras, however, does require removing one lens and putting on the next. Even the available zoom lenses on an SLR still require changing the focal length manually.

Going wide. The wide-angle setting on the lens allows one to work in small, cramped spaces like this tiny bookshop. With the lens set at a wide angle, the videojournalist can capture everything from precarious stacks of books to overflowing shelves without having to pan the camera. Many pros, regardless of the camera they're using, employ a wide-angle lens most of the time. With a wide-angle lens, they can either fill the entire frame with their subject by standing extremely close or can stand back and take in the whole scene.

When shooting outdoors to achieve a broad vista effect, the videographer can call on the same wide-angle lens used indoors. Capturing Les Gorges du Verdon, known as the Grand Canyon of France, required a wide-angle lens to take in the huge sweep of landscape that included the river, the pedal boats in the foreground, and the mountains in the distance.

Manufacturers sell wide-angle adapters that fit onto a camera's original lens. They usually cost much less than a separate, standalone wide-angle lens. The wide-angle adaptors are designed to fit a variety of cameras. Be careful when buying a wide-angle adaptor, though. Make sure it is sufficiently wide so as not to cut off the edge of the image produced by the parent lens.

- Videojournalists say the wide-angle lens, which lets them work near their subjects,

▼ **Wide-angle Lens.** With the lens set on wide-angle you can show an entire room without panning. (Photo by Ken Kobré)

gives their pictures more of an intimate feel. Because this lens allows coming in really close, the viewer almost becomes a part of the conversation.

- When working in tight proximity to a subject, people irrelevant to the story can't wander into the picture frame and block the camera's view.

- Getting near a subject sometimes is the only way to get clear audio in the field. If using a wireless mic is impossible, shooting with a wide-angle allows you approach your subject and be near enough to record the person's voice with the on-camera mic.
- A wide-angle lens allows for steadier handheld shots.

◄ **Wide-angle Lens.**
Wide-angle settings on the lens help capture grand vistas like this shot of **Les Gorges du Verdon, in southern France.** (Photo by Ken Kobré)

◄ **Wide-angle Lens.**
Wide-angle lenses help you work close to your subjects.
(Photo by Ken Kobré)

TOO CLOSE FOR COMFORT

It's true that you can focus very close to a subject with a wide-angle lens. But the closer anything is to the lens, the bigger it will appear in the picture. Standing relatively close to and above someone and then tilting the camera down to include the subject's full length will cause the person's head to appear to be the size of a basketball and his feet small enough to fit into baby shoes. Obviously, try to avoid using the wide-angle lens when it distorts someone's features.

A wide-angle lens close to the subject and pointed down distorts the person's whole body.

Standing on the ground and pointing a wide-angle lens up to include a building's full height causes the structure to look as if it's falling over. This happens with any lens, but the phenomenon is particularly exaggerated with a wide-angle lens because it allows the photographer to stand close to the base of the structure while still including the entire building in the image. Photo 1 was taken at the base of the building. Photo 2 was taken with a normal lens and farther away.

Wide-angle lens

Medium telephoto lens

(Photos by Ken Kobré)

(1) Wide-angle lens

(2) Normal lens

TELEPHOTO LENSES BRING ACTION NEARER

When a photo's subject is far away, a telephoto lens can be a video-journalist's best friend.

(1) Wide angle

(2) Telephoto

Videojournalists also deploy telephoto lenses when getting close is prohibited, such as at ceremonies like this Bar Mitzvah. (Photo by Ken Kobré)

TIP Although you can get shaky video with any lens length you use, the problem is particularly exaggerated with a telephoto setting.

Everyone's hands shake just a bit, and this slight trembling is magnified by the telephoto lens. This tremor can translate to images that bounce up and down on the screen. And if you're walking while shooting video, the final footage can be decidedly unfortunate.

Some cameras have a built-in mechanism in either the camera's body or the lens that can, to some extent, electronically or optically counterbalance shaky hand movements and smooth out the resulting video. Software can also come to the rescue of bouncing video to help smooth out the screen images. But eliminating all shakiness is impossible.

See a side-by-side demo of a camera's optical stabilization/vibration reduction feature.

Remember that most camera makers recommend that you *not* use the anti-shake feature when the camera is on a tripod.

(See Chapter 6 for information about using tripods to eliminate shaky shots.)

◄ **Telephoto Lens.** Shooting athletes in action is an obvious example of when the telephoto lens is indispensable. (Shmuel Thaler, *Santa Cruz Sentinel*)

Limited to One Lens

You don't have to use a zoom lens to shoot everything from close-ups to wide shots. Many pocket-sized video cameras have a fixed lens that does not zoom. And with most smart phone cameras, you are better off not zooming because they accomplish this task digitally.

To frame tightly with these fixed-lens cameras, just walk up close to your subject. For a wide shot, back away as far as you possibly can. Being limited to a fixed lens in a low-end camera is not as great a hindrance as you might imagine. Using a video camera no larger than a cell phone, this writer produced a short video about a 300-year-old olive mill still powered by a water wheel that turns a huge millstone inside to crush the olives. For a detail shot of a worker's face, the videojournalist approached him and held the video camera about three feet away. For an overall shot, the shooter backed up as far as possible in the room and held the camera as high as he could reach. The final video might certainly have looked different had a larger camera with a built-in zoom lens been used, but the visuals from the pocket camera looked entirely professional. Below is a set of pictures showing what's possible with a fixed-length lens. ■

▲ **One Lens.** This series of images was taken with a fixed-focal-length lens. For close-ups, the shooter brought the camera close to the subject or to the olives. (Photos by Ken Kobré)

▲ **Measuring Light.**
A memorial service was held for Deputy Game Warden Ernest Berry, who had been murdered in pursuit of a poacher. Left on automatic, the camera's light meter would have measured the brightness of the sky and produced an underexposed picture. (Jeffrey D. Allred, *Desert News*)

Camera Exposure and Handling

When you first enter a dark room, everything appears black. Then your pupils open and your eyes gradually adapt to the darkness. Now you can begin to see details in the room that were at first obscured. Your eyes have temporarily become more light-sensitive. When you go out again into bright light, you are temporarily blinded and can't see immediately because there is too much light coming into your open pupils. However, they quickly close down to handle the initial jolt of light, and your eyes become less sensitive until they adjust completely to the situation.

This symbol indicates when to go to the *Videojournalism* website for either links to more information or to a story cited in the text. Each reference will be listed according to chapter and page number. Links to stories will include their titles and, when available, images corresponding to those in the book. Bookmark the following URL, and you're all set to go: http://www.kobreguide.com/content/videojournalism.

When you go from a well lit to a darkly lit room—and back again—your pupils adjust very quickly. They automatically change in size to let in more or less light. In addition to a change in pupil size, your eyes actually change chemically to adjust to light levels over time.

The automatic exposure function of a video or still camera operates in a manner similar to how your own eyes work. A video camera set to automatic exposure lets in more or less light by physically opening up or closing down the lens's iris depending on the brightness of the scene. Some less-expensive video cameras adjust to different light levels by cleverly changing the electronic sensor's sensitivity or "gain" in a manner parallel to the way the eye becomes more light-sensitive in a dark room and less light-sensitive in a bright room.

Top video cameras handle brightness using both methods. They change the diameter of the iris, as well as adjust the sensitivity of the electronic gain.

AUTOEXPOSURE WORKS MOST OF THE TIME

The autoexposure feature of many video cameras is amazingly accurate. Travis Fox, who shot many video stories for the *Washington Post* and who freelances for *Frontline* now, sets his camera on automatic "Iris Priority." This setting lets the camera adjust exposure automatically by changing the iris of the lens. He likes working in this manner. "If I have a lot of back light, rather than adjust exposure I prefer to rotate my angle," he says.

The video camera may not be able handle the intense brightness. Even if the camera or you have closed down the iris as small as it will go, the scene may still be too bright. Some cameras have a built-in **neutral-density (ND) filter** to reduce brightness. Think of a neutral density

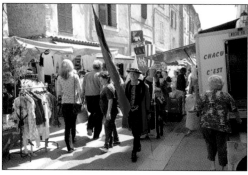

▲ **Neutral Density Filter.** When you shoot in a very bright situation: the beach, the ski slope or sometimes just in the street on a sunny day, you may need to add a neutral density filter to reduce the scene's overall brightness so that the camera can correctly expose the images. (Photo by Ken Kobré)

Whether it's a physical filter or an electronic adjustment, remember to remove the neutral density filter when moving to a darker environment.

MANUAL EXPOSURE FOR MORE CONTROL

"While it is true that most professional lenses do have 'auto iris,' pros don't use them 99 percent of the time," says veteran television shooter John Goheen of Terranova Pictures.

It's true that although autoexposure works remarkably well, it has limitations, such as in bright backlight. Because the camera's electronics can't read your mind or anticipate your personal vision for the shot, however, many cameras do allow overriding autoexposure.

If you see that the image is too light or too dark, you can adjust its brightness. Some video and hybrid SLR cameras require switching the camera to manual exposure (if available) to change the amount of brightness.

As you shoot more, you will discover when the camera can think for itself and when it requires human intervention. The camera's automatic features usually do a good job but they cannot anticipate your creative desires.

► **Electronic neutral-density.** (ND) gray filters are built into this camera's lens. The user must change them manually when necessary. With a message on the LCD screen or viewfinder, the camera often signals an alert when to add these neutral density, colorless filters.

filter as gray, colorless sunglasses for a lens. ND filters cut the total amount of light entering the camera. If the camera has built-in ND filters, a message usually appears on the LCD or viewfinder screen indicating how much filtration is necessary and which filter to select.

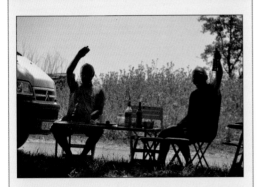

If your subjects are picnickers in shade with a bright blue sky behind them, the video camera is likely to respond to the brighter background and underexpose the picnickers, turning your subjects into silhouettes. After all, the camera does not know whether you want to correctly expose the bright background or the shade-sheltered pair.

Sometimes a silhouette is perfect. Other times you want to lighten your subjects so that you can see details in their faces as well as what's on their plates. Many cameras have a specific "backlight-button" that will let in more light (or increase the gain) and better expose your happy picnickers. When you change venues, always remember to turn off the backlight-button compensation feature.

On automatic, the camera does not know how dark and moody you might want the overall look and feel of the footage. The camera does not know when you want a silhouette and when your want detail in the shadows. Only you can make those artistic choices—and this kind of creative input requires manually controlling the camera. You are the artist, journalist, producer, and photographer. You can't blame poor footage on your equipment.

Zebra Patterns Show Overexposure

Some higher-end video cameras have a special overexposure protection aid called "zebra patterns" that visually indicate any part of the picture that will appear washed out.

The zebra option ensures you don't over-expose a scene. With the zebra option on, you can manually adjust the iris when the pattern is visible in highlighted areas, and back off until the pattern vanishes. If you are taking pictures of a snow-capped mountain and the 100 percent zebra stripes appear over the whitest area, you need to decrease the exposure until the zebra pattern disappears.

The 70 percent zebra is primarily used for interview shots to properly expose facial skin tones. With Caucasian skin highlights, the camera operator adjusts the camera's iris so the 70 percent zebra pattern appears on the highlighted areas of the subject's face. Typically, in a well-exposed interview shot, zebra lines will show up on the forehead, nose, and cheekbones. With a little practice, you become quite adept at setting exposure for faces with this tool. Darker-skinned faces will display a smaller version of the same pattern; very light-skinned faces will display larger highlight zones showing the zebra pattern. You simply need to mentally adjust for the skin type of the face you are shooting. At 70 percent, the wavy lines over white items in the scene, like a stack of paper, a white blouse, or a reflection on stainless steel, are acceptable.

TIP In your desire to avoid overexposure, do not attempt to eliminate all zebra stripes. In general, a few highlights in the brightest part of the image, such as reflections off a mirror or from silverware, are often desirable.

DEALING WITH DARKNESS

Less-expensive video cameras offer no exposure options. What you see on the screen is what you get. The camera is doing the best it can. Unfortunately, the best it can do is not always good enough in low light because lower-end cameras cannot pick up detail in shadowy areas. Where there should be detail, the cameras instead records noise. (See figure below.)

▲ **Overexposure Warning.** With the zebra pattern feature turned on, a series of slanted lines will indicate the danger areas. These lines are just visual cues, *not* part of the final image. With the camera set at 100 percent zebra, the areas with undulating stripes will be completely washed out when the final footage is viewed.

◄ **Low Light.** In some situations, such as shooting inside a dramatically lit memorial, autoexposure may not bring the image's brightness to an acceptable level. Notice the colored green and purple specs in the enlargement. These specs occur when the image is underexposed and are called "noise." They tend to make the image look degraded. (Photo by Ken Kobré)

Many higher-end cameras allow the adjustment of some settings to compensate for low light. Usually, the camera adjusts the brightness level by changing the size of the lens' iris. However, you can also alter the brightness of a picture by changing the electronic sensitivity of the image sensor. As mentioned earlier, this electronic sleight of hand is called adjusting the **gain**. Some cameras allow setting the gain manually to a higher level. Cranking up the gain does increase the sensitivity of the sensor, but it can also introduce more noise into the footage. Sometimes, of course, a little noise is the necessary trade-off for capturing footage in low light.

TIP Changing "gain" means essentially the same thing as changing the ISO on your digital still camera. In both situations, you are electronically changing the sensitivity of the camera's sensor.

As a last resort in very low light conditions, some cameras allow manually reducing the shutter speed to admit additional light to register on the image sensor. The shutter speed of a video camera usually opens and closes in 1/60 of a second per frame. Reducing the shutter speed to 1/30 of a second can work, but 1/15 of a second or slower is likely to produce blurry images with what's called **shutter lag**. The shutter lag is a ghostlike image that appears to be trailing behind the primary picture, almost like a specter. This happens particularly when the subject is moving or you are panning the camera. Although reducing the shutter speed results in brighter video, a jumpy, stroboscopic effect may result if there is any action.

Most pros don't recommend changing a video camera's shutter speed. Yet despite the somewhat questionable special effect that changing shutter speed may cause, there are occasions—primarily very low-light news and documentary

situations—in which imperfect video is better than no video at all. Learn more about shutter speed and stroboscopic effect.

WHEN AUTOMATIC EVERYTHING MAKES SENSE

Should you shoot using automatic settings, or should you always manually adjust the settings on your camera like the veteran TV pros? On cameras like the ultra-small pocket-video cameras, point-and-shoot cameras, or cell-phone cameras, the manufacturer has solved the problem for you by making the equipment completely automatic. If you are shooting with one of these, you can stop reading here.

Most higher-end cameras offer a range of manual and automatic controls. So when are you better off adjusting settings manually? And when can you relax and let the camera do the driving?

Professionals usually recommend shooting video stories using the manual settings as often as possible. And the pros are right, of course. Practice shooting your camera on the manual settings whenever possible. But here's a little secret: the auto controls in the latest sophisticated cameras are remarkable—for sound level, brightness, color balance, and even focus. So clever are some of these cameras' automatic settings that sometimes the camera's choices are actually better than yours might be. This can be true even when you have enough time to set the controls yourself. Using automatic, you can be reasonably assured of having usable video footage without glaring brightness changes or dropped sound that can't be corrected during postproduction editing.

It's not easy for the solitary videojournalist to carry on an intelligent interview with follow-up questions while simultaneously fidgeting with focus, exposure, and sound levels. When you're alone in the field trying to do it all, the auto button on a good high-end camera is your best friend.

When people see your video story, they won't turn to their friends and say, "That was shot on automatic or that was shot on manual." Whether they're excited or bored by your piece, they are more likely to comment on its content or its storytelling success or failure. Unless the exposure is glaringly off, people won't comment on whether you pushed auto or manual buttons. If shooting on automatic allows you to concentrate on what your characters are saying or helps you to observe and record what they are doing, by all means, go for automatic.

KEEP IT STEADY

Okay, admit it. You love the freedom of shooting video without a tripod. Go ahead, shout it from the rooftops.

Now, let's talk about why you should be using a tripod. It's a fact. Human hands are an unsteady substitute for solid tripods.

Nothing screams "Amateur!" louder than shaky footage onscreen. An otherwise stationary interview subject who appears to be weaving and bouncing on the screen is a sure-fire signal that the videojournalist was handholding the camera—and it's a sure-fire way to make viewers feel seasick without boarding a boat.

▲ **Tripod.** To eliminate camera shake, use a tripod whenever possible. (Photo by Ken Kobré)

Use a tripod ("sticks" in video lingo) when shooting:

- A building with distinct lines
- A seated or standing subject giving a long interview
- A pan or tilt of a scene
- A close-up of a fixed object
- Anything shot with a telephoto lens
- Anytime you can

See a short online video on using a tripod, "The tripod: Three legs are better than two hands."

Tripods do hamper flexibility and can interfere with experimentation, but footage shot on a tripod simply looks more professional.

◀ **Tripod for Interviews.** Always use a tripod for interviews so that the subject's face looks stable in the final video. (Photo by Betsy Brill)

Specialized lenses, electronic camera options, or editing software can't yet solve all the problems of shaky footage.

"I always ask myself, 'What is motivating me to go handheld?'" says Lisa Berglund, senior producer at World Vision. "Am I doing it because I'm lazy, or because the action is moving around me and I fear I will miss the moment if I stay on the tripod?"

Berglund's question to herself is good one to ask yourself, too: "Why am I shooting handheld?" The general rule is to keep the video camera on a tripod whenever possible for an interview. But if you're going down a street, in a moving procession with your subject, chasing after a mom trailing her toddler, or in a news situation such as a demonstration, a riot or a war, viewers will probably not find the handheld camera movement disturbing.

Checklist for using a tripod

- Make sure your horizons are straight.
- Take your hands off the camera during the shoot. Fiddling with the controls while shooting defeats the reason for using a tripod.
- Always keep your eye on the viewfinder or LCD screen to know what is going on in your shot.
- Turn off image stabilization.

Note that image stabilization (IS) and vibration reduction (VR) lenses look for vibrations in your camera in order to reduce blurry pictures. However, if they don't experience any camera movement, like when you are using a tripod, these features can actually cause the image to appear to have apparent camera shake. That is why camera manufacturers, in what seems to be counterintuitive advice but is not, recommend turning off this feature when your camera is on a tripod.

The Search for Tripod Nirvana

Here's the dilemma. The heavier the tripod, the more stable it will be, which is ideal. Unfortunately, the heavier it is, the less likely you are to haul the thing along with you when you are on a shoot and need it.

A solid tripod reduces the chance of the camera blowing over in the wind. Its substantial weight reduces wiggle when you pan, zoom or tilt. However, the weightier the tripod, the less convenient it is for lugging—and the more likely it will be left at home. One idea is to outfit your tripod with a sling strap that allows you to carry it on your back and keep your hands free.

▲ **Small tabletop tripods** like the GorillaPod help to stabilize small video cameras but won't work well with larger models. (Photo by Betsy Brill)

Just remember that any tripod, regardless of its heft, is better than no tripod at all.

Compromise: select a tripod strong enough to hold your camera but light enough that you won't mind carrying it on a long hike. When you find the perfect balance, you will have reached tripod nirvana.

Other Desirable Features for a Tripod

Aside from finding a tripod that is not too heavy or too light—but just right—you might need one with a **fluid head**. A fluid head allows smoothly panning or tilting the video camera. Fluid tripod heads offer a certain amount of resistance as you push the tripod handle that helps keep the camera steady as you rotate from one direction to another. It takes some practice. But in the long run, a fluid head is a valuable feature for shooting video.

▲ **Tripods** come in all sizes. Be careful to buy one that is strong enough to hold your camera but light enough to lug around for many hours.

A **built-in spirit bubble level** helps you set up the camera so that it is level with the horizon. Adjust the tripod head until the bubble is in the middle of its glass container. This should ensure that the footage will be level with the horizon.

A **quick-release plate** allows easy and quick removal of the camera from the tripod—useful when action develops while the camera is on the tripod and you need to get it off fast to handhold a shot.

TIP Remember to turn vibration reduction (VR)/image stabilization (IS) *off* when using a tripod. Under VR or IS, the lens will behave abnormally if it is expecting normal movement but getting none.

Monopod

Think of a monopod as a single tripod leg with a mount on top. The camera attaches to the monopod just as it does to a tripod. A monopod extends and collapses like a tripod leg. It is lighter than a tripod, and many videographers find it useful for stabilizing the camera in fast-moving or crowded situations.

A camera mounted on a monopod can be easily braced against your body. With the camera on the monopod at its shortest length, brace the monopod against your stomach—into your belt

if you're wearing one. Your body, your arms, and the monopod create a perfect triangle. You are likely to find that in certain circumstances where using a tripod isn't feasible, this tactic will help stabilize the camera and at the same time relieve the weight from your back and arms during long shoots.

Even when handholding the camera, leaving it attached to the monopod at its shortest length can help compensate for the camera's

▲ **A monopod** is one-third as good as a three-legged tripod but does help stabilize the camera by eliminating vertical motion. (Photo by Ken Kobré)

▲ Use a monopod in your belt or waistband for long interviews (careful on this one!) to help stabilize the camera and give your arms some assistance. (Photo by Ken Kobré)

swing while shooting. The monopod serves as a counter balance to the camera and acts a bit like a poor man's Steadicam—the fancy rig used by Hollywood photographers to steady the camera during handheld movie shoots.

The "Crane Shot" on the Fly

When you can't find a high perch or you forgot to bring a ladder or a crane:

- Attach the video camera to the monopod.
- Flip out the LCD screen and point it down.
- Press the start button.
- Extend the monopod to its full length.
- Hold up the monopod-camera as high as you can. Rest it in your belt if you're wearing one.
- Frame the shot, with the camera held high, by looking at the LCD screen high above you.
- Lower the camera when finished and turn it off with the on/off button.

You will have captured a high-angle "crane shot" and given your video a "Hollywood" look. Although it's no substitute for a three-legged tripod or an actual movie crane, a monopod is a relatively cheap, convenient way to stabilize the camera that does not hamper freedom of movement.

▲ **The Crane Shot.** Hollywood movies almost always end with a shot taken from a crane that lifts the camera high into the sky. By attaching the camera to the monopod and extending the monopod to its full length, you can give your documentary the same effect. You can still view through the LCD screen, but you have to bring the camera down to eye level to start and stop the recording with most cameras.

Because the camera is extended on a single pole above your head, the top-heavy rig will tend to sway and be difficult to stabilize. Shoot a *lot* of footage and discard the jerky images during editing while preserving those that add drama. (Photo by Ken Kobré)

STABILIZING THE HANDHELD VIDEO CAMERA

At some time in your career you will need a tripod but be without one. What to do?

HOW TO SHOOT HANDHELD (IF YOU MUST!)

LOOK FOR A SOLID SURFACE

To avoid camera shake—without a tripod—try to stabilize your camera on the ground or on any other solid surface. (Photo by Ken Kobré)

- Keep your lens zoomed to its widest angle.
- Brace the elbow of the arm holding the camera tight against your body.
- Plant both feet comfortably and lower your center of gravity slightly.
- Steady yourself against a wall, fence, post, or other stable surface, if available.
- Avoid zooming.

Resourceful videojournalists have found a number of creative substitutes that work in a pinch. Try resting the video camera on back of a chair, on the ground, on a bean bag, on a table, or, in fact, on any stable item you find that will help cut down the shakes. Bracing the camera on just about anything stable will help reduce jumpy footage and produce a more professional-looking image.

LAST RESORT FOR SHAKY SHOTS

Using an editing program's **image stabilization** feature, if available, can help reduce some of the amateurish, often disturbing effects of handheld shooting. If you've shot from a car window, for example, running the resulting footage through image stabilization software can smooth out the ride a bit—but don't count on it for the full journey. ■

▲ **Early Morning Light.**
By selecting the time of day
to shoot, you can control
the quality of light in your
pictures, as was done in this
early morning shot of ties for
sale in **Venice, Italy.** (Photo by
Ken Kobré)

Light and Color

Many times, you have no control over when or where you will shoot when gathering documentary footage. If the subject is a wrestler, you are likely to be in a gym, regardless of the poor quality of the light. If the subject is a new Marine recruit, you'll need to be there before dawn for roll call. Sometimes, though, on certain stories, you can decide when to shoot and when to interview, or—if all else fails—you can bring your own lights and create whatever atmosphere you need for the shoot.

Lighting conditions can affect the whole feel of a story. Basically, you can control four qualities of light: intensity (bright or dim), contrast (hard or soft), color (warm or cool), and direction (front, side, back, top, bottom).

This symbol indicates when to go to the *Videojournalism* website for either links to more information or to a story cited in the text. Each reference will be listed according to chapter and page number. Links to stories will include their titles and, when available, images corresponding to those in the book. Bookmark the following URL, and you're all set to go: http://www.kobreguide.com/content/videojournalism.

TIME OF DAY IS CRITICAL

When shooting video outdoors, timing is everything. Every day, from sunrise to sunset, color changes, intensity changes, and mood changes. If you are shooting a story about the life cycle of rosé wine, you want to record in the fields early in the morning to showcase the vines under the soft dawn light. If you record the same fields later in the day, they will look more ordinary, less magical. Unless you have snagged Clint Eastwood for an interview and want to show off his craggy face, you should avoid the noonday sun. Harsh sunlight is rarely flattering at the noon hour.

▲ Notice how the building looks completely different depending on when it was shot—late afternoon, just after sunset, or at night. The choice of when to shoot can completely transform the emotional impact of images. (Photos by Adam Lau)

► **Dawn.** When possible, start shooting early in the morning. For soft shadows and monochrome colors, dawn is ideal. (Photo by Ken Kobré)

► **Midday.** The daytime sun adds strong, deep shadows to this scene of farm workers cutting lavender in France. (Photo by Ken Kobré)

▲ **Sunset.** Don't put away your video camera as the sun goes down. Here, the sky warmed after sunset, and lights on the buildings in San Miguel de Allende further dramatized the scene at dusk. (Photo by Betsy Brill)

▲ **Night.** Even at night, you can often continue shooting by taking advantage of any possible available light such as the head lamp of this grape harvester. (Photo by Ken Kobré)

► **Seeing Color: The Eye versus the Camera.** Through the magic of the human brain, our eyes would see the white paper in these photographs as white whether viewed inside or outside the art gallery. Of course, a camera's sensor does not have our brain's adaptability. However, many cameras do have a color-correcting feature, usually called "white balance," that can ensure white is white once the camera is "told" the kind of light under which it is working.

Under the tungsten light inside the gallery, the camera's daylight setting results in white paper with a yellowish tint (A). But once the tungsten setting is selected, the camera corrects the color to record the paper as white with no color bias (B).

With the camera's sensor set to tungsten but used outdoors, the paper records with a bluish tint (C). Once the camera's white balance is set to daylight, white looks white (D). (Photo by Ken Kobré)

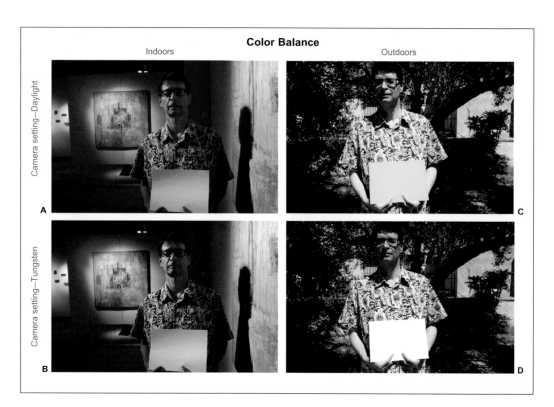

Color Balance

Indoors — Outdoors

Camera setting—Daylight

Camera setting—Tungsten

A — C

B — D

WHITE BALANCE ENSURES CONSISTENT COLOR

Try this experiment: hold out a piece of white paper and take it from a room lit by a lamp directly outside to an area lit by the sun overhead. The white paper is white, right, both indoors and out?

Now, with your video camera's white balance set to tungsten (the lightbulb symbol), record the white piece of paper while outside in bright daylight. Return to the original room setting where you began and photograph the paper without changing the camera's white balance setting. Is white still white?

Different light sources reveal different colors. The color of direct sunlight is different (more blue) than the color emitted by tungsten light (yellowish). Fluorescent light is greenish.

Your magical brain is at work. Knowing that the piece of paper is white, your brain psychologically and instantly reinterprets the change in color from one light source to another. Thus you always think you are seeing white paper regardless of the color of the light that actually is tinting it. This phenomenon is known as "color constancy."

Lacking the psychological ability to know that white paper is white, the video camera simply records the paper as tinted by whatever light rays reflect off it. To the video camera, the white paper looks quite different under the sun than it does under the glow of lightbulbs.

The white balance feature on video cameras is the secret to reproducing colors as *the human brain interprets them*. This feature detects and attempts to electronically neutralize the color shifts engendered by different light sources and to compensate for whichever light source is available: a fluorescent-lit laboratory, an office lit by tungsten bulbs, a sunlit beach, or the shade under a tree.

We need to tell the camera what color white is.

Auto White Balance Works Most of the Time

Most video cameras have the capability to automatically measure the color of light at a scene and to set the white balance accordingly. In the following circumstances, the camera's automatic white balance feature works quite well:

- Outside on sunny days
- Inside when all the light is coming from incandescent lightbulbs, such as in a living room
- Inside under fluorescent lights
- Inside under energy-saving bulbs

Also, automatic white balance is usually the preferred choice when you're moving back and forth from inside to outside, or from sunshine to shade. If you're attempting to manually adjust the white balance between every venue, even the most perfectly color-balanced images won't compensate for missed action.

When Auto White Balance Doesn't Work

The following four situations may challenge your video camera's auto white balance feature:

- Rooms with mixed light from multiple sources, such as window light mixed with incandescent lamps
- Ballparks or parking lots with sodium-vapor lights
- Rooms with walls painted in strong colors
- Snow-covered fields or ice rinks

Dialing in a Preset White Balance

When shooting for an extended period in one location, consider using the camera's preset white balance feature. The following settings are available on most video cameras. (Check your camera's manual.)

- Daylight
- Cloudy
- Shade
- Fluorescent
- Tungsten
- Fluorescent H (for newer daylight-balanced fluorescents)

With a specific light source identified and preset, the camera will not be fooled by strongly colored situations such as a living room painted red or a hospital corridor painted green.

"High definition cameras seem to be much more sensitive to any change in color temperature," warns John Goheen, of Terranova Pictures. "This is especially true when shooting outdoors. Any change in light from direct sun to shade can change the consistency of color. I find myself color balancing far more often with HD than I ever did shooting with SD formats." Goheen notes that in the end, you can do color correction during editing. "But, as they say . . . there's nothing better than doing it the right way the first time."

Custom White Balance for Highest Accuracy

For even more consistent color, use the camera's Custom White Balance feature.

In the comparison pictures shown on this page, the interior of the art gallery has no windows to allow outside light to penetrate. It's illuminated solely by tungsten lightbulbs. In a situation like this, you could leave the camera on auto white balance and let the camera decide the best color correction, but the results still might have a light yellowish tint. Alternatively, you could select a preset option, in this case incandescent (lightbulb icon), or opt for a custom reading to ensure the most accurate color rendition.

◄ **Automatic white balance** in this situation left the picture with a slight yellow tint. (Photo by Ken Kobré)

◄ **Custom white balance** gives the best result, eliminating the tint that affects the color of the wall and the actual colors of the painting. (Photo by Ken Kobré)

Keep in mind that neutralizing a scene with the white balance feature on either automatic or custom is not always a good idea. If you're following a surfer on the beach at sunset, turning the reddish hue of your subject's white T-shirt into a neutral tone is likely to sap the beauty from the entire scene. In this kind of situation, you should set the white balance to outdoors (the sun symbol) to preserve the warm tones of the setting sun.

Steps for setting a custom white balance.

Professional videographers always try to set a custom white balance manually with a white card in order to achieve perfect color balance. Especially in interview situations when the subject is not moving, you almost always have time to get perfect color adjustment. You don't want your subject to have a bulb-induced golden glow that makes him look like he's been at the beach when in fact he hasn't left his library in weeks.

◄ **Custom White Balance.** To ensure perfect color balance for your shot, stand in the light in which you are going to shoot, point the camera at a white sheet of paper positioned in that light. Then, follow the directions given in "Steps for Setting a Custom White Balance." (Photo by Ken Kobré)

Taking the time to manually adjust the white balance will assure accurate, realistic skin tones:

- Stand in the same light conditions as your subject.
- Select "custom white balance" on your video camera.
- Place a white card (objects such as a white shirt will do) in front of the lens so that no shadow strikes it.
- Place the white card near where the interview subject's face will be, especially if there are multiple light sources in the room.
- Zoom in so that the card (or white object) fills the image frame.
- Press the white balance (WB) button. (See your camera's manual for specific instructions.)
- Confirm that the camera has created a new custom white balance setting. The camera should convey a message.
- Maintain this setting as long as you continue to shoot under the same lighting conditions.
- Remember to reset the white balance when you move to a new location and a different light source. If you've white balanced

for the sun, don't forget to reset the white balance when you move to the shade. If you don't, your footage may turn blue.

Saving the Day When All Else Fails

No matter how hard you've tried, sometimes you forget to set the camera to the correct white balance. Some editing programs do allow adjusting the color during postproduction. This adjustment step is time-consuming but can sometimes rescue what otherwise would be unusable footage. (See Chapter 13, "Editing the Story.")

QUALITY OF LIGHT

Amateurs are often poorly advised to "stand with their camera where the light comes from over the shoulder." This setup creates safe but usually uninteresting front light in which the entire subject is evenly lit with precious few shadows visible. Back or side lighting creates a much more dramatic look, with shadows to lend depth and tone to the images.

Light casts shadows that can emphasize or diminish texture and volume. Selecting the most appropriate light depends on the characteristics

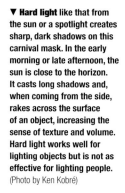

▼ **Hard light** like that from the sun or a spotlight creates sharp, dark shadows on this carnival mask. In the early morning or late afternoon, the sun is close to the horizon. It casts long shadows and, when coming from the side, rakes across the surface of an object, increasing the sense of texture and volume. Hard light works well for lighting objects but is not as effective for lighting people.
(Photo by Ken Kobré)

of your subject and the tale you are telling. Do you want your story's main characters to look worn, or would you prefer to show them relaxed? Is your subject a farmer or businessperson? Is the point of your story how youthful an older person looks? Or does it concern a young person prematurely aged by disease or drugs? If you want to emphasize a person's wrinkles, shoot in hard sunlight. The direct rays of the sun leave deep shadows on the face. If you want to soften your interviewee's appearance, which is usually the situation, avoid that midday sun and shoot under a cool porch awning where the light will be indirect and shadows and highlights will be evened out.

When looking at the quality of light on a scene, consider:
- Direction of the light
- Shadows cast by the light
- Position of the camera

Before you shoot, take a moment to test alternatives to improve the quality of light in your footage:
- Move the camera to another position so as to capture the scene in a more dramatic light.
- Move the subject of an interview to a more flattering, less glaring light.
- Use a reflector to bounce some light into the subject's face. Even a sheet of white paper can act as a reflector.
- Add artificial light (discussed shortly).

BACKLIGHTING CHALLENGES

A bright light source, such as the sun aimed at the camera, can present challenges for the videojournalist. Sometimes you can use this type of lighting for dramatic effect. But you need to be aware of the pitfalls as well.

Fill Lighting

When recording an interview outdoors with the sun behind your subject, the person's face may not be not sufficiently lit. In this case, using a white fill card can brighten the person's face. When shooting interviews, bring along large white cards, foam core, or a foldable reflector—just in case. The best technique is to hold the reflector in front of a subject whose back is to the sun. The light from the sun coming from behind will bounce off the reflector onto the subject's face.

▼ **Diffused or soft light** illuminates all parts of a scene evenly. The light reaching the courtyard in this picture was diffuse. It bounced off the gray walls and pavement as a young man who had had polio walked upright for the first time with his new braces. The light rays scattered in many directions. Shadows, if they are present at all, are relatively faint. Outdoor diffused light gently bouncing off an area's walls can be beautiful for interviews, too.
(Photo by Ken Kobré)

▶ A portable passive **reflector** made from cloth or foam core can bounce light onto an interview subject's face and so eliminate harsh shadows. (Photos by Ken Kobré)

The challenge for the one-man-band is obvious. It can be tricky to hold the reflector, run the camera, and carry on an interview all at the same time. Sometimes you can get a bystander to hold the reflector. Alternatively, you might add a light stand to your interview lighting kit and attach the reflector to it.

Stan Heist, an award-winning Baltimore videojournalist turned teacher, observes, "When I worked in a team I would use light reflectors like a Flexfill, but solo it's pretty tough. Instead, I look for natural reflection (such as a white box truck, a car windshield reflector, even a small legal pad). The principle is the same, but much easier than holding a floppy reflector."

Lens Flare

You really do want to use a lens shade at all times. Hollywood cameras have huge, boxlike lens shades. If your video camera does not have a lens shade, buy one. And

▲ Always use a **lens shade** or your hand to prevent direct light from entering the lens.

if your video camera can't accept a lens shade, hold your hand out flat like a visor to block the sun's direct rays from reaching the lens. (Be sure to watch the monitor or viewfinder so as to keep your hand out of the picture!)

Dirty Lens

When you are shooting a backlit subject—bright light is streaming toward you and into your camera lens—you must be doubly aware of this situation because any dust, dirt, or other particles present on the front element of your lens or UV protective filter will show up onscreen as out-of-focus, distracting blobs in the final footage. Even with the most careful cleaning of lenses and filters, backlighting still brings out tiny particles of dust you may not even have noticed. If you have thoroughly cleaned your lens with a soft cloth or lens tissue and you still see spots when you shoot directly into the sun, your only alternative may be to try reframing your shot so as to avoid the sun's direct rays.

INDOOR AVAILABLE LIGHT

Whenever possible when shooting video, use a room's natural light. Shooting under available light is always easier and often better than adding light to a scene. With natural light you don't have to drag out the lamps, set up the light stands, or run extension cords all over the room.

Natural light is honest. It shows if the person lives or works by window light, overhead fluorescent tubes, or the light of a fireplace. Each light source conveys a different mood.

▲ **Lens Flare, without Lens Shade.** When shooting toward the sun or a lamp, light can strike the lens directly. This can cause bright circles or can degrade sharpness and wash out color, as in this image of a woman at a café. Sometimes lens flare can add excitement or convey warmth. Usually, though, it looks like a mistake.

▲ **Avoiding Lens Flare.** To avoid lens flare, use a lens shade or block the incoming light with your hand, a magazine, or anything else that may be handy and serve as a visor for your lens.

Your role as videojournalist is to pay attention to what light is available. Note whether the room is lit by north light coming through a skylight or from a 25-watt lamp-shaded lightbulb in the corner. By shooting from different angles and directions, the skillful videojournalist can usually find the ideal way to record the scene unfolding before the lens.

Modern video cameras can perform well practically anywhere there is enough light to read a newspaper. Although setting up complex lighting for a scene in a Hollywood movie is common, most documentary photographers avoid the hassle and prefer to use the light that exists. Remember that if you are concentrating on setting up the perfect lighting, you could be missing the real moments taking place around you.

Look for Natural Light for Interviews

The secret to good lighting is to place your camera or your subject in such a way as to use the natural light to best advantage. Ideally, side light makes the most dramatic light for interviews. Whenever possible, place the interviewee so that one side of the face receives indirect light from a window and the other side is in partial shadow.

ARTIFICIAL LIGHT

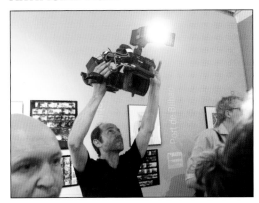

Sometimes, when the level of light is very low, there's just not enough to capture clear, sharp video images. Though you can rectify this with a still camera by putting the camera on a tripod and slowing down the shutter speed, the option of decreasing the shutter speed does not work as well with a video camera. In video, if the shutter speed is too slow, the resulting footage looks jerky.

▼ **Window Light When Available.** Near a window or lamp, the light probably will be directional, with bright areas fading off quickly into shadow. (Photo by Ken Kobré)

◄ **A battery-powered portable light** attached to the top of his camera enabled this videographer to shoot a guided tour in a dark museum. (Photo by Ken Kobré)

Outdoors at night or indoors when the light is so low you can barely see your hand, you will need to add some extra light to shoot high-quality video. You can, of course, put a light on your camera. Or you can set up one or more lights in the room. Sometimes just one light bounced off a white or light-colored ceiling is enough to improve the quality of video. Depending on your subject and the time you have to set up, you might want to use two or three lights for a portrait-like interview.

Single On-Camera Light

Essentially, any on-camera light directs most of the light to the nearest subject and leaves the farthest subject in the dark. Unfortunately, the on-camera light, because of its small size, also casts harsh, unnatural shadows from the front subject onto the background. Also, a small on-camera light source is generally unsatisfactory because it is unlikely to cover the entire scene captured by a wide-angle lens. When this is the case, the on-camera light brightens the center of the picture but leaves the edges unnaturally dark.

All in all, a portable on-camera light tends to give video footage an artificial "police lineup" look because the light eliminates any of the situation's natural ambience. Nonetheless, if you are caught in a dark location and have no other choice, an on-camera light can save the day—or night.

Bounce Light for a More Natural Look

If you find that you need to shoot in a cave-like room with barely any illumination, the easiest option is to bounce a light off the ceiling. Put the light on a light stand and aim it almost straight up. Place it out of the camera's view. Now you can shoot freely with enough light to make a high quality image—with natural-looking illumination.

Here is how the bounced light works. Light rays from a floodlight exit the lamp in a bundle—about 2 or 3 inches in diameter. As they head toward the ceiling, the rays spread out. By the time they reach a typical ceiling, the rays cover an area of the ceiling about 10 feet across. Because the surface of the ceiling has some texture, the rays bounce off it in all directions, evenly lighting a much larger area below. The effect is a shadowless light.

Bounced light has at least two advantages over direct light aimed at a subject. Bounced light eliminates unattractive shadows produced by direct light. Bounce light also helps spread the light across a group evenly, removing the annoying effect of burning out those people in front or letting those in back go dark.

You also can bounce light off a wall, partition, or any other large, white, or light opaque object. Bounced light from a ceiling results in a soft, relatively shadowless effect similar to that

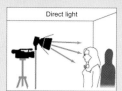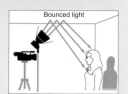

On-camera direct light shows photographer Annie Leibovitz in a most unflattering manner. It produced those reflections in her glasses and developed a harsh shadow under her chin.

Bounced light off the ceiling evenly lights the scene. Both Leibovitz and the picture she took are evenly exposed.

If you aim a floodlight straight toward a subject it will often produce a harsh shadow on the rear wall. By aiming the floodlight upward and bouncing the light off the ceiling the harsh wall shadows disappear. This bounce technique produces an even, natural-looking light. (Photos by Ken Kobré)

produced by fluorescent tubes found in most modern buildings. Light bounced off a wall or partition gives a broad, directional effect similar to light from a window.

Note that you can only use this bounce technique only if the ceilings are not too high. Bouncing the light off the ceiling will not work in a church, a gym or, of course, outside. You can use the bounce light technique while leaving all the room lights as you found them. By combining bounced light and available light, the overall scene is brighter without losing its atmosphere.

TIP When shooting still photos for multimedia, you can achieve the same effect with a flash that tilts toward a ceiling or wall, or with a pop-up flash bounced to the ceiling with Professor Kobré's Lightscoop®.

Soft Box for Portraits

Sometimes videographers bring along a lighting kit for interviews. The kit often includes a soft box with the front panel made of a translucent piece of material. The nylon fabric of the soft box is held together with tension rods. The inside of the box is white or silver and the front panel contains several layers of diffusion material. With a light situated inside the box, the setup is mounted on a sturdy stand.

The light travels through the layers of cloth on the front of the soft box. The cloth spreads the rays from the bulb evenly over an area as wide as the front panel of the box. The assembled soft box and light stand are a bit like a portable window through which light passes for a natural, softening effect. The portable window can be moved where it is needed.

With light diffused by a soft box, the demarcation between shadow and highlight on the subject is gradual as opposed to the abrupt hard lines produced from a direct, harsh spotlight. With the soft box, shadows on the background are also less distinct.

For an effect similar to a soft box, you can also direct your light into a white lighting umbrella. For an even softer effect, turn the light around so that it shoots through the umbrella's fabric.

Placing the soft box or umbrella to the side of the subject creates a dramatic side-lit portrait. Positioning it directly in front will create fewer shadows, effectively deemphasizing wrinkles in someone's face.

For optimum softness, whether it's positioned on the side or in front, a soft box or umbrella should be as close as possible to your subject. The closer the light is to the person, the softer the facial shadows. When close enough, the umbrella light almost seems to wrap around the person.

Remember to look in the video camera's eyepiece or LCD screen to be sure that direct light or the light stand itself is not in the picture.

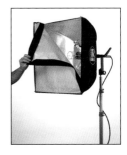

▲ A **soft box** distributes the lamp's rays over a surface as wide as the front of the box. Directing light through a soft box creates a natural look for portraits. The soft box leaves fewer harsh shadows on a subject's face than direct light.

CAUTION WHEN USING A SPOT OR FLOOD LIGHT

ELECTRICAL CONSIDERATIONS
• Spot and video floodlights draw a lot of current. Turn off toasters, dishwashers, and other high-draw electrical appliances when you're ready to turn on the video lights. You don't want to blow out an electrical circuit.

SAFETY CONSIDERATIONS
• **Use the correct equipment.** Use light modifiers such as umbrellas, soft boxes, and diffusers specifically designed to safely withstand the high temperatures generated by video hot lights. Soft boxes and umbrellas designed for still photography and electronic strobes can catch fire when exposed to the heat of continuous video light sources.
• **Bring heavy-duty cords.** When using video hot lights, avoid a potential fire by using only heavy-duty extension cords.
• **Use weights on light stands.** Should someone happen to bump your stand, serious accidents can occur. Sand bags or other heavy weights on the bottom of the light stand can prevent potentially costly disasters.
• **Quartz bulbs need special handling.** Don't touch quartz bulbs with your fingers. The natural oil from your fingers sticks to the bulb and causes a heat build up in the spot where you touched it. Over time, that bulb is more likely to blow out. If you have to change the bulb, wait for it to cool down and insert a new one holding onto the glass covering with a facial tissue, handkerchief, or cloth of some kind.
• **Wear gloves.** Because lights stay on for long periods of time, they get hot. Use special heat-resistant gloves or oven mitts when handling hot lights.
• **Move hot lights cautiously.** Better yet, let them cool down before moving them.

MOVING THE MAIN LIGHT

High 45° Lighting (Rembrandt Light). This is the ideal position for the main light when setting up an interview.

Side-Lighting. A main light that is at about a 90° angle to the camera will light the subject brightly on one side and cast long shadows across the other.

Bottom-Lighting. Light that comes from below looks distinctly odd in an interview. Light, whether outdoors or indoors, almost never comes from this angle. Lighting from the bottom casts unnatural shadows that can create a menacing effect sometimes called "Halloween lighting."

Butterfly Lighting. With the light high and aimed downward, the nose shadow leaves a small butterfly pattern on the upper lip. This lighting arrangement is often used for "beauty portraits." (Demonstration photos by Dave Hall and Sibylla Herbrich)

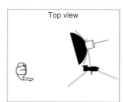

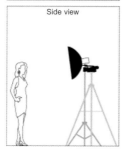

Front Lighting. When the main light is placed near the camera, the face looks flatter and skin texture tends to disappear.

For high-end interviews like those on programs such as *60 Minutes* or the national nightly news programs, lighting technicians set up three or more lights before the camera starts to roll.

This series of pictures shows an interview set up with a main light, fill light, background light, and hair light. The examples show the effect of each light separately and when all used at the same time. ∎

With the **main light,** often called the **key light,** high and to the side of the camera at about 45°, shadows model the face, creating a more rounded shape. Both the subject's eyes receive light. A triangle of light falls on the eye on the shadowed side of the face. A main light in this position is called **Rembrandt lighting** because the Flemish painter often arranged his sitters so that light fell on their faces in this manner.

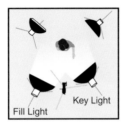

The photographer turned on the **fill light** on the opposite side of the subject to lighten the shadowed side of the face. The photographer could also have used a **large white fill card** or **portable reflector** in front or to the side of the subject to achieve the same effect.

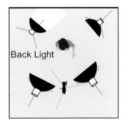

Here, only **the background light** is on. A background light helps to separate the subject from the background.

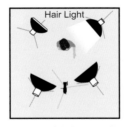

Only the **hair light** has been turned on for this image. The hair light adds a highlight to the top of the subject's head and is especially important if the person has dark hair. You can use either a **soft box** or a light with a **snoot**—a cone-like device that fits on the front of the light fixture and funnels the light into a small area—to furnish the hair light.

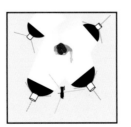

For the final setup, **all four soft box lights** are on.
(Demonstration photos by Dave Hall and Sibylla Herbrich)

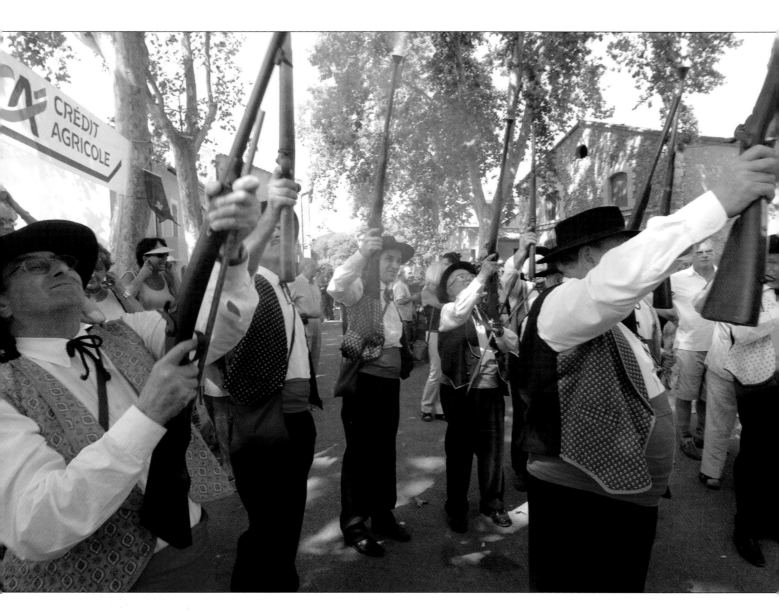

▲ Sound of Gun Fire.
Although you probably can imagine the sound of the guns firing at this traditional wine festival in the village of Montfort, France, the impact would be much stronger if you could hear the actual blasts. (Photo by Ken Kobré)

Recording Sound

When it comes to video and multimedia, sound is *king.* You're reading this statement written by a visual guy who started out as a professional photojournalist and who wrote the book on becoming a photojournalist.

But even I have to admit that in the world of multimedia and videojournalism, sound is the most important element . . . not pictures.

Allow me to repeat that. For multimedia and videojournalism, *sound is the most important element.*

This symbol indicates when to go to the *Videojournalism* website for either links to more information or to a story cited in the text. Each reference will be listed according to chapter and page number. Links to stories will include their titles and, when available, images corresponding to those in the book. Bookmark the following URL, and you're all set to go: http://www.kobreguide.com/content/videojournalism.

SOUND IS VITAL TO UNDERSTANDING

"If you close your eyes while watching a news program like *60 Minutes*, you will find that you can absorb the story with no problem. The images enhance the story, but it is the sound that is vital to understanding," says Dirck Halstead, a digital video pioneer whose workshops train photojournalists transitioning from still to video storytelling and whose website, *DigitalJournalist.org*, provides a wealth of information for multimedia and video producers.

The corollary to Halstead's observation is that if you turn off the sound and only watch the images, the piece won't hold your interest for long. Few video stories stand on their images alone.

Recall a recent film you saw in a theatre. How did you describe the movie to friends? Did you go into ecstasies about the lighting of a great scene that occurred 45 minutes into the movie?

More than likely, you outlined the movie's plot. Told the story. It's the sound that provides the narrative—the plot drives the story.

Because of and thanks to the sound, the storyline holds your attention and provides information that you will remember. Pictures merely adorn and intensify what the story wants to say. Of course, images carry an emotional punch that enhances the piece. But images alone are not enough make a video story work.

"Great sound is the glue that holds everything together. Sound is crucial to the success of any film project be it documentary, slideshow, or even a short web clip," says Lisa Berglund, senior producer at World Vision, also an NPPA Ernie Crisp Television Photographer of the Year. "Videographers often underestimate the power of sound—not only the power it has to make a good project into an extraordinary piece of work, but also its power to undermine and even ruin the strongest of stories."

Beyond Picture Captions

The use of audio opens up rich possibilities that are unavailable when publishing pictures in a printed newspaper or magazine. In print, textual information about the photograph is often limited to a terse caption. When they have the opportunity to speak in their own voices, characters can recall their history as well as explain their plans for the future. Audio interviews give images context and help to explain why an event is taking place. Natural sound provides texture and communicates a sense of place.

Kim Komenich, a winner of the Pulitzer Prize for his still images and an early adopter of multimedia and video, says that interviews and the recording of natural sound can even explore abstract concepts. "One perfect word might be worth a thousand pictures," he says.

NATURAL SOUND IS NATURALLY . . . BETTER

Natural sound, also called nat sound or ambient sound, is any sound other than a formal interview. Nat sound includes conversations and dialog and also casual sounds from the environment.

Stop for a moment. Listen to what you can hear right now. You may hear a computer hum, a radio or television playing somewhere, people talking in another room, the wind blowing, cars passing by, a baby crying, your own fingers on the keyboard.

Natural sound lets viewers share what the character is hearing. Complete stories with clear nat sound allow the pictures, dialog, and sound captured on location to tell the story. The sounds bring viewers into a room when events are unfolding in real time. This nat sound type of documentary lets viewers draw their own conclusions without benefit of a voiceover narrator.

When your characters actually forget about the mic (microphone, pronounced "mike")—and they can and will—the natural dialog that evolves on its own can provide the richest form of sound for a documentary.

Using wireless and shotgun mics that pick up a narrow cone of sound allows you to record—relatively unobtrusively—comments and interactions that reveal mood, define personality, and give an audience spontaneous bursts of information rather than the sometimes stiff responses elicited in a formal interview.

Sound of the Environment

Remember to record relevant background sounds like water wheels, rushing streams, grinding gears, and so on. If, for only a moment or two, viewers feel as if they are on the farm, in the slaughterhouse, or on the street where your story takes place, you have succeeded.

Here's a little assignment. Watch Associated Press photographer Julie Jacobson's story about the Coney Island roller coaster—but turn off the sound. Now watch it again with the sound on. Which version brings you into the story most effectively?

◄ Coney Island's Cyclone turns 80 years old.
(Julie Jacobson, Associated Press)

American radio programs such as *This American Life* (PRI) and *All Things Considered* (NPR) provide excellent examples of the power of natural sound. With nary an image, the background sounds of everyday life often play behind the words of the main subject in these stories. Occasionally, they also fill the pauses between verbal exchanges in an interview. As a result, these audio-only pieces manage to become shockingly visual to the listener.

Note how natural sound is used in the short documentary "One for the Birds." In this story, a person who records birdsongs meets an artist who "sees" sound. It's all about listening to natural sound.

Sound of Voices. For a three-part multimedia series for the *Los Angeles Times* titled "The Lifeline," photographer Rick Loomis and reporter David Zucchino recorded the actual words of wounded soldiers in Iraq who were calling home to tell their families what had happened to them.

The team also recorded some of the doctors during surgery. The natural sound of doctors, medics, and patients talking, backed by the clangor and clamor of a busy operating room gives the piece an authenticity that would have been missing in a formal voice-over interview.

"I cried," wrote one *Times* reader on the outlet's website, "when I watched and listened to the words scribbled by a wounded soldier. The poor man had a tube inserted in his throat that prevented him from speaking. His message was being communicated to his family back home by a nurse via telephone."

There can be drawbacks to natural sound. Information can spill out haphazardly, too rapidly, or in highly emotional bursts. When this kind of thing happens, it may require the addition of supporting material via a voice-over narration.

▼ **The Lifeline.** Here the reader hears a nurse make a call for an injured soldier who cannot speak. (Photo by Rick Loomis, *Los Angeles Times*)

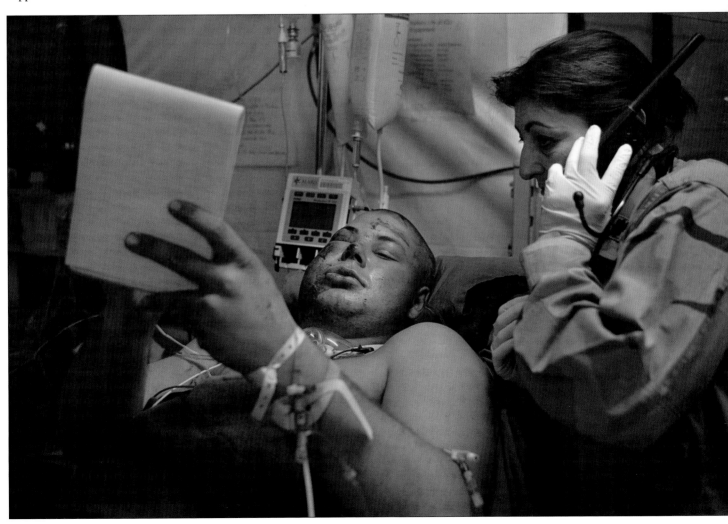

Audio as Opener

Natural sound segments are useful as "establishers." Many documentaries start or are "established" using a segment that places viewers in the midst of some action, whereby they get the sense they are actually experiencing what's going on.

In an extensive documentary about White City in southern Peru, students from the University of North Carolina and the Universidad Católica de Santa Maria used the ambient sound of nuns praying to introduce "Cloistered for Christ," a multimedia piece about women living apart from society.

Collecting Nat Sound

As your character moves about—even if the action seems to have gone dull—continue to record. You might capture some seemingly mundane—but actually telling—moments of the person's life. With a careful choice of sufficient recorded nat sound comments, viewers can feel personally involved in the unfolding of an unguarded day. Viewers like to make their observations based on what they see and what they hear. Without a voice-over narrator authority figure explaining what is happening, viewers can draw their own conclusions.

▶ Cloistered for Christ. Twenty-three nuns live a cloistered life behind the walls of Santa Catalina Monastery in the heart of Arequipa, Peru. Listen for how the producers used natural sound to start this video. (Kate Lord, Andrea Ballocchi and Nick Vidinsky, University of North Carolina, Chapel Hill)

▼ Capturing Sound and Pictures Simultaneously. Pete Souza, a still photographer for the *Chicago Tribune* at the time, and later the White House photographer for President Barack Obama, followed then-Senator Obama's trip to Africa but was unable to mic him wirelessly. While Souza concentrated on shooting stills, the *Tribune* reporter with him handled the recorder to capture natural sound. (Photo by Peter Souza, *Chicago Tribune*)

TIP It is always a good idea to record sound for about a minute while no one is talking. This minute of what is called "room tone," whether recorded indoors or outdoors, will come in handy when you edit. You might have to remove a distracting noise from the audio track, or insert a still photograph, but you will need something to replace the missing audio underneath the new images. You can use "room tone" to accomplish this. Without the room tone, the audio track would go completely dead. With "room tone," you will have just enough low-volume noise for the audio track to sound quiet but normal.

AUDIO TOOLS OF THE TRADE

In addition to using the built-in audio recorder found in video cameras and in hybrid digital cameras with video capability, you can also use a handheld audio recorder to capture sound. If you record sound this way, you can add it to your multimedia piece in postproduction.

▲ A "dead cat," or windscreen, covers the mic of a handheld recorder to cut down noise from the wind. Note the journalist's earphones, which allow monitoring and, if necessary, correcting for any problems with the sound being captured. (Photo by Ken Kobré)

Using Handheld Audio Recorders

Storytellers shooting stills for multimedia use handheld audio recorders to capture interviews and natural sound of high quality. Videojournalists sometimes use these devices in lieu of a second camera, placing a recorder in one place to collect sound at a consistent level while shooting video elsewhere. For example, using this method, if you are recording a band with a handheld recorder, the recorded band music will remain at the same audio level even if you continue shooting outside the hall where the performance is taking place. You can then edit the music and visuals together later.

Handheld devices store the sound on the recorder's internal memory or on a solid-state flash memory card like those used in most digital cameras.

Digital audio files can usually be downloaded directly onto a computer or transferred via the flash memory card. The recorder's internal drive or flash drive's capacity determines the amount of audio that can be recorded at one time.

Audio-in and audio-out ports on hand-held audio recorders also allow the addition of external microphones or even headphones for monitoring sound quality.

The most desirable feature on these devices is their ability to determine quality. When the choice is available, select 16 bits as the sample size and 48kHz as the sample rate, which is the standard for audio to stream on the Internet.

Types of Handheld Audio Recorders

◄ **Digital Audio Tape** (DAT) recorders are expensive and relatively fragile. DAT recorders have been used widely in professional broadcasting due to their ability to render high-quality sound. Typically, they can also transfer recordings to a computer digitally.

◄ **Solid-state recorders**, already less expensive than DAT recorders, are coming down in price. These devices can record sound onto memory cards, such as Secure Digital (SD) and Compact Flash (CF) cards. They compress sound on the fly into formats of your choice. This saves storage space for longer recording sessions. The recorded sound can then be downloaded directly to a computer.

◄ **Hard-disk recorders** capture compressed or uncompressed sound onto high-capacity disk drives inside the recorder. This digital sound must then be copied from the recorder onto more permanent media, such as a CD or a computer hard drive.

Other Recording Options

If you just need to do a voice-over for your narration, consider using your laptop computer. In the field, though, you will likely select a device that can record both video and audio at the same time. These devices include anything from a smart phone to an expensive dedicated video camera. Each tool has its advantages and disadvantages. Smart phones are convenient, but without external mics, they can't capture crisp sound. Full-featured video cameras deliver impeccable quality but are cumbersome to lug

around. When choosing your equipment, weigh all the variables for the job at hand before you make your final selection.

Note: If you have a choice, always select 16 bits as the sample size and 48kHz as the sample rate to capture the highest-quality sound with your recording device, whether it's a laptop, cell phone, pocket video, hybrid camera, or small or large video camera.

◄ **Your own computer** can be transformed into a sound studio. You can easily record your own voice using the computer's built-in mic or, if it has the capability to accept one, an external microphone.

◄ Your **smart phone**, in a pinch, can record audio. Some phones even accept external mics.

◄ **Pocket video cameras** record sound, and some accept external microphones that make them far more versatile for shooting video stories.

◄ **DSLR cameras** can record audio and video. Many have both a built-in mic and the capability to accept an external mic.

◄ Some **small video cameras** will accept external mics but only a few include a way to monitor the sound directly with headphones.

◄ **Higher-end video cameras** include manual control of sound levels and essential audio-in and audio-out ports for adding external microphones and headphones.

With some computers, you can even attach a high-quality external microphone. Beware that the sockets of some laptops that accept external microphone can add noise to the recording and possibly be too insensitive for professional microphones to work well. If your computer has this problem, you can add an audio box. Audio boxes typically contain a microphone pre-amplifier and an analog-to-digital converter. The box plugs directly into the computer and then the microphone plugs into the box. Now the mic will deliver the sound you have been looking for. Check out Internet tutorials on recording sound.

When considering a handheld recorder or camera, look for one with an **XLR** socket, as this option provides a secure connection with a ground wire that reduces undesirable static interference. Recorders and cameras with two **XLR** microphone sockets offer a significant advantage by allowing placement of microphones on two subjects at the same time or the use of a shotgun mic and wireless mic simultaneously.

Recording Sound with the Video Camera's Built-In Mic

The built-in mic on cell phones, video, and hybrid SLR cameras will work for picking up music from a loudspeaker, the general ambient sound of a party indoors, or the rushing water of a stream outdoors. But for recording interviews or dialog, a built-in microphone simply cannot capture professional-quality sound.

▲ **Built-in microphones, regardless of the cost of the camera, rarely capture pristine, clear sound.** (Photo by Ken Kobré)

- **Quality:** Built-in microphones are notoriously of inferior quality. Knowing that most pros are going to add external mics anyway, manufacturers invest very little in their cameras' built-in microphones.
- **Design:** Most built-in mics are designed to pick up sound all around the camera. If you are trying to record a person in front of you who is speaking, any ambient noise elsewhere in the room is likely to interfere.
- **Using the built-in mic in a pinch:** What if you're stuck and have to use a built-in camera mic for an interview? The best approach is to record your interview in as quiet a place as you can find and position the camera and its built-in microphone as close to your subject as possible. Then, don't move the camera with its mic during the interview.

- **Get closer:** All microphones, built-in or external, work best when close to the source of a sound. Keep in mind that if you do back away from your subject for a medium or overall shot, the internal mic also will be that much farther away from source of the sound. As you back away, the sound will naturally fade. That, quite simply, is basic physics and there is no way around that problem with a built-in mic.

Recording Sound with a Hybrid Camera

Most hybrid cameras that record video and sound in addition to still pictures do not provide a socket that accepts headphones. The cameras' inability to accept headphones makes it impossible to detect extraneous noise or to determine whether the camera is even recording the audio.

Also, hybrid cameras often don't offer a means of manually controlling the sound. The hybrids relegate sound control to an **automatic gain control (AGC)** feature built into the camera's electronics. (More on AGC coming up.)

If you're working with an SLR that does have an audio-in port, select a mic with an XLR connection for best quality and lowest susceptibility to noise interference.

▶ This **pre-amp** will take the signal from a microphone with an XLR plug (three-pronged) and adapt it for a mini jack (small 1/8th-inch plug) that goes into your camera.

Whether you use a mic with an XLR or a 1/8-inch connection, you may need a "pre-amp" adapter box to boost the quality of the sound coming in through the mic.

Attach the pre-amp box either to the bottom of your camera using the tripod socket or to the top of your camera under the rails of the hot shoe where an external flash normally goes. Now plug the pre-amp into the camera's audio-out port and the microphone to the pre-amp. This bulky and somewhat expensive combination of mic and pre-amp box will produce professional-quality sound even with a hybrid camera. With some pre-amps, you can adjust the volume level as well as monitor the audio with headphones.

Another solution for recording sound with a hybrid camera is to use a high-quality handheld recorder as the go-between. With an external mic connected to a handheld recorder and the recorder connected to the camera, the

camera captures the sound gathered by the mic. The handheld recorder allows volume control that is impossible with the hybrid alone. Also, headphones can be attached to the handheld recorder, which will allow you to monitor the quality and the volume of the sound. See more on recording sound while shooting with a DSLR.

Record sound and video but sync later.
Many handheld audio recorders have exceptionally good mics, so some videojournalists prefer to capture audio with a handheld recorder that is not connected to their hybrid or video camera. They prefer to sync the sound later. Using a recorder apart from the camera allows placing the device close to the source of the sound. During editing, the hybrid camera's video and the recorder's audio can be synced together.

The key to syncing the camera and handheld recorder is to simultaneously record some kind of reference audio on each device. Even if it isn't used in the final piece, the reference audio can be used to sync the externally recorded sound back to the video from your camera. During editing, you would use a plug-in for Apple's Final Cut Pro, such as PluralEyes, that can automatically sync the audio back to your video.

As hybrid cameras evolve, they will become more "video-like" and eventually will include features that allow you to easily plug in an external mic, directly adjust sound levels, and monitor sound with headphones.

A MICROPHONE FOR EVERY OCCASION

So you now know that the best way to record audio is to use an external microphone. Your choice of the right mic will make a tremendous difference in the quality of sound for your documentaries. In fact, even professional videographers will tell you that the quality of the microphone can be more crucial than the quality of the camera itself.

Whether used with a handheld audio recorder or a video camera, condenser and dynamic microphones are typical choices for best quality recording.

To record top-quality sound, expect to pay top dollar. The more expensive mics from respected manufacturers such as Beyer, Sennheiser, Tram, Sony, Audio Technica, or Lectrosonic do a much better job than lower-priced competitors.

But price is not the only consideration. Each microphone has certain fidelity characteristics for the bass and treble sounds. Compare different mics by testing them with the same recorder or camera, then listening to the results.

Microphone Types
Dynamic Microphone

▶ **Dynamic microphones** or handheld mics are used by many news correspondents for one-on-one interviews. The dynamic mic collects but does not amplify sound. This type of microphone, also called a "stick," is a decent choice for voice-overs. For cleanest sound, hold it close to the speaker's or your mouth—at a distance of about the width of your fist.

Condenser Microphone

▶ **Condenser microphones,** such as the "shotgun" mic shown here, are preferred by videojournalists. They require batteries to boost the audio signal level. These mics pick up softer sounds than do dynamic mics, but on the downside, can also collect more general ambient room noise. They can be used directly on the camera to pick up general sound and candid dialog or used handheld for interviews.

A unidirectional condenser microphone such as the shotgun mic is a good choice for the voice-over. The shotgun mic has a narrow pickup pattern, which cancels out a lot of extraneous sounds. To be effective, this type of microphone needs to be aimed directly at the speaker's mouth but at least 4 to 6 inches away to prevent the audio from becoming distorted and unusable.

Lavalier Microphone

▶ The **lavalier microphone** (**lav** or **lapel mic**) is a small mic used for video recording. This microphone is great for interviews because it mostly picks up the voice of the subject while blending in some of the environmental sounds. However, for recording a voice-over narration, its omnidirectional pickup pattern makes it less than optimal. In a quiet environment, it should produce adequate sound for the voice-over. But hold it gingerly or clip it on your shirt to prevent handling noise. For best sound, speak over top of it, not directly into it.

The tiny lavalier or lav mic can be attached directly to an audio recorder or video camera via a cable, or it can transmit sound wirelessly via a transmitter attached to the subject's belt or other clothing. The best—and more expensive—lavs pick up the sound in what is called a cardioid, or heart-shaped, pattern. This pattern is ideal for interviews. With the lav clipped to a subject's shirt, the little microphone will record clear dialog without picking up much ambient noise around the person. Most lav mics are condenser-type microphones and need batteries.

Lav mics come in two varieties, one with a cord and the other cordless. Each type has a small clip for attaching to collars, ties, or other clothing.

With the wired lav mic, run the cord from inside the subject's clothing and out to the video camera. The wireless mic also has a cord that must be hidden under the subject's clothing and is attached to a wireless transmitter worn by the subject in a pocket, on a belt, or attached to a skirt or pants. The transmitter sends a signal carrying the sound to a receiver mounted on the video camera.

Lav mics are condenser-type microphones and need batteries.

Lavalier + Wireless Transmitter. Here is what a wireless transmitter outfit consists of: the lavalier mic connected via a wire to a body-pack transmitter and a receiver that conveys what is recorded to a camera or audio recorder. The audio signal travels from the mic via the wire to the transmitter, which operates like a miniature radio station. The signal from the transmitter travels over the airwaves to the receiver. The receiver itself is plugged into a camera or a handheld audio recorder.

A good wireless system frees a subject to move naturally and the photographer or videojournalist to concentrate on capturing candid interactions.

Although manufacturers are hesitant to state an arbitrary distance limit for their equipment, a good wireless mic and receiver seem to work efficiently within a 75-foot range. Be aware, though, that the wireless signal is subject to interference from both television and cell phone signals.

And keep in mind also that when it comes to microphones and wireless systems, you get what you pay for. "I don't skimp on my mics, and especially not my wireless," says World Vision's Lisa Berglund. "I have had numerous friends buy less expensive wireless systems to save money and they all have regretted it."

Other considerations: Ultra High Frequency (UHF) transmitters have a greater range than

▲ The **wireless lavalier mic** on the left is attached to a sender. The signal is transmitted to the wireless receiver on the right, which can be plugged into a video camera (or handheld recorder).

those with Very High Frequency (VHF). UHF transmitters are also less susceptible to electrical interference than VHF transmitters.

Beware of cheaper VHF wireless mics for recording professional sound for your video or multimedia documentaries. You are likely to find that the VHF transmitters produce poor sound quality, and their propensity to pick up noise from other electronic equipment will prove more frustrating than not having a wireless mic at all.

Most wireless mics can broadcast using several channels. The cheaper models have from four to sixteen channels; the more expensive have a hundred or more.

"Wireless mics are a fantastic option," says Jesse Garnier, former web services manager for the Associated Press, "but they are very susceptible to interference, static, and particularly cellphone signals. Stress-test all of your equipment to identify the kinds of situations that might cause problems and could force you to switch to wired microphones."

Microphone Recording Patterns

Omnidirectional. **Omnidirectional mics** find every sound, including those whispered by the videojournalist behind the camera—annoying chatter known as camera talk. The on-camera built-in microphone in SLR cameras and video cameras is usually omnidirectional, meaning that it will pick up sound from every direction.

Most lavalier mics are omnidirectional, but placed close to the subject's mouth, they work well for interviews.

▼ **Boom.** A sound engineer using an omnidirectional mic has attached it to a boom to pick up crowd sounds. In an emergency, a solo videojournalist with access to a boom pole might ask a friend to hold the boom and mic. (Photo by Ken Kobré)

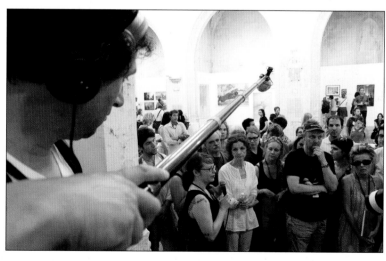

Unidirectional. **Unidirectional microphones** pick up sound mostly from the direction in which the microphone is pointed. Unidirectional microphones come in two varieties: cardioid and hypercardioid. A cardioid mic picks up sound in a heart-shaped pattern. Most of the sound the mic picks up comes from the direction in which the mic is pointed. But some of the sound also comes from the left and the right of where the mic is aimed. A hypercardioid mic, also called a "shotgun" mic, picks up sound from a much narrower area. It records right where the mic is aimed.

You can handhold a unidirectional mic, mount it on a camera or suspend it from a portable pole called a boom. Booms are lightweight and collapsible. Nonetheless, a separate person has to hold the boom. Unidirectional mics do not—despite what you may have seen in the movies—have a supernatural ability to record conversations hundreds of feet away.

HOW TO USE A MICROPHONE
Shotgun Mic

A unidirectional mic collects sound in the pattern of a widening cone. When filming at a gathering, for example, the microphone will record the voice of the person directly in front of the mic; but it will also pick up the more garbled sounds of people in the same path behind the speaker.

The shotgun's reach is limited by the loudness of a certain voice in contrast to the background sound. For example, the shotgun mic will pick up a solitary subject's voice even if

the person is 10 or 15 feet away. If, however, the same person is at a noisy party, his or her voice will no longer be distinct at the same distance.

Also, keep in mind that if a shotgun microphone is attached to the camera and it's necessary to move the camera to photograph action elsewhere, you may find yourself turning the microphone away from your principal speaker. This change in orientation would naturally cause an unfortunate drop in the sound level of the speaker's voice.

Aiming the Mic. A poorly aimed shotgun mic attached to the camera can actually miss the subject's voice and instead amplify background noise behind the person.

You can take the shotgun mic off the camera to use it for interviews. Just be careful that you aim it accurately toward your own mouth when you ask questions and toward the mouth of your interviewee for the responses.

Lavalier Mic

Placing the Lav. Positioning a lavalier mic about two buttons below an interviewee's collar is standard practice. To attach a lav mic to a subject, first bring the cord up through the person's shirt so that it won't show in photos or video footage. Although lavalier mics themselves are well hidden in Hollywood movies, letting the mic show is accepted practice in documentaries. Most people are accustomed to seeing the tiny black sensor clipped to a subject's lapel or T-shirt and aren't suffering under any illusion that the subject is unaware of the mic and

▲ **Limiting the Sound Pickup.** The shotgun mic, in use on this camera, has a hypercardioid (narrow) pickup beam. The camera will record primarily the sound produced directly in front of it. By monitoring the sound with headphones that cover his ears, the videojournalist hears the sound exactly as it is being recorded. (Photo by Ken Kobré)

camera. Install the lav mic in such a way that it will not rub against the subject's clothing. The friction of the mic against fabric can cause a scratching sound.

With the lav clipped to a subject's shirt, the microphone will record clear dialog without picking up much ambient noise around the person. Even if the person wearing the mic turns his or her head while speaking, the microphone tends to pick up only sound that is near.

If you are interviewing two people and have only one lav mic, locate it on the collar of one subject but on the side nearest the other person. If the subjects are sitting or standing close together, the mic will usually pick up the sound of both voices.

When in the field, it's important to confirm that the channel on the mic and transmitter match the channel on the receiver. If you're getting interference from other microphones or from TV transmissions, change channels on both the transmitter and the receiver. You will know right away if there is any interference because you will be wearing headphones and will hear static.

Lav with handheld recorder. A lav mic is also an option for multimedia producers recording a subject with a handheld audio recorder while shooting still pictures. Attach the lav mic to the audio recorder and put the recorder itself in the subject's pocket. With the recorder and mic on the subject, you are free to move about naturally, unimpeded by the necessity of holding an audio recorder or a microphone in your hand. The downside of this setup is that there's no way to use headphones to monitor the quality of the sound the recorder is picking up. Also, unless the recorder is voice-activated, you will record a lot of dead air.

Lav = freedom. A wireless mic system with headphones is the ultimate choice for multimedia and video documentary makers. It's an expensive option, but the wireless system allows both subject and photographer easy, natural movement. And for the multimedia maker shooting stills, it allows monitoring sound.

"I rely extensively on wireless mics," says Goheen of Terranova Pictures. "I actually have access to at least four and sometimes five mics on my camera at any one time . . . and I am not using a mixer . . . this is not the norm, of course . . . but it suggests how much value I put into gathering audio. The wireless mic is a great tool to use for capturing all kinds of sounds . . . not just interviews. I have miked trees and fence posts in order to capture the crisp chirps of birds, or placed it on a flagpole to get the flapping sound from the flags. You name it . . . I've put the mic anywhere there was sound to be captured."

When people are free to move about, they often forget about the wireless mic. They automatically become less inhibited about being recorded and thus act more natural and spontaneous. Another advantage to this system is that you are wearing headphones and will therefore be able to hear and record your subject talking at a distance—even around the corner or down the hall.

▼ **Attaching the Lavalier.** John Goheen prepares to place a wireless lavalier mic on a small boy.

ESSENTIAL ACCESSORIES FOR RECORDING SOUND

In addition to choosing the right microphone, you also need some other essential accessories to help you capture high-quality sound for your projects.

Windscreen

Whichever microphone you choose, always use a windscreen when you are outside. Windscreens help keep wind noise out of your recordings. Even a lav mic usually comes with a tiny windscreen. The windscreen for a shotgun mic is called a "dead cat" or "fuzzy sock." This very hairy version of a windscreen is highly effective at reducing wind noise. A shotgun mic covered with a windscreen should be mounted in shock mounts that attach to the camera or to the boom, advises John Hewitt, emeritus professor of video documentary at San Francisco State University. "If you handhold a mic, even the friction from your hand on the barrel of the mic can add noise to the recording."

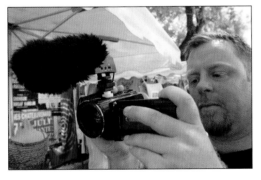

▲ **Windscreen.** A windscreen placed over a microphone cuts down noise from passing air currents.

Headphones

"Not wearing headphones is akin to shooting an image without looking through the viewfinder," warns multimedia expert Brian Storm. "We've all shot from the hip now and then. But would you do an environmental portrait that way?"

Headphones are the only way to truly monitor what the microphone is picking up. If you're not wearing headphones, you simply won't hear the quality of the sound coming in or even know whether your equipment is working.

"I find that without headphones, you can't hear the good sounds that will help mold your story, nor can you hear the bad sounds that could be hindering it," says World Vision's Lisa Berglund. "Capturing great sound is equally as important as making sure you are aware of the bad sounds like white noise (an air conditioner, refrigerator, ticking clock, for example), airplanes, car alarms, cell phone interference, generators or wireless cutting out."

Earbuds and light headphones do allow you to hear interference such as a crackle from a loose wire connection. But these small headphones also let in environmental sounds that aren't necessarily being recorded. That alone can make your work more frustrating.

The more isolating, larger headphones cut off most outside sound so that all you are hearing is the audio actually being picked up by the mic. Headphones are bulkier than earbuds but provide a better measure of the quality of sound being recorded.

On most handheld recorders as well as on medium- to high-priced video cameras, you will find an audio-out socket that will accept the cable jack from headphones. There are a number of different-sized sockets that are standard in the industry including sub-mini, mini, 1/8-inch, and others. If your headphone doesn't fit the outlet on your device, buy a converter to reduce or enlarge the jack size.

RIDING GAIN ON YOUR MICS

Whether you are pointing a shotgun mic to collect natural sound or you have attached a discreet lavalier mic to your subject's shirt collar, you must constantly monitor the quality of the sound being recorded.

▲ **Headphones:** don't leave home without them.

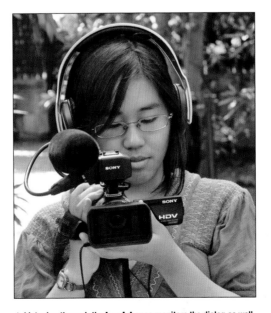

▲ Listening through the **headphones** monitors the dialog as well as the audio for any undesirable interference. (Photo by Ken Kobré)

Spend a moment recording some small talk with your subject, or have the subject recite the ABCs or a favorite poem. Then listen to the selection before starting the interview or the shoot. This delay may be a bit awkward, but it may also save you from recording an unusable interview.

What to Listen For

When recording an interview, you obviously will be listening to what your subject is saying. But you also must pay attention to all of the following technical considerations so that your subject's words are not drowned out by extraneous snaps, crackles, and pops.

Listen for:

- **Scratching sounds** caused by the lav mic's contact with the subject's clothing. Adjust the mic to avoid this interference.
- **Irritating or interfering sounds** from nearby music, an air conditioner system turning on or off, or a refrigerator's buzz. You might actually have to switch off the radio, squelch the air conditioner, or unplug the refrigerator.
- **Unclear** subject's voice. If the voice is not crystal clear, make sure the mic is near enough to the person's mouth.
- **Low volume.** Check to see whether the volume is sufficiently loud. You may need to adjust the audio levels.
- **Static caused by loose audio cables.** If this is the case, you need to verify the connections and check to see whether a wire has come loose or is broken.

Controlling Volume

The best way to ensure good sound is to know how to set and monitor the volume control on your video camera. As with other camera controls, you have a choice of manual or automatic, each with its advantages and disadvantages.

Manual volume control: "riding gain." Some cameras have audio volume meters that may appear on the LCD screen or in the viewfinder. These allow you to see if the volume is staying within a usable range. Monitoring the meter

can be difficult when trying to shoot and record sound simultaneously, but it's essential to capturing usable audio.

Beware of some inexpensive to intermediate camera audiometers. Some overmodulate by equalizing all the loud and soft segments. Others don't show the sound level at all. On some cameras, it's difficult to see the sound level, especially when all the controls are on a flip-out LCD menu.

Professional videojournalists often set the audio level by hand, using a volume meter located either on the camera itself or on the LCD screen. The volume meter displays the sound level. In this way, they can constantly monitor the sound level and adjust it throughout the recording session. In fact, in feature-length documentaries, a person separate from the videographer handles the microphones and monitors the sound. But if you are a one-man-band, you alone will be shooting and monitoring sound.

A **decibel** (dB) is the unit used to measure the intensity of a sound. Meters measure decibels from −30 (very quiet) to +6 (off-the-scale loud). Some meters show the dB level in numbers. Others just indicate the ideal volume level and the blow-out zone.

To produce the least noisy recording, set the recording volume to peak at −12 dB. This is to avoid "clipping" or seriously distorting the high end of the signal. Do not let the sound level go too high or too low. Once the sound level hits the "danger zone"—usually above 0 dB, the sound fidelity cannot be recaptured in the editing process. "Always record a little low," says Goheen of Terranova Pictures. "You will more than likely be able to boost the level in editing but if you overmodulate—i.e., have the volume level too high—there is nothing one can do to correct the distortion." When the original was barely audible, bringing up the volume level later in an editing program is less than satisfactory. When recording an interview, have the subject speak in a natural voice and set the volume level high but not so high that it goes over 0 dB. Then leave it alone, says Goheen. You will need to change it only if the person becomes noticeably quieter or starts to shout during the interview.

Adjusting the sound volume while on the move can be a challenge for the backpack journalist—who is simultaneously busy framing the shot, adjusting the focal length of the lens, and making sure the exposure and focus are okay, not to mention conducting a thoughtful interview with good follow-up questions. This juggling act takes practice.

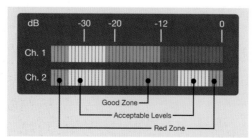

► **Digital Audio Display.** Try to keep the sound level between −25 and −12 decibels. Avoid letting the sound level reach the red zone.

1 When placing the mic, closer is always better.

2 You can't hear problems without headphones.

3 Monitor volume controls and stay within limits.

4 Listen for annoying sounds in order to eliminate them or wait for them to end:
 - Unwanted radio music
 - Television
 - Airplanes or vehicles
 - Machines or appliances
 - Construction
 - Alarms or sirens
 - Unrelated conversation

5 Always start by recording one minute of room tone (no dialog; no one speaking).

6 Continue to record important dialog even if the picture is poor. You can split the audio and video tracks later and use only the relevant sound with other images in your final video.

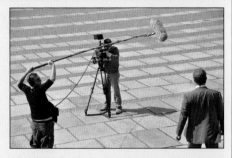

▲ In this **three-person video crew,** the soundman stands off camera. He aims the shotgun mic at the end of a boom pole toward the correspondent. (Photo by Betsy Brill)

Automatic volume control. Even skilled video shooters often forgo full control over sound by relying on the camera's automatic volume control features. Automatic gain control (AGC), also called automatic level control (ALC), is the term describing the camera's sound level monitoring system.

AGC strives to record all sound within a fixed volume range. When a sound is very loud, AGC softens it; when a sound is very soft, AGC tries to boost it. In effect, AGC limits the volume's dynamic range to an acceptable level that the camera is capable of handling.

However, because AGC is always striving toward the middle, it's likely to amplify ambient sound when no one is speaking or to subdue the sound of an emphatic interviewee. When recording something like music with quiet and loud passages, the AGC will tend to compress the dynamic range by making the quiet passages louder and the loud passages quieter—not what Beethoven had in mind at all.

Also, depending on the model of your camera or audio recorder, AGC can produce strange quirks. For example, when a person resumes speaking after a pause, the first words may be over-amplified until the AGC finds a comfortable level.

Yet on many cameras and recorders, AGC produces remarkably consistent volume levels without any tweaking during the recording session. If you're working alone in the role of backpack videojournalist, consider putting the audio on automatic and leaving the driving to the device. ■

▼ Automatic gain control (AGC) automatically suppresses any extraordinarily loud noises such as the sound of a gunshot. (Photo by Ken Kobré)

▲ **Last Roll of Kodachrome.** In this video, photographer Robert Cohen narrates and describes how he dug a final roll of expired Kodachrome 200 out of the back of his freezer, carefully and lovingly shot 36 frames at the Missouri State Fair, and then drove the film hundreds of miles to Kansas to have it developed before the only remaining laboratory closed forever. (Photo by Robert Cohen, *St. Louis Post Dispatch*)

Combining Audio and Stills

Slideshows date from the latter half of the 1800s when explorers returning from the North or South Pole, Africa, or the tip of South America shared photographs of their adventures—in slideshows. The black-and-white or hand-tinted color images, fixed on glass plates, were shown using oil-lit "magic lantern" projectors. The images, accompanied by commentary, entranced and excited audiences. For the first time, at the beginning of the 20th century, audiences could not only hear about, but—more important—see for themselves the pyramids of Egypt or Mount Kilimanjaro. In the sliding glass plate slide shows by Jacob Riis, for example, people at last saw for themselves the shocking slum conditions of New York City.

This symbol indicates when to go to the *Videojournalism* website for either links to more information or to a story cited in the text. Each reference will be listed according to chapter and page number. Links to stories will include their titles and, when available, images corresponding to those in the book. Bookmark the following URL, and you're all set to go: http://www.kobreguide.com/content/videojournalism.

FROM SLIDESHOWS TO MULTIMEDIA

Technology definitely improved with the invention of the lightbulb. Then, starting in the mid-1930s, slideshows evolved for ordinary people via another leap in technology—the advent of 35mm Kodachrome color slide film and the Kodaslide projector.

▲ **Lantern slide projector, London 1880.** (Photo by Holger Ellgaard)

▶ **Lantern slide** images on glass plates were projected onto a screen. (Photo by Andreas Praefcke)

Presentations became more sophisticated but still basically remained limited to projecting single pictures that were (or not) accompanied by the words of a narrator. Eventually some slideshows became what we called "filmstrips" in the 1950s and 1960s. Filmstrips provided the basis for many an elementary school's geography, science, and history presentations.

Zooming forward a few decades, presenters began to exploit yet another wave of technological innovation to use computers to manage sound abetted by a projector that threw their still images onto multiple screens. Such projections created a sound-and-light multimedia experience.

When personal computers came along, the sound-and-light experience moved into homes, offices, and classrooms—and inevitably they also moved from those flat, white screens to computer monitors connected to the Internet. Rather than an in-person narrator, these new shows included a soundtrack to accompany the still images.

What should we call this hybrid, which now includes audio, still images, and sometimes, even video? We use the term **multimedia** as a standard throughout this book to indicate a blend of audio with still and/or video images.

INTERLOCKING IMAGES AND SOUND

When producing multimedia, you must keep **audio** uppermost in your mind. Creating a powerful piece demands that the words and images work together directly because eventually they are presented—and absorbed by the viewer—simultaneously. Still, the audio comes first.

When you shoot pictures and record sound, think of yourself as a radio reporter with a camera. Think: "What interviews and live, natural sound must I collect to communicate my story regardless of whether the audience ever sees the still pictures or video?" Keep the audio uppermost in your mind and isolate it from the pictures at first. Then ask yourself: "Which pictures should I take to reinforce my audio story line?"

▲ **Waveform.** The louder the sound, the taller the line in this audio editing program.

STILLS VERSUS VIDEO FOR MULTIMEDIA?

With the availability of inexpensive video cameras, why do photographers shoot stills for a multimedia project instead of video? The answers range from necessity to artistic choice.

The Case for Stills

A still photographer's unique skill may be necessary. Photographers who have spent their lives shooting stills are likely to be more skilled with a traditional camera that they know intimately rather than with a video camera they don't know well at all. Assigning someone like the extraordinary still photographer Sebastião Salgado to shoot a video would make no sense at all.

Only still images are available. When Brian Storm of MediaStorm produced the report on the black market trade in endangered animals, photographer Patrick Brown had already shot photographs for a book. Brown had found the still camera easier to use discreetly when trying to shoot in dicey situations. Going back for the same images with a video camera would have incurred huge expense and potential danger—and might not have strengthened the piece.

A video camera can be too obtrusive. Matt Gross, who writes and shoots the *New York Times* "Frugal Traveler" blog, notes that when he pulls out a video camera—even a tiny one—people on the street tend to shy away from his lens.

Using a still camera, a photographer can shoot a few frames and discreetly slip the camera

▲ **Large video cameras** can distract subjects. (Photo by Ken Kobré)

under an arm or into a coat pocket, whereas a video shooter must record at least 10 seconds to capture sufficient footage for an editable clip. With video, there's no pulling out the camera for a quick few photos and then nonchalantly strolling away.

Video may be prohibited. At some concerts, sporting events, or theaters, the management doesn't want spectators with a video camera to record the complete game or performance and later illegally sell or exhibit the results. Sometimes, however, they do allow still cameras. Prohibitions against video in places like these present problems for videojournalists.

A range of lens choice is necessary. Single-lens reflex (SLR) still cameras offer a wide choice of lenses, from fisheye wide-angle to 600mm telephoto. These definitely allow more visual options and greater control over foreground and background sharpness. With hybrid SLR cameras that shoot video as well as stills, this currently crucial difference between video and still cameras is becoming less critical.

◄ **Interchangeable Lens Camera.** Shooting with an SLR camera allows the photographer to select a range of lenses from wide-angle to telephoto. (Photo by Shmuel Thaler, *Santa Cruz Sentinel*)

▼ **Black Market.** The multimedia story "Black Market," about illegal trade in animal parts, was originally shot as still images for a book. Inside Scotland Yard's animal protection unit, an officer displays a tiger's head seized during a raid in London. (Photo by Patrick Brown)

Capturing the "decisive moment" may outweigh continuous action. When shooting stills, the photographer searches for the one perfect moment in which composition, light, movement, and body language all convey a coordinated message. A one-second video clip of the same moment does not carry an aesthetic and emotional wallop equal to a perfectly framed and precisely captured still image. A still image will remain on screen long enough for viewers to absorb its full meaning and artistry.

When Video Is Better

Capture motion. The video camera is ideal for capturing sustained movement, recording the flow of the action. Although the still camera, for which each image is static, captures a quintessential visual moment, the video camera registers what happens before, during, and after the "decisive moment." Video links all the individual moments together.

Synchronous sound. Video records synchronous sound and images. The mouth of someone speaking moves in exact time with the words the viewer hears. The viewer sees the slap of a boxer's glove while hearing the punch land in the same instant.

More realistic. Video is more realistic and parallels viewers' actual experience of the real world. Although a still photo can become an icon, video absorbs viewers in a new world.

▲ **From the Wreckage.** In this multimedia story about Detroit's car industry, the producer used both still images and video. (Kathy Kieliszewski, executive producer, *Detroit Free Press*)

Some stories are simply better illustrated with video. Brian Kaufman produced a story on a mentally impaired bowler who had thrown multiple perfect 300 games. A story like that is stronger for seeing the man bowling, witnessing his form, his power, his determination. That type of action story would not have been communicated as effectively with stills.

Combining Stills and Video

Many projects mix video and stills. In the *Detroit Free Press*'s story about the American car industry, "Rising from the Wreckage," still images help convey history and video provides the medium for current interviews.

Brian Storm, founder of MediaStorm, believes video is best when action is involved and still photography is best for capturing decisive moments.

► **Candid Moment.** Jim Enderle of the *U.S.S. Wasp* is embraced by his wife Cindy and their two sons, Jeffrey, 6, and Lorenzo, 4, at the U.S. Navy Memorial Foundation Homecoming Statue dedication ceremony at Town Point Park in Norfolk, Virginia. (Roger Richards, *Washington Times*)

HOW TO SHOOT STILLS FOR MULTIMEDIA

Still photographers shooting for print are like hawks stalking their prey. One moment. One instant. One press of the shutter and they have swooped in for the capture—a prize-winning photo caught on a CF card.

Shooting stills for a multimedia project does require the eye of a hawk, but one must also develop the ear of a deer to be able to hear and record the perfect sound or quote. Moreover, we need the patience and industry of a beaver to build a complete project that is sure to hold the viewer's attention.

One Picture is Never Enough

Through multiple pictures and audio, the multimedia shooter needs to present events both before and after the peak action so that the viewer can grasp the storyline and make out the significance of the images.

Although storytelling approaches are often said to be universal, the difference between shooting still images for a print layout and still images for multimedia is not unlike the difference between writing 17-syllable haiku and writing a 500-page novel. Both forms use words, but novels and multimedia use a lot more of them. Rather than photographing one decisive moment, you must capture the telling sequence, which always consists of a series of photos. Kim Komenich, a professor at San Jose State University and award-winning former photojournalist, calls this approach the search for the "decisive sequence."

An average magazine story in *Esquire* or *Rolling Stone* might use six images. A multimedia piece—even a three-minute report—needs forty to sixty or more different images to engage a viewer enough to maintain attention on the pretimed piece. Forty to sixty photos is a lot of pictures.

Simply adding more pictures from a routine assignment can prove to be a photographer's trap. David Leeson, a photojournalist whose still images have helped win Pulitzer Prizes for *The Dallas Morning News*, says, "It's challenging enough to get ten or twelve great storytelling images for a typical print assignment." He claims that the other twenty-eight or more stills in most multimedia presentations tend to be weak. "Those are the images that would have wound up in File 13—the trash can."

Gary Reyes of the *San Jose Mercury News* says that his shooting style changes radically when he is producing a multimedia piece. The newspaper might use only one or two images, but Reyes says he needs about eighteen images—five seconds per image—to complete a one-and-half minute multimedia story. "You don't want to have to throw in one or two crappy images just to fill out the slideshow. Every frame becomes more important," he says.

Shoot Sequences Like a Videographer

Videographers covering a story will shoot a series of shots—wide, medium, close-up, reaction, and point-of-view—that they later will edit and combine into a smooth sequence of images that combines into a cohesive series—the building blocks of a complete story. (For a complete description of shooting the sequence, see Chapter 10, "Shooting a Sequence.")

When shooting stills for multimedia, look for the following:

- **Wide shot of the scene (WS).** Either use a wide-angle lens or back up to shoot an establishing shot of every scene. Try to find a high angle from which you can take the overall shot.
- **Medium shot (MS).** Come in as close as you can but not so close that you can't capture action as it unfolds.
- **Close-up (CU).** Record individual detail shots of relevant objects such as hands and faces that move along the storyline. Viewer delight lives in those details.
- **Reaction shot of observers (RS).** How do the people nearby or an audience respond to your subject's personality, jokes, songs, discussions, or lectures?
- **Point-of-view (POV).** Let the viewer see the scene through the eyes of the primary character. Show what the character is looking at and, if possible, shoot it from the person's eye level.

Stills that Add to the Story

Multimedia pieces require unique types of photos not found in typical print stories:

- **Watch for transitions to introduce and end sequences.** Subjects taking a bus/car/subway to arrive and to leave a place and images of the outside of a building to establish where the action will take place are examples of necessary transition photos.

▲ **The Lifeline.** Having followed a severely wounded soldier home from Iraq, the videojournalist ended the piece by showing the young man's resumption of life, albeit a new one without legs. (Rick Loomis, photographer, *Los Angeles Times*)

Shoot continuously. Fire rapidly using the "continuous" camera setting to capture a sustained series of images as your subject jumps, runs, walks, or talks. A series of quick shots, sometimes referred to as a flip-book or animated technique, can help simulate the illusion of real motion in your multimedia piece. When shot and played back fast enough, the resulting images can approach the natural movement captured by a video camera. Photojournalist Ed Kashi employed the technique to dramatic advantage in showing life in "Iraqi Kurdistan."

Build up to an event. Arrive before the action starts and record the preparation.

Capture the closure. Photograph the end of an event, right down to the last guest leaving and the deflated balloons sagging to the ballroom floor. For a story rather than an event, look for a situation that seems to bring the piece to a close.

Copy photos from a photo album, refrigerator, or wall. These kinds of snapshots or random photos can help provide graphic visual history that will coincide with the stories your characters reveal about their past.

Take portraits of every significant person whose voice is in the story or who is referred to in dialog or an interview. Use clean, simple, backgrounds. Take many portraits. Photograph subjects while talking and while silent. The audience always wants to see the person who is speaking or being referred to.

▲ **Portraits are a Must.** You will need portraits of everyone you interview for the multimedia piece. (Photo by Ken Kobré)

Change focus to change emphasis. Switch focus. Start with the foreground sharp in one frame. Then switch focus so that the background is sharp in the following frame. This approach is excellent for redirecting viewers' attention from one person or place to another.

Frame horizontally. When possible, images for multimedia should be framed horizontally. Multimedia players on websites are in the shape of a horizontal box. Vertical pictures will work, but they will be smaller than if they were horizontals, have a black band on either side, and generally look out of place in multimedia pieces.

Compose the image including some extra space on the edges of the frame that extend beyond the key subject. This wider composition is particularly important if you are not sure how the images will be used in the final presentation. Some projects require 4×3 proportions (the shape of the traditional television screen); others require a 9×16 HD format.

▶ **Focus Pull (Rack Focus).** Using the technique of focus pull, also called rack focus, you can shift the point of focus from near to far while keeping the camera's aperture open to its widest setting, and cause the viewer to pay attention to different parts of the picture. (Photo by Ken Kobré)

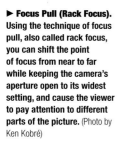

HOW TO RECORD AUDIO FOR MULTIMEDIA
The Challenges of a Circus Performer

Merely trying to hold a weighty single-lens reflex camera and manage all its buttons, dials, and adjustable rings while you are trying to set, activate, and point an audio recorder's microphone can challenge the most agile and experienced professional. At first, it's a bit like simultaneously patting your head and rubbing your stomach. When you've finally got the knack, you will feel like a circus performer spinning ten plates in the air at the same time.

Some practitioners say, however, that though challenging and risky, documenting people in action on camera while recording their voice at the same time is not only possible, but can even produce riveting dialog.

One downside of simultaneous shooting and recording is that the sound of a still camera's shutter can be annoying on an audio track. To avoid the clicking sound completely, just stop shooting when a subject is pouring out his or her heart. You can tactfully begin again during pauses.

Some pros recommend that when taking stills, concentrate on stills. When recording

▲ **Interviewing** with an audio recorder and separate mic often requires using both hands. Does this storyteller know whether the speaker's voice is being properly recorded? (Photo by Betsy Brill)

audio, focus on that. Once you commit to putting down one piece of equipment and picking up the other, live with that decision. This approach ensures that you are using the right tool for the right job at the right moment.

Which Comes First, Picture or Sound?

"Which should I work on first, pictures or sound?" muses Nat Meyer of the *San Jose Mercury News*. "That depends. If there's sound that I think might be gone in a few minutes, I'll probably break out my MiniDisc and start recording. If the light is perfect but fading, I'll most likely make pictures first."

Meyer is of the school of multimedia producers that accepts the fact that you simply will miss some great sound when you shoot pictures, and you are bound to miss some pictures when you record sound. "For interviews, you can either choose to ask questions before or after the event you're photographing," he says. "I've done both. The majority of the time I get to an assignment, then talk with a subject for several minutes before shooting a frame. So why not take live audio during those few minutes? Later on, it will also be beneficial to re-interview the person. Once you know what you've photographed, you should have a general idea of how you are going to sculpt the slide show. Thus you can ask questions which relate to your vision."

Brian Storm of MediaStorm is a kindred spirit to Meyer. "I've tried shooting and collecting sound at the same time," says Storm. "It doesn't work for me very well. Getting good sound takes just as much skill, energy, and focus as getting good pictures; it's tough to do both things at the same time"

Headphones Are a Must

Wear headphones while recording audio with any device—and in any situation. With headphones in place, you will know whether the sound of the shutter's click is truly distracting or not really noticeable. Also, only when wearing headphones can you evaluate the general sound levels of the place in which you're working. This is ultra important for static interviews as well as in active situations. In a restaurant kitchen, for example, the banging of pots can convey a sense of reality to a story. But this ambient noise may also drown out the chef's tasty advice during the interview. You won't know for sure what it all sounds like if you can't hear what is being recorded.

Recording interviews

First, put down the camera. Then:

- Find a quiet place to hold the interview.
- Hold the audio recorder in front of the subject's mouth about 3 or 4 inches away. Or, place it on a table in front of the person for a sit-down interview but keep it as close as possible to the subject's mouth. Putting the recorder on a low stand might help.
- Keep the mic just below the person's chin. If you put the mic directly in front of the subject's mouth, you will pick up popping sounds created by breaths between statements.
- Feel free to forgo an external mic when interviewing with a handheld audio recorder, as most of these deliver excellent sound.
- Wear headphones attached to the audio recorder to monitor sound levels.

▲ Hold the microphone **three or four inches** below the interviewee's mouth, just below the chin for the clearest audio recording. Keep the mic below the subject's mouth to avoid hearing annoying "pops" as the air comes out of the interviewee's mouth. And wear headphones so that you will hear what actually is being recorded. Note the use of a windscreen on the recorder to muffle the sound of wind. (Photo by Ken Kobré)

Shooting and Recording Simultaneously

Sometimes a second pair of hands can be invaluable when you are trying to record sound and images at the same time. If you are working alone on your story, is there someone around whom you might quickly train to help handle the recorder while you shoot? A family member or colleague? Or, perhaps, a bystander in a crowd?

Velcro. One photographer suggests gluing a piece of Velcro® to the audio recorder, then wrapping a band made from the facing piece of Velcro around your wrist. With the recorder attached to your wrist, both hands will remain free to operate the camera. The downside to this clever idea is the proximity of the camera to the microphone. The sound of the shutter clicking is likely to prove annoying in this case. No matter what, always use headphones attached to the audio recorder to monitor the sound.

Voice-activated audio recorder. Place the recorder, camouflaged from view, in your subject's shirt pocket. Turn the recorder on and just let it run. Use either the built-in mic or a lavalier ("lav") mic. If there is any "dead sound" as a result of using this technique, you can remove it when editing. The downside to this approach is that because the recorder is on the body of the subject, you can't wear attached headphones for monitoring sound quality.

Wireless lavalier. To produce the most professional audio results, place a wireless lavalier mic and transmitter on your subject. You will wear the wireless receiver, the audio recorder, and headphones attached to the recorder. This setup will free the person to move about unencumbered by wires—and free you to concentrate on pictures instead of chasing around with a microphone in one hand and your camera in the other. Because a wireless mic is on the subject and not on your camera, it will lessen (though won't altogether eliminate) the clicking sound from your still camera's shutter. A wireless mic also allows backing away with a telephoto lens. This arrangement will increase the distance between subject and camera and decrease the loudness of the shutter's click picked up by the wireless mic.

STORYTELLING WITH AUDIO

Most multimedia reports break down into the following styles of audio: a report with only natural sound, a report with a voice-over correspondent, and a report narrated by the person who also created the visual images.

A Report with Only Natural Sound

▲ **Playing Italy's Finest Violins.** A pure audio report with only natural sound is rare but possible. Shooting for the *New York Times*, David Yoder photographed a story called "Playing Italy's Finest Violins." The piece showcases a master violinist who plays historic instruments to keep them in shape. The only sound for the entire piece is the music played by the violinist. Produced by Joshua Brustein, the report also included captions and an accompanying written article by reporter Ian Fisher. (Photos by Dave Yoder, *New York Times*)

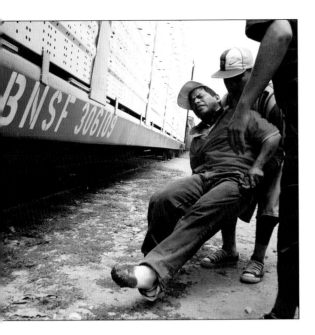

A Report with a Voice-Over Correspondent

The voice-over correspondent is usually the reporter accompanying a photographer. In the *Palm Beach Post*'s effective multimedia piece "Train Jumpers," writer Christine Evans' voice-over, backed by natural sound, provides facts and conveys heart-rending individual stories that further bring to life Gary Coronado's powerful, award-winning images. The project successfully documents the dangerous, desperate journey of Central American immigrants to *la tierra prometida*—the promised land of the United States and the jobs it represents. Coronado rode the rails himself for months to document the treacherous quest for a better life. The reporting/photography package not only captures the perilous journey but also introduces groups trying to help the desperate immigrants who are wounded or mutilated along the way.

A Report Narrated by the Image Maker

Perhaps the most gut-wrenching example of a photographer narrating his own piece is called "The Reach of War: A Deadly Search for Missing Soldiers." While *New York Times* photographer Michael Kamber was accompanying a platoon of soldiers on patrol in Iraq, one soldier was killed and others wounded. Kamber's photographs and eyewitness account bring the viewer directly into the harrowing experience. Kamber's voice-over explains the story and also provides incredible tension and depth. Kamber not only notes what happened when the soldier was injured but also observes what did not happen. "No screaming, never rushed," he says of the medic, who stays calm through the ordeal. This kind of personal observation, something a still photograph cannot capture, is priceless in a dramatic story like this.

◄ **Train Jumping: A Desperate Journey.** The photos and story document the attempts of Central American immigrants to jump a train to the United States to find jobs. The writer provided the voice-over. (Photo by Gary Coronado, *Palm Beach Post*)

EDITING MULTIMEDIA

Along with transitional images, you want to be thinking about visual variety in much the same way you would for a picture page or for a video sequence (more on that later). The edit needs wide, medium, and close-up shots in order to establish the scene, introduce the character, and show the action or conflict.

Image Pacing

In multimedia, good pacing is a delicate achievement. Viewers accustomed to fresh televised images flashing on a screen every few seconds tend to expect the same when watching a multimedia piece. Of course, you cannot regularly achieve a 30-fps image bombardment using stills, but you do not want to bore viewers either. Leaving images on the screen for too long is likely to send them clicking away to another story on the Internet. Conversely, viewers will not have sufficient time to absorb each image if it passes through too quickly. Assess the readability of the image when considering length of time on screen. A complex image with layers and emotion may need a few seconds longer on the screen than a simple image that features only one detail of the scene. As a rule, pictures in a multimedia piece should be on screen for five to eight seconds. A picture on the screen for more than eight seconds will seem to an audience as if it's been hanging there for an eternity.

When viewing Gary Coronado's "Train Jumpers" online, watch for the effective pacing of images during a series in which a young man races for a rapidly passing train and misses.

▼ **The Reach of War: A Deadly Search for Missing Soldiers.** The photographer not only shot the pictures but also wrote and recorded his own voice-over narrative. (Photos and story by Michael Kamber, *New York Times*)

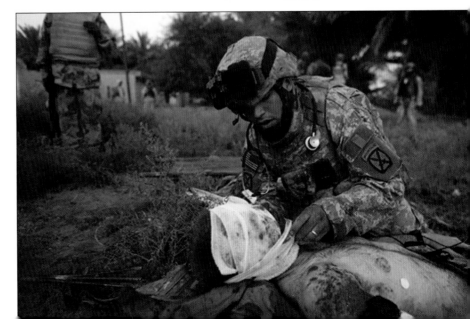

When Images, Sound, and Text Compete

Although many multimedia reports include images, sound, and text, do not assume that viewers will read captions while looking at pictures and listening to audio. Despite all the hype we hear today about multitasking, scientists have proven that the human mind can do only one thing at a time. The brain can move quickly between activities, but it jumps linearly. You might say that the mind "cannot walk and chew gum" at the same time.

Plan your presentation so that viewers can concentrate on watching and listening to your multimedia piece. Think about how you examine a picture layout in a newspaper, magazine, or book. You cannot possibly read the captions at the same moment you are looking at the pictures. In fact, you may look at all the pictures before you return to the captions. Imagine adding narration or dialog to that mix. With a multimedia piece, do not expect the viewer to read slide captions while also listening to the sound and studying the image all at the same time.

Transitions for Multimedia

A transition photo works to bridge concepts and thoughts cohesively.

Each picture should have its place and should enhance what the viewer is hearing. Be careful not to be too literal—say dog, see dog—but understand that the pictures and sound must blend together well. In the *Los Angeles Times* story "Waiting to Die," Edwin Shneidman compares his aging body to the decaying statue in his yard. With that metaphor in mind, the photographer uses a series of pictures, not only of Shneidman in various states of physical being, but of metaphoric images like two empty chairs that represent his mental state. At 90 years old, Shneidman believes he won't live to see 91, and a photograph of various timepieces, clocks, and watches on a table in his home are photographed as a still life to reinforce the hard-to-illustrate imagery of time running out. Without these transitional photos so aptly illustrating Shneidman's state of mind, the multimedia piece could have been nothing more than a series of portraits of a frail old man "waiting to die." The transitional photos were not throwaway pictures. They were an important bridge that interconnected key storytelling moments in a well-wrought multimedia piece.

Ambient sounds can also provide a transition from one section of your story to another. Sometimes you want to start the sound a few seconds before you show the image it goes with. This technique of leading with sound, called split editing, can smooth the transition from one aspect of the story to another. Usually the viewer does not even notice this sleight of hand.

Multimedia Takes Time

Your production time of a linear story will generally be much longer than producing or editing a story in still images. Keep in mind that by production time, we refer to the time spent behind the computer or with other producers—not out in the field recording and photographing. Many producers say that for every minute of final audio you will produce, plan to spend one hour, and for every final video you produce, plan to spend three.

Nancy Donaldson, a multimedia producer at the *New York Times*, says each project on which she's worked takes a different amount of time to

▲ **Waiting to Die.** This elegy-like story uses photos of the subject as well as symbolic images that represent his life.

▲ A transitional photo of these two chairs implies that two people used to sit and talk. (Photos by Liz O. Baylen, *Los Angeles Times*)

▲ **Ambush and a Comrade Lost.** U.S. troops along with Afghan National Army soldiers use night vision goggles to move in the dark to seek information about the death of their fellow soldier, Pfc. Richard A Dewater. (Photos by Tyler Hicks, produced by Nancy Donaldson, *New York Times*)

produce, and she stresses that yours will almost always take longer than you think—especially if you are a beginner. A multimedia news story covering an ambush of U.S. soldiers in Afghanistan was shot and recorded over two days by an embedded photographer. (An embedded photographer eats, sleeps, travels, and ultimately goes on missions with a company of soldiers.)

Donaldson then spent two full 10-hour days to produce the piece on deadline. That story took at least 15 hours of work in the field by a photographer and reporter and another 20 hours behind a computer to make a multimedia piece of less than 3 minutes in length. This is a pretty standard amount of time for this type of story. If you are a beginner, plan on spending at least double the time it would take an experienced producer like Nancy Donaldson.

Soundslides: Easy Editing Software

Once you have finished editing the sound, you will begin to combine it with your photos to make a multimedia piece.

Soundslides is a simple, popular software application that photojournalists use to combine sound and images to create multimedia pieces for the Internet. Since 2005, Joe Weiss's revolutionary Soundslides software has enabled hundreds of newspapers to produce multimedia pieces for their websites. For the first time, picture stories could be easily narrated—by the reporter, the photographer, the subject—and even augmented with natural sounds. Its low cost and simplicity of use have made Soundslides the preferred product of its genre. The website slogan for Soundslides is "Ridiculously simple storytelling," and it is precisely that.

The Soundslides program basically digests JPEG photos and sound files and outputs them

as a Flash animation file ready to display on the Internet.

First, you might edit your audio track using a separate program like Garage Band or Audacity, Sound Forge, or Sound Studio. Next, upload that audio file into Soundslides as an MP3 file. Then upload a selection of still photographs in the order in which you want them to appear. In the Soundslides program, you can rearrange the photos later if you need to tell your story differently. The length of the audio track determines the final story's length. Each picture is shown in equal amounts of time as divided by the number of uploaded photographs. A 60-second audio file and 10 photos, for example, result in 6 seconds per photo. You can still manually adjust the duration of each photo's onscreen time, but the total length of the piece will remain constant based on the 60-second audio file. Soundslides also allows adding panning and zooming movements to the pictures. Check the Web for reviews of various sound editing software packages.

The downside of using Soundslides to produce your multimedia piece is that any change to the audio requires returning to the audio software, making the changes there, and then reimporting it into Soundslides. Then you must reimport the images, and finally, you must reset the pacing of the still pictures. For instance, if you have edited and imported an interview along with some still pictures and then realize you would like to add music, you have to start all over: add the music to the audio track, reimport the new track and the old pictures into Soundslides and rearrange the pictures and the duration of time they show. (Altering the audio track is likely to result in it being a different length, which means Soundslides will have to redivide the photos to match the new length.)

Alternatives to Soundslides for preparing multimedia presentations include Apple's Final Cut or Adobe Premiere. Soundslides is easy to learn and quick to use, but Final Cut and Premiere make it easier to edit the audio and pictures simultaneously. They also offer more control over the final piece.

For those who use a PC, Microsoft's Photo Story 3 is a free alternative to Soundslides. Photo Story 3 allows smoothly combining images and sound.

You also might want to check out some of WordPress's slide show plug-ins. They come in all flavors and work seamlessly if your website uses WordPress.

▲ **Soundslides** is software used to combine audio with still images.

► **Get closer.** This was the advice of legendary war photographer Robert Capa: "If your pictures aren't good enough, you're not close enough." Often, the key to photographic pizzazz is to move in and capture details, leaving out extraneous background. (Photo by Pete Erickson)

► **Frame precisely.** A corollary to "get closer" is to "frame precisely." Framing carefully while coming in close can eliminate parts of a distracting background while still leaving enough of it to provide a sense of place. (Photo by Juan Gomez)

► **Be patient.** Before starting to shoot, let people get used to you. As they relax, they start to forget the camera is there and go back to work at whatever they were doing before you showed up. You can catch candid shots this **way.** (Photo by Ken Kobré)

◄ Throw the background out of focus by using a wide aperture (f/2.2 in this example) so that the busy background won't distract from main subject. (From the project **21st Century Communism**.) (Photo by Tomas van Houtryve)

◄ **Think "variety."** Be imaginative. Take shots from different angles, locations, and distances. In any situation, look for a good subject/object for a close-up, then back off a little for a medium shot, and finally, get high and wide for an overall shot. (Photo by Shmuel Thaler, *Santa Cruz Sentinel*)

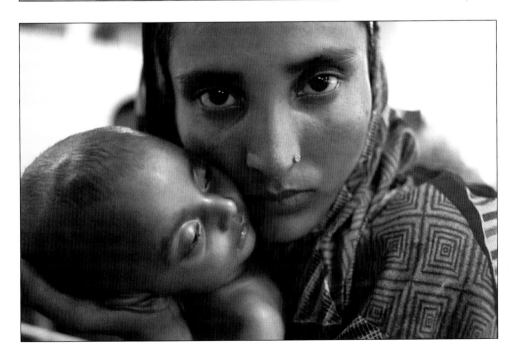

◄ **Use natural light.** Don't use direct flash if you can avoid it. It looks forced and washes out colors and facial features. Instead, adjust your ISO to 800, 1600, or higher. One of these ISO settings will result in sharp indoor photos without flash. (Photo by Ken Kobré)

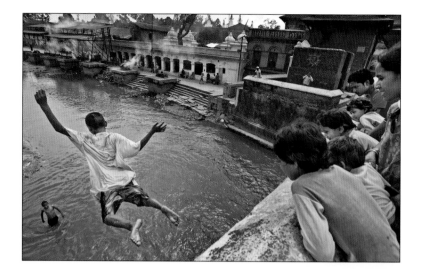

► **Don't ask people to act or pose for you.** Instead, capture them in the middle of an activity so the photo tells us something about their personalities, situation or interests. (Photo by Jana Asenbrennerova)

► **Use flash sparingly. Bounce the light if possible.** An external flash can be pointed to the ceiling or wall to redirect, broaden, and soften the light. If you're using the camera's pop-up flash, consider instead sliding on the Lightscoop®, a mirrored device that will redirect and bounce light from the camera's pop-up flash. (Photo by Sherri LeAnn)

► **Shoot at dusk or at night.** These times of day offer interesting shadows and light. Street lamps or even holiday lights—if they're bright enough—can provide atmosphere. In low light, put the camera on a tripod to allow longer exposures. (Photo by Pete Erickson)

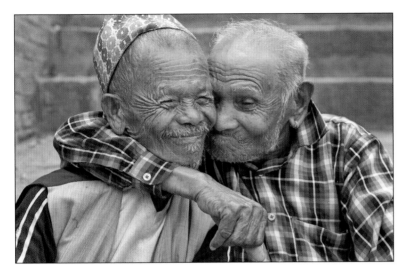

◄ **Avoid posing portraits.**
People are only human.
Asking someone to stand
or sit straight up results in
uncomfortable-looking, tense
postures that say nothing
about the person. When tak-
ing portraits, a little leaning
or slouching is desirable.
(Photo by Jana Asenbrennerova)

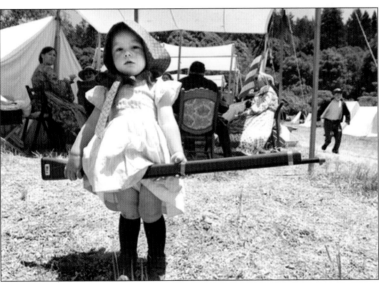

◄ **Change your perspective.**
If you're photographing
young children, for example,
try getting down to their
level. Witnessing the world
from their perspective will
add a refreshing point of
view to your pictures. Notice
how adults, no matter their
size, appear gargantuan from
a child's perspective. (Photo
by Shmuel Thaler, *Santa Cruz
Sentinel*)

REMINDERS

- **Study your camera's manual.** You really do need to learn how to adjust your own camera. Learn about its available functions and locate all buttons, dials, and menu items so that you won't become befuddled on an assignment.
- **Shoot twice as much as you're used to shooting.** Don't skimp. One difference between an amateur and a professional is that the professional shoots a huge quantity of pictures from a variety of angles, distances, and heights, and then discards all the weak, out-of-focus, poorly composed images, and saves only the best.
- **Improve your skills.** If you're looking for a good general book about photography for beginners, try *Photography,* Barbara London, Jim Stone and John Upton (Prentice Hall). If you've got the basics down, go to the next level with *Photojournalism: The Professionals' Approach,* Kenneth Kobré (Focal Press/ Elsevier). ■

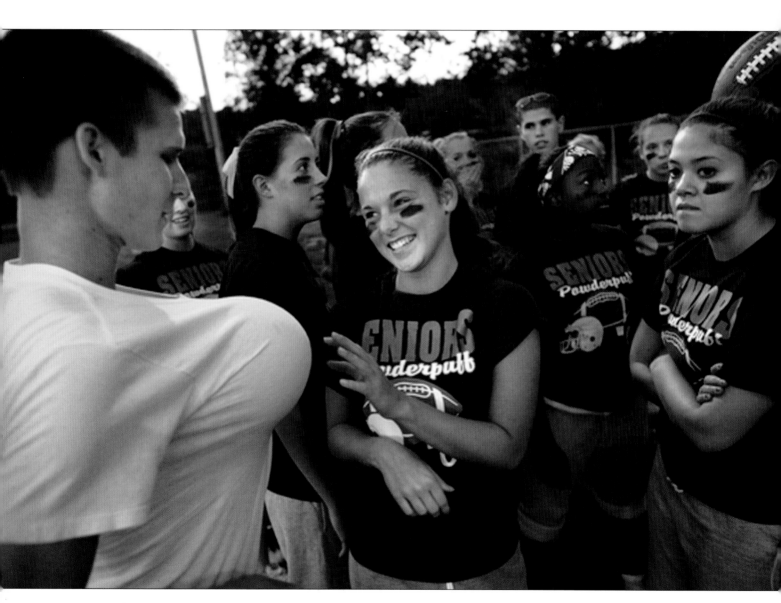

▲ **Powderpuff Cheers. Keep the camera rolling so you won't miss funny moments like this one at a powderpuff football game.** (Photo by Josh Meltzer, *Roanoke Times*)

Shooting a Sequence

Videos and multimedia projects are assembled from individual shots, and those shots are collected into sequences and scenes. Then, the scenes are stitched together in the editing process to form a seamless whole.

Think of writing an essay: you put words together into sentences, then string the sentences into paragraphs, and then assemble the paragraphs into sections. Once you have your sections in order and they read coherently, you have your essay! A similar process is at work in video and multimedia.

This symbol indicates when to go to the *Videojournalism* website for either links to more information or to a story cited in the text. Each reference will be listed according to chapter and page number. Links to stories will include their titles and, when available, images corresponding to those in the book. Bookmark the following URL, and you're all set to go: http://www.kobreguide.com/content/videojournalism.

THE FIVE-SHOT FORMULA

"One shot is never enough," warns Rolf Behrens, a veteran freelance video shooter from South Africa. For Rolf, just one shot of an incident will not produce enough footage to edit. And each shot must run for a minimum of 10 seconds. For a usable sequence, multiple shots of each scene are a must. Memorize this mantra—"one shot is never enough"—and your footage will be more professional right from the start.

When you watch documentaries or go to a movie, observe that they consist of a series of individual shots stitched together into a story that holds your attention. Though you can identify a wide range of different camera placements, zooms, dollies, and pans, most documentaries—and even fictional films—are built with five basic camera shots:

- Wide shot (WS)
- Medium shot (MS)
- Close-up shot (CU)
- Point-of-view shot (POV)
- Reaction shot (RS)

These five shots are your "bread-and-butter" coverage.

Recording the five basic shots for every situation may sound tedious. It is sometimes even impossible . . . and doing so surely will produce more footage than will ever make it to the final documentary. But just as the goods in a pantry don't make a meal until the proper ingredients are mixed in a recipe, all those shots seem unrelated only until it's time for the final edit. Like a chef who doesn't use every ingredient in a pantry, you may not need every single shot in order to blend a satisfying story. But although the chef can run to the store to pick up a missing spice, there's no going back for the essential footage you may have overlooked. The five basic shots for each situation may seem like overkill, but if you have shot them all, you will see that they provide all the necessary ingredients for cooking up a visually rich story.

Ideally, shoot all of the five basic shots for each different scene of the video. You read that right—at least one of each basic shot for each scene.

PUTTING THE SHOTS TOGETHER TO BUILD A SEQUENCE

Let's think about telling the story of the members of a local climbing club and their activities off as well as on the mountain.

You obviously need footage of the climbers preparing for, ascending and subsequently descending a mountain; you should also include how the club members put their sport to good use in order to actively support their local community. A public demonstration that includes teaching local children how to rappel down a town's ancient five-story clock tower offers the ideal opportunity to capture not only this exciting event but also the members' commitment to the townspeople. Over the course of the day, each willing child will trot up to the roof, be harnessed, and then will descend from the top of the tower to the ground.

You could shoot this whole event by standing back and recording one child descending the clock tower from start to finish. Most amateurs would press the button to "start" when the child appears at the top of the tower and press it again to "stop" once the child touches the pavement below.

The descent might take five minutes. Unless you are closely related to the youngster, can you imagine watching all five minutes?

A professional handles the same situation by recording at least 10 seconds of each step in the **series** with a number of **different** kinds of shots. Edited together, the shots will form one sequence in the larger story. The edited sequence will last a much shorter time than five minutes.

This series of images that you will use to build into a sequence when editing the piece includes **wide**, **medium**, **close-up**, **close-up detail**, **reaction**, and **point-of-view** as well as **low-** and **high-angle** shots. When edited together, a sequence holds far more visual interest than does an uninterrupted five-minute clip taken from a static camera positioned in one location.

Five minutes of real-time footage from a static camera position is almost unwatchable. With a well-edited series of short shots, however, the same five-minute event can be quite thrillingly revealed to the viewer in less than 20 seconds. The viewer has no trouble accepting that time has been compressed. Knowing where to place each scene is the very nature of visual storytelling. As you cut from one shot to another in a sequence, you are urging the viewer to suspend disbelief and allow emotions to do the watching.

Note that the little story told in the rappelling sequence is but one part of the greater story about the climbing club and its members. The boy being helped out of his harness is the end of the sequence, not the end of the story.

1 From the ground take a **low-angle wide shot**, also called an establishing shot, to show the top of the tower. Looking straight up, this shot gives a sense of distance from the ground. An additional wide shot could have been taken from farther away to show the height of the building.

2 Now, head up the stairs for a **medium shot** of the child being helped into his climbing harness.

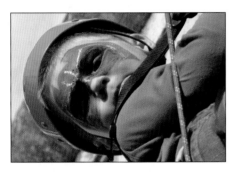

3 From a lower tower window, shoot up for a **close-up** of the child's face and his reaction to what he can see below.

4 Now shoot down to show what the child sees—the boy's **point of view**.

5 Head to the ground and from a **low angle** shoot up as the youngster and his coach slowly descend.

6 Try a medium **close-up** of the belayer as he handles the safety ropes for the pair.

7 Look for a **close-up** detail (often called a **cutaway**) such as the ropes lying on the ground. During editing, you will use this shot to take the viewer away from the action for a second.

8 Aim up at the youngster and his mentor and shoot from a **low angle**.

9 Here's a **high-angle medium shot** you would have taken while still on the tower, placed here to demonstrate that in the final edit, you will be able to include the anxious parents looking up at their son as he gradually progresses downward.

10 Back off a few feet to take a **wide shot** of the youngster when he's finally soloing toward the ground.

11 Capture in a **medium shot** where the future mountaineer is being guided to the ground with the help of his sister and the rope handler on the ground.

12 End the sequence with a **medium shot** of the boy being helped out of his harness.

The more individual shots a sequence contains, the more visually exciting the reportage. Television ads, which are most absorbing and excruciatingly expensive on a per-second basis, sometimes contain more than 100 separate shots for a brief 30-second spot.

TIP For ease of editing later, every shot should be recorded for a minimum of 10 seconds. Of course, the shots can be longer. But anything shorter than the minimum 10 seconds will be almost impossible to trim during the editing process.

STRATEGIES FOR NAILING THE BASIC FIVE

▼ The ship *M/Y Steve Irwin* is dwarfed by an iceberg as it sails Antarctica's Southern Ocean. (Photo by Adam Lau)

Here are some strategies to make sure you capture all the shots required to produce a great video or multimedia piece.

Wide Shot Shows a Location

The term wide shot is also referred to as the long shot or establishing shot. Don't worry about the precise name. Just concentrate on the reason for shooting it and don't come home without it.

"For a good wide shot, you shouldn't have to tilt the camera to see everything," warns Steve Sweitzer, former news operations manager of WISH TV, Indianapolis, and adjunct professor at Indiana University–Purdue University Indianapolis.

Observers present at any event move their eyes from side to side to take in the entire scene. The wide shot allows viewers to orient themselves to a scene. Without a wide shot, viewers' brains cannot very easily evaluate the others. They don't know where they are or what they are supposed to be seeing.

To establish location for each sequence or the entire story itself, video shooters typically use a wide shot. The overall result shows where the story is taking place: inside, outside, country, city, land, sea, day, night, and so on. This shot defines the relative position of the participants. In a confrontation, for example, an overhead wide angle shot would show whether the demonstrators and police were a block apart or across the street from one another. The overall shot also allows viewers to judge crowd size and evaluate the magnitude of an event.

As part of every sequence, the wide shot shows the location of the unfolding action. For some stories, a wide shot might include only an overall view of a room. For others, it might encompass a city block, a neighborhood, or even a whole town. The scope of the shot depends on the size of the scene and its eventual use in the story.

To photograph an overall of a room, you'll want to find a ladder, get up on a chair, or—if nothing else is available—stand on a table or a desk. Anyway, it's always advisable to bring your own ladder. It's difficult to know ahead of time what you might or might not be allowed to stand on. So come prepared.

Your ladder may come in handy outside unless you can find a telephone pole, a leaf-less tree, or a nearby building that will give you the height necessary for an effective wide shot.

When caught in a flat area, even the roof of your car will add some height to your view.

The wider the angle on your zoom lens, the less distance from the scene you will need to be. Your simplest option may be to set the lens on wide angle and hold the camera high above your head with the LCD screen tilted down. This position of the camera itself will give you some height, while you will still be viewing what you're photographing with the monitor. However, for a major story that encompasses a vast area, such as a flood, hurricane, or conflagration, try getting a ride in or—if it's important enough—renting a helicopter or small airplane to capture the magnitude of the destruction.

Medium Shot Shows the Action

The job of the medium shot is to carry the bulk of the story. Frame the shot close enough to see the participants' action, yet far enough away to show their relationship to one another and to their environment. The medium shot contains all the storytelling elements of a scene. Like a news story lead, the MS footage must tell the whole story quickly.

Medium shots allow viewers to follow the action and observe body language but still observe peoples' faces. You will need to shoot many medium shots because most videos usually contain more medium shots than any other kind.

▲ **A ladder** comes in handy when you need to shoot from a high angle. (Photo by Ken Kobré)

▼ The medium shot of this food giveaway in Jerusalem shows the action. It is wide enough to show the physical setting in which the action is taking place, yet close enough to see facial expressions.

A medium shot gains dramatic impact when it captures action. Action often happens quickly and leaves the shooter little time to prepare. Shooting action is like shooting sports. For both, you must anticipate when and where the action will take place. If a man engages in a heated argument with a police officer, you might predict that an arrest will follow. Aim the video camera when the argument starts and don't stop shooting until the confrontation has ended—peaceably or not.

Whenever possible, start shooting before the action begins and let the camera roll. Don't interrupt. You can always edit out the dull moments later. If you hesitate to shoot, waiting for just the right moment, the quarrel might end while you're still fiddling with the equipment. In addition to starting to shoot before the action begins, you must anticipate where the action is going next and position the camera there in time to record the next segment of the conflict.

"Let the camera observe the action," says John Hewitt, Emeritus Professor of Broadcast at San Francisco State University. Set up the shot and wait for the action. "Keep the camera still and let the characters' action take place within the frame." Sometimes the action will end in a few seconds; other times, you will need to keep rolling for minutes.

Don't distract your audience by constantly readjusting the composition and lens focal length as you record the scene. Relax. Let the action roll out. Follow the action if it moves. Have patience. Something will happen. Remember to let each shot tell a tiny story before hitting the pause button.

Of course, if the action is repetitive, you will need to move around with your camera in order to capture different angles. Editing together the shots taken from different angles of a repetitive action will help add zest to the final footage.

For the medium shot, a wide-angle lens setting works well if you can stay in close to your subjects. Many videographers shoot almost everything with the lens set to wide angle. They move away or come in close but keep the camera's zoom lens on its widest focal-length setting. Shooting close in with a wide angle provides intimacy by bringing viewers into the middle of the action. Shooting the same scene on a telephoto setting—even framed in the same way—requires standing much farther away and leaves viewers feeling as if they are peeking into a private moment as an outside observer.

Of course, when covering a dangerous situation or one in which your own movement is severely restricted, the telephoto setting still captures a fine medium shot, even though it will not net the same intimacy.

Close-Up Adds Drama

Nothing beats a close-up for drama. The close-up slams the viewer into eyeball-to-eyeball contact with the subject. At this intimate distance, a subject's face, whether contorted in pain or beaming happily, elicits viewer reaction.

A close-up is like an intimate portrait. The video camera can catapult the viewer to within inches of a stranger's face. This type of shot eliminates the normal space barriers most people maintain during a routine conversation. According to Michael Wohl in "The Language of Film," this is one reason fans often feel they actually "know" famous actors. (Though the feeling is certainly not mutual!)

When shooting close-ups, avoid the wide-angle setting on your lens. At a close distance, the wide-angle perspective causes objects in the center of the picture to be unnaturally enlarged.

▶ In a Congolese church on Easter Sunday, the close-up image of a choir member singing pulls in the viewer.
(Photo by Ken Kobré)

People's noses look out of proportion. It's quite unflattering (see Chapter 5, "Camera Basics"). The medium-to-telephoto setting is best for photographing faces close up.

"Although most stories only contain a few wide shots, there should be lots of tight shots. I've seen some great stories that were primarily close-up shots," says Steve Sweitzer, a seasoned professional who has been shooting and editing video news for 30 years.

The close-up detail shot, sometimes called a **cutaway**, is used during editing to shift viewers' attention from the flow of the action. The best cutaways are the ones that have some logic to them and relate to the scene.

Close-up detail shots also play a big role when being viewed on the small screen of an iPod, smart phone, or tablet. Although objects in a wide shot are likely to be lost, a close-up detail shot practically rises and says hello from a tiny screen.

Watch for telling close-up details—like a trumpeter's lips or a card dealer's hands—which will add relevant, visual variety to the story. In a piece for *Time* magazine, "The Lord's Resistance Army Hunts Children in Sudan," Ed Robbins came in close when a young escapee showed the actual wound resulting from being stabbed with a bayonet. The close-up of the boy's awful injury drives home the rogue army's brutality.

Cutaways are crucial for editing. Cutaways will bridge together shots in the edited piece. A cutaway draws visual attention from the action for a few seconds so that directional movement

in one shot, for example, doesn't conflict with any action that follows (see "Obey the 180-Degree Rule," described shortly).

◄ **Close-up detail** of grapes **in the early morning.** (Photo by Ken Kobré)

TIP A close-up of a detail alone is useless. The close-up detail shot needs context—where it is located, who is involved. If you have shot a close-up detail of an object in someone's hands, your story also needs a shot showing the person. The close-up shot is just one of the five basic shots needed for each situation you are photographing.

Point-of-View Shot

A **point-of-view shot** captures what a subject sees by putting the camera in almost the same position as the subject. In a hypothetical shooting situation, your first shot may show a side view of an artist dabbing oils on a canvas. The next shot then could show how the canvas appears to the painter's eye—from his or her "point of view".

▼ This point-of-view shot shows what the boat captain sees as he guides his canoe down the Congo River in the Democratic Republic of the **Congo.** (Photo by Ken Kobré)

▲ **Action.** The first shot shows a man pretending to drive a motorcycle. (Photo by Ken Kobré)

▲ **Reaction.** The second shot shows the reaction of his hypothetical rider. (Photo by Ken Kobré)

Reaction Shot

When someone says or does something exceptional, shocking, or funny, the viewer wants to see how others respond. The reaction shot is often (but not always) a close-up of someone reacting to a comment or action. This shot helps define the effect of the shot that came just before it. In the pair of images on this page, a man pretends to drive an imaginary motorcycle. The **reaction shot** shows his partner laughing. The woman's tickled reaction is almost contagious.

"I often refer to these shots as 'Action' and 'Re-action,'" says John Goheen, of Terranova Pictures. "For every action there is going to be a re-action. The action part is usually pretty easy to identify, while identifying the re-action can take more effort, especially for the inexperienced eye."

In a Hollywood movie, the camera captures the action and reaction of a conversation by cutting back and forth between two people as they talk. If a man and a woman are arguing, the camera might focus on the woman as she waves her hands or sticks her index finger in the man's chest to make her point. Then the camera might cut to the man as he winces, sticks out his tongue, or otherwise reacts to her vituperations.

For any situation with an audience, always shoot a number of reaction shots. In pure visuals, the reaction shot shows the impact of what they are watching. If the story is about a performer, the reaction shot might capture whether the crowd is wide-eyed in amazement, teary-eyed in sympathy, or just slumped in their seats looking bored.

Framing. When shooting people, be sure to frame the shot so the characters have "looking room." If looking to the left, your character should be positioned on the right side of the

▶ **Framing.** Videographers make use of foreground treatment, such as in this shot in a sewing school. The use of a foreground object can add another dimension to a two-dimensional medium. (Photo by Ken Kobré)

screen. Usually, when shooting a person or an animal moving across the screen, try to lead the action. If something is moving right to left across the screen, you want to keep the moving body on the right side of the screen with extra space on the left of the screen. The person or animal now has room to "move" into the picture frame. If a dog is meandering from right to left, pan the camera with the dog so it always has some "running room" on the left, ahead of him.

Alternatively, you might want to keep the camera stationary and let the dog enter and leave the frame. When a subject enters or leaves the frame, the clip might be invaluable during editing.

▲ **Eye direction.** Usually try to compose the shot so the subject is looking into rather than out of the frame. (Photo by Ken Kobré)

FIVE-SHOT FORMULA

	TYPE OF SHOT	LENS SETTING	ADVANTAGE	TECHNIQUE
	Wide **WS**	Wide angle	Shows where the action takes place	Chair, ladder, building, monopod
	Medium **MS**	Normal	Moves the story forward	
	Close-up **CU**	Telephoto	Telling details	Move in close
			Face	Use telephoto setting
		Macro or close-up setting	Objects	
	Point of view **PoV**	All lengths	What the subject is watching	Place yourself behind subject
	Reaction **RS**	All lengths	Shows the effect of the speaker or the action	Capture the audience reaction

A-, B-, AND C-ROLL
A Bit of History:
The Origins of A-Roll and B-Roll

The terms A-roll and B-roll are leftovers from the days when television news crews used film and not videotape. As late as the 1970s, news photographers recorded images with a film camera, and audio was documented with a separate sound recorder.

A news photographer shooting film often shot only silent footage. Later, in the editing room, a soundtrack that might include an announcer's voice, music, and perhaps even sound effects were married to the silent images that had been shot in the field. Separate film rolls allowed the editor to dissolve between shots.

The **A-roll** carried the narration track, images, and sound for reporter stand-ups and interviews—all the synced sound. The silent footage containing action was called the B-roll.

▼ **B-Roll of Action.** A clip of this dramatic scene of a Japanese whaling boat bearing down on a group of an anti-whaling demonstrators in a light pontoon could be used as B-roll footage while a voice-over narration or an interview with members of the group, recorded later, could be used to clarify what is going on. (Photo by Adam Lau)

The B-roll was made up of all the pictures used to illustrate the A-roll. The two rolls were paired, and mixed during projection, and the result was called A/B-roll editing.

Filmmakers and videographers often include in B-roll footage in which visuals don't have to be synced to sound. This distinction has nothing to do with the quality of the footage.

A-Roll

A-roll typically includes all interview footage and reporting commentary. In this kind of situation, the viewer can see the person and hear what he or she is saying. Likewise, the viewer would expect to hear a correspondent's voice while seeing the reporter's mouth move in sync with the sound.

B-Roll

B-roll comes in two flavors: specific and generic.

Suppose you are working on a story about a group that is trying to stop the killing of whales. If your voice-over describes a specific incident that took place when a small group of demonstrators tried to block a Japanese whaling boat from operating near Antarctica, the B-roll would show that particular incident.

Separate A-roll interviews with the group members might describe the reason for the protest. Then, during editing, the shots of the Japanese whaling vessel bearing down on the demonstrators' inflatable pontoon boat (B-roll) could be combined with the voice-over of interviews explaining their cause. The B-roll footage of the incident would run while the demonstrators' voices tell what was happening and why. The B-roll images help to "verify" what the demonstrators describe in their A-roll interview.

Generic B-roll, on the other hand, sometimes referred to as **wallpaper**, is footage that doesn't advance the story. Wallpaper simply keeps the screen filled with images as the dialog spills out. For instance, to accompany the story on anti-whaling protests, the producer could use generic B-roll "wallpaper" file footage featuring whales swimming in some ocean, somewhere. The pictures would flow across the screen but not advance the story. The generic images of whales would not tell the viewer anything about the actions of this particular anti-whaling group.

" 'Wallpaper' is a derogatory term describing the random inclusion of unrelated video to cover timeline space," says John Hewitt, Emeritus Professor of Broadcasting at San Francisco State University. "Wallpaper shots do not comprise a sequence and often lead to confusion."

Notice how traditional six o'clock television news often reports and illustrates stories about the economy using generic B-roll "wallpaper." The correspondent will recite the employment figures, for example, while showing footage of carpenters hammering at construction sites. The pictures of construction workers nailing boards are so generic that the footage can be used whether the economy goes up or down. These "wallpaper" pictures do not serve a real journalistic purpose except to fill visual airtime. Avoid them whenever possible by shooting lots and lots of B-roll directly related to the topic you are documenting.

C-Roll

There should now be a third category called C-roll, in which the C stands for candid.

Today's video cameras record and synchronize audio and video at the same time. This setup is sometimes referred to as "SOT" or **S**ound **O**n **T**ape terminology that soon will make no sense since digital video is recorded directly to a hard drive or compact flash card instead of to tape. Yet the concept of SOT is ideal for candid shooting of active situations.

SOT is the most compelling footage you will record. Candid SOT moments are often more revealing and storytelling than a formal interview in which the main character or even a correspondent's voice-over explains a situation. Recording candid action with natural conversation conveys the sense that viewers are overhearing what subjects really say to one another while involved in an activity. In fact, they are.

CATCHING MOMENTS

As Brian Kaufman, staff videojournalist for the *Detroit Free Press* says, "Moments are really key. Most videos are built through a series of interviews, sound bites and maybe some natural sound breaks. But the best stories also capture those naturally occurring moments that happen between people."

Moments will reinforce interview sound bites and/or strengthen the narrative. In "The Boys of Christ Child," a modern orphanage on Detroit's West Side, Kaufman uses moments to enhance key points being made in the story. In an interview with Mr. Dave, one of the home's counselors, he talks about teaching the boys— many of whom suffer from severe emotional scars and developmental issues—to learn from their mistakes, work hard to do the right thing, and not be a quitter. To bolster that message, Kaufman uses a scene where Kevin, an older boy, is teaching Jalen, a younger boy, to tie his shoes.

Kevin says, "Don't ever let me hear you say that you can't do something. You can. You just don't want to. You can do anything you set your mind, heart and soul to. Now tie that shoe." The scene then cuts to a medium shot of Jalen attempting to tie his own shoe. The visual cuts back to a wide shot of Kevin actively helping Jalen tie his shoe. Then there is a cut to Mr. Dave, who says, "I think they are pretty prepared. If they're not,

▲ **The Boys of Christ Child.** An orphanage setting gave the videojournalists who worked on this story ample opportunity to shoot candid pictures. (Lead Photographer: Kathleen Galligan; Videographer and Producer: Brian Kaufman; Photographers: Regina Boone, Brian Kaufman, Romain Blanquart, *Detroit Free Press*)

they soon will be." A cut back to Jalen and Kevin in a wide shot just as Jalen looks up at Kevin and says, "I got it right?" That interaction between the boys spoke to the very essence of the message that Mr. Dave was making in his efforts as a counselor.

As important as moments are, they are not always easy to get. Capturing moments requires a great deal of patience and results in a great deal of footage. Grabbing real, unscripted moments is the very peak of videojournalism. They let viewers see and hear what is happening rather than hear a reporter telling them what they should think and feel. Only by hanging out with your subjects for hours, days, and sometimes even weeks, can you capture real moments.

If you are trying to record natural, revealing moments, it helps to be able to sense when something dramatic is likely to take place. Cultivating this sense comes with experience, but it eventually helps make your available shooting time more efficient. Using the wireless mic, smaller video or hybrid cameras and unfettered access, the modern videojournalist can record poignant, honest moments that infuse a story with soul.

This style of shooting is called observational, or sometimes *cinéma vérité*. Frederick Wiseman's documentaries are known for this approach. Wiseman shoots unstaged and unmanipulated action as he simultaneously records audio and images. He lets the camera roll as real life unravels before his lens. His films *High School*, *Hospital*, and *Welfare* allow audiences to watch and listen to the real lives of high school teachers, nurses, doctors, and welfare clients.

Capturing candid footage takes time, a lot more time than doing an A-roll interview and finding B-roll footage to support it. If you want candid footage, you will have to hang around with the primary character and wait patiently for things to happen. Television shooters meeting deadlines for the 6:00 p.m. news rarely have the luxury of hanging out and waiting for storytelling candid moments. But videojournalists shooting features for the Web find this an invaluable technique for capturing compelling footage.

BUILDING THE STORY VISUALLY

Good stories generally have a beginning, a middle that has a complication and resolution, and an ending. Those elements form a story arc that typically begins by building toward the complication, reaches the climax with a resolution, and then offers a satisfactory conclusion. (See Chapter 1, "Telling Stories.")

In a documentary, characters often tell their own stories, whether they are primary participants, witnesses, or experts. They quite naturally reveal who is involved, what is engaging them, and when, where, why, and how the story is unfolding.

Visually, the parts of the documentary, opening, complication/resolution and closing are built from a series of **shots**—similar to the way a written story is built with sentences and paragraphs. Each raw shot from the camera begins when the videographer starts recording and ends when the shooter stops or rests the camera on standby. The shot may be as short as 10 seconds (the very minimum) or may roll on for a minute or more. Longer shots can be shortened during editing.

So think of the **shots** as sentences. As sentences, **shots** will be joined into **sequences** (paragraphs) and the sequences into **scenes** (chapters). In literature, writers use transitions to link paragraphs and chapters together. Likewise, **transition shots** bridge one scene to another. **Scenes**, linked by **transitions**, will support the story arc as it builds and unfolds.

Along the way, the visual shots will show the subjects telling their story and present in sequences, scenes and transitions the how, what, when, and why that form the story. The establishing shot will tell the viewer where the action is taking place. And, finally—after the buildup—the complication and the resolution are shown, and the piece will end with a closing shot.

Shooting Order for Features Is Unimportant

Generally, you can shoot the five basic bread-and-butter shots without regard to order. As you will arrange the order of the shots when editing, your first shot could be the one that ends your story. In the sequence described earlier of the little boy rappelling down the clock tower, the high-angle medium shot of the parents was taken while the videographer was descending the tower but used later in the sequence of the final edited footage.

Your subject's action and dialog will dictate some of your shooting options. Always record action immediately, as it is taking place. Never assume that the person will do or say something again. You don't want to miss real, candid moments that might not recur.

And, of course, don't ask your subjects to repeat anything just for the camera.

Clip One **Clip Two**

▲ **Think Ahead to Avoid Confusing Cuts.** Editing Clip Two to run immediately after Clip One will cause the subject's head to appear to suddenly swivel on-screen. Avoid this problem (called a **jump cut**) ahead of time by shooting a **cutaway** clip of the subject's hands or some other close-up to place between clips One and Two.
(Photos by Ken Kobré)

Aside from the fact that repeating dialog is unethical in most journalistic situations, people simply never sound the same when they repeat something said in earnest or with emotion.

Don't Depend on Reshoots

Don't bank on coming back on another day to pick up the shots you missed on the first pass. Your subject will surely have changed clothing by then, or the sky will have transformed from clear blue to overcast. Trying to edit shots taken at different times and under different lighting conditions is difficult, if not impossible, to execute smoothly. Collect all the fundamental shots—those basic five mentioned earlier—when you are on the scene the first day.

Look for Transitions

Just as writers need transition words to link changes in topics, you will need visual transitions—a scientist entering her laboratory, a busy subject driving from one place to another—some kind of action that brings the viewer to a new place with the character.

Tight shots also make great transitions from one section of the story to another. You may also want to consider using a "natural wipe," like a car passing through the frame, that can serve as a transition shot between two different scenes of the story.

TIP Sometimes, out of the blue, a character's most revealing quotes start coming once the formal shooting session has ended. Even if you have packed your bags and are ready to leave, don't hesitate to grab your camera and start shooting again.

Shoot to Avoid Jump Cuts

The jump cut typically occurs with interview footage in which the camera was locked on the subject. A subject always moves slightly during an interview. When it's necessary to edit an interview using two clips taken from different parts of it, the subject's head appears to jerk on screen at the edit point. The audio will sound perfectly normal, but the footage will convey an abnormal and often distracting twitch.

Interview cutaway shots may include a reporter taking notes or listening, or a detail of the interviewee's hands. You can place the cutaway between the two parts of the interview and the viewer will not notice that the subject's face has moved a bit.

The 180-Degree Rule

Two subjects (or other elements) in the same scene should always have the same left/right relationship to each other. Changing position from one side to another while shooting can create editing problems later because the subjects themselves will appear to change sides on screen.

Maintaining consistent screen direction is referred to as the **180-degree rule** (see diagram). Think of an imaginary line running between the noses of your two subjects. This line is referred to as the **axis of action** or the **line of action**. You have 180 degrees within which to shoot on one side of the line, but if you cross over it, your characters will appear to flip sides. To avoid editing problems later, never cross that imaginary line.

◄ **Obey the 180-Degree Rule.** Stay on one side of an imaginary 180-degree line when shooting two people talking. This will help avoid the problem of the subjects' heads appearing to change screen direction when the clips are edited. If you cross over the 180-degree line, the couple will appear to reverse sides of the screen.

 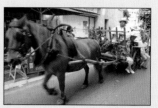

▲ When edited together, clips taken from the north and south side of the street make the carts look like they changed direction.

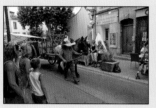

▲ Note how the **cutaway** of the horse's head provides a visual buffer between the shots of the carts. The horse's headshot neutralizes the conflicting screen directions of the two other shots. (For more detail on the 180-degree rule, see KobreGuide.com.)
(Photos by Ken Kobré)

If the problem of screen direction strikes you as complicated for two people talking, how about when you're shooting a parade celebrating ancient farming methods? You've set up your tripod on the south side of the street. You start the camera rolling as a line of horse carts approaching from the left passes in front of you. What happens if you then cross to the opposite side of the street to photograph the rest of the parade from that side?

Yes, the horses are still coming from the same direction. However, editing together the footage of them shot from both sides of the street will make it appear as if they are running into each other. One shot will show the horses going from left to right on the screen, when suddenly the second shot will show them rolling from right to left. This apparent reversal in direction is visually confusing to viewers, to say the least.

Maintaining the same apparent screen direction is crucial to avoiding this kind of visual confusion. Fortunately, the thoughtful shooter has plenty of options from which to choose in order to avoid colliding footage while editing.

PICK A SIDE

One obvious solution is simply to stay on the same side of the street. The ensuing shots will show the next group continuing from left to right. The direction for everyone will stay consistent.

Think of an imaginary line drawn down the middle of the street (the 180-degree line) with an arrow going in the direction in which the parade is advancing. Any number of the shots taken on one side of the line can be edited together with shots taken from that same side.

LOOK FOR VISUAL BUFFERS

Sometimes you must shoot from both sides of the street. How can you reverse the cinematic direction on the screen without disturbing the viewer? This is a case where the prepared shooter must think way ahead to editing the final piece.

Shoot from a Neutral Position

Take a shot with no left or right direction. For example, photographing from an overpass as the parade passes beneath will cause action to come from the top of the screen toward the bottom. When edited, the overhead shot can be followed by action coming from either right or left.

Another solution is to shoot from the middle of the street as the parade continues toward or around you. Now the direction is neutral because the horses are coming straight at you. Again, this neutral shot can be edited between shots from either side.

These kinds of shots edited between footage from the two different sides of the street allow viewers' minds to accept the sequence as natural.

Shoot Cutaways

In addition to shooting the action from a neutral direction, shoot a detail in the scene that has no implied movement at all. Cutaway shots like this include close-ups, audience reaction, and objects that typically have no particular left-right direction. A shot of bystanders, for example, will provide a visual buffer to prevent the horses from appearing to collide on screen regardless of the apparent direction from which they are coming. ■

ADDING VISUAL VARIETY

By default, most amateur video is shot strictly from eye level. Guessing at a reasonably average height, think of this habit as the 5'6" syndrome. Avoid the 5'6" syndrome at all costs. Otherwise, all your shots will have a dull sameness to them.

Shoot down from a 30-story building or up from inside a manhole. Either way, the viewer gets a new, sometimes jarring, but almost always refreshing look at a subject. Even when covering a meeting in a standard-sized room, standing on a chair or sitting on the floor while shooting can add interest to your images.

Get High, Legally

Even before you start shooting, look for ways to take the high ground. Whether going out on a catwalk or shooting from the balcony, find some way to look down on the scene. High angles often are used to establish location or to show the size of a crowd.

The digital video camera enables shooting from above your head. To do so, open the LCD screen and point it down. With the lens set to wide angle, hold up your camera, extend your arms far above your head, and aim the lens in the general direction of your intended target. Watch the LCD flip-out screen to frame the shot. Start shooting.

As mentioned earlier, some photographers go so far as to bring their own stepladders to ensure they can shoot from an elevated position.

You can extend your height by mounting the camera on a monopod or tripod. Start the camera rolling, hoist the whole affair as high as possible into the air, anchor it in your belt or hold your arm close to your body, and monitor the scene with the flip-out screen. Photographers call this over-the-head leap of faith a Hail Mary shot.

Even if the LCD on your camera doesn't flip out, you can use this technique by simply aiming the camera in the approximate direction of your subject. Now, regardless of your religion, say a few Hail Marys and pray that the pictures will come out well framed and in focus.

Remember that the camera is not very steady swaying above you, so shoot a lot of footage to assure getting at least a few seconds or, at best, minutes of rock-solid video.

▼ **Shoot from the Balcony. Former president Gerald R. Ford lies in state in the Capitol Rotunda.** (Photo by Shmuel Thaler, *Santa Cruz Sentinel*)

Sometimes used to create an **overall or establishing shot**, this kind of overhead shot can provide an unusual view and works especially well when in crowds or when competing with other photographers for footage of the winning athlete after a sports event.

The Hail Mary is also effective on dance floors or at street fairs, where it's hard to isolate people from distracting, busy backgrounds. Coming up close to a person, holding the camera high, pointing it down, and shooting for at least ten seconds, you will see that the ground or pavement provides a visually clean, nondistracting background.

How Low Can You Go

"Get down. Get dirty. Get your camera where the action is," says Bruce Chambers, an outstanding feature photographer for the *Orange County Register.*

▼ **Low Angle.** For a really low angle, place the camera directly on the pavement. (Photo by Kaia Means)

Video cameras and their flip-out LCD screens allow shooting from (literally) ground level. With the lens on wide-angle, place the camera as low as possible—even on your toes— aim, and shoot. If you don't have an LCD screen that tilts, you can check the results right away, and if your aim was off, reorient and shoot again.

"We can take viewers to places they haven't been before," says John Goheen, photographer and producer at Terranova Pictures. "Few people are going to lie flat on the ground to see the texture of the cobblestone or practically taste the water from the stream rushing past the lens. But these types of scenes can do that" for them.

When to Move the Camera

The five basic shots listed earlier, whether taken from a high angle or low, typically involve the camera remaining stationary while the action

▲ **Ground Angle.** With the LCD screen flipped out, you can place the camera low for a dramatic angle. (Photo by Betsy Brill)

unfolds in front of the lens. However, you also can move the camera itself or zoom the lens while shooting to add visual variety to footage. Panning, tilting, and zooming may seem familiar if you have been using a still camera, but don't be fooled!

Although still and video photographers each pan, tilt and zoom, the visual results are completely different. The still photographer shooting at a slow shutter speed while panning the camera or zooming the lens produces a partially blurred image—an often-striking effect in stills. The same pan or zoom shot in video, though, produces sharp continuous footage. Additionally, the video camera can move while the subjects are moving—either parallel to them, or toward or away from them. All of these techniques can be used to enhance or detract from the visual appeal of your video.

Avoid Zooming the Lens

The most overused button on a video camera is the zoom control. Yet zoom shots rarely add much to any story. "The eye can't zoom," says Pulitzer Prize–winning photojournalist Kim Komenich, "so a zoom instantly puts the viewer into a situation that is not real."

In his book *iMovie: The Missing Manual* (O'Reilly), David Pogue observes, "For the camcorder operator, zooming imparts a sense of control, power, and visual excitement. For the viewer, zooming imparts a sense of nausea. Overly zoomed and swish panned shots are a quick giveaway that a rank amateur has shot the footage."

TIP "Another good reason not to zoom is that it's tough to handhold a steady shot if you are zoomed in," notes Steve Sweitzer, former news operations manager for Channel 8 WISH in Indianapolis. "To prove the point, handhold your camera, zoom in on something across the room and try to hold that shot steady. Then put the lens in the wide position and walk up to the object and take the same shot; you'll instantly see the difference."

Okay. Okay. What about MTV?

You might have seen a shot that zooms so fast you feel like you're in a time-travel machine, pans executed as if they were shot from a centrifuge, and camera tilts violent enough to throw off a pinball machine. And then there were those

▶ If you must zoom, do it in one direction—either in or out— but avoid going in both directions in the same shot. Hold the shot steady for at least 10 seconds at the beginning and at the end of the zoom. (Photos by Ken Kobré)

angles so severe that even teetotalers think they've been on a night of serious binge drinking. What is going on here?

MTV's shooting style provides eye-candy to accompany music. The music's driving beat powers the piece while the sometimes-chaotic images add visual spice to the mix. For MTV, the fast-cut, zoom-in-zoom-out style maintains a large audience and has spawned a unique visual shooting language of its own. Most documentaries, on the other hand, try to emphasize a story's content rather than to support the beat of popular music or to show off a photographer's shooting style.

Generally speaking, we want the camera to bring us into situations as if we were there. We walk toward something to see it more closely. To achieve the natural equivalent of walking into a scene, you need to physically move the camera itself forward. This is called a "dolly in" shot (more on this shortly). We walk up to something or someone; we don't zoom with our eyes to get there. Keep in mind that the "zoom-in" shot actually changes the focal length of the camera lens from wide angle to telephoto.

Having warned against excessive zooming, there are times when zooming the lens will be necessary.

If you absolutely must zoom, hold the shot steady for 10 seconds before starting. Begin gradually. When you end the zoom, hold the shot for another 10 seconds at the new focal length. These pauses before and after the zoom allow the viewer to become oriented before the movement starts. As you zoom, it's usually necessary to gradually tilt the camera up or down a bit to maintain proper framing throughout the shot.

Again, zoom-in-and-out changes the lens' focal length from telephoto to wide angle and then back to telephoto. Professionals consider a zoom-in followed by a zoom-out within the same shot exceptionally poor camera work. Also, during editing, avoid putting two zoom shots together. The effect for the viewer is like being on a horrible roller-coaster ride.

The exception to the zoom rule: emotional faces. Sometimes during a painful interview, videojournalists carefully zoom in and hold tight to capture a particularly emotional moment.

You must know when to hold and when to zoom in a touchy circumstance such as shooting a character in tears. Also, the speed of the zoom is crucial. Ideally, the speed of the zoom should

be so subtle that the viewer won't even notice that the framing is changing. A quick "whip zoom" is too obvious, draws attention to the technique, and pulls the viewer's concentration away from the emotional situation.

If you suspect that your subject may say something emotional or dramatic during your on-camera chat, try to adjust the framing of the shot in the lens before starting to record the actual interview. Without recording, zoom in for the eventual close-up to adjust the composition. Then widen the lens for a looser shot to start the interview. This will prepare the camera to zoom smoothly should the need arise later.

Although zooming in to an extreme close-up of an emotional face can be seen as a cliché, used sparingly and shot professionally it can also be an effective story-telling tool.

Remember never to use a camera's "digital zoom," which results from software manipulation rather than lens movement. Digital zoom produces undesirable electronic noise in the final footage. (See Chapter 5, "Camera Basics.")

Some video cameras zoom with a turn of the lens barrel, others via a press of the finger on a rocker switch that causes the lens to zoom at a steady speed. Even the speed of a zoom can be selected on some cameras. Others zoom faster or slower depending on how much pressure is applied to the rocker switch.

TIP For more about using the zoom watch (1) "Video Sequence With and Without Zoom: French Café" and (2) "Video Sequence With and Without Zoom: Fabric Merchant."

Pan Cautiously

Pan shots result from slowly swinging the camera to follow action without changing the camera's position. Suppose you are covering the Tour de France. As the riders pass, you will follow them with the video camera to keep the lead rider continuously in the frame. A smooth pan is one in which the rider stays in the same approximate place in the frame during the entire shot.

Videographers also pan to mimic the action of a human head. We turn our heads in a semicircle to take in a wide view of a scene. Someone arriving at a mountaintop, for example, is likely to absorb the vastness of the scene below by surveying it with a continuous sweep of the head.

The pan shot can take in as much area as the photographer likes and can also be used effectively to establish location.

It is difficult to shoot pans without creating shaky images. A sturdy tripod with a "fluid" head and steady hands are a must for swinging the camera at a slow, steady pace. Also, position your body so that you are facing the direction in which you will *end* the pan, called "the position of comfort." Your body will be slightly twisted to start the pan, but you will relax during it. Start your pan slowly, speed up slightly, and then slow down just before the pan comes to rest at the finish.

"Pans work best if you can follow something, like a car or bike" according to Steve Sweitzer, a seasoned video professional. "Also, pans are more likely to succeed if the movement is left to right; because we read left to right, our eyes are more comfortable moving in that direction." Says John Goheen of Terranova Pictures, "If you are going to pan, use it to *follow* action. I believe the camera was created to capture action . . . not *create* action."

Tilt Up or Down Rarely

Besides panning left or right, slowly tilting the camera up or down during a shot can help establish location, such as outside a tall building. Tilting the camera is a way to show the height of person, a structure, or a mountain or to emphasize relationships between something high and something low. If possible, always allow the viewer to discover something at the end of a tilt. For example, a tilt may start at a man's tennis shoes, but as it moves up, it might then reveal that he is wearing a tux. The best reason to tilt is to convey height—and to provide a payoff at the end of the shot.

Motivated Zooming, Panning, and Tilting

If you are going to zoom, pan, or tilt, remember that each camera action should have a logical starting place and a visual destination, a payoff, for the viewer when the movement ends.

If photographing a flower vendor, for example, you might position the camera across the street in order to encompass the flower stand. The zoom would start out wide and hold for at least 10 seconds in the wide position. Only then would the camera slowly zoom onto the merchant and his customer—and hold there for at least another 10 seconds. The close-up view of the florist is the payoff at the end of the zoom.

The movement starts at a logical place and arrives at a satisfactory destination. A camera move that ends in a payoff like the flower vendor is called a "motivated" pan, zoom, or tilt. The motivation of the shot is to find a particular person, place, or thing. Aside from motivation, speed of the camera movement is important—keep it *slow* so that your viewers don't feel seasick.

TIP Keep in mind that editing pans, zooms, or tilts for the final piece is often a challenge. It is almost impossible to cut a zoom or pan in a way that makes visual sense. Pans and zooms really need starting and ending points, so an editor is obliged to use the whole segment. Because some zooms or pans can run as long as 20 seconds, they can slow down an otherwise well-paced documentary.

Dolly Shot

A **dolly shot** refers to moving the camera toward or away from a subject while keeping the lens at the same focal length. It takes its name from the sturdy wheeled cart—a dolly—used by Hollywood photographers to roll a mounted camera on a track or a smooth surface toward or away from the subject. The camera itself is completely stable, and the cart provides smooth movement.

The dolly shot has more impact when the camera moves past objects. A camera moving toward someone working in a factory would pass people, machinery, and so on, and provide a sensation of real forward movement that is completely different from the effect of zooming the lens. That is why cinematographers prefer the dolly shot to the zoom. The effect is more natural. In the real world, we walk up to greet a person or to view something. We cannot zoom our eyes.

▲ Example of a **motivated zoom** with a payoff. (Photo by Ken Kobré)

▲ **Tracking Shot.** Here, the camera was on a boat going at the same speed as the cyclists. (Photo by Ken Kobré)

▲ **For a do-it-yourself dolly, try a chair with wheels.** (Photo by Ken Kobré)

Tracking Shot

The **tracking shot,** also called a **truck shot,** describes a camera moving with, and often parallel to, the subject. Also shot from a dolly or "truck" in the world of movies, an effective tracking shot can add energy and variety to footage. Though shot without a dolly, the series of photos above is an example of a tracking shot. The photos were shot from a canal boat moving at the same speed as the bicycles. The framing remains the same, with the couple as main subjects; the camera's speed and distance from the subjects also remain the same. The trees between the camera and the subjects cause the viewer to lose the riders momentarily but then see them reemerge an instant later further along the trail.

Documentary shooters and videojournalists rarely have the luxury of using a dolly for moving-the-camera shots. Shooters often imitate dolly shots and tracking shots by just walking or running with their subject while handholding the camera. Very occasionally, the jerky footage that results from the camera bouncing in rhythm with footsteps can be effective. Most of the time, its impact is distractingly stomach-churning.

The success of a dolly shot and or a tracking shot rests with keeping the camera stabilized while moving it. Think wheels. Find a shopping cart, a wheeled office chair, or maybe even a bicycle, skateboard, or other contraption that can be rolled relatively smoothly toward, away from, or alongside the subject.

Camera Stabilizers for Better Handheld Shooting

Hollywood cinematographers who don't want to be restricted to shooting on a cart of any sort often use a camera stabilizer, such as a Steadicam, for "handheld" dolly shots or tracking shots. This contraption, which attaches the camera to the mobile photographer, absorbs sudden movements, including the up-and-down motion of walking. The device allows the camera to remain level even as the cinematographer walks, climbs stairs, or just swings the camera from left to right.

Some videojournalists use a lightweight camera stabilizer for the same purpose. An Internet search will turn up some of these gadgets as well as plans for making an inexpensive DIY version.

Here's some really good news. If you did not use a dolly or a camera stabilizer when you shot in the first place, software solutions can electronically remove a lot of—not all—the shakes after the fact. Check it out.

WHEN TO STOP SHOOTING AND REFRAME

Regardless of what you're shooting, you must always decide when to keep rolling and when to stop and change angles for a new shot.

In general, let the action finish before you move to start another shot from a different angle or before zooming the lens.

While photographing an arrest at a demonstration, this writer shot the action as a policeman handcuffed a young woman. But he had to decide whether to keep rolling with a medium shot that included the action or to come in for a close-up of the protester's face. Documentary shooting requires constant trade-offs between continuing to record one shot or stopping to get a new perspective by changing position or lens length.

▶ **Lightweight camera stabilizers for small cameras come in all shapes and sizes.**

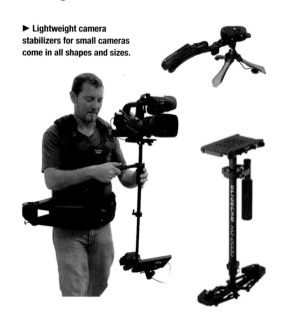

TIP Sometimes you must keep shooting to avoid missing important action. Other times you must keep the camera rolling so as not to lose important dialog. In both circumstances, you can later separate the audio and video during editing and use one or the other, as you deem necessary.

Each Shot Can Tell a Tale

Shoot each shot as if it were telling a short tale. Press the button to start and let the camera roll until an action is complete. The videojournalist must keep the camera rolling as each short, short tale unfolds.

PRACTICING WITHOUT A CAMERA

As you start to watch a documentary, a news show, or a movie, concentrate for a few minutes not on the plot or subject matter, but on the camera work. Notice the nature of each camera move. Observe. Analyze the choices.

For example, if the piece starts with a wide shot and then cuts to a close-up and back to a wide shot, what was the purpose? What was

achieved? See if you can start to anticipate the next type of shot the editor will use.

As you watch any fiction or nonfiction film, mentally flipping your concentration from run-of-the-mill viewer to analytic observer is a bit like having an "out-of-body" experience. You will drift back and forth between being an observer of the technique and being an engaged, standard viewer—then back again.

Another way to accomplish this kind of shot-by-shot visual self-training is to watch a movie without sound. Keep your eyes peeled to analyze the shots and scrutinize the editing. Learn by watching. Just as an athlete learns from reviewing game action during a playback session, you can improve your own shooting by studying the work of others.

Finally, here is some "homework" that will really expand your mind. Try counting the number of individual shots—from close-up to wide, zoom, pan, tilt, and more—in a TV commercial. Note how many shots are squeezed into a 30-second ad.

To return to the basic rule of thumb for shooting video discussed at the beginning of the chapter: shoot and move, shoot and move to edit and produce a satisfactory, successful documentary. **One shot is never enough.** ◼

▼ **Let the Action Finish Before Finishing the Shot.** This series of images comprise a single medium shot of a woman trying on a hat. The shot begins with her picking up the hat, climaxes with her putting it on her head, and ends with her returning the hat to the table. (Photo by Ken Kobré)

See **KobreGuide.com** for a video on how to shoot and edit a sequence.

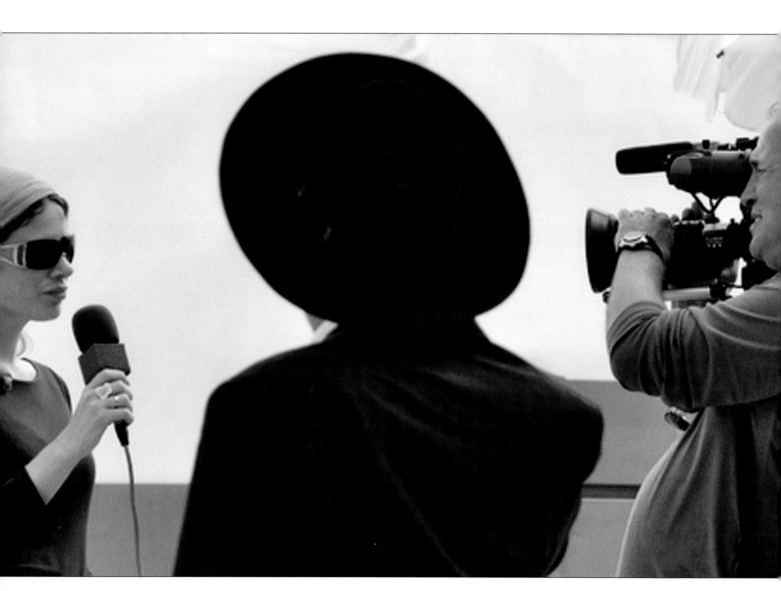

▲ **Interview.** A reporter
interviews an ultra-orthodox
Jew in Jerusalem. (Photo by
Betsy Brill)

Conducting
an Interview

Jerry Lazar

Editorial director, *KobreGuide.com*

In addition to learning the technology of recording video

and audio, videojournalists also need to master the tech-

niques of interviewing. Being a good interviewer requires

more than just holding a microphone in front of someone's face.

Being a good interviewer means knowing what questions to ask.

TELLING THE STORY FROM MANY POINTS OF VIEW

A good story needs a central protagonist—a hero, if you will.

So start by asking yourself, "Who embodies the essence of

this story?"

This symbol indi-
cates when to go to
the *Videojournalism* website
for either links to more infor-
mation or to a story cited in
the text. Each reference will
be listed according to chap-
ter and page number. Links to
stories will include their titles
and, when available, images
corresponding to those in the
book. Bookmark the follow-
ing URL, and you're all set to
go: http://www.kobreguide.com/
content/videojournalism.

Sometimes this choice will be obvious and sometimes not. At times, a decision to deliberately gravitate toward a less obvious choice can set your story apart from others on the same topic.

For instance, instead of experts or opinion-makers typically called upon by journalists to give the "official" word, you might pursue interview subjects less accustomed to being in the public eye. These people will probably not be as comfortable or as polished in front of a camera as the former, but that slightly rough quality often turns out to be an asset.

For Djamila Grossman's story about heroin addiction, he found a convicted addict who actually had asked for a maximum prison sentence. Of course, the videojournalist could simply have interviewed drug experts, rehabilitation professionals, social workers, and police officers. Instead, he decided to interview this particular drug addict who was trying to get clean.

▲ **Heroin Addict Finds Hope.** The story's producer focused on an addict to convey a more realistic vision of problems of going straight. (Video by Djamila Grossman, *Standard-Examiner*)

Here's a checklist of what to look for when selecting the central character in your story:

- Knowledgeable? Informed? Involved?
- Affected/impacted by the story?
- Primary mover/shaker in the story?
- Strong feelings and opinions about the subject?
- Articulate and willing and able to speak candidly on camera?
- Reputable? Credible? Reliable? Trustworthy?
- Cooperative?
- Representative of a larger group, trend, or perspective?

But one person does not a story make! Think how boring a book or movie would be with only one character in it. The same is true of videojournalism and multimedia storytelling. An alarming number stories fail because they feature only one character source.

Constantly ask yourself, "What other perspectives are there? Who can best represent and articulate them?"

As you research and gather information for your story, search for names of individuals in previous accounts in newspapers, magazines, books, and on the Web. As you start contacting them, via phone or email, always ask them, "Who else should I talk to?" That's one way to cultivate fresh perspectives—and perhaps even find the ideal "hero" for your story.

Contrasting Points of View

Whenever you can show a contrast between two sides of an issue, two points of view, two opposing characters, you have the potential for a good story.

Mel Melcon of the *Los Angeles Times* built a clever story by contrasting a Marilyn Monroe imitator and a Marilyn Monroe wax figure from Madame Tussaud's Wax Museum. Interviews with the lookalike and the museum's PR person representing the wax Marilyn provide the contrasting points of view.

The best stories, in fiction and in real life, are those with intrinsic drama that is the result of showing two or more people in conflict. So always try to explore individuals' motives—and then find someone who represents a competing interest or point of view.

Three years ago, Monica Long was told that a mammogram indicated ductal carcinoma in situ, or D.C.I.S., an early form of breast cancer. As a result, she had a quadrantectomy, in which about a quarter of her breast was removed. When Long's medical records were reexamined later during a routine checkup at a different facility, she was told that she had never had cancer at all. Experts say that her case is not all that unusual. Videographers Stephanie Saul and Shayla Harris, working for the *New York Times*, not only interviewed the doctor who caught the mistake but also allowed the doctor who gave the original diagnosis a chance to respond.

▲ **Pathology of Errors.** Besides interviewing the central subject, the producers of this video interviewed doctors on both sides of a controversy over whether the patient really needed to have a breast operation for cancer. (Produced by Stephanie Saul and Shayla Harris, *New York Times*)

For another example that requires multiple points of view, consider the debate over a proposed city council measure that requires restaurants to provide health insurance for all their employees. Rather than featuring only the politician who sponsored the legislation, your story might center on a popular waiter at a local restaurant. But will you just follow him about his day and let him explain how important it is to have health care coverage? Well, that may be part of the story, but let's also hear from the supporting and opposing lawmakers. Let's hear from restaurateurs who favor the measure, and those who oppose it. What do they think the impact will be on their business? Let's hear from the rest of the wait staff and the kitchen crew. Are any of them opposed to the legislation? During your sleuthing, keep your eyes and ears open for unexpected sources that may be directly or indirectly affected by the matter at hand, even customers, for example.

▲ **Battle of the Blondes.** This multimedia piece presents a synchronized sparring match between two Marilyn impersonators—one live, one a wax model—who spend their days on Hollywood Boulevard. Melissa Weiss has played Marilyn Monroe on Hollywood Boulevard for the past nine years. Interviews with Weiss and a PR representative for Madame Tussaud's provide the contrasting narration. (Produced by Mel Melcon, *Los Angles Times*)

As you pare down your potential interview subjects, here are some other questions to ask yourself:

- How and why is this person knowledgeable about this subject?
- Can this person's information be independently confirmed through other sources?
- Who does this person speak for, or represent?
- What is this person's reputation?
- Why is this person willing to talk? Does his eagerness to participate affect his or her credibility as a reliable source?

HOW WILL INTERVIEWS BE USED IN YOUR STORY?

As you plan and prepare for your interviews, think about how they will be used in your video story. In typical TV news reports, for example, the subject and interviewer are on camera together, and we see and hear both of them during the interview—either in the same frame or, preferably, in alternating sequences.

▲ **Extreme Couponers Get Groceries for (almost) Free.** In a story about clipping coupons for supermarket discounts, Treasure Phillips tells her tale. However, the viewer never hears the original interview questions that stimulated the answers. (Videojournalist: Jacob Templin. Supervising Producer: Craig Duff, *Time.com*)

But for telling stories in short documentaries, the following situations are the better options:

- Subject is on-camera, and we see and hear her responding to questions. The original questions being answered, however, have been edited out.
- Subject is on-camera, but we hear the interviewer's questions off-camera.
- Subject's voice responds to questions while we see B-roll footage of what the person is talking about.

Each interviewee may be used once or twice in the final story. Or they may appear throughout the video. You will most likely use some combination of these alternatives to weave your story together. Sometimes the central character's voice narrates the entire video, essentially describing the footage as it's shown.

BACKGROUND RESEARCH

The most critical aspect of interview preparation is researching your topic and your subject. Research not only helps you prepare excellent questions, but provides you with a high level of comfort and authority while you're conducting your interview.

Nobody expects you to become an overnight expert, but your interview subjects will generally be more cooperative if they feel you've done your homework and are taking them, and their pursuits, seriously. Some talk-show hosts claim they like to know as little as possible about their guests, so that they can ask "average person" questions. But they're usually being disingenuous, as their producers provide them with well-researched questions on file cards. And those who really do pride themselves on their ignorance frequently stumble and look foolish when they pose questions that reflect their lack of preparedness. Asking "average-person questions" is time-wasting and insulting to their guests, as well.

The best interviewers—such as NBC's Bob Costas and NPR's Terry Gross—are, as you can readily tell, exceptionally well prepared. They're able to steer in-depth discussions in unexpected directions.

The purpose of all your research is to ask good questions, so begin by envisioning specifically what kinds of information you're hoping to glean from your interview. You will be looking for someone who can describe an issue or an event or a process in a clear and engaging way. You'll want to try as discreetly as you can to extract opinions and attitudes. You'll also need to make sure in advance that your subject's responses will be lucid and complete. And with the subtlest approach possible, you also will want to get the person to respond to other perspectives—even the most contrary or competing ones, if applicable.

The more you know, the better your questions will be. The better your questions, the better their answers will be. The better their answers, the better your story will be. In short—if you want to end up with an excellent story, you must set out to obtain excellent information before you ever start.

▲ **Terry Gross** is the host of *Fresh Air*, a Peabody Award–winning weekday radio show of contemporary arts and issues. *Fresh Air* is among public radio's most popular programs with five million weekly listeners. (Photo by Will Ryan)

FINDING THE FACTS

When it comes to research, web search engines are your best friends. There is no excuse these days to conduct anything less than an exhaustive exploration of the person you're interviewing and the ideas and areas you'll be discussing. Search the general topic and see what comes up. There will probably be so much data that you'll have to narrow the search. Do make sure your web information comes from reliable sources such as original research in journals, government sites, and data available in the public record, including published reports in the *New York Times,* the *Wall Street Journal,* and other news organizations that typically explore multiple sides of topics.

Don't stop with online research. Libraries are still valuable reference centers, and reference librarians can be invaluable in helping narrow research. Don't forget books and video.

You'll also be calling sources for facts and figures necessary for the story. Although they themselves may not warrant on-camera interviews, sources such as these can often lead you to others who may be camera-worthy. Be discreet. But don't be afraid to pick peoples' brains for references.

If you're working on a story about a resurgence of sales of vinyl record albums, a record-industry trade association spokesperson may provide a valuable statistic. Using that statistic may not warrant an on-camera interview, but you may be able to use the data in a voice-over narration, on-screen text, or graphics. Also, you might ask that first person to recommend a record company executive for an interview.

What are some of the things you need to know before you can develop the questions for your interviews about the comeback of vinyl?

- **History.** What's the story behind vinyl records? When were they invented? How long were they in use? When did they fall out of general use? Why are people buying them again?
- **Controversial issues.** Find out anything regarding the medium's longevity. What devices played the music? How was the quality of sound?
- **Follow the money.** Does vinyl cost more or less than CDs to produce?
- **Contrarian point of view.** Who thinks vinyl is outdated and gone for good?
- **Who has the facts?** People in academia study all kinds of wondrous things. Are there professors of history or popular culture to query? What about canvassing musicians themselves? Or finding out who is developing new recording/storage technologies?

A far more serious, tragic story required extensive research that provided *New York Times* reporters Gabe Johnson and Michael Moss entrée into the loosely regulated meat-packing industry, where lax safety precautions have led to

PRE-INTERVIEW CHECKLIST

John Knowlton, Journalism professor, Green River Community College

- Have I made clear the purpose of my interview—both to myself and to my subject? (What do you really want from this interview and how eager are you to obtain this information? The more specific your purpose and the more apparent your enthusiasm, the more likely you are to gain cooperation.)
- Have I made it clear (to myself and to the subject) why I want information from this particular individual? (A source may be flattered to be singled out.) Have I eliminated my own preconceived biases and eliminated my emotional barriers to communication?
- Have I done preliminary research on the person and the topic to be discussed—read things about him or her, done preliminary interviews so that I can develop new areas of inquiry?
- Has my research included preparation for "small talk" or "icebreaker" kinds of commentary?

(For example, review news accounts of recent Supreme Court decisions when preparing to interview a lawyer.)
- Before requesting the interview, have I prepared a few "sample" questions cold-bloodedly calculated to be both provocative and ego-reinforcing?
- Am I prepared to use my listening "down time" effectively? (Your mind runs three to four times faster than people's speech, so you can tune in and out of the conversation. You can make effective use of the "nonlistening" time to evaluate what is being said, make comparisons with other data, take notes, and to think up new questions.)
- Am I (or will I be by the time of the interview) well-rested, well-nourished, and sober with all my mental faculties alert so that I can catch the fine nuances of meaning or things left half-expressed or even unsaid—in short, am I ready to listen between the lines?

a surge in food poisoning cases in recent years. Consuming a home-cooked hamburger containing a virulent strain of E. coli bacteria nearly took the life of a young dancer, Stephanie Smith, and left her brain damaged and paralyzed.

By focusing on the numerous stops along the trail—from stockyards to your dinner plate—this investigative video piece provides a clear explanation of what can, and has, gone terribly wrong with our food regulatory systems. By bookending the story with one woman's heartbreaking consequences of unwittingly eating an E. coli–infested hamburger, it turns a scientific story into a personal—and *frightening* story.

▲ **Tainted Meat.** The *New York Times* reporters used the case of Stephanie Smith, who was brain damaged because of meat she had eaten, to tell the story of lax food regulations. (Produced by Gabe Johnson and Michael Moss, *New York Times*)

PLANNING THE INTERVIEW

Thoughtful interviews are well planned. Planning means contacting your subjects, explaining your story and why you need their input. It also requires detailing who your story is for and how and where it will be used. Good preparation also demands you arrange a mutually suitable time and place for the interview. And it means preparing questions that will elicit the most informative and engaging responses. Never just show up on someone's doorstep unannounced, expecting a thoughtful and cooperative subject to be waiting for you.

There's no need to go into exhaustive detail in your initial contact. You want to offer just enough information so your subject will be prepared for the interview, but won't give them the opportunity to rehearse responses. Offer general areas of conversation you'll be exploring, but don't provide a list of specific questions, as that will ruin any chance for spontaneity.

Choose a time and location that will provide minimal distraction and noise. Ideally, you can shoot your subject in his or her "natural habitat"—at work or at home, or in a location that's appropriate for the story itself. Make sure to schedule enough time—and remember to include time for setting up your location for recording optimal audio and video.

You don't want to be rushed. Depending on the nature and complexity of your story, you may need to make multiple visits, at a variety of locations—especially if you're following a process over a period of time. Or things can become more complicated as you unearth new information that requires an on-camera response or rebuttal from other sources. Let the subject know that.

How much time should you request for your interview? That really depends on too many factors for us to generalize. TV news reporters are accustomed to getting in and out fast. They have frequent and rigid deadlines to meet and they know that only a short sound bite—a telling comment or observation extracted from a longer interview—will be used for their minute-long

▶ **Pullman Porter and Family Patriarch.** Mel Melcon of the *Los Angeles Times* interviewed and photographed Lee Wesley Gibson, who turned 100 in July 2010 and worked for the Union Pacific Railroad for 38 years. The *LA Times* staffer interviewed the centenarian in a quiet place with little distracting noise but took pictures of Gibson in a number of locations, including an old Union Pacific railroad car, the subject's house, and at a funeral. (Produced by Mel Melcon, *Los Angeles Times*)

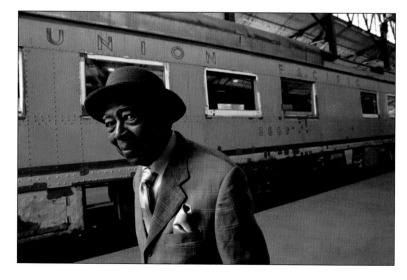

story. They realize there is no point in burdening the editor (most likely themselves) with wading through a half-hour conversation for the "money" quote. Instead, they fire off three quick questions, and they're good to go.

Videojournalists face fewer such constraints. But at the same time, busy audiences do expect and appreciate economy. Even though stories can be told more expansively, nobody has the patience to sit through rambling monologues, especially when so many other online distractions beckon.

What If the Person Doesn't Want to Talk with You?

If someone does not want to be interviewed, that's certainly his or her right. Plenty of people are wary of strangers in general and journalists in particular. Even a public official is not obligated to grant an interview. But if a source is important to your story, here are some tips for enticing him or her to cooperate:

- Don't use the word "interview"—it can be off-putting. Say you'd like to talk or chat. It sounds less intimidating. (But be clear that your conversation will be on camera.)
- Like a good salesperson, try to intuit what's causing the resistance and overcome specific objections by anticipating and accommodating the person's concerns.
- If it's a question of the person not having enough time right then, offer a more convenient time or place—perhaps in the person's car on the way to work.
- If someone is afraid of looking bad or sounding stupid, explain why his or her perspective is so vital and necessary for your story.
- If the person claims to have nothing to say, reiterate the information you are seeking. If he or she still feels uncomfortable, at least ask for suggestions of other possible sources.
- If you're having trouble getting access to a source, particularly one in an official capacity who may be surrounded by protective underlings, be persistent. Call, write, email, or just show up. Find a mutual acquaintance (or another source) to serve as intermediary.
- Be clear that the story will be told with or without the person's cooperation—and so to be fair, you want to provide an opportunity to tell his or her side of the story.

- Appeal to the person's vanity. Each person has something special and important to contribute to your story. Emphasize the person's unique contribution.

What If the Person Asks You What to Wear?

Sometimes your subjects will ask what to wear for the interview. If the story is about a retired soldier, you might suggest his or her uniform. A costume might be appropriate for a stage actor before or after a performance.

More general useful advice is that blue is a color that shows well on screen and is not distracting, as are pastel colors. Most critical is what *not* to wear for a video interview:

- Bright white reflects the maximum amount of light and can throw off exposure.
- Black is too harsh, can suck up all the light, and throw off exposure.
- Bright red "bleeds" on screen and is distracting.
- Stripes, herringbone patterns, small intricate designs, and checks can actually pulsate on screen. Hats, sunglasses, or tinted glasses tend to hide the face and be hard to light. Large, dangling earrings distract and can make noise or hit the microphone during head movements. Logos make the interview look like an advertisement. Shiny objects, including ties, can end up looking like plastic or mirrors.

DEVELOPING YOUR QUESTIONS

The two most important things you will be bringing to your interview (besides your equipment) are your list of questions and your sense of curiosity.

You'd be amazed at how many would-be interviewers leave those things at home, and instead think that the most important thing to bring is themselves—their own sparkling wit and personality. They somehow forget that the interview is about the other person.

Your curiosity is probably what got you impassioned about storytelling in the first place. Good interviewers are curious about the world and are sincerely interested in other people and what makes them tick.

As you're preparing your questions, invite interested friends and associates to contribute as well. Nowadays, the Web makes it especially easy for journalists to solicit questions for upcoming interviews, especially via social media such as Facebook or Twitter. You can invite input from

total strangers who may share an interest (and even some expertise) either in your topic or in your interviewee.

Now that you've learned all you can in advance about your subject, and have determined what fresh information, ideas, and emotions you'd like to see shared with you and your audience, you need to structure a conversation designed to elicit all that. Even though some interviewers smugly pride themselves on their provocative or challenging questions, in truth, a question is only as good as the response it evokes. This fact is doubly true in videojournalism, where you're unlikely to include the questions when editing.

Remember: you're a journalist, not a talk-show host.

Core Questions

In addition to standard biographical background questions, nearly all your inquiries will focus on:

- What your subject has done, is doing, or plans to do
- What your subject thinks about _____
- How your subject feels about _____
- What your subject knows about _____
- What your subject has experienced regarding _____

▲ **Tami Tushie's Toys.** Just as their mothers may have done, women still give parties in their homes to sell merchandise to friends and neighbors. These days, plastic containers or candles aren't the only things being sold. Tami Tushie is a working hostess of "Pure Romance" parties, where she hawks sex aids—lotions, potions, and toys designed to perk up a woman's sex life. Notice how the story answers the who, what, where, when, and why questions readers have. (Produced by Melody Gilbert, Kiersten Chace, Adrian Danciu and Emily Rumsey)

What people remember most about a story is usually not factual. Rather, a viewer recalls the emotions the story stirs up and the senses it awakens. That's why asking how a subject feels, in every "sense," is a completely useful and valid interview tactic.

"Describe what it was like to _____" is a good phrase for teasing out how a subject feels about something without asking "How did it feel to _____?"

Allow flexibility, so that the conversation can follow a natural course and go down unexpected but fruitful paths.

Keeping in mind that your story will follow a narrative arc—rising action, conflict, and resolution—you'll want to ask questions that lend themselves to that dramatic structure:

- How did you get started?
- What is your goal?
- What drives you? Why are you passionate about this?
- What are the obstacles or hurdles preventing you from reaching that goal?
- How have you overcome them? How do you plan to overcome them?
- What does the future look like?

TIP Remember to listen to your subject's answer, not prepare for the next question. Your next questions could expand on what the interviewee just said before you change topics and take the interview in a new direction.

Types of Questions

There are two general types of interview questions—closed-ended and open-ended. What's the difference? A closed-ended question can be answered with a "yes" or a "no" or a one-syllable word, whereas an open-ended question cannot. The best questions are open-ended because they lead to expansive responses. Look at the difference:

Closed-ended: Do your teenage kids respect you?

Open-ended: Tell us about your relationship with your teenage kids.

Closed ended: Are you going to vote in favor of this legislation?

Open-ended: What do you think about this proposed legislation?

Closed-ended: What's your favorite hobby or activity?

Open-ended: What do you do on weekends?

Questions to Close

Here are some other tried-and-true "closers" that you can adapt for your purposes:

- What is the significance of what you've told us today?
- What have you learned from this experience?
- What would you like our audience to do about this?

- Is there anything you would have done differently, knowing what you now know?
- What are your plans for the future?
- What obstacles and challenges lie ahead?

It's also a good idea to ask whether you can call on the subject again if you need further information.

Finally, always ask your subject, "Is there anything else you would like to add?"

Structure Your Questions in Themes

So that you're not hop-scotching all over the place, structure your questions to be clustered around themes. (Editing will also be easier.) Know well ahead where you plan to begin, and where you hope to end.

The first question should be nonconfrontational—just to get everyone relaxed and rolling. Save tougher questions for later in the interview, especially if they're confrontational in nature. The final question might be an open-ended summation, along the lines of, "So what's the most important thing we should remember about _____?"

Organize the Questions with Bullet Points and Key Words

Instead of writing specific detailed questions, consider writing a list with bullet points and memory-jogging keywords. That way, you won't fall into the trap of reading the questions verbatim, like a spelling bee moderator, or worse, a police interrogator. You'll also be more inclined to pursue the interview as a conversation, which is conducive to the subject's sharing stories. Conversation is preferable to Q&A, which more often produces clipped, lifeless responses. To make sure you aren't leaving out important themes you intend to explore, or information you need to get on-camera, do, of course, consult your list.

CONDUCTING THE INTERVIEW

Respect other people's busy schedules by arriving punctually and prepared. Dress professionally, or at least appropriately for the setting. Your appearance affects how people relate to you. You want to do everything you can to win your subject's trust and confidence.

Before You Start

If you think there is any possibility you will need them later, take care of signing release forms first.

If you're at your subject's home or office, look at the surroundings to get a sense of what the person is like. A picture on the desk or wall may lead to small talk with your subject, serving as an "icebreaker" before the formal interview begins. Look for personality clues and identify any items that might be relevant to the discussion and might be used as visual props.

Take charge of the shooting circumstances:

- Find a suitable spot, with even, non-fluorescent lighting and a minimum of ambient noise.
- Arrange your seats so that you are relatively close and facing each other.
- Ask everyone present to mute their phones, and everyone other than the subject not to speak.
- Unplug noisy appliances.
- Mic the subject, and, if your questions also need to be recorded, perhaps yourself.
- Record some sound and check the audio quality. (See Chapter 8, "Recording Sound," for more on the technical logistics of recording the interview.)

Prepping the Subject

Put your subject at ease. Begin with a bit of casual small talk—traffic, weather, sports, and the like. Be sure to say "thank you" in advance for the time being generously shared with you.

Ask the person to look into the camera and say and spell his or her first and last name distinctly and to say, for example, "My name is _____ , and I'm a [profession] for the [name of company, etc.]."

▲ **Popular Science.** David Frank and Natalie Angier put the forensic science teacher and his students at ease during an interview for a story about what maggots reveal about decomposing bodies—and the popularity of this new high school science topic.
(Produced by David Frank and Natalie Angier, *New York Times*)

To make the interview easier to edit, ask your subject to incorporate your questions into the answers. Provide an example. "For instance, if I ask, 'Where did you grow up?' it would be good if you could respond, 'Where did I grow up? I grew up in Philadelphia.' By including the questions in the answer, you will avoid a one-word response, like 'Philadelphia.'" Rehearse with your subject by asking the person's favorite ice cream flavor. If he gives a one-word answer like "Chocolate," then ask him to respond in a complete sentence that incorporates the question: "What kind of ice cream do I like? I like chocolate ice cream."

For another example, if you ask, "What went through your mind when the winds and water of Katrina came roaring through your neighborhood?" the answer might go like this: "What went through my mind when Katrina hit? I thought the wind was going to blow us away!" When you get back to the editing suite, you'll be able to use that quote anywhere, because it's a complete statement.

During the Interview

Remember that being interviewed is not a natural activity for most people, so it's up to you to put them and keep them at ease. Your body language speaks volumes. Maintain comfortable eye contact and lean forward in a manner that says, "I'm interested" without seeming overly intense.

Some videojournalists take notes during an interview. Note taking allows them to see the answers to their questions and make sure they have follow-up responses. Notes also help when it's time to edit. Other videojournalists find that interviewing the subject, checking the focus and framing on the camera, making sure the sound

SOME DON'TS AND DOS TO REMEMBER WHILE YOUR SUBJECT IS TALKING

DON'T:

- **Don't kid yourself into thinking that sharing your personal secrets will entice them to share theirs.** It won't. It only makes them think you're wasting their time. Nobody cares about you. Even famous interviewers like Oprah Winfrey and Barbara Walters succeed in ferreting out private insights without tipping their own hand or heart.
- **Don't do all the talking.** Again, it's not about you. You're not there to impress anyone. And don't clear your throat—just ask your question.
- **Don't preface questions with** "I'm wondering if … " or "I'd like to ask you this … " or "Here's a question … ." Also, don't offer your opinion as an opening statement. Get to the point. Pretend it's a 140-character tweet.
- **Don't interrupt.** Your voice will ruin the subject's audio track.

DO:

- **Do heed the power of silence.** If your subject answers a question tersely, incompletely, or unsatisfactorily, just sit quietly and look at the person instead of moving on to the next question. The silence may seem uncomfortable, but before long, he or she is likely to jump in and fill it. Your silence also conditions subjects to avoid simplistic or pat answers, and it shows them that you expect them to work a little harder and think things through. Psychotherapists use this moment of silence technique on their "subjects" all the time. You can do it too.
- **Do listen! Listen! Listen!** And show that you're listening (and not just getting ready to pounce on the next question on your list). Otherwise, you might miss the revelation of a key piece of information that begs further exploration.
- **Do use body language** to change the interview's direction. If you're getting an unusable long-winded answer, use body language (e.g., raising an index finger) to subtly but silently interrupt, and then say, "I understand, but … ." And then pose your next question.
- **Do resist the urge to say "mmm-hmm" or "yeah"** or emit other reflexive responses that are likely to intrude into the final audio. Instead, nod in acknowledgement, or use approving facial expressions (smile, raise eyebrows, and so on).
- **Do guide the interview** by using your list of topics and questions, but be open to possibilities. If you're listening carefully, you'll find plenty of opportunities for unanticipated follow-up questions that take you down unexpected yet fruitful paths.
- **Do repeat the question** if you don't get a satisfactory answer to a question; don't be afraid to rephrase it and try again.

has no interfering hisses, and so on, is enough of a job, so they don't add note taking to the list. You will find your own method of working after your have tried several one-on-one interviews.

How to Ask Questions to Get the Best Response

The single most important follow-up question is: **"Why?"**

The single most important follow-up question to a follow-up question is: **"Why?"**

Try a psychotherapeutic technique. "Mirror" your subject by **repeating the tail end of his or her response** as a method of eliciting an expanded answer as well as verifying your understanding of the response. **Subject:** "I think global warming is a fraud and climate scientists have deceived us for years.' **You:** 'Climate scientists have deceived us?' **Subject:** 'Yes, climate scientists were afraid of losing their grant money, so they rigged their data. . . .'

Ask **one question at a time**. Multi-part questions are too confusing and don't lend themselves to coherent, cohesive responses.

Keep the questions **short**. It's the answers that are important.

If anyone starts reeling off statistics, or any abstract concepts, ask for **concrete, real-world examples**.

Prod the storyteller who lives within all of us: **"What happened next?"**

Be unfailingly **polite**. Take the high road.

Common Problems and Dilemmas

Despite the best research and preparation, even the best interviewers are sometimes confronted with problems and dilemmas during an interview.

What should you do if the subject offers only monosyllabic responses? Skilled interviewers often follow up with questions such as . . .

Q: "Why?"
Q: "Can you expand on that, please?"
Q: "If you had to explain it to _____, what would you say?"
Q: "Tell me more."

Ask questions that call for a story:

Q: "What motivated you to become active in environmental causes?"
A: "My mother"
Q: "How so?"
A: "She took me to a rally when I was 12."
Q: "Really? Take me back to that event, and walk me through it. What were you thinking and feeling?"

What if the subject offers a lot of long-winded responses? Preface your next question with . . .

Q: "Briefly, Miss Jones, before the (video) battery dies, I want to make sure I get these few quick questions in . . ."
Feign disinterest.
Put down your list of questions or your notebook.

What if the subject is dodgy and evasive or outright lying?

Don't ever call anyone a liar or even suggest that he or she is not telling the truth.
Re-ask:
Q: "But XYZ has another perspective on that . . ."
Q: "For those who say [the opposite], how would you respond?"
Catch the lie on camera. Then unravel it when you interview other sources.

CONFRONTATIONAL INTERVIEW

What's the best way to conduct a confrontational interview, without losing the subject's participation or cooperation?

There's no better case history of this than David Frost's historic adversarial interview with Richard Nixon, available on DVD. (Or you can enjoy the dramatic re-creation in the movie 'Frost/Nixon').

▲ **The Epic Battle for the Truth: Frost/Nixon.** Poster from the movie about David Frost's interview with Richard Nixon.

Writing in *American Journalism Review* and using Frost/Nixon as an example, CNN's Mark Feldstein offers a "how-to" primer for confrontational interviews that includes these suggestions:

- **Take charge** immediately by interrupting self-serving filibusters and by carefully avoiding pleasantries that might weaken the necessary resolve to go for the jugular.
- **Go for the tight shot.** Prepare to zoom in slowly on the interviewee's face when the exchange grows heated. This cinematic effect visually reinforces the editorial goal of zeroing in on the quarry.
- **Use props.** As every good trial lawyer knows, tangible exhibits such as video, photos, and documents not only help buttress a cross-examination but also add theatrical flair.
- **Set up targets to lie.** You can't force anyone to do so, of course, but it is always better to provide an opportunity to tell a falsehood on-camera before (not after) you pull out the smoking-gun memo that proves culpability. A single lie captured on-camera shakes the foundation of everything else the subject says afterward.
- **If you've the luxury of having a second camera,** keep it rolling no matter what. That way, if your subject rips off his microphone or storms out of the room, you have footage of his defensive tantrum. Also, the second camera comes in handy if interviewees blurt out embarrassing comments during a lull when they think they are not being recorded.

Are any of these tactics unfair? Not at all, Feldstein says. "No more so than the carefully coached evasions, posturing, pontificating, stonewalling and outright lying that your target has perfected over a lifetime."

AFTER THE INTERVIEW

After the interview is over, you may be tempted to breathe a sigh of relief, pack up your gear, say "Thanks," and head out the door. But hold on—your work isn't quite done yet:

- Confirm that your video and audio functioned throughout the interview.
- Exchange contact information, and invite the subject to call you if he or she thinks of anything pertinent after the interview.
- Arrange for future interviews, if needed.
- When you get back to your work space, tie up any loose ends by doing the following:
- Transcribe and organize your handwritten notes while they're fresh in your memory.

- Write down any observations made during the interview, including questions for other sources, and ideas for additional video, that will support or refute what the person has just said.
- Verify facts, dates, statistics, and quotes.

HOW A VIDEO INTERVIEW DIFFERS FROM A PRINT INTERVIEW

Unless you're following your subject over a period of time, or in a variety of locales, you'll probably get only one shot at an in-depth video interview. If you forgot to ask a question, or later think of a follow-up question you wished you'd asked, it's probably impractical to go back for another formal shooting session to capture that one quote. Besides, the subject will probably be wearing different clothing from the original shoot, the lighting conditions may differ, and so on.

Now, if it were a print interview, you could just phone, ask your question, and insert the response wherever it fits best in your story. Not so easy with video. Instead, you would need to add missing information with your voice-over (VO) narration (if there is one) or perhaps with text that runs over the footage.

On the Record

By definition, a video interview is "on the record," whereas the subject of a print interview can try to negotiate conditions before imparting information (e.g., "off the record" or "not for attribution" or "confidential").

If the subject of a print interview mispronounces a word, or uses faulty grammar, or has a strong accent or even a speech impediment, all that may go unnoticed or get "cleaned up" in print. A video interview, by contrast, hides nothing. Certainly, some sections may be edited out, but otherwise what you see (and hear) is what you get.

TIP Learn from the best. Watch how the masters conduct interviews. Find journalists you enjoy watching, and study their techniques.

Better yet, as you're watching an interview on television or on the Web, imagine you're in the interviewer's chair. Listen carefully, and think about what question you would ask next.

If you're watching a video story in which the subject does all the talking, with the questions edited out, write down what questions might have elicited those responses.

What more would you like to learn? What other questions would you have asked?

AUDIO LOGISTICS

Now that you've learned how to prepare for and conduct an interview, here are some practical considerations for recording audio and video.

For a "sit-down" interview, your first challenge will be where to record the conversation. Start by finding the quietest place possible. Stand for a moment in each room of the subject's house or office, and just listen.

Check Ambient Noise

What noises do you hear? Do you hear the sound of the refrigerator going off and on? Can you hear the sound of the freeway traffic zooming by or the ticking of a wall clock? Repetitive noise like a hammer banging or a fan whirring is particularly irritating. Even sophisticated editing software cannot eliminate distracting noises like these.

As MSNBC multimedia producer Jim Seida observes, "We turn off the background noise in our minds—a radio playing, pen tapping, an air conditioner, but the recorder amplifies background noise, which removes it from its original context."

Make an On-Location Sound Studio

When you survey a situation for an interview location, look for a room with padded couches and thick drapes that will absorb sound.

"Sit on a couch rather than on a kitchen chair," advises Brian Storm of *MediaStorm.org.* "Cover a table with a blanket. Close the curtains. Turn off the computer. Unplug the fridge. Just remember to plug it all back in before you leave.

"What you're trying to do is create a sound booth for the interview wherever you are. This process is extremely important to the final product and equates to shooting an image against a clean background, as opposed to a busy one."

In extremes, Storm recommends interviewing in a car with closed windows. He cautions to avoid places with lots of echoes like gymnasiums or hallways. A small tiled bathroom is the worst place of all.

"If you have to interview someone in a space with bad acoustics, you can compensate somewhat by placing the microphone very close to the person's mouth," says Storm. "This will effectively amplify the person's voice and thereby reduce the ambient noise."

Placing the Mic for an On-Camera Interview

Ira Glass is the host and producer for the highly successful *This American Life,* an hour-long weekly program on Chicago Public Radio that is distributed by PRI. The program is well known for its ability to tell profound, almost visual stories in interviews. No pictures. Just sound.

In his booklet *Radio: An Illustrated Guide,* Glass says that placement of the microphone is the single most important factor in capturing a high-quality recording.

Proximity is the most important factor. Glass tries to locate the microphone four inches from an interviewee's lips. This proximity helps bring out the natural bass in the subject's voice and makes the person sound more "present." When the mic is close like this, the recording sounds richer and captures less of the natural hum in most rooms.

With the microphone this close, interviews can be marred by the sound of the subject breathing. Avoid recording the breathing sound by positioning the microphone below the subject's mouth rather than directly in front of the person's face.

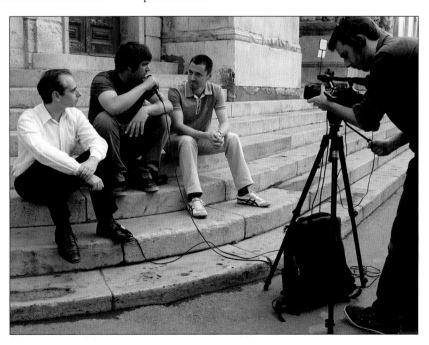

◄ **Wired Mic.** The videographer uses a microphone attached to the camera by a cord. He has placed the video camera on a tripod at about eye level with the interviewees. He is wearing headphones. (Photo by Ken Kobré)

Techniques of Recording a Good Interview

- Shoot with the red record light on the top of the camera turned *off*. This signal alerts you to when the camera is recording but can be distracting to your subject during an interview.
- Use wired or wireless lavalier mics or a handheld mic.
- Use both a shotgun and a wireless lavalier mic at the same time to help guarantee you've recorded everything.
- Keep the camera at least 8 to 10 feet from the interviewee—possible if you have one person operating the camera and another doing the interviewing, but harder if you are working solo.
- Use windscreens over the mic if you're recording outdoors and there is a breeze or a risk of a breeze coming up.
- Try to avoid placing an audio recorder with a built-in mic on a table between you and your interviewee. If you must place one on the table, put it on a soft surface such as a towel or a sweater to avoid the bounce-back of sound waves hitting the hard table and echoing into your microphone.

Shut Up, Please

If there are other people present during the interview, do not be embarrassed to politely ask anyone in the room to be quiet. Extraneous voices will dramatically reduce the impact of the interview. Ask everyone nearby to shut off their cell phones and unplug their landlines. There is nothing more distracting during an intimate interview than the obnoxious sound of a telephone ringing exactly when the subject is about to reveal something personal.

The Sound of Silence

Now that you are set to record the interview, take a minute to record silence. Of course, there is no complete silence. Your 60-second recording will pick up any ambient sound in the room, even if it's just the "room tone" of a quiet room. Later, while editing, you will find 60 seconds of room tone very useful. This audio can be used over places where a door banged, someone coughed, or you need to add a pause between a subject's sentences. (For more about recording interviews, see Chapter 8, "Recording Sound.")

Interviews in the Field

Of course, you cannot carry out all interviews in a sound studio, real or even contrived on the spot.

▲ **Deadline Every Second.** By putting a tiny wireless lavalier mic on the subject, the videographer was able to interview the photographer during his assignment. (Photo by Ken Kobré)

Interviewing someone as he is working has the advantage of saving time and bringing viewers into the subject's life.

In a documentary about the work of AP photographers, for example, a photojournalist was interviewed as he was covering a wildfire—allowing viewers to actually accompany the photographer on his assignment.

Despite the sound of fire crackling, the photographer's voice remained clear because a wireless lavaliere mic placed close to his mouth captured his speech while muffling the background sound. The ambient sound in situations like this helps reinforce what is being said.

VIDEO LOGISTICS
Keep the Background Simple

Besides trying to find a quiet place for your interview, consider what the background behind the subject will look like on screen. Try to interview people in their natural environments. Their personal workspace or living quarters lets viewers learn a bit about them. If possible, meet the subject at the site of a key element in the story.

▲ **Reginette's Story.** Bill Greene of the *Boston Globe* shot from a low angle and used a wide aperture on his lens to blur the background for his story about a 13-year-old girl who lost her leg in the Haiti earthquake. (Photo by Bill Greene, *Boston Globe*)

This can evoke powerful feelings and memories of the actual event for the subject and help viewers relate to the story.

Whether outdoors or inside, study the potential background carefully. Avoid having the proverbial potted plant appear to be growing out of the back of your subject's head. Other backgrounds that can be distracting include strongly patterned wallpaper, or a sign with bold lettering. Viewers may lock their attention onto these distracting elements and fail to digest what your subject has to say.

Interviewing subjects in front of a sunlit window presents two additional problems. First, the window is often lighter than the person, and anything bright in the video frame can be distracting to viewers. Also, if people pass outside the window, their movements will draw attention away from the person speaking.

The easiest way to achieve a nondistracting background is to pick a location that is visually simple. Don't be shy about rearranging a couch or table, moving pens and paper on a desk, or pushing potted plants out of the frame of your shot to improve the background for the interview. You also can ask the subject to change positions to improve the shot's composition.

If you're stuck with a distracting background, try to limit the light falling on it. You might have to close the drapes to a window or turn down the lights in the room. The tricky thing is to still leave enough light striking the person being interviewed.

TIP To avoid problems later, run this test. If you're shooting the interview in someone's home, position the camera and subject and then record a few seconds without the subject talking. Hit playback. Besides listening for any irritating ambient noise like the sound of a refrigerator or air conditioner, watch for bright lights or distracting graphics that might ruin the visuals of an otherwise great interview.

Framing the Interviewee

The basic interview shot includes the subject's head and shoulders and not much else. Commonly called a "bust" shot in video lingo, the close-up interview shot is framed tight just above a subject's head and extends down to a few inches below his chin. Don't waste excessive empty space above someone's head. Position his face slightly off to one side or the other of the frame.

Leave enough "nose room" so the frame's edge does not cut off an important facial feature. Leave a little room below the person's face—space you can use when editing to add a title with the person's name.

For a psychologically neutral shot, adjust the camera's height to meet the subject's eyes. Avoid having the camera pointed down toward the person, as this angle can suggest that the subject is subordinate and insignificant. From the other extreme, angling the camera up makes people seem extremely tall and therefore overly important and dominant.

FRAMING THE INTERVIEW

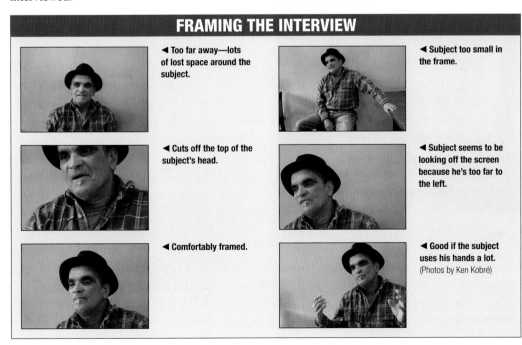

◄ Too far away—lots of lost space around the subject.

◄ Subject too small in the frame.

◄ Cuts off the top of the subject's head.

◄ Subject seems to be looking off the screen because he's too far to the left.

◄ Comfortably framed.

◄ Good if the subject uses his hands a lot.
(Photos by Ken Kobré)

When the subject is talking about something personal or emotional, prepare to go for the extreme close-up. Adjust the lens or bring the camera nearer so that just the person's face fills the frame. This extreme close-up shot pulls the viewer into the same emotional space as the subject and helps to cement a bond between them. *60 Minutes,* the most popular investigative journalism program on television for many years, often uses the extreme close-up technique to heighten the impact of their interviews. The shot is effective when someone reveals a loss or a bad guy admits his crimes.

Keep the Subject's "Eye Line" Even with the Lens

During the interview, the subject should look at you, not at the camera. You want to control the subject's "eye line"—where the person appears to be looking. You don't want anyone to appear to be looking at something off screen because viewers will wonder what is happening that they cannot see. Position your own head next to one side or the other of the lens. By positioning yourself in this way, you will control the subject's eye line. When the subject locks gaze with you, viewers have the sense that the interviewee is having a natural conversation with someone just off camera. You might have to stay in this awkward position for the whole interview, but your final shot will look professional!

"Put the camera at eye level when you are shooting interviews," reminds Steve Sweitzer,

former news operation manager for WISH television in Indiana. "Both the camera and the interviewer should be at the same level as the interviewee's eyes. So, if you're talking to kids, get down on your knees."

Ideally, Interview, Shoot, then Interview and Shoot Again

Photographers often must simply shoot first and ask questions later. If a student wearing a shark costume is walking across a college campus, shoot, shoot, shoot. Capture the candid moments when they occur. Do not interrupt the action until you have observed how other students react to this "fish out of water." Only then should you interview the walking fish and, hopefully, some of the passing students who have turned to react.

Sometimes you must ask questions first and shoot later. When working on a story about a geology professor who is going to lead a field trip to the local mountains, interviewing the teacher first is likely to lead you to watch for scenes that include the kinds of rock formations that coincide with the purpose of the trip. Had you not interviewed the professor before the hike, you would have been likely to miss photographing formations on the tour.

The real answer to "Which comes first, the interview or the photography?" lies in the need to do each more than once.

If you start with the interview and then shoot, you can watch for images that support the

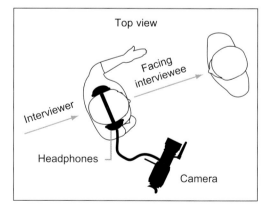

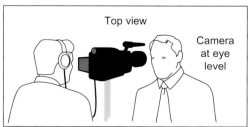

▲ **Watch the direction of the eyes.** For the primary interview for the documentary, the videographer stood just to the left of the camera in order to keep the subject's eye line even with the lens. (Photo by Ken Kobré)

▶ Try to maintain the best subject "eye line" for an interview. Adjust the camera so that it is at the same height as the person's eyes. Now position yourself on the left side of the camera, at the height of and as close as possible to the lens.

Oded Balilty's photo won the Pulitzer Prize for news

▲ In the documentary **"Deadline Every Second: On Assignment with 12 Associated Press Photojournalists,"** the videographer on camera interviewed AP photojournalist Oded Balilty as he related the situation that was unfolding the day he shot a **Pulitzer Prize-winning image.** (Produced by Ken Kobré and John Hewitt)

subject's remarks. Following this round of shooting, the best journalists will follow up with a second interview. The second interview provides another opportunity to seek information based on what was observed and photographed.

Depending on the subject's level of interest, you may even want to show him or her the footage you have shot and have the person comment, on camera, about the situations you photographed.

In fact, showing subjects your original footage, or even photographs or historical documents while recording them as they relive the experience or otherwise react to what is before them, provides dynamic material for marrying words and images during editing.

In particular, recording subjects' observations about footage you have shot of them generates a tight lock between images and audio that results in the clearest possible material for a multimedia or videojournalism piece.

(See also Chapter 9, "Combining Audio and Stills," for a further discussion of the problem of when to conduct the interview and when to shoot the candid photos.) ■

LOGISTICS CHECKLIST

- Check to make sure everything is working before you leave home or the office.
- Get to the shoot early and check all equipment again.
- Set up and check everything again.
- Start recording and check everything again.
- Wait to ask the subject to sit or stand in place until you are ready to shoot.
- Use the LCD viewfinder to confirm that you like where the subject is looking. The person will want to look at you, and that is good. Stand next to the camera's lens.
- Watch for distracting items or action in the background. Avoid poles, trees, picture frames, or windowsills coming out of heads!
- Come in close with the camera. A big face is good, especially for online video viewers.
- Pay close attention to the light! If you're in bright sun, protect the subject from squinting, but also make sure the sun isn't directly behind the person. In a home, you may need to move the lamps or close drapes for better lighting.
- Stay in one place and maintain eye contact with the subject. If you walk around, the person's eyes will be following *you*. That will look weird.
- Wear headphones! All kinds of noise can come along and ruin the audio during an interview. In many cases, you will not notice if you are not monitoring the sound.

▲ **Recording Narration.**
Often you must record the
voice-over narration track
yourself. (Photo by Stanley
Heist)

Writing a Script

Stanley Heist

Lecturer, Philip Merrill College of Journalism, University of Maryland

Imagine yourself as a composer writing a piece of music to be played by a world-class symphony orchestra. At your disposal are the woodwind, brass, strings, and percussion players, all ready to work together to produce beautiful music at your command. Your goal is to make these elements work together harmoniously in a manner that will be enjoyed by an appreciative audience. The decisions you make as you put your pen to staff paper determines whether the instruments play in concert or in chaos.

This symbol indicates when to go to the *Videojournalism* website for either links to more information or to a story cited in the text. Each reference will be listed according to chapter and page number. Links to stories will include their titles and, when available, images corresponding to those in the book. Bookmark the following URL, and you're all set to go: http://www.kobreguide.com/content/videojournalism.

In many ways, you can look at the videojournalism story you will produce in a similar fashion. As a videojournalist, you are the composer, but instead of musical instruments, you use **video**, **natural sound**, **interviews**, and often **voice-over narration** to communicate information to an audience. Employ these elements successfully, and you'll produce a beautiful story that is memorable and easy to follow. Toss them in haphazardly, and the same parts will still be there—they will just be in discord.

As a simple, linear outline of steps, it may appear that the *writing* portion of the process happens just before you must record the narration. However, the way we produce visual stories is much more involved. The truth is, the writing process begins from the first moments the story is conceptualized and ends only when the story is exported from the computer. Denise Bostrom, a professional scriptwriter and teacher of scriptwriting at City College of San Francisco, notes, "I've scripted many doc films before they're shot: for a proposal, *and* to save money and actually map out the content needed to cover."

Throughout the entire process, every decision influences how an audience will accept a story. The process is organic, and influenced by many factors: the sources selected for information, the interview questions and the answers they provide, the natural sound you capture in the field, the visual evidence you seek and gather in your videography, and the choices made in the scripting and editing process. All of these decisions dictate the direction a story will eventually take you and your viewers. This is why, from the moment you begin thinking about a story, it is so important to always keep in mind the end product.

THREE APPROACHES TO NARRATION

There are three approaches to narrating a video or multimedia piece. You can use an on-camera reporter. You can record a voice-over narration after the piece has been shot. Or, you can use natural sound—dialog, interviews, and ambient sound—to tell the story.

On-Camera Reporter

An on-camera reporter speaking directly to the audience is a common way we experience video stories while watching the six o'clock television news and often in documentary filmmaking as well. This way, the reporter sets up the elements of the story as it progresses.

At its best, the reporter's script is an easy-to-understand, relatable companion to the visuals and sounds in the piece. At its worst, the reporter's sound bite is distracting, unnatural, and it removes viewers from the experience of the story.

For the traditional on-camera **stand-up**, a reporter looks directly into the camera and delivers a few lines to viewers. Here is the rationale used in broadcast news for stand-ups:

- Introduces the journalist to the audience
- Creates a sense of "liveness" that can help establish credibility for viewers
- Gives the audience a "familiar face" that they have gotten to know over the years of viewing a particular channel
- Provides an opportunity for the journalist to put on a demonstration for the audience, such as how to fix a faucet
- Quickly tells the reader the facts of the story

The downside of having a reporter explain the story on camera is that it takes the focus off the story and its subjects and redirects the attention to the presenter. It also often deflates the drama, because we're told about the events, rather than seeing them unfold—as occurs in a natural *cinéma vérité* style. As a result, viewers may pay more attention to the on-camera reporter than to what the journalist has to say.

For this reason, in this book we emphasize either using voice-over narration or allowing the subjects' own voices and observations to tell the story, either through interviews or sound recorded while they go about their normal activities.

Voice-Over Narration

A voice-over narration is recorded after shooting a story is finished. The videojournalist doesn't decide what to say in a narration until everything has been shot and reviewed. The voice-over narration emphasizes the content of the story, not the personality of a reporter standing in front of a camera. Really good narration actually adds depth to the story by informing us about what we're not seeing.

Voice-over narration can be especially useful in situations dealing with:

- **Complex concepts, such as in economic, scientific, and industrial stories.** Experts in these fields have extensive knowledge but often need help simplifying the facts for an audience. A meteorologist could explain the development of super cell thunderstorms

in the Midwest in terms that might be understood by fellow scientists but not by the general audience. A voice-over narration track can help clarify some of the more complicated details.

- **Historical pieces for which primary sources are no longer available.** A story about the Civil War would benefit from narration because there are no survivors of that era. That's not to say it is impossible to pull off—there are a lot of experts on the subject—but narration allows you to share the exact information you found in your research.

- **Situations in which key sources are unavailable to go on camera.** This is no excuse not to do a story. Whether it is distance, the desire to remain anonymous, or some other factor that is getting in the key source's way, narration can tell the complete story.

- **Stories that need additional context than that provided by sources.** There are (at least) two sides to every story. For example, although your subject may explain why she believes a certain law needs to be repealed, she may be less likely to explain the benefits of the law. A narration can explain the opposing side and put a situation into context from a neutral perspective. A narration often helps to clarify certain sections of a documentary, or to add back-story, or in some way to deepen the story.

- **Stories in which the subjects speak little or no English.** Sometimes you will encounter subjects who have a terrific story to tell but have difficulty communicating it to an English-speaking audience. Narration is often a better choice in this situation.

For example, this writer once shot a story about a children's ice hockey team from China that visited Baltimore for summer camp. Interviews were not very helpful—only one child on the team spoke English. Careful narration along with using images and sounds of the kids just being themselves made the story memorable.

In a story by Ed Rollins for *Time* magazine about children abducted by a rebel group in southern Sudan, a voice-over stitches the story together because the boys could not speak English.

Sometimes voice-over narration can sound like the **voice of God** speaking. The narrator speaks down to the viewer from a position of an all-knowing authority. It is especially an issue

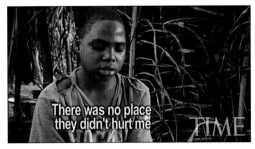

▲ **The Lord's Resistance Army Hunts Children in Sudan.** Fifteen-year-old Moses and two other children were abducted in the night from a farm village and subjected to gruesome atrocities by lawless members of a rebel group who regularly seize and enslave boys from rural areas in southern Sudan. The voice-over helps to explain the story. (Produced by Ed Robbins, *Time*)

when the voice seems to come from nowhere, and is not appropriate for the subject matter.

Scriptwriter and teacher Denise Bostrom observes, "This style of voice-over was particularly evident in early '50s documentaries post WWII. On the other hand, docs produced today with an unseen narrator like Peter Coyote—whose voice seems to be used everywhere—seem more 'natural.'"

The older films today appear laughable because people in normal conversation simply don't speak to each other in an announcer's voice. The so-called "voice of God" is not natural or conversational. In a 1997 article for *Film History*, "Historicizing the 'Voice of God:' The Place of Vocal Narration in Classical Documentary," Charles Wolfe describes this form of narration as aggressive, absolute, and "fundamentally unrepresentable in human form." For the viewer, this style often comes off as arrogant, condescending, and detached.

The role of voice-over narration, sometimes called a **reporter track**, isn't to be all knowing or authoritarian, but instead to set up details and reveal facts as the videojournalist knows them. A narration should allow the visuals and sound to speak for themselves. In this way, we write **objectively** (present the facts as we know them from a neutral position) and use sound bites, succinct or telling segments of interviews or recorded natural sound **subjectively** (our subjects communicate their emotions, opinions, and experiences).

Natural Sound

A third approach to storytelling is to use only **natural sound and sound on tape,** a technique sometimes referred to as *cinéma vérité*. In this case, there is neither a reporter on camera nor a voice-over narration. According to Alan

Rosenthal's book *Writing, Directing, Producing Documentary Films and Videos,* this style was born in the 1960s when cinematographers could take advantage of lighter and more mobile equipment to gather stories on their own. *Cinéma vérité* allows the recorded elements—natural sound, sound bites, and visuals—to present the story.

Many documentarians choose to use the *cinéma vérité* approach:

- Interview subjects tell their story in their own words.
- No third party (a reporter or narrator) steps into the process of storytelling.
- The audience experiences the piece as being told *in the subjects' own words.* From the viewers' perspective, there is nothing between them and the subjects; this approach can build a sense of intimacy.
- Viewers interpret the material themselves and draw their own conclusions.
- Viewers are not distracted by trying to determine the possible bias of an on-camera reporter or off-camera writer for the voice-over.
- The producer does not need to take time to record a voice-over.

As is true with all storytelling decisions, the use of an on-camera reporter, voice-over, or purely natural sound should be based on *which is the best way for the viewer to experience the story.*

By the way, many beginning videojournalists choose to forgo narration simply because they are not fond of their own voice. But not having a perfect voice is a poor excuse for choosing this approach. As we will discuss later, it is not necessary to have a great voice to be an effective narrator.

Natural Sound or Narration? A Test

Putting together a natural-sound story without any voice-over narration can be tricky. You must be certain that you have the proper elements to tell the story completely. If you can answer "yes" to each of these questions, chances are good that your story possesses the elements necessary to be told in natural sound. If not, then you will probably be better off writing some narration.

- Do I have sound bites that explain each point of the story?
- Are my sound bites expressed in complete thoughts? Do they require only minimal internal editing?

- Do I have visuals and sound that can easily explain the "who, what, when, where, why, and how" of the story?
- Do I have opposing viewpoints to give the story balance when necessary?
- Do I have enough appropriate footage to give the story context?
- Do I have a succinct opening sound bite that logically begins the story?
- Do I have imagery that corresponds?
- Do I have a solid concluding sound bite that wraps up the story?
- Do the visuals support the words?
- Do I have audio that sounds clear and is easily understood by the average viewer?

Challenges of the Scriptless Story

Make the decision whether to use narration *before* you shoot one frame of video because the success of a natural sound story will depend entirely on the elements you gather. If you go "all natural," you will need sound bites or visual evidence to support all of the necessary elements of the story. These include the introduction of characters and plot points in such a way that viewers can easily understand them. Typically, a natural-sound story requires much more raw material to work with than a scripted piece, because without a script to explain the story, you must capture *all* of the story elements in the shooting. And all those elements don't always occur precisely when you are there with your video camera.

To accomplish the scriptless story, you'll need to seek out responses during interviews that will stand alone without the benefit of an on-camera reporter or a voice-over narration.

To achieve some scriptless stories, you will need to pre-interview and then script the documentary very tightly based on the information you've learned—before you begin shooting. You must ensure that the story can be told entirely by on-camera subjects.

Be prepared for things to change. Sometimes stories are planned to be natural-sound pieces, but when the elements fall short, narration becomes the better option. It is possible (but unlikely) to go the other way—to shoot a story as a narration piece, and decide during the logging process to turn the story into a natural sound piece. Discovering that you have the elements to do a natural sound piece without advance planning is usually nothing more than a happy accident. No matter which direction chosen at the outset, you must remain flexible throughout the process.

▲ **Start the Video.** Youth from the Mormon Church participate in a handcart event near the Utah-Wyoming border. Look for opening shots that help develop the exposition of a story. (Photo by Jeffrey D. Allred, *Desert News*)

▲ **End the Video.** Always make sure you have a closing shot like this one of 3-year-old Mia Peterson, who cries with her mother, Rebecca, as she waves goodbye to her dad. Her father, along with other members of the 2nd Battalion, 211th Army Aviation Regiment, is departing for a 12-month deployment. (Photo by Jeffrey D. Allred, *Desert News*)

AFTER THE SHOOT

After you have finished shooting for the day, download all the material to an external hard drive. Then take the time to label each individual clip with a unique name. Transcribe the audio from any of the clips that contain potentially usable dialog.

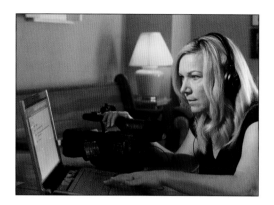

◄ **Reviewing the footage.** WBFF-TV reporter Kathleen Cairns reviews media after a **shoot.** (Photo by Stanley Heist)

Labeling and transcribing are parts of the process that are tempting to skim through, or even skip altogether. After all, you should have a pretty solid idea of what was recorded, because you did all of the shooting, right? Unfortunately, memory and reality often differ vastly. So don't allow yourself to cut this corner. Even the "one-man-band" who does it all needs to transcribe in order to review material before he or she can organize it or write to it.

◄ **Look for the Juice.** Original notes: 00:04:18 WS > Kid with flag **(Translation:** 4 seconds, 18 frames, wide shot, moving to the right across the frame, Kid with flag.)

You don't need to log every shot—just the ones you think will help when writing the script. Look for action and moments in the raw material and make a note. In this compelling shot, the Beijing Cubs, a youth hockey team from China, takes the ice behind their flag. Note the time code, framing (wide, medium, or tight), the direction in which the action is happening, and anything else to help you describe the shot.

The more aware you are of the elements you have to use, the more accurate and efficient the editing and writing will be. Often you'll discover elements for your piece that will surprise even you . . . who witnessed it all. Offhand comments someone has made. Funny expressions on a subject's face or natural sound picked up by the mic. Other times, your recollection of an event is much more dynamic than it really was. Labeling and transcribing are the points in the process where you take stock of what you actually have that's usable, so you may write your story with confidence.

Log Those Shots

If you will be the person editing the final story, it isn't necessary to note all of the visuals, but you will probably find it helpful later if you note or "log" key images with video and filmmaking shorthand: **WS** for wide shot, **MS** for medium shot, **CU** for close-up, **POV** for point-of-view shot, and **RS** for reaction shot. **FG** denotes action in the foreground, **BG** action in the background. Keyboard carets such as <, >, ^, and v can help explain the shot's screen direction. Screen direction means the direction the action is going, or which way an interview subject is looking. (For more on screen directions and types of shots, see Chapter 10, "Shooting a Sequence.") You also should be listening for **natural sound** or **nat sound (NS)**, those little bits of environmental sounds that you can pepper into your piece later to help with the pacing or to give the story a more natural feel. Honking car horns, a ringing phone, chirping birds—they all provide natural sound that you can use for emphasis. Finally, the acronym **SOT** (Sound on Tape) in this context refers to observations or conversation recorded while a subject is in action. Even though recording tape is all but disappearing, the term remains.

Also think about jotting down your shots in the field, too. Many pros keep a reporter's notebook so that they can log pertinent details as they happen. For an even more professional approach, use a "script supervisor form" to log the production and content info in a clear and organized manner. Making notes in the field also helps you determine whether there are missing shots or overlooked answers to questions so you can recall them before wrapping up field production.

One additional benefit of being a fastidious note-taker, says Mike Schuh, an Emmy award–winning reporter from WJZ-TV in Baltimore, is that it gives you immediate feedback on your performance as a news-gatherer. "A really meticulous log of what you have shot in the field will help you to pinpoint your successes as well as your failures. The next time you go out you will probably not repeat those mistakes."

Even if you're working by yourself and are under deadline, taking the time to know what sound bites and visual moments you have recorded will make scripting and editing that much more efficient later. "What you're looking for," says Schuh, "is *the juice,* or the elements needed for the story."

At first opportunity, Schuh goes through his raw media files and types onto a page those elements he's likely to want in his piece. "I start at the beginning and go to the end, in sequential order," Schuh says.

It's important to see everything, even if it's just a quick scan through the raw material. Be discriminating in what you actually detail. If you log everything with too much detail, you'll never finish, he cautions. In the end, a successful log for Schuh is when almost all of the elements that he notes in his log end up in the story, with little left over.

Label Your Clips in the Editing Program

Most editing programs allow you to label clips as they download to the computer. Labeling will be helpful, especially for finding sound bites and video in the editing process. At the very least, you can make some notes in the program about the interviews and include short descriptions of B-roll.

A more in-depth option is to write a log on a separate form, such as in a scriptwriting program, a word processing program or in a notebook. The advantage to having all of your information together on easy-to-access pages is that you can find the material quickly when it comes to writing.

However you choose to label and transcribe, it is best to do it in a quiet place where you will

be able to concentrate. Using headphones helps eliminate distractions.

Take stock of all of the elements: the visuals, the natural sounds, and, of course, the interviews. Look for the *natural moments*— such as subjects showing emotion or interacting with one another. As you find an element that you want to save for later, make note of what it is, who is doing it, and where it is happening. All of these notes will be helpful later while writing and editing.

WRITING THE SCRIPT

Now that you've determined where you are going to take your viewers, it's time to start scripting the piece. To save money and time, scripting should begin before production and then be refined in postproduction and editing.

If you are using *cinéma vérité* to tell your story, a "script" will consist of your subjects' sound bites and the visuals that support them organized so that they tell the story without narration.

Writing a narrated script should be relatively easy, considering that much of the hard work is already behind you. Still, there are some good principles to follow as you write.

Write for the Ear, Not for the Eye

The printed word can be read and reread for clarification, but with video the viewer will get only one shot at comprehension. **Keep it *simple,* and keep it *conversational.*** Many scripts look brilliant on paper, only to sound stiff or confusing when read aloud. Your audience *hears* your words. They don't read them, so avoid complex and verbose sentences. Instead, aim for short, declarative sentences or phrases. Consider this example, with accompanying video of a high school student on stage at a theatre rehearsal:

> From watching his hard work at rehearsal, it is evident that Taylor is dedicated to the theatre program.

versus:

> Taylor's dedication shows . . .

In the first example, the phrases "from watching his hard work" and "theatre program" are redundant, as we are already watching his hard work on stage. Also, "shows" is much more efficient and easier to hear than "evident."

In the second example, only the important words are used. Because we see Taylor up on stage, the line "Taylor's dedication shows" supports the visual.

VIDEO SHORTHAND

Logged footage:

03:08:06 WS, 2S> Rebecca SOT: "He's very special to me, he's different. That's why I plan to get his name tattooed on my body." (:12)

Translation from shorthand notes to English:

The shot occurs on the footage at 3 minutes, 8 seconds, 6 frames. It is a wide shot. There are two people in the picture. Rebecca says, "He's very special to me, he's different. That's why I plan to get his name tattooed on my body." The shot lasts for 12 seconds.

Does the shorthand make better sense now?

Use Active Voice

Subject-verb-object. This simple formula works well. Avoid the "to be" verb—"is," "was," "will be." When you change this verb from passive to active, you will by necessity select an action verb. In the following example, the verb goes from "is" to "trains." Now you have some concrete action to shoot.

> The puppy is trained by Grace (**passive voice**)
>
> versus
>
> Grace trains her puppy (**active voice**)

Use Ellipses to Mark Pauses

Ellipses are an easy way to visually reference where you want pauses to occur in a narration. Pauses signal dramatic emphasis and break up sentences so they're more conversational. The visual break (. . .) allows you or a narrator to notice it while reading and thus avoid accidentally running through the intended pause. Using ellipses as a pause allows you to omit unnecessary words. The pause gives a dramatic emphasis, and signals that there is significance in the thought.

> Grace trains her puppy, but it is her parents who learn the lesson.
>
> versus
>
> Grace trains her puppy . . . her parents learn the lesson.

Introduce Important Characters with Words

Be certain to introduce people who are significant in your story through a line of script—or a sound bite in which they can introduce themselves—rather than using type alone under the picture, a technique called a "CG" or **c**omputer-**g**enerated lower third graphic. For ancillary characters—or someone who appears briefly—a CG alone is fine and additional setup is not necessary.

The second time you mention someone in the same story, it is more formal to use the subject's last name only. But in stories that are more emotion-driven, informal, involve children, or have multiple characters with the same last name, you can consider calling a subject by first name. Use your discretion—if you're unsure, go with the last name.

When describing someone's occupation for the first time, his or her **title** goes first, then the **name**. In the following examples, the second one puts the subject's name immediately before the action (does tricks); the former has "trapeze artist" in that position, which creates a brief disconnect between the subject and the action:

> Hailey Smith, trapeze artist, does tricks . . .
>
> versus
>
> Trapeze artist Hailey Smith does tricks . . .

The Strength of a Sentence Is at Its End

The final part of the sentence often has the most resonance with the audience. Decide what you want to emphasize, and place that thought at the end for maximum impact

> *In an instant, there was jeopardy for Peter's dream.*

The emotive parts of the sentence, *jeopardy* and *instant* are in the middle, thus losing emphasis.

> *In an instant . . . Peter's dream was in jeopardy.*

Here, the word of maximum impact is "jeopardy." If you want to emphasize the concept of jeopardy, this would be effective.

> *Peter's dream was in jeopardy . . . in an instant.*

Here, the emphasis is on "instant." If you want to emphasize how fast the change happens, this phrasing would work.

Set Up the Visuals, Don't Describe Them

You want to strike a balance in which the words set up the visuals so that you are not explaining what viewers can see for themselves. Trust that viewers are looking at the screen and collecting information from what they see. Visuals should be supported with words so that the audience does not feel like it is being spoon-fed and can observe and interpret the action on their own.

Let's say, for example, you're doing a story about a dog whose paralyzed rear legs are supported by a little wheelchair in order to herd sheep—a compelling visual story! When introducing the dog to the audience, you could write a line that says:

> Duke uses a wheelchair to herd the sheep.

This is an example of writing *exactly* what the viewer sees. It doesn't give the viewer the chance to discover what's happening, but instead it spoon feeds the information. By contrast, a more powerful line would be:

> Duke goes to work for the cause.

◄ **"Duke goes to work for the cause."** The viewer can see that Duke has a wheelchair. You don't need to tell viewers what they can see for themselves.

This phrasing alerts viewers that Duke is about to do something special, and then we see him do it.

A good way to think about this is to "say it" with words and "prove it" with the visuals.

Sound bites for emotion, narration for facts.

Use sound bites that are **subjective**, that give opinions, express emotions, and convey feeling. Avoid using those that give basic information—you can write facts such as numbers and dates into the voice-over script. A not-so-compelling sound bite:

> "Thirteen homes were damaged, two of them destroyed by the storm in this neighborhood." (The quote is emotionless. The quote contains important facts that could be handled better in the written narration.)

versus a compelling sound bite:

> "Even though we lost our home, we have a new appreciation for life." (Emotional. Succinct. Powerful.)

Don't Steal the Thunder from the Sound Bite

Set up the sound bite so that the character has the most powerful words:

> **Narration:** Mary considers the damage minor, compared to losing someone she loves.
>
> **SOT (sound on tape, comment recorded during subject's activity rather than later in an interview):** "Even though we lost our home, we have a new appreciation for life."

Here the narration is redundant. Compare:

> **Narration:** Mary keeps everything in perspective.
>
> **SOT:** "Even though we lost our home, we have a new appreciation for life."

In each the narration sets up the subsequent quote.

Let the narration deepen the content or move the story further. If the narration merely reiterates what the subject is saying, then it's stopping the action, which you don't want to happen. Think of your job as a pin setter at a bowling alley. You set up the pins, and your subject knocks them down.

The Mouse Is the Ultimate Control

Keep the story moving so that the audience is not tempted to click away. Once a point is covered, move on to the next one.

Pace

Pace your stories in an appropriate and varied way. Moments of tension should be written with quick lines of narration and short sound bites, while moments of reflection should go longer and have some room to breathe.

Use Short Bursts, or "Pops"

Use a short burst of natural sound to reinforce key messages in a narrative. You can even use everyday sounds that you might otherwise take for granted. A door slamming, cash registers ringing, birds chirping—they all give the viewer a different feeling about the piece's pacing, setting and emotion.

Present Tense

Keep your verbs in present tense. Use "says" rather than "said" when setting up a sound bite and "does" rather than "did" when talking about an action. An obvious exception would be in cases of historical reference (President Lincoln *gave* the Gettysburg Address, not *gives*).

Build from Small to Large

Another consideration when making complicated material more digestible is to start small and scale up. This builds a natural crescendo for viewers that can help maximize impact. This is especially useful when dealing with stories involving numbers that are hard to conceptualize or put in perspective.

For example, if you're going to list the top five parking ticket scofflaws in your city, it's natural to start with the one with the least tickets and build up to the most egregious. This builds tension in an otherwise boring list of numbers. The viewer is not likely to remember the *exact* figures, but they will understand easily that the last one is significantly larger than the first.

Another way to handle big numbers is to turn them into something that people can easily visualize. Attempt to illustrate a scale that can be easily conceptualized—something is "as big as three football fields," is "taller than the Empire State building," or "if placed end to end would stretch around the world" are helpful **analogies** that make abstract concepts more easily understood.

Finally, when dealing with numbers, if a specific figure isn't absolutely required, it's usually permissible to approximate. For example, by car the distance from Philadelphia to Boston is 307.5 miles. It's much easier for you to *say* and for the viewer *to hear* "about 300 miles" or "a little more than 300 miles." For very large figures, try to find a way for viewers to understand the context quickly. When talking about a percentage of a population, instead of saying "twenty percent" say "one in five." The last thing you want to do is make viewers do math in their heads, especially when they should be paying attention to your story.

Which "Voice" Is Best?

First person (I) is usually reserved for instances when you as the videojournalist are a direct participant in the story. This is very rare, and should be used with great care because doing so implies bias.

Second person (You) is also rarely appropriate for documentaries. When narrating to an audience, you are not claiming that the audience is an active participant. They experience the story, but they are not directly involved in the process.

Third person (Jane Doe/He/She) is usually appropriate. Your role as an observer is best portrayed in this manner. It is important, however, to remain objective and natural and to avoid the mistake of being omniscient and booming. This is the voice of God effect mentioned earlier that turns off many viewers.

SCRIPT FORMAT

The actual script (see example) is formatted into two columns such as that for "P-Nickerson story." On the right are the narration track, natural sound bites and sound bites written out in full, and narration script. On the left are your video cues for the edit. If you are editing your own story, it's not necessary to write every video cue—you should have an idea of what shots you want to use by now. However, if you are writing to *specific* shots, this is the place to note them.

P-NICKERSON'S STORY
9/59/04

Tape #	Time Code	Time	Format	Date
Unknown	Unknown	04:50	PKG	9/29/04

News Central Archive

Production Cues:	Text:
[0]	(NATS-[0]-turning farm gauge)
TAPE 3 3:04:55---	THE SIMPLE SERENITY OF THE EASTERN SHORE.
[1]	[1](NATS)-crop duster-
TAPE 3 3;42:17--GREAT NATS-- AND COUNTRY SHOT	IT'S WHERE CORNFIELDS CAN OUTNUMBER CARS...
	[2](NATS)-crickets-
[2]	AND STEEPLES ARE THE ONLY SKYSCRAPERS.
CRICKET SOUND	
	-Music???? (soft piano-solitude)
CORNFILELD-CHURCH-FARM SHOT???	
	(voice) [3]"its nice being out here.. kind of quiet"
[3]	[4]A TOWN LIKE STILL POND IN KENT COUNTY, DOESN'T GET TO GREET A LOT OF VISITORS.
TAPE 3 3:20:44---	
	(NATS) [5]
[4]	
	IT NEVER HAS A TRAFFIC JAM. [6]
welcome sign	
	[7] (voice) "and we'll play football today..."
[5]	
	AND ALL OF THAT SUITS THE NICKERSON'S JUST FINE.
car passes in still pond	
	[8](NATS) "ready??? catch..."
[6]	
	[9](nats (CATCH) "all right")
--OMIT--MAYBE TOO LONG???	
	[10](PHIL NICKERSON) "its a nice place for the kids to grow up"
[7]	
	[11](NATS) -Baxter running after the ball-

▶ In this **sample script**, the video notes are on the left and the audio notes, narration, natural sound dialog, and music are in the right-hand column.

When writing the script, most reporters start from the beginning and go straight through to the end. Some videojournalists, however, find it easier to write the beginning lines and the closing lines first, and then work through the middle. The front and back approach allows you to concentrate your strongest efforts first on the two most important parts of the script and then fill in the middle later. That strategy also helps when dealing with temporary writer's block. Especially when working under deadline, spending too much time looking for particular words of inspiration can make the edit a real time crunch. Having a detailed outline helps avoid writer's block during the scriptwriting process.

Traps to Avoid While Writing

* **Falling in love with your words.** Knowing what to leave out is just as important as knowing what to put in. Sometimes a line of track or a sound bite seems really valuable because it is clever, but if it doesn't fall within your focus, leave it out.
* **Writing for print.** One of the toughest challenges for writers starting out is the temptation to write narration as if it is a term paper. Read your lines of track aloud to see if they are written for the *eye* or for the *ear*.
* **Cliché.** Sometimes a cliché is effective, but more often than not it's a sign of lazy writing. It's easy to say that something that is expensive "costs an arm and a leg," but that lacks originality. Use this temptation as an opportunity to be more creative. Invent your own clichés.
* **Giving away the surprise.** Almost every story has some opportunity for surprise. Think about what makes the story or the subject special. That's usually where you'll find it. Don't start the piece by giving away the best element. Instead, allow the audience to discover the surprise for themselves—it will be much more powerful.
* **Parroting.** When writing into or out of a sound bite, be sure to *set up* the sound, not just speak the same words that the subject is about to utter. As mentioned earlier, don't steal the thunder of the sound bite. When the voice-over track and subject's sound bites say the exact same thing, one of them needs to go.
 Narrator: "Davis says it was a terrible ordeal."
 Dave's sound bite: "It was terrible."
* **Forgetting your audience wasn't there.** Because you researched and shot the story, you have much more intimate knowledge of the story than does your audience. They are not experts on the subject. So be sure that they are learning what they need to know. If there's time, it's very helpful to screen the rough-cut with some nonexperts to find out if the piece is clear to them—or not.
* **Dumbing it down.** This is a common complaint about television news. Just as it's important not to talk over the heads of the average viewer, no one needs to be spoon-fed everything, either.
* **Follow up with an Internet search.** One of the benefits of online journalism is that the audience can go deeper into a story if they feel like they want to know more. Give the audience a URL so they can search for more information about a topic.

Read It Over

Finally, when you've written your script take a minute and read it over, aloud. Do the words flow naturally? Are there grammatical errors or phrases that sound odd when read? Revision is a major last step—even for seasoned pros. "I am an obsessive reviser when I have time," says Boyd Huppert of KARE-TV in Minneapolis. "I will write, and then I will reread and rewrite, and I'll go through a script line by line until it says something to me. I'll look at a line and think, 'What does this say? Can I say it better? Is the strength of the sentence at the end of the sentence, which is where it should be?' A good sentence should build. 'What can I do with this to make it more interesting?'"

Take time to review your script and solicit feedback from others—especially anyone who's not as familiar with the story as you are. Huppert sometimes shares his scripts with his family—whom he calls his "focus group." A fresh set of eyes—even untrained ones—can go a long way in making the story memorable.

Screenwriter and teacher Denise Bostrom suggests that listening to someone else narrate the voice-over is also great way to hear how the narration sounds. She also suggests showing the piece to an audience without sound to see if they can grasp the subject just by the strength of the visuals.

PREPARING TO RECORD

Now you're ready to put your hard work into words and create the voice-over, which can be spoken directly into your computer. Many non-linear editing programs allow you to record your

▲ **The Car as a Temporary Sound Booth.** WBFF-TV reporter Kathleen Cairns prepares to record a voice-over in the car. She will lower the jacket over her head to help muffle any echo from the windows. (Photo by Stanley Heist)

▲ **Bad Location for Recording Voice-Over.** This narrator is in a poor location to record an audio track. He's in a large, hollow conference room. The white board and table will cause his voice to echo, and the microphone is much too far away from his mouth to get the clearest sound possible. His posture is hunched over, which will limit the power of his diaphragm.

▲ **Good Location for Recording Voice-Over.** In this location, an empty office, the reporter should find better success. He is using a shotgun microphone with a narrow pickup pattern directed at his mouth; he is standing up straight; and is next to a carpeted cubicle wall, which will absorb some of the sound.
(Photos by Stanley Heist)

narration, which can be a great advantage. You can edit the video and record a voice-over at the same time on the computer. Many computers have a built-in microphone, which eliminates the step of recording your script into the camera first and then downloading the file into the computer. Also, you have access to the video itself if you wish to review any shots or time a segment exactly with the narration. Finally, when dictating the narration into your computer, if you choose to revise your script in the editing process, you can rerecord the voice-over immediately.

If you don't have inputs for professional-level microphones and a mixer for your computer, though, the audio quality may not be as good as it could be if you recorded the narration into your camera.

Microphone Choices

Regardless of whether you record into your camera or directly into an editing program via the computer, you should select the best mics for the job. Test your mics to see which gives the best result for your voice-over narration. (For more on audio recording, see Chapter 8, "Recording Sound," and Chapter 11, "Conducting an Interview.")

Location, Location, Location

Choosing a location to record your voice-over track is just as important as selecting the microphone. If a soundproof audio booth is not available, find a location that is small, away from sound, free of fans and other white noise, and has no reflective surfaces that may cause an echo. When nothing else is available, some pros sit in a car to record their audio. They can drape a jacket over their heads to prevent their voice from reflecting off windows. A closet can also work,

provided that there is no echo when speaking. Soft objects such as clothing dampen some of the echo, but a utility closet with bare walls would likely produce an unacceptable sound.

Sit Up Straight!

Wherever you record a voice-over track, maintaining a proper posture will help you get the most of your voice. Stand up when you deliver your lines. Never slouch. Poor posture will crush your diaphragm, which will limit your ability to project and speak clearly. A straightened back also makes you feel more confident, and that confidence will be transmitted through your speaking voice. Smiling will help, too.

THREE, TWO, ONE . . . YOU'RE RECORDING

Once a suitable location is found, it's time to begin the process of recording. Do an audio check for levels first by reading a few lines of your script.

This is the time to relax, review the script one last time, and prepare to speak at a normal level.

When you have an acceptable audio level, it is time to record the narration. Begin at the start of the script, give a countdown from three, and go. It should sound like this:

> Three . . . two . . . one . . . (pause one second, keeping rhythm) [READ YOUR FIRST LINE OF NARRATION]

Scripts written for narration are often broken into small sound bites divided by a series of ellipses. Once you get started . . . read through the first section of script up until the end of the first sound bite . . . Sound bites usually consist of one or two short phrases . . . then . . . give a pause for editing. Read the next section of the script . . .

Stopping and restarting in between narration tracks causes a natural interruption in the flow, which anchor/reporter Greg McQuade from WTVR in Richmond, Virginia, says makes your voice sound more newsy than natural. "When I first started out I was holding the scripts, tracking '3 . . . 2 . . . 1 . . . ' (between each section of script), and they sounded like news track," McQuade says. "I would listen to myself, and it was as if I had changed personality in the audio booth. It didn't sound natural. I wanted to sound like Greg telling a story to a friend, I didn't want to sound like 'journalist Greg McQuade' in an audio booth." By stopping for only a brief pause between script sections, McQuade finds that his narrations sound more conversational.

Conversational Means Believable

Another suggestion for sounding conversational is to try to speak with the same mannerisms that you would outside your video production. If you are animated and speak with your hands, put the script down, and read the narration with your hands free to move. If you are holding the microphone, mount the script to a stand.

One way we talk to friends is by using hand gestures. "We all do it whenever the message is important to us. It's a visual way of being more clearly understood," says vocal coach Nick Dalley of Intentional Communication, Inc. Dalley recommends keeping at least one hand available for gesturing while recording your voice. When recording a narration, McQuade follows that advice, even though he knows no one is *seeing him* in the audio booth. This way his voice speaks with the same intonation when recording a narration as it would with a friend on the sidewalk.

Try visualizing another person in the room with you. If you are comfortable with the way you deliver your lines, the audience will find them just as comfortable and normal.

All of this effort to sound natural will make you sound more believable, says vocal coach Dalley. Gone are the days of the Ted Baxter–like "whiskey baritone" voice and the authoritative voice of God effect discussed earlier. In other words, you don't need to be blessed with—or try to emulate—a perfect voice to be considered an effective communicator. Dalley says that good audio narration means having a clean and easy-to-understand voice—one that sounds much the same as one friend talking to another.

Have You Got Rhythm?

Another consideration is the **rhythm** that your voice creates. When you listen to yourself read your lines, do they begin to have the same length, the same pattern in syllables, or the same intonation? Is it beginning to sound like a poetic cadence? It's easy for your narration to become predictable without even trying. Read these three lines aloud:

> Smith walks into the diner . . . he has a seat at a booth . . . he orders a small coffee.

Hear the rhythm develop? It becomes predictable. Now, try this:

> Smith walks into the diner . . . he has a seat at the booth and orders a small coffee.

Same phrases, but turned into one short phrase, followed by a long phrase (reworked with the conjunction "and"). A simple solution can shake things up. As Dalley points out, we don't normally speak in a predictable rhythm, nor should we voice a narration that way.

Use Your Vocal Range

Avoid speaking in a monotone. That's not to say that you should try to go outside your normal vocal range. (Viewers are good at spotting false qualities.) But speaking within your natural range, feel free to use all your normal tones.

Hit Periods

Stop at the period for as long as it takes to breathe. When you do not take advantage of the period for breathing (or swallowing), you'll be required to breathe in the middle of the next sentence. Breathing mid-sentence comes across as breathless and out-of-control.

Take a Listen

When you have recorded the track, listen to it. Make certain that the audio levels are consistent, and that there is no undermodulation causing a hiss, or over-modulation causing distortion. If the sound is clean and clear at a full audio level, then the story is ready to go to edit.

Remember, sounding good does not mean sounding *perfect.* For the audience, a quality voice is one that is easy to understand, and sounds human.

Be Flexible

Finally, some of the best writing happens with the revisions you make during the edit. The KISS rule—*Keep It Simple, Sweetie*— applies here as well. Sometimes a compelling story can be sabotaged by a desire to impress the audience with complicated verbiage and techniques. There is another old rule—this one from show business—to consider: *Always leave them wanting more, never wishing they had less.* Keep these things in the back of your mind as you approach your work, and you should find the process of writing and narrating an enjoyable one for years to come. ■

▲ **Editing Software.** Apple's
Final Cut Pro X software for
editing video.

Editing the Story

Kathy Kieliszewski
Deputy Director of Photo and Video, *Detroit Free Press*

E diting does not start in the editing room. From the story you choose to the questions you ask to the variety of shots you record, all the way to your piece's final cut, you are editing. At each point in a story, you must be thinking about producing the final product. Which shots are necessary to make sequences? What quotes and natural sounds will fully convey the story? If you have been thinking about the edit from start to finish, you will be able to assemble the sound and visuals to seamlessly form a well-structured story once you finally sit down at the computer.

This symbol indicates when to go to the *Videojournalism* website for either links to more information or to a story cited in the text. Each reference will be listed according to chapter and page number. Links to stories will include their titles and, when available, images corresponding to those in the book. Bookmark the following URL, and you're all set to go: http://www.kobreguide.com/content/videojournalism.

And it is at this stage in the process when you will appreciate an old adage that says the best video makers are those that have been editors.

Once you are wearing your editor's hat, you will want to wring the photographer's neck (that would be your own neck) for forgetting the 180-degree rule, for shots that are too short to edit cleanly into sequences, for zooming back and forth rather than moving in or out with the camera. You will want to yank the interviewer's ears (those would be yours) for failing to wear headphones and not noticing an annoying scratchy sound interfering with your subject's moving story. You may have to call upon all your skills and resources to pull the piece together. You may have to ditch it completely. But perhaps for your next story, your shooting and recording efforts will become remarkably more refined.

Some editing programs available today include: Apple's iMovie and Final Cut Pro X, Adobe's Elements and Premiere Pro as well as Avid's Xpress Pro Studio HD. Alternatively, you might want to learn to edit with one of the free software programs such as Pinnacle's Videospin, VideoThang or Microsoft's Movie Maker. All of these programs are constantly evolving and changing. You will need to refer to their manuals online or search the Internet to find the most current instructions that will help you to use the program efficiently. There is additional material on editing at KobreGuide.com.

YOUR VIDEO EDITING SOFTWARE

Because there are so many different video editing programs available, it is impossible to provide a step-by-step guide to building and editing your story in every software option. Instead, we identify some key concepts you'll come across in most programs.

At KobreGuide.com, you will find links to a variety of training resources.

- Online courses
 - *Lynda.com* is an online training site for a range of different editing programs. The courses use a series of video clips to teach in a gradual, easy-to-follow, step-by-step method.
 - New York Video School provides a series of short, easy-to-follow tutorials that show how to perform the basics for shooting and editing journalistic videos.

- *MediaStorm.org* provides online training for professionals working to expand their storytelling capabilities, advanced students in multimedia reporting and production, motivated citizen journalists, teachers looking for quality educational content for the classroom, and newsroom editors in need of resources for their team.
- How-to Books available on Amazon
 - Apple Pro Training series
 - *Final Cut Express 4: Visual QuickStart Guide* by Lisa Brenneis
 - *Final Cut Pro Workflows: The Independent Studio Handbook* by Jason Osder and Robbie Carman
 - *Final Cut Express 4 Editing Workshop* by Tom Wolsky
 - *Adobe Premiere Pro CS5 Classroom in a Book* by Adobe Creative Team
 - *Sam's Teach Yourself Adobe Premiere Pro in 24 Hours* by Jeff Sengstack
 - *Focal Easy Guide to Premiere Pro: For New Users and Professionals* (The Focal Easy Guide) by Tim Kolb
 - *Adobe Premiere Pro for Dummies* by Keith Underdahl
 - *iMovie '11 & iDVD: The Missing Manual* by David Pogue and Aaron Miller
 - *iMovie '09 & iDVD '09 for Dummies* by Dennis R. Cohen and Michael E. Cohen

Most programs follow the same basic layout of tools and conventions, making it relatively easy to switch from one to the other.

Nondestructive Editing

Editing with a nondestructive editing program such as iMovie, Final Cut, Studio, or Premiere does not actually affect original digital video files. Instead, your work directs the software to the location of the file on the computer and identifies when to start and stop playing the clip you are assembling. Regardless of how many times you change or reedit, the original file remains intact.

Save Early and Often

Most software programs have an **autosave** function that can be set to save at specific intervals. You will discover how incredibly helpful this is once you have forgotten to save, the program crashes, and all your work and time

disappear. You will be able retrieve the most recently saved project file from the autosave vault. Even without using autosave, you will avoid a lot of future headaches if you manually save early and often!

GETTING ORGANIZED

Once you've shot interviews, gathered spontaneous dialog and lots of video footage or photos, written your commitment statement, and voiced the narration, you are ready to start assembling the pieces into a cohesive story. But first, you need to get organized.

Storyboarding

Making a plan for your story's narrative arc is called **storyboarding**. You'll want to do this before, during, and after the field reporting, making changes along the way. You might be able to storyboard some stories in your head, but for most of them, you'll want to work with a physical storyboard.

Storyboards are basically visual outlines that help organize a story. Originally used for movies, they consist of notes and sketches of scenes or even parts of scenes. Below each visual are partial or whole dialogs and notes for the scene.

You may want to make small prints or screen grabs of each scene for your storyboard and lay those out on a long table. This method will not only help visualize the story, but more important, will walk you through the narrative and

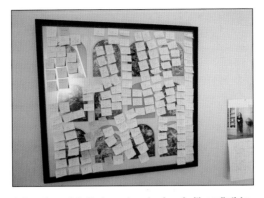

▲ Some journalists like to create a **storyboard** with small sticky notes that they can lay out on a table or wall near the computer. These notes contain two- or three-word descriptions of scenes or quotes from interviews or dialog as reminders of what is taking place.

allow you to reorganize scenes and experiment with possible alternative arcs.

At some point, you may be collaborating with other journalists, producers, or editors with whom you'll want to share these storyboards. Digital storyboarding programs, including a free one called Celtx, are particularly useful for collaborating.

When working on the storyboard, remember to write a commitment statement (see Chapter 4, "Producing a Story") as the first main heading. Think back to the basics of outlining a story or a report. That outline usually had a thesis statement that you then needed to prove. In essence, the commitment statement serves the same purpose as a thesis statement: in

◀ **Naming Each Video Clip.** Students log their clips at a video workshop in Perpignan, **France.** (Photo by Ken Kobré)

one sentence, tell what this story is about. The outline should cover the main points of the story and a description of each scene that will move the story forward. The outline should describe the opening, how the main points are going to be shown, and then the closing.

However you choose to build your storyboard, you'll find creating one useful in planning for your story arc and perhaps even trying out other options. When and if your storyboard is really complete, weaving the final story together in whichever video editing program you use will be a breeze.

Setting Up Your Project

Getting organized is a crucial part of editing. On even the simplest of stories, you may have two or three interviews, more than an hour of B-roll, and multiple photographs. The interviews, B-roll, and photographs are called a project's "assets."

First, set up a **project folder**, usually on an external hard drive with more than adequate space. A full project complete with all its supporting material may range in size from a couple of gigabytes, or gigs, to hundreds of gigs. In that main folder, you will nestle additional folders for different types of files and media.

To save yourself the trouble later on, take a moment to gather all the pieces that will be integrated into your video before even creating the project file.

For example, when the *Detroit Free Press* produced "Rising from the Wreckage"—a five-part documentary on the rise, fall, and reinvention of the auto industry—the project folder consisted of 13 subfolders. These organized everything for the project, including footage shot by the *Free Press*, imported footage from various other sources, PDFs of newspaper pages, photographs, music, titles, and scripts.

These folders were then sorted into six sections called bins in the editing program used by

the *Free Press*. The bins were labeled: Footage/Media, Intro/Outro/Titles, Music, Narration, Photos, and Sequences. Nested in these main bins were other bins used to sort the video by interview subjects, various B-roll, and types of footage.

Import the original video file you shot with your camera onto your external hard drive and into the project file. Leave it there and try to avoid moving it. If you do move the project file by choice or by chance—or any of the project's video or audio in the subfolders—the link between them and the editing program will break and you will have to reestablish links between the original file and the edited piece.

Refer to your own software's manual for a complete description of how to set up your files. Also check out the editing section of this book's website.

Labeling Your Clips

Once you download files from the video camera to the hard drive, immediately label each video clip individually. Each clip is really one of those shots you made while recording video. It's the material recorded from the moment you press "record" to the moment you stop recording. Another clip results from the next stretch of moments between record and stop.

The term "clip" is a holdover from the days of editing film, when sections of film would be clipped for editing. With that step eliminated, editing software recognizes each segment (shot) downloaded from the camera and allows labeling of those shots, which at this point come to be referred to as "clips" in many editing programs—and by most video editors.

You will need to develop your own clip naming convention to save time when you want to go back and locate the appropriate clips for editing. Label each interview clip with a few critical words of the sound bite. There usually is a place in the browser window, sometimes called "log notes," to place a more complete transcription of a sound bite.

Some programs will automatically analyze downloaded video files. These scan the material and create tags such as: camera data, shot type, and whether the shot contains one person, two people, or a group. These tags can be used to sort, filter, and search the clips. You can also assign your own keywords to the clips.

For more about using your program, go to KobreGuide.com.

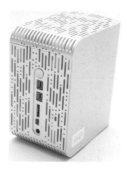

▶ Most videojournalists store their projects on an **external hard drive** because video files eat up so much hard drive space. A variety of hard drives available today are suitable for video storage. When working on "Rising from the Wreckage," *Detroit Free Press* videojournalist Brian Kaufman used a 1-terabyte (1,000-gigabyte) drive to hold the project.

Transcribing the Interviews

In a *Detroit Free Press* documentary on the life and death of legendary Detroit Tigers announcer Ernie Harwell, 15 people were interviewed for the story. In addition to a previous interview with the main character, Harwell himself, interviews featured former broadcast partners, Detroit Tigers baseball players, everyday fans, and baseball experts. Their relevant quotes, edited down, help tell the story. Footage of Harwell calling baseball games from the broadcast booth was interspersed with peoples' comments on the broadcaster's announcing style.

The Harwell story also included historic photographs as well as some footage from his funeral. These visuals played while the 15 interviewees were talking.

To pull together the story, the editor transcribed all the interviews and natural sound dialog. This transcript was vital to the editing process. For shorter stories, videojournalists on deadline don't always have the luxury to transcribe interviews, but for longer documentaries, this step is crucial.

▼ **Historic Photo.** Ernie Harwell, legendary Detroit Tigers announcer, takes a closer look at the action on the field. (Photo by Scott Eccker, *Detroit Free Press*)

The *Free Press* editors used the transcript to form a "paper edit" script. They could then eliminate all of the original questions. In the paper edit, the editors cut and rearranged the responses so that the answers flowed into a coherent story. The editors then tested the story by reading and timing the script themselves. Finally, they added a narration to compress important details of Harwell's career. By combining voices and visuals, the editors created a meaningful video documentary.

◄ **Statue of announcer Ernie Harwell with his microphone in Detroit.** (Kathy Kieliszewski, executive producer and video editor, and Mandi Wright, lead videographer, *Detroit Free Press*)

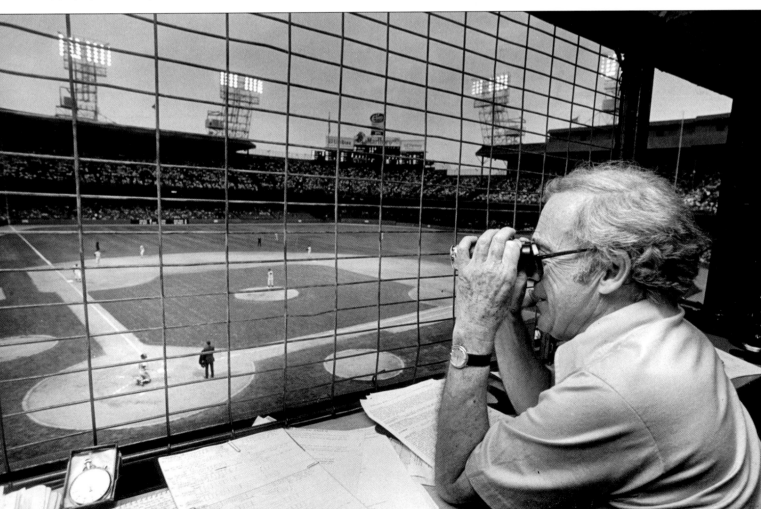

PUTTING IT ALL TOGETHER

Video editing is the process whereby individual clips are joined in sequences and the sequences are linked to create a coherent and compelling story. Learning the basic principles of editing enables you to create video and multimedia pieces that grab and hold your viewers' attention.

Audio Before Visuals

Brian Kaufman, an Emmy award–winning video-journalist and editor at the *Detroit Free Press*, says that audio *is* the story. "Nothing else matters until you can tell the story through audio," he says. He suggests closing the editing software's window that displays visuals to prevent yourself from looking at images while laying down audio tracks.

You should be able to just listen to the story and have it make sense. If you have beautiful visuals but a weak interview and no natural sound, you will have something pretty to look at, but the story is likely to be incomplete.

So editing begins with the audio. You will need to listen to the interviews, identify relevant quotes, and then transcribe those quotes. Transcribing will reveal whether the story can be told without a narration or needs a voiceover to provide details or background that support your subjects' quotes. In either case, seeing the words on paper allows easily arranging the quotes and narration into a comprehensive story before ever sitting down at the computer to start editing.

So the audio part of your story actually should sound like a radio documentary. If it makes sense without pictures, a story will be even more successful with visuals.

Having the *Free Press*'s Ernie Harwell story transcribed on paper allowed the editor to relate the potential visual components to the words being spoken.

Edit your audio material in this order:
* Interviews
* Natural-sound moments
* Voiceover narration
* Music

SAMPLE SCRIPT

Here is a sample of that script. The left side lists the audio. This includes the formal interviews, the natural-sound bites, and the script for the voice-over narration. The right side lists the visuals:

Audio	Visuals
Dickerson SOT There were just certain elements of his style that I really liked and try to incorporate in how I call the game.	See Dickerson
Script: Dan Dickerson replaced Ernie as the play by play announcer for the Tigers when Ernie retired.	
Dickerson SOT I think it is a different style because of how he started and how I started—50 years after he started in terms of the information you have available and how you approach a game.	Dickerson in the booth at Tigers game
Script: 50 years ago, announcers didn't always travel with the team . . . but they still had to call the game . . . so the only information they had was a ticker tape sent over from a telegraph operator who would transmit the information back to the studio from the ball park.	Photo from Baseball Hall of Fame of radio announcers recreating game
Ernie SOT	Use old-time radio visuals here
McGraw SOT I imagine recreating a game from hundreds of miles away must have been great training, but I still can't imagine doing that.	See McGraw
Ernie SOT on recreation	Cut to Ernie

TYPES OF CUTS

Editing programs allow the shortening of clips, cutting out the beginning or end, for example, to leave only an important section in the middle. Although you will have shot a minimum of 10 seconds of video, an edited clip may last only a second or two. Some may run for 30 minutes or more. A 5-minute documentary might consist of hundreds or even thousands of individual clips put together, but each clip must be edited separately.

The Common Cut

Joining two clips with a **cut** simply means abutting one shot against the next. A clean video cut between two shots is usually no more noticeable than switching our attention from one person to another during a conversation. We do not notice that our eyes scan a distance between the speakers. We just realize that at one moment we are looking at one person and then, seemingly instantaneously, we are looking at another. Most documentaries consist of a series of clean cuts between hundreds or even thousands of individual clips.

Cutting on Action

Cutting on action is when the cut happens at a point of action. Editors start the cut at the beginning of the action or even into the action. They cut from one view to another view that matches the first clip's action. Although the two clips may actually have been shot hours apart from each other, cutting on action gives the impression of continuous time when watching the edited piece.

By having a subject begin an action in one clip and carry it through to completion in the next, the editor creates a visual bridge that distracts the eye from even noticing the cut or noticing any slight continuity error between the two clips. An example of this cut might show a man, from the back, walking through an open door to leave his office. The next shot, taken

WORKING WITH MUSIC

Music can be created and recorded by the editor/producer. It's also possible to pay royalties to use certain music. Another source for music is easily downloaded, royalty-free tunes that are in the public domain. Check Creative Commons for copyright use guidelines.

Also, music can come from ambient sound from, say, a car radio, a live band, or other source playing while a scene is being video recorded.

Music can be a powerful way to set the tone and dictate the pace for a video. It can also be overdone and manipulate viewers' feelings.

It's important not add emotion or drama with music that doesn't already exist in the story. If you have shot a scene with a strong emotion, don't add music that may compete and potentially overpower it.

Familiarize yourself with different types of music and understand how those genres fit into different scenes—hip hop and a rodeo might not be the best match, just as country music will probably not mesh with a heavily suburban setting.

In a beautifully paced video, "William and the Windmill," by Randy Risling and Lucas Oleniuk from the *Toronto Star,* the music is an integral part of the storytelling. A tribal-like beat accompanies the visuals and natural sound of the windmill turning. The combination transports you to Wimbe, Malawi, the setting of the story. The natural sound of the windmill turning meshes so beautifully with the percussion tones that it seems as if they are one song.

The music changes as William achieves the goal of building the windmill and then subsequent windmills—intensifying the feeling of triumph and success. The ending is brought full circle with the return of the intro music. It is a perfect example of how music in the edit can enhance a story by setting the pace, giving a sense of place or mood, and reinforcing key emotional moments without overpowering the narrative. ■

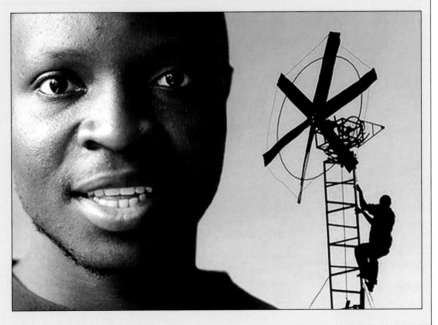

▶ **William and the Windmill.** This *Toronto Star* video tells the inspiring success story of a poor African boy who comes to be a local—and international—hero. The music helps to carry the story.
(Randy Risling and Lucas Oleniuk, *Toronto Star*)

from outside the office building, would show the man just as he exits the door. Cut together, the action would seem continuous.

Cutting on the Rest

Cutting on the rest means waiting to make the cut until the subject has walked through the door and stops, say, to look around. He is searching in the parking lot for his vehicle. The next cut would be to the scene after he looks around. This clip could have been shot from his point of view, showing the parking lot.

Avoid Cutting During Pans, Zooms, or Tilts

Avoid cutting during pans, zooms, or tilts to another shot that contains a pan, zoom, or tilt. Moving shots like these need to have a steady, fixed beginning and ending to work successfully. Cutting from one zoom shot to another will completely disorient viewers.

Cutaway

A **cutaway** is a close-up of some detail that is inserted between two clips of action. It is often used to cover a break in the action or to speed up the action. For example, a woman is decorating a Christmas tree. You start with a wide shot showing her start to hang an ornament on the tree. Then you cut to a cutaway close-up of the ornament itself. Then you might go back to a medium shot as she finishes attaching the ornaments. The cutaway, like sleight of hand during a magic trick, distracts the eye and obscures the real time an event or action requires. A cutaway allows you to speed up or slow down the action on the screen. Suspending and adjusting a tree ornament might have taken a few minutes in real time but the cutaway allows it to play out in just a few seconds on the screen.

Parallel Cutting

Parallel cutting is used to show two parallel actions taking place at the same time. In the very first silent films, a movie might show a heroine strapped to the railroad tracks, then cut to the approaching train, and then back to the heroine struggling to free herself, and then back to the approaching train. Two parallel but separate scenes—the trapped woman and the train barreling down the tracks—are cut together. This type of edit adds obvious tension to a scene.

An example of parallel cutting is seen in the *Free Press* "Rising from the Wreckage" series discussed earlier. An autoworker yells, "I say union"

and the video cuts to other workers in another part of the picket line yelling, "We say strike." The next shot is a car driving by with a passenger raising a clenched fist in solidarity with the strikers followed by another shot of strikers and passing cars. All of those actions are meant to appear as if they are happening at the same time—and for the most part they are—but there is no way everything could have been recorded in a single shot.

Jump Cut

The **jump cut** occurs when a piece of video from one part of an interview is spliced with another segment from the same interview, causing the subject's head to appear to jerk at the edit point. The solution is to cover the jump cut with a cutaway. (See Chapter 10, "Shooting a Sequence.")

Match Cut

A **match cut** joins together scenes that have similar visual elements to establish or reinforce a relationship between the two scenes.

One of the filmmaking's most famous match cuts appears in Stanley Kubrick's *2001: A Space Odyssey*. Near the beginning of the movie, an ape throws a bone into the air. The next cut is of a similarly shaped space station floating through space. The juxtaposition is jarring, yet viewers can link the two shots because of their visual similarity.

You don't have to be Stanley Kubrick to do a match cut. It can be an effective tool to link two seemingly dissimilar scenes together.

A potter forms a bowl by hand. A match cut might show the potter's hands lifting the bowl off the wheel in the first clip cut with a second clip showing those same hands placing the bowl in the kiln. By cutting the first clip so the hands are in the same place on the screen as the hands are at the beginning of the second clip, you are matching the action of the hands from one moment to the next. The match cut helps smooth the transition from one clip to another.

Being able to create match cuts, of course, relies on forethought while shooting the potter at work—watching those hands at work and photographing them at similar angles during the stages of the process. It's one more example of editing before you ever get to the stage of sitting down to the computer.

The Split Edit

A **split edit** is when either the audio or video of a scene arrives before the other starts. Viewers will hear the sound of the next scene before they

see the action associated with it. Example: you have framed a tight head-and-shoulders shot of a racecar driver being interviewed. The only audio is his voice. Then the audience hears the sound of a racetrack while they are still seeing the driver's face. Then the visuals of the track appear while the sound of the roaring cars continues.

A split edit simply brings in audio before its accompanying video appears. Jumping with both audio and video directly from the person talking to the sound and scene of cars on the track can be a bit startling.

You can also perform a split edit by leading with the visual and following with the audio.

Split edits are sometimes called **L cuts** or **J cuts** depending on whether the audio (J cut) leads the video or the reverse (L cut).

"Split edits make your edit points smooth and professional sounding," says Colin Mulvany, a videojournalist at the *Spokane-Review*.

Screen Direction

Screen direction is simply the action needed to move in the same direction on the screen from one shot to the next. You can't have a car going from left to right in one shot and then in the next shot see the same car moving right to left down the same road. (See Chapter 10, "Shooting a Sequence," on how to avoid this problem when shooting.)

Cross Dissolve

A **cross dissolve** allows two scenes to overlap—one fades out as the other fades in. A cross dissolve between two scenes works as a transition when moving from one time period or place to another. It also works to reinforce the relationship of scenes to each other. You might dissolve between a beach scene in Hawaii and one in Los Angeles, for example.

"Use sparingly," says Mulvany of the *Spokane-Review*. "Most beginning editors put in too many cross dissolves because they didn't sequence their video and need to transition from one similar wide shot to another. As my own sequencing abilities improved, I noticed that I started using fewer dissolves. I look back at my early work and cringe at all the needless cross dissolves."

Dip to Black

For a **dip to black**, also called a **fade in fade out dissolve**, the clip fades to a black screen and then fades up on the next clip. Dip to black should be used sparingly. Used appropriately, the

effect can signal the end of a major segment of the video and indicate that you will be transitioning to an entirely separate segment.

▲ **Avid Studio**

TIP Cross dissolve and dip to black are examples of video transitions between two clips. For them to work properly requires having some non-vital visuals, called a "handle," at the end of the first clip and at the start of the second so that they can overlap without losing crucial material. Otherwise, the editing program won't have anyplace to insert the transition. The software requires the few unused seconds from each clip to create the actual transition. If you need to use the entire clip and can't edit it, you won't be able to insert a transition—one of the many reasons to shoot at least 10 seconds for every shot.

Constructing a Sequence

Sequencing creates movement in video. Beginning videojournalists often shoot one wide shot of an unfolding scene. A single, wide shot results in a static view of even the most dynamic event. Sequencing adds emphasis by allowing cuts to a close-up of a key emotion or showing what the main subject is seeing with a point of view shot.

A sequence is built from a series of individual clips shot at the original scene. A clip edited to its essence might last from a few seconds to ten seconds or more.

These clips should include the five basic shots: wide shot, medium shot, close-up, point of view, and reaction shot. They can also include other types of shots like a dolly shot or a pan. (See Chapter 10, "Shooting a Sequence.")

To construct the sequence, place several short clips next to one another. In the example on the following page the video cuts between an overall, a close-up, and medium shots. The images are from a sequence about an operating room in the Democratic Republic of Congo that has no electricity or running water.

OPERATION

In an operating room in the Democratic Republic of Congo, doctors work without running water or electricity. Each of the five clips in the sequence will run from two to ten seconds when edited.

(Photos by Ken Kobré)

Wide shot—high angle

Close-up—face

Medium Shot—low angle

Close-up—detail

Wide shot—closer

The order of the clips for this surgery sequence depends on how you want to tell the story. You could start out with a wide shot of the room or with a tight close-up of the patient.

You are likely to have taken many different shots from a variety of angles. Depending on the complexity of the scene and what you are trying to say, you may actually be using ten or more clips to create one sequence.

You don't have to include the basic five types in every sequence, nor do you have to lay out the shots in the order that you took them. The more types of shots, though, the more visually absorbing a sequence will be. The final length of a sequence will depend in part on how long each clip runs and in part on the time necessary to accompany the audio track.

Use text judiciously. Most online video stories are accompanied by some text, but don't make your audience read screen after screen of text, especially at the start. Excessive reading has a high chance of boring viewers, and if you have only 10 seconds to grab attention, written text usually isn't the way to start. So, if you must use text, do it for the right reason and not at the beginning. Use it to move the story forward quickly if, for example, introducing your subject takes too long or if the person takes too long to make point in an interview. Or you may need to use text to provide some quick historical background.

Headquarters of the Associated Press — the world's largest news and photo agency

◄ Intertitles provide an alternative to voiceover narration. In the documentary "Deadline Every Second," the use of intertitles made narration unnecessary. (Producers Ken Kobré and John Hewitt)

Add text to a documentary in two ways. You can add words as the video runs, usually in the lower third of the frame, or you can split the video stream by displaying what's called an intertitle—type on a plain background.

Some producers prefer to use intertitles instead of a voice-over to set up a story or convey specific information. This device has been used since Hollywood's era of silent movies. Besides setting up the story, they can serve as a break between sections of the piece. Some producers feel intertitles help to avoid the "voice of God" effect (see Chapter 12, "Writing a Script") of an unseen narrator. Others argue that intertitles can interrupt the flow of a story and add extra work for viewers.

Don't let intertitles be an afterthought, though. Keep them simple, and proof them carefully.

EDITING A REPETITIVE ACTION

BOWLER EXCEEDS EXPECTATIONS

Sequencing was key in the story about Kolan, a developmentally disabled bowler who has rolled many, many perfect games. As Kolan took his turn with the ball over and over again, the videojournalist photographed different shots that were edited to convey one roll of the ball. (Produced by Brian Kaufman, *Detroit Free Press*)

Some of the images from the bowling sequence:

Shot 1: extreme close-up of Kolan shining his bowling ball

Shot 2: close-up of Kolan's face

Shot 3: wide shot of Kolan from behind looking down the lane

Shot 4: medium shot of Kolan's feet walking toward the lane

Shot 5: medium shot of Kolan's arm going back for the throw

Shot 6: medium shot of the ball release

Shot 7: point of view (seeing what Kolan is seeing)—shot of ball rolling down the lane and crashing into pins

Shot 8: medium shot of Kolan turning to return to his seat

Shooting this sequence was possible because Kolan used the same repetitive motion as he repeatedly threw the ball down the lane. This allowed the videojournalist to record different aspects of the sequence at different times during the same night of bowling. These various elements were then effectively edited into a smooth composite sequence. With multiple cameras and a Hollywood action budget, this sequence could have been shot once and then the views of the different cameras edited together. Short of a multiple-camera approach, a one-man-band like you has to shoot repetitive action several times from different perspectives and angles in order to build a sequence from multiple shots.

Sequencing also helps compress time. Although throwing a bowling ball is not the most time-consuming activity, Kolan's throw when sequenced in this manner consumes a few seconds less than real time. ∎

OVERALL ISSUES TO CONSIDER

The Opening Sequence

In the opening sequence of "Belle Isle Revealed"—the story of Detroit's signature park, an island in the Detroit River that is under attack from invasive species—one of the island's naturalists is seen on the riverbank hauling in a fish net in a wide shot that includes the bridge leading to the island.

Free Press video editor Brian Kaufman establishes that we are indeed on Belle Isle with that opening shot. He cuts to the net being lifted from the water in a medium shot, not yet revealing what has been caught in the net and thus setting up a small amount of suspense. Then we see a tight shot inside the net of fish flapping

around, followed by a medium shot of the naturalist pulling a fish from the net and saying, "This is a round goby."

Kaufman quickly cuts to an extreme close-up of the goby in the naturalist's hands. He lets that scene play out a little longer with another wide shot showing the naturalist on the shore again,

◀ **Belle Isle Revealed.** Movies often start with a wide shot of the location, such as this one of Belle Isle. (Produced by Brian Kaufman, *Detroit Free Press*)

▶ Adobe's Premiere Pro.

but with Detroit's skyline in the background. Then there is a cut to an extreme close-up of him pulling a fish out of the net, a medium shot of him dropping the fish into a plastic bag taken from a high angle, and then one more close-up of the fish in the bag.

"I have no rule about what scene to select to start the opening sequence," Kauffman says. "It's whatever makes sense for that particular scene in that particular video, based on the shots before and after it, in harmony with the narrative that's running underneath it, plus the overall mood you're trying to convey."

Pacing

A story's success is heavily tied to its tempo. The way the surprises are revealed and the way the quotes, narration, and nat sound are edited together to create a natural rhythm works to set the pace of the story. The pace should fit the mood and subject of your video.

Great video is like great music: it depends not only on a melodic line but also on the pace of the individual sections. The pace of music is often set with a beat throughout, but some parts of the score are played faster and others are performed more slowly to provide contrast and variety to the whole composition. The same thinking can be applied to video stories. Some parts need to drive the story; others cry out for a slower rhythm.

Think about what is being said in a story, how it is being said, what is being seen while it is said. Try to match the pacing to reflect that. The pace of the *Los Angeles Times* story "Waiting to Die" (see Chapter 9, "Combining Audio and Stills") is very slow, like that of the subject's labored breathing and halting speech cadence. The photos are quiet and reflective. If he were a fast talker or being rushed to the emergency room instead of talking very calmly about his visit to the emergency room, the slow pace would not match what is being seen and heard.

In a lecture at Macalester College in St. Paul, radio storyteller Ira Glass discusses pace in terms of a "45-Second Rule." Include an anecdote and then reflection for 45 seconds, he says, followed by another anecdote and reflection for 45 seconds, and so on. (You can see an edited version of Ira Glass's transcript online at *current.org*).

Sample a few videos yourself. You may not find all anecdotes hitting at exactly 45 seconds, but in well-done videos, a story plays almost like a song with syncopated beats. In Brian Kaufman's piece "Carrier of the Economy," an anecdote and reflection occur about every 30 to 38 seconds. Although shy of the 45-second mark, the rhythm is strong and the pacing well established from beginning to end. (See Chapter 3, "Successful Story Topics.")

Tom Putnam, a producer and director whose work has appeared on PBS and Sundance, believes that pacing is everything. "Even being a few frames off on the wrong cut can throw off the whole balance of a scene, and if it's the wrong scene it can wreck a movie."

How do you go about the process of determining pacing? Listen to the whole story at one sitting. Have others listen and watch their reactions. Ask yourself, "What else can be cut?" Rigorously follow the rule that less is more. A video editor is like a sculptor, after all, removing the inessential to create a masterpiece.

▲ Apple's iMovie

STEPS IN EDITING A VIDEO

Editing a video involves the following steps: making an outline, assembling all the pieces of the project, creating a rough cut, adjusting and fine-tuning the audio, and adjusting and fine-tuning the video. In the "fine cut," the rough edges are polished to add the credits, check the final run time, and get the piece ready for distribution.

▲ Apple's Final Cut X

Outline

See the section "Storyboarding," earlier in this chapter.

Assembly

Once you've created a complete project file and transcribed all the quotes, you are ready to start. Here is where you will order all the actual pieces—including interviews (SOT or A roll), voice-over and nat sound, and visual sequences (B roll)—by placing them in the editing software's timeline. Here is where you begin to see the bare bones of the story in the editing program and can consider whether the organization you've mapped out still makes sense or is missing anything.

At this point, individual clips have not been finely trimmed. You have not yet added transitions. You have not created intertitles.

Rough Cut

Finding the perfect organization for a story can be the most difficult part of the documentary process. Creating a rough cut will be the first step in seeing all the pieces cut together—video, audio, music, titles, and so on. At this stage, you don't need to worry whether each clip is the perfect length. With the rough cut, you are just going to get an idea how all the parts to this video puzzle will fit together.

Time for Feedback

Often at the *Free Press,* when a video is at its rough-cut stage, a group will gather to watch it and give feedback:

- Were there times the story dragged?
- Did a visual hang on the screen too long?
- Did it not stay up long enough?
- Is the rhythm uneven or not in sync with the mood of what is being said or seen?
- Is it a quote that is the problem or a visual?
- Are there not enough nat sound breaks or too few moments?

- Does the music match or conflict with the mood of the piece? Are the cuts in the video disconnected from the music or in sync with it?

All of these things affect pacing, and having extra sets of eyes and ears on your piece can provide an objective view of how the story moves along or doesn't. Be sure to take this feedback seriously and drag yourself back to the computer to polish the final piece.

Fine-Tuning the Audio

Once the story is ordered on your timeline, listen to it. Does it make sense? Are there any quotes that feel too long? Is there enough natural sound? Do the quotes and narration work together? How do the transitions work? The story should be based on a solid sound bed of audio. When you listen to the story, it should sound as if it were broadcast from a radio station.

Putting the finishing touches on your audio is a tedious but necessary part of the editing process. Adjust all the audio clips until they peak at about −12 dB.

Brian Kaufman of the *Detroit Free Press,* a proficient editor and expert in finessing the editing process, says audio should sound smooth and seamless throughout. One way to ensure you are hearing audio at its clearest is to always mix audio while wearing good-quality headphones.

Kaufman isolates individual tracks—turning off the volume on the other audio tracks—to get the sound level consistent across all the A-roll. He then isolates the B-roll track, adjusting where necessary. Finally, he listens to all the tracks together. B-roll audio typically fades in gradually just prior to a visual appearing on the screen and then fades out gradually, too.

Unblended audio is jarring to listen to. A sequence unfolding in a quiet office may transition to a busy street scene, for example. By pulling out extra frames of sound from the quiet office and overlapping that with those of the busy street and vice versa, the ear will not be ripped from scene to scene.

Editors use what's called an **audio cross fade** to smooth out editing points between cuts. Fading the sound makes the edit seamless, and a cross fade does this quickly.

Don't hesitate to cut out long pauses, stutters, and uhs and ums from interviews. Be mindful that when you do, you are likely to be cutting the video, as well.

▲ **Rising from the Wreckage.** Credits were extensive for the five-part documentary on the rise, fall and reinvention of the auto industry. They included acknowledging everyone from executive producer to scriptwriter. (Kathy Kieliszewski, executive producer, *Detroit Free Press*)

Fine-Tuning the Video

Once satisfied with the audio portion of a story, you can now start working on B-roll visuals—matching the visuals with the corresponding parts of the audio.

With the audio track and video track in place, view them together. Do the words and video complement each other? What you hear and what you see are heavily linked. A piece of video may correspond with its appropriate audio, but it's visually jarring if the video comes in one frame too early or one frame too late.

Now watch without the audio to see if the video makes sense alone:

- Does the story make sense visually?
- Do the sequences work?
- Do any of the visuals feel static or unnecessary?
- Where might video transitions such as fades or dissolves be necessary?

TIP Correcting color is possible in professional video editing programs that employ a simple color correction filter. Click the icon representing the filter, often an eyedropper, on what should be a neutral white in a clip—and presto—instant color cast correction. Usually, that is all that is necessary. It's a great way to instantly warm a color balance that is too cool and blue.

Video finessing can include adding motion to still photographs (zooms, pans, or tilts) à la Ken Burns. Although this motion can help emphasize a relevant part of an image, use a light hand. If overused, all that movement can feel forced. Stay true to video editing rules.

Giving Credit

The Complete Film Production Handbook, Eve Light Honthaner, Focal Press, includes an entire section on screen credits. Determining credits for a movie or video production can be a complicated process. There are even union and guild guidelines that dictate how credits appear and in which order.

You are unlikely to face these issues—at least at first. A simple video like those you are likely to produce—those in which you conceived the story idea, shot it, and edited it—need only one credit. "Video produced by" will usually suffice.

Otherwise, credit can usually be determined by the importance and the amount of work any given person contributes. In a complicated story, like the *Detroit Free Press's* "Rising from the Wreckage," the credits were extensive. This writer was the executive producer and project

leader on this story. Her job was to oversee the production of the video and all the visuals—video and photos for broadcast, print, and online—hence the lead credit.

Brian Kaufman received the second credit on the list for his exhaustive work as editor and producer. When thinking of order, consider whether the video would exist without a person's input. The goal is to give credit where credit is due when talking specifically about the video.

Executive Producer & Video Project Leader: Kathy Kieliszewski

Video editor and producer: Brian Kaufman

Lead Videographers: Romain Blanquart, Brian Kaufman

Videographers: Alexandra Bahou, Eric Seals, Marcin Szczepanski, Mandi Wright

Video Narrator: Mike Brookbank

Lead Script Writers: Brian Kaufman, Kathy Kieliszewski

Script Writers: Nancy Andrews, Mike Brookbank, Ron Dzwonkowski, Jim Finkelstein

Some credits are obviously mandatory and required. Licensed material such as footage, photography, or music often requires credit to the content providers. In the case of the *Detroit Free Press's* "Forty Years of Respect"—a look at Aretha Franklin's 1967 hit 'Respect'—the *Free Press* paid for the right to use that song in its production and was provided language to use in the credits.

"Respect" performed by Aretha Franklin Courtesy of Atlantic Recording Corp. By arrangement with Warner Music Group Film & TV Licensing

In cases where you may have paid for royalty-free music—stock music usually licensed for a single fee—the credit requirement often is the name of the song and artist. The same can

▲ **Forty Years of Respect.** The video producers were required to include in the credits that they had permission to use the song "Respect." (Nancy Andrews, online and video executive producer, and Mandi Wright, video and audio, *Detroit Free Press*)

apply to photography or video footage, so it is important to check the source and go through proper licensing of content in your production.

Frequently, you will see "Special Thank You to" listed in credits, and although not required, this is a great way to acknowledge people who went above and beyond to make your video happen in terms of granting access or helping with research in a unofficial way.

In the Ernie Harwell story from the *Detroit Free Press* discussed earlier, special thanks were given to a number of people, including Harwell's lawyer, who made the announcer's private collection of photographs available for the video.

Often, subjects are not given special thanks in order to avoid the appearance of favor being exchanged—such as a credit in the production in exchange for participating in the story. If you are unsure, leave it out.

As soon as you create something, you are the copyright owner of that creation, but including the copyright symbol along with the date lets others know that the work is copyrighted. This line is usually placed at the very end of the credits. Adding "All Rights Reserved" is an additional notice to potential infringers that the copyright holder has the right to create additional or derivative work such as a novel or a motion picture based on the original content.

As an alternative to "All Rights Reserved," you can share your video with others and allow them to put it on their website, re-edit it, or use part of it for a their own creative project. Creative Commons licenses offer a way to preserve your original copyright while sharing your work more widely.

Total Run Time

When editing a story for television, total run time, or TRT, is limited. In any given newscast, a finite amount of time must be divided between news, weather, traffic, and sports. On the Web, TRT is theoretically unlimited, but viewers' attention is certainly finite.

The most terrific quote, exquisite photograph, or surprising video moment should be killed if it doesn't support the central point of your story. The tongue-in-cheek adage of this philosophy is "Kill your baby."

Jeff Malmberg, a producer and editor whose work has appeared on ESPN, the History Channel, and A&E and whose first feature-length documentary, *Marwencol*, won the grand jury prize at SXSW 2010, believes less is more. "Don't overstay your welcome and don't answer

everything. An audience with questions is what I want. Make them connect the dots at dinner afterwards—allow them to interact with the material just like you were able to."

Studies show that online audiences are watching more and longer web video. A July 2010 report by comScore, Inc., a research firm, found that 178 million Americans watched online video content in that month with the average length coming in at 4.8 minutes. Does that mean you should make all your videos 4.8 minutes? Of course not!

◄ **Marwencol.** Here, Mark Hogancamp sets up a scene in a movie he created that was peopled exclusively by toy soldiers. "Don't overstay your welcome and don't answer everything," says the documentary's producer, Jeff Malmberg. "An audience with questions is what I want." (Photo by Tom Putnam. Courtesy of The Cinema Guild.)

The length of a video must be determined by its content. Boyd Huppert, of KARE 11 TV in Minneapolis, says he determines the length of his stories in terms of surprises—little gems of information and moments sprinkled throughout a story that will be talked about in more depth later. "If I can identify ten surprises, I can write a four-minute story. If I can find only three surprises," he says, "I will quickly lose your attention if I still try to write a four-minute story. Three surprises may sustain only a 90-second story. Granted, not everyone looks at things this way, but it's how I determine the length of my stories. When I've used up my surprises, the story must end." In other words, your story's length should be determined by how many engaging things you have to tell and show the viewer.

IT'S SHOWTIME!

Even if you've already had a viewing, gather your own audience one last time to watch the video for accuracy, pacing, and fairness.

Are they engaged from beginning to end? If not, where are the slow parts and how might you tighten them up? Did the pacing match the tone and subject matter of the story? Were the viewers left confused at any point? Were there technical problems?

Once you address any remaining issues, lock down your edit—and start the export! ∎

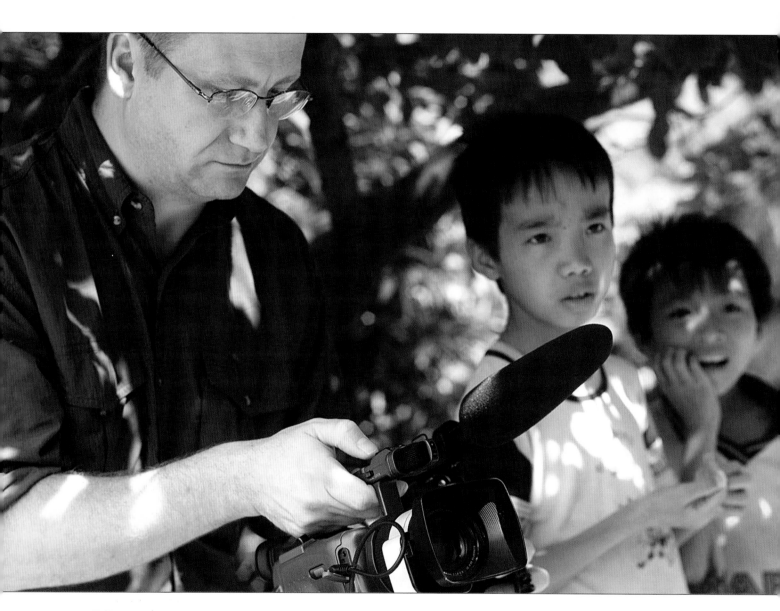

▲ **Making the Right Choice.**
Video and multimedia
producer Fritz Nordengren
shoots a video in Vietnam for
a nonprofit charity. "Morals
are a choice between good
and bad," he says. "Ethics
is when someone makes a
choice between two right
options." (Photo by Huy Nguyen)

Ethics

Donald R. Winslow
Editor, *News Photographer Magazine*

A s storytellers in a competitive environment, our goal is always to tell a fair, complete and accurate story. But at the same time, don't we also hope to tell a story in such as way as to snatch and hold viewers' attention? Can those be conflicting goals?

How do you stay within the ethical boundaries of the profession and still produce eye-grabbing video stories?

PHILOSOPHY OF ETHICAL DECISION MAKING

Videojournalists make ethical decisions based on three different principles: **the Golden Rule**, **the Greater Good Rule**, and

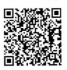

This symbol indicates when to go to the *Videojournalism* website for either links to more information or to a story cited in the text. Each reference will be listed according to chapter and page number. Links to stories will include their titles and, when available, images corresponding to those in the book. Bookmark the following URL, and you're all set to go: http://www.kobreguide.com/content/videojournalism.

the Absolute Right and Wrong Rule. Sometimes following these principles can lead to the same conclusion; at other times, they point to very different courses of action.

The Golden Rule

"The Ethics of Reciprocity," of Greek origin, is also known as "the Golden Rule." It says, "Do unto others as you would have them do unto you."

Ethicists have interpreted this rule to mean that we should treat others as we ourselves would like to be treated in the same situation. We must understand the implications and impact that our choices will make on the lives of others. Translated to videojournalism, that rule would state, "Take other peoples' pictures in the same way you would want your picture to be taken." If you were severely injured in a car accident, how would you feel about a videojournalist photographing you bleeding and injured, and then showing the footage on the evening news?

The Greater Good

The Utilitarian concept of the greater good, which can be traced to the Greek philosopher Epicurus, was popularized by British jurist Jeremy Bentham and English philosopher James Mill in the 1800s. The principle holds that within the potential rules of action, one should act only based on what the outcome will be, and that one's choice should be determined by which outcome will do the greatest good for the greatest number of people.

Journalism generally operates on the Utilitarian principle of making decisions in which the end result does the greatest possible good for the greatest number of people. For instance, you might be photographing a car accident. The very act of shooting pictures of victims might bring temporary emotional harm to the injured, but it might also save hundreds of lives if seeing the final footage serves to make viewers more cautious in the future.

The Absolute

The Ten Commandments serve as an example of an absolutist set of rules. For instance, "Thou shall not kill" is a fixed notion, with no leeway whatsoever. Regardless of the benefits to society (the greater good) such as killing during war or in self-defense, all killing is viewed as unjust. From the Absolutist point of view, killing is always forbidden—regardless of any possible benefit to society.

In the videojournalism profession, the National Press Photographers Association (NPPA) provides a code of ethics that might be considered the Ten Commandments of visual journalism. The code's Absolutist principles are listed on NPPA's website.

When Principles Collide

You will often hear that "people have a right to their privacy." How does that notion work in conjunction with the idea of journalism serving a greater good? A video clip depicts family members in the throes of horrible grief, reacting to the drowning of a child. Those operating on the idea of a greater good might believe that broadcasting this scene will make people think more carefully about swimming safety and accident prevention; those who adhere to the Absolutist principle of privacy would oppose publishing the picture. The absolutists would argue that regardless of any possible social benefit, the family's right to privacy might now trump the possible social gain. "Privacy" means exactly that—not having one's personal space in any way violated. Privacy is private. The Golden Rule would lead you to ask, "If this were my child who died, would I want a video camera recording my grief and would I want millions of people to see me breaking down?" Obviously, different videojournalists would have different reactions to the Golden Rule in this situation. Ironically, any of the choices might be ethical, depending on who you are and which underlying principles you choose to apply in this each case.

TELEVISION JOURNALISM ETHICS IN THE "GOOD OLD DAYS"

Today's ethical standards of storytelling evolved during a time when television ethics weren't so clear-cut. When Darrell Barton started in television news in 1967 for KAKE, Channel 10 in Wichita, the ethics of doing feature stories were very loose. "You could bring along your own characters," Barton recalls, "to role-play storylines as needed in order to create or recreate the visuals you needed for storytelling."

Barton knows of a story in which two journalists were doing a piece on a giant slide in Wichita. To make it interesting, they "developed" a storyline about a girl being afraid of the slide and her boyfriend convincing her to go down it.

▶ **Preventing Future Deaths?** The boy in the body bag had just drowned. This family was grief stricken. Might running the picture in the paper, on TV, or the Internet help prevent future accidents? (Photo by John Harte, Bakersfield, California)

They selected a pretty girl and her boyfriend to act out the roles. Set to triumphant music, she conquered her fears "and they lived happily ever after."

Barton recalls another incident in which two relatives of a photographer were used to impersonate the characters in a state fair feature about a lost boy on the midway and his big sister, who finds him. In both instances, the use of role-playing subjects was condoned because it abided by the ethical standards of the times.

"I won an award with a dance contest feature story where I took the winners to a park and let them dance to a tape," Barton says. He set up the scene and shot the video. "That was the last time I ever did anything like that because it won first place in a Gulf Coast News Photographers competition. Bob Brandon's story on a train derailment explosion won second. I got the award, and Bob spent three weeks in a hospital. I was 'shamed' into honesty," he says.

Though the networks' definition of "staging" was pretty broad, there was a lot of "creativity" being applied until the day CBS News issued a Standards & Practices policy that said no one could stage events—ever—without being fired. And anyone who failed to report another journalist staging could also be fired.

"The amazing thing was," Barton recalls, "they meant it. I mean you couldn't even ask someone to wait a moment while you moved ahead of them. Then I found out it was a great way to work. It made you sharp. It made you feel 'clean.' If it happened, you shot it. If you missed it, you missed it. If it didn't happen, it didn't happen."

► Look to professional associations for guidelines on making ethical choices.

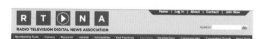

▲ **The Radio Television Digital News Association (RTDNA).** RTDNA is a professional organization exclusively serving the electronic news profession, and consisting of more than 3,000 news directors, news associates, educators and students.

▲ The **National Press Photographers Association** is an organization consisting of still photographers, TV photographers, and videojournalists.

▲ The **Society of Professional Journalists** includes among its members professional writers, producers, photojournalists, videographers, and videojournalists.

JOURNALISM CODES FOR STANDARDS AND ETHICS

As a profession, journalism has created and followed its own set of ethical standards. Professional journalism organizations such as the National Press Photographers Association (NPPA), the Society of Professional Journalists (SPJ), and the Radio Television Digital News Association (RTDNA) have over time written and refined codes of ethics that individuals and entire news organizations can elect to embrace. Despite varying slightly from group to group and outlet to outlet, journalism's ethical standards all share some basic principles: truthfulness, accuracy, objectivity, fairness, and accountability (which lately has been called "transparency").

Citizen Journalists

Web bloggers and citizen journalists could follow a similar prescribed code of conduct if they decide to adopt such standards. *Cyberjournalist.net* has developed a code for citizen journalists. The code is a good road map, but the difference between the blogger and the professional working for a salary from an outlet such as a newspaper, broadcast network, or online publication is that the professional has editors and managers to supervise and enforce ethical standards. Freelancers, solo videojournalists, and independent web bloggers are, by definition, "self-regulating."

If you are working for an established journalistic organization, an ethical breach usually results in discipline from your employer. Disciplinary action can range from a relatively minor reprimand to the loss of a job. Regardless of where you work, though, if an ethical breach crosses legal boundaries such as committing a crime; slandering or libeling someone; or infringing someone's copyright, the issue may actually lead to criminal or civil proceedings.

▲ **Demotix: News by You** is a website that allows citizens to put up their images and helps them sell the pictures to news agencies.

For the sake of journalism's credibility, many traditional editors of established publications believe it's necessary to take extra precautions when publishing the work of "citizen journalists." Editors point out that self-appointed journalists don't have a track record or established trust and credibility. In fact, there are those who go to great lengths to dupe news organizations or foist a hoax. So citizen journalists' work must be held to a tighter standard, if only because a news organization has no leverage over the individual if the reporting turns out to be false.

The Web has its own way of punishing wrongdoers. Although the editor of a traditional publication can't fire a citizen journalist, watch guards on Web certainly can expose doctored stories or pictures. Web mavens have exposed a number of fake pictures and called them out as ethical missteps.

Avoid Gifts or Bribes

When completing a piece on a story about, say, a homeless man in your town, you might be tempted to give an obviously needy person money in exchange for recording some pictures and asking a few questions about his life.

You feel sorry for him. He could use a solid meal and a place to stay. Why not give him a bit of cash?

Don't do it!

The journalism profession has a strict code that prohibits reporters, photojournalists or videographers from paying subjects for interviews, information or access. This code of ethics does not allow giving gifts in exchange for an on- or off-camera interview. Journalists simply must refrain from the temptation to hand over money. Some media organizations even prohibit buying a prospective subject a meal.

Why? First, let's call it what it is, or at least what it is seen to be: A bribe.

The reason for the "no bribe" rule is that once journalists pay for information, their relationship with a subject becomes a business proposition. This business arrangement can impact the veracity and accuracy of information conveyed.

The street person, for example, might not tell the whole truth or the "same truth" if he knows his answers are tied to a monetary reward. He might say what he hopes the interviewer wants to hear in hopes of getting a still greater payoff.

Also, a bribe sets a precedent. Subsequent journalists are likely to be asked for more and more money in exchange for an on-camera appearance.

Perhaps most important, the public has less trust in a report that involves exchanging money for an interview.

Bottom line. Avoid "checkbook" journalism by never offering and, if asked, refusing to give cash for contacts.

ETHICAL TRAPS
To Shoot or Not To Shoot?

When an unexpected event unfolds rapidly in front of the camera, photographers must decide whether they should be shooting. Almost always, the answer is "shoot." The rule is to shoot now and decide (discuss and edit) later. The moment can never be recovered if it's lost. Ethical decisions about what to show and how to show it can always be discussed long after the fact. But from the videojournalist's point of view, if the picture or the moment is not captured, it may as well never have happened.

When Darren Durlach, senior multimedia producer for the *Boston Globe* and an Ernie Crisp NPPA Television News Photographer of the Year, arrives on the scene of a story—if there's not something "blowing up or burning" that he has to capture immediately—he first assesses the sounds he's hearing. He wants to determine what sounds are going to be happening only for the next few moments so that he can record them before they go away. He then tries to evaluate what sounds will still be going on in ten minutes or even an hour later.

First things first. After ranking those sounds according to potential longevity, he goes about the task of capturing the audio that is likely to cease soon, followed by the audio that will still be around later. This way, Durlach never panics from realizing, "That sound is gone;

▼ **Darren Durlach,** WBBF-TV Baltimore, at the scene of a car accident that killed a 16-year-old pedestrian the previous day. (Photo by Mike Buscher)

I should have captured it first." Also by using this approach, Durlach doesn't place himself in a position of feeling pressed to ask someone to "do it again."

Suppose Durlach misses good video when he is busy shooting his audio? "Those are the breaks," he says.

Juxtaposing Clips Can Change the Meaning of the Story

There are hundreds of edits in a video even as short as 90 seconds, points out Jorge Sanhueza-Lyon, multimedia producer and photojournalist at the *Austin American-Statesman*. "There are so many ways to juxtapose clips that could make a story seem to go one way or another."

Sanhueza-Lyon, who also teaches at the University of Texas–Austin, tells his upper-level and graduate students about how easy it would be to alter the reality of a story by merely changing the context of video clips during editing. To illustrate his point, he shows the students raw footage from his stories, unedited. Then he shows them the various ways those clips could be assembled to tell entirely different stories by changing the order of their viewing.

For example, Sanhueza-Lyon shows raw video from a fire scene including a series of crowd and reaction shots. At most news scenes, a photographer can find a selection of people reacting differently: grieving bystanders, nonchalant gawkers, or maybe even people who are having a good time and laughing about something unrelated to the fire.

"How you pick which one of those shots to show next, after the fire pictures, gives context to the story," Sanhueza-Lyon says. "You are telling the viewer that the crowd was either just hanging out and 'doing their thing,' or were really angry or hurt or concerned, or were trying to make sense out of what was happening, or alternatively, were reacting inappropriately … whichever shot you pick to show next can result in a completely different story."

Slowing Down or Speeding Up Video

While editing, says Stan Heist, former videographer for channel WBFF in Baltimore, "changing the speed of video can have a substantial effect on how it is perceived. It can be tempting to slow down or speed up video to fit a specific need or want," he says. For instance, you might not have enough arrest footage in front of the courthouse to cover the voice-over script. Should you stretch out the arrest video,

running it slower than normal, to cover the voice-over track?

"Take a video of someone walking and slow it down—oftentimes the viewer's perception of that person will seem ominous, sinister, or somehow guilty. That same scene, sped up, can give the appearance of someone who is harried, foolish, or superhuman. In this case, the audience may be in on the joke, but are you intimating something about your subject's character by using this effect? Is it a fair effect?

"The question I ask myself centers on intention and how I believe the viewer will view the edit," say Heist. "Am I trying to 'fool' the viewer into believing something is real that isn't, or are they in on it?

▲ **Stan Heist**, Channel WBFF Baltimore.

Color Balance Can Color the Outcome

Heist also notes that adjusting color balance in the camera and in postproduction involves ethical choices. He poses this theoretical question: "What would happen if the videographer made a mistake when setting the white balance in the field. Let's say it was set to a cooler than natural color. Then the footage would have a blue cast. If the shooter warmed up the footage during editing by adding red and yellow filtration to the color balance, is this videojournalist fiddling with the truth? The footage will ultimately be neutrally colored but will it have been artificially manipulated?

Heist believes that correcting a mistake in color balance during editing is acceptable behavior because you're trying to match reality. But he says making a shot in the edit bay "cooler" (more blue) than the original scene to make it appear more "sinister" or "unhealthy" is an example of an ethical mistake. There is a subtle but clear-cut difference between the two. Correcting mistakes is ethical, but giving the footage a sinister look that was not present in the original scene is not.

Turn Down Distracting Background Sounds

Indiana University journalism associate dean James W. Brown shot a video story on a bicycle shop. In his edited piece, there is distracting background sound from a radio. He took his piece to WISH-TV veteran videojournalist Steve Sweitzer for a critique. Sweitzer told Brown that he needed clean audio to go with his video. Due to the radio sounds in the background on his recorded tape, he simply didn't have it. "Do you mean I should have turned the radio down or off?" Brown asked.

"Yes, under certain circumstances," Sweitzer replied. "Ask yourself what the story's about; if the radio's a part of the story, then by all means, leave it in. But if the sounds coming from the radio are just a distraction from your story (the sound drowns out the dialog between the repairman and the customer, for example), "you might have to exercise some control over the background noise caused by the radio," said Sweitzer.

In other words, turn down the radio.

Sweitzer says that if you did not want to change the radio volume for ethical reasons, then maybe you could use a lavalier microphone rather than the stereo microphone on the camera. Even changing mics doesn't solve all distracting noise problems, Sweitzer says. "Sometimes you have to tell someone to quit talking or shut a window to eliminate lawn mower noise outside."

In the case of the radio blaring in the bicycle shop, the ethical concept of "the greater good" is behind Sweitzer's advice of turning down the sound—most viewers will benefit more from hearing the dialog clearly than from having the music interfere with what is being said.

However, the Absolutist who says "thou shalt not alter anything" might warn the videojournalist not to touch the radio dial. This approach requires finding some other way to shoot in the noisy environment or not shoot there at all.

For the Associated Press, the world's largest news gathering organization, its standard for audio is very clear-cut: "Audio actualities must always tell the truth. We do not alter or manipulate the content of a newsmaker actuality in any way. Voice reports by AP correspondents may only be edited to remove pauses or stumbles."

As for audio editing, "AP does permit the use of the subtle, standard audio processing methods of normalization of levels, general volume adjustments, equalization to make the sound clearer, noise reduction to reduce

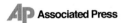 **Associated Press**

▲ The **Associated Press** "Standards and Practices" statement lays out clearly the rules of the road for videojournalists working for the world's largest news-gathering agency.

extraneous sounds such as telephone line noise, and the fading in and out of the start and end of sound bites—all of the above provided the use of these methods does not conceal, obscure, remove or otherwise alter the content or any portion of the content of the audio." For anything other than these adjustments, any AP employee must consult with a supervisor.

Cleaning Up Quotes

In audio, you can edit someone's quote for clarity, as is done on NPR and PRI. Yes, you can get fired for editing that same quote in a print article. In written text, however, you can paraphrase or add ellipses to indicate omitted material, neither of which is possible with radio.

Senior photographer and picture editor James Estrin of the *New York Times* says that he and his *Times* colleagues have settled on "not cleaning up audio too much. We tend to like to rely on giving the listener the subject's patterns of speaking, even if that includes a few 'ums' and 'aws' in their delivery."

Sliding Sound Around

Unlocking the audio and video tracks during editing allows you to slide the sound bite or natural sound under other video shots that were taken at a different moment. The act of moving the sound file around, unhooked from the original video file, is called "slipping sound."

With interview footage, most professionals have no problem with unlocking the sound track from the video track. The audio can be combined with B-roll video that illustrates the thrust of the interview. That technique, as old as theatre newsreels before the dawn of television, is called editing with an A-roll (voice from the interview) and B-roll (supporting film clips). (See Chapter 10, "Shooting a Sequence.")

The ethical dilemma for some journalists arises when the editor combines natural sound recorded at one moment with video recorded at another moment. For example, during clashes in Israel between the Israeli army and Palestinian youth throwing rocks, the sound of gunfire was going off all the time. When the camera was pointed at the soldiers, the sound of the gunfire

was loud, but when the camera was pointed away, toward the protesters, the gunfire sounded muffled. Obviously, the sound of gunfire was constant during the uprising, and the only reason the sound dipped in volume was that the camera and shotgun mic had been turned from the source of the sound. Is it ethical to transfer the sound of the gunfire to accompany all the footage of the clashes, whether the video showed the soldiers or the youth? If you were present during the conflict, you would have heard a steady rata-ta-tat beat of shots being fired regardless of the direction in which you were looking. Continuing the audio sound track with all video footage of the conflict was nearer to reality than having the sounds of gunfire fade in and fade out as they were actually recorded.

▶ **Jorge Sanhueza-Lyon,** *Austin American-Statesman,* **recording video of a circus in Austin, Texas.** (Photo by Donald R. Winslow, *News Photographer Magazine*)

Some visual journalists see no problem with the practice of "sliding sound." Multimedia producer Sanhueza-Lyon in Texas says sliding sound from one image to another is a necessary technique: "Viewers have been programmed or educated to understand that in anything and everything they see, hear, read or view, some editing and some efforts at presentation have—at some level—taken place. It's *all* a construction of some kind or another".

The multimedia piece consisting of still images with narrative sound, for example, is by definition an artificial construction. Unless the

photographer is capturing natural sound while shooting still images and is using the image time code and the audio time code to match them perfectly in presentation, it is an artificial combination of elements. The capturing of perfectly synchronized still images and separately recorded audio is highly unlikely. If it were to occur at all, it would merely be a happy accident.

NPPA's ethics chair, John Long, however, is very clear-cut in his opposition to sliding sound, whether in video or multimedia. He says there's no place for it in journalism. "Whether it's moving the sound of thunder closer to the image of a lightning bolt, or adding siren noise from another source, or rerecording audio after a still camera has stopped its annoying habit of making motor drive noise . . . this is lying," he says. "If the initial audio fails, find another way (such as using a voice-over), but be careful not to create the impression with the viewer that the audio and visuals are from the same moments."

In the emerging field of videojournalism, handling audio raises questions that have different answers at different organizations. Some editors have no problem with sliding sound if it doesn't change the story, create a different reality, or deceive viewers. For some news organizations, sliding sound is an "editing" decision and not an "ethical" choice. Other journalists put their foot down on allowing this procedure at all.

If you're not working for an established organization and you're a solo videojournalist, you're going to have to decide on your own where to pitch your ethical tent because the industry has believers in both camps. If you feel you're deceiving your viewers, or if you would be uncomfortable with them knowing the methods you've used to create the combination of pictures and sound, don't make the dubious edit. Find another way around the problem.

Music—Present or Added During Editing?

Some video producers add music to the story after it has been shot to heighten the mood of a piece. Adding additional music that was not captured during the original shoot is controversial. Many documentaries use music added after the fact. *This American Life,* on PRI, often adds music to further the effect of the reporting. Of course you wouldn't want to add "Light My Fire" by the Doors to a story about a two-alarm blaze that occurred last night. Discretion and good taste must prevail.

▲ Dave Delozier KUSA-TV's videojournalist. (Photo by Matt McClain)

KUSA-TV Denver veteran solo videojournalist Dave Delozier says that although music doesn't always exist in the field, he thinks viewers are smart enough to understand when music has been added to work with the feeling of the story. "Does it work with the story or does it interfere with the story? If it works with the true feeling of the story and doesn't get in the way, I have no problem with the use of music in a feature story," Delozier says.

Staging Still Goes On Today

First Lady Michelle Obama came to Camden Yards (a Baltimore baseball stadium) to encourage obese children to become more active. It was a highly organized public relations event, and she was supposed to play with the kids. Instead of playing, she just stood with them and talked. But one of the network photographers yelled out during the event, 'Can you make her play with the kids!' "Aside from being very rude, it was completely unethical," says Darren Durlach, who worked for WBFF-TV in Baltimore.

Durlach points out that sometimes on shoots that involve an interview, a reporter or producer may ask the subject to do something like walk down a hall or to take a book down from a

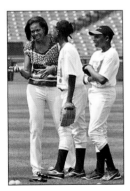

▲ Staging the Moment When First Lady Michelle Obama came to Baltimore, one of the network photographers yelled out during the event, "Can you make her play with the kids!" Was that okay?

bookshelf. "I haven't gotten a shot like that in five years, and when I get back to the edit bay I've never said to myself, 'I wish I had a goofy shot of them walking down a hallway, it would really make this story.' I think shots like that make a story reek of fakeness."

So instead of asking the subject walk down the hallway, Durlach asks, "What would you be doing if we weren't here right now?" The takeaway for videojournalists: let the subject go back to his or her normal routine. Begin photographing once "normal" is back under way.

Still, the subject is doing something for the camera. Even if what he's doing is what he'd be doing normally, just being there shooting makes the situation contrived. The difference is subtle and may split hairs, but capturing images of someone doing what they'd normally be doing still is more honest and more accurate than fabricating a situation like walking down the hall for extra visuals that may be useful during the editing process.

Just sitting at a desk, "sitting there," as Durlach says, may not be visual fireworks, but it's more truthful than the total fabrication of asking someone to walk a particular way down a hallway.

"For me," says Durlach, "it comes down to doing my best to blend in and avoiding manipulation and influence over the scene. I find that the best approach is to try to stay out of the way and avoid giving direction even if the subject asks for some. Instead, I do my best to anticipate action and be prepared to shoot the breaking moment before the action happens. The moments I capture are much more genuine and natural than if I had created them.

"For instance, ask someone to pick up a phone so you can shoot them doing it and they'll do it in a way that will be trying to please you—which usually looks fairly awkward and unnatural. However, if you wait for the phone to ring and catch it on video as it happens, it will be natural. Sometimes keeping this mindset of limiting shooting to real moments makes for a slower shoot, but that's okay with me."

Former TV professional Heist, now a professor at the University of Maryland, says, "Knowing what to expect in any given situation will help you anticipate and be prepared for the action. Before shooting, I like to ask my subjects what I may expect to see while I am with them. It helps me anticipate what will happen so I don't miss the natural moments or become tempted to ask the subjects to do something for me."

TEST FOR ETHICS

Here are a couple of quick self-tests for trying to solve an ethical dilemma:

Test 1: "Am I comfortable with the viewer knowing how my images and audio were made?" If you, the videojournalist, can honestly answer that question with a frank "yes," then what you've done is probably okay.

Test 2: Test your decision by asking yourself, "Who benefits?" Often the manipulation you plan on making does not benefit the viewer but rather satisfies your own esthetic sensibility. "Does asking someone to walk down the hall a second time so you can shoot video you missed the first time really benefit the viewer? Be careful that the decisions you make are made in order to improve viewers' ability to understand a story and not to impress your boss or win a prize.

CASE STUDIES

Here are two case studies to test your understanding of journalism ethics. After reading the facts of each case, ask yourself what you would have done in a similar situation before knowing the outcome of the case.

Fake Dogfight, Real Ramifications

Emmy Award-winning KCNC-TV reporter Windy Bergen and videographers Jim Stair and Scott Wright produced a four-part series on dog fighting called "Blood Sport." The series was to run on the NBC affiliate during "sweeps week," one of the three periods of time each year when viewership is measured to determine a station's annual ratings. Competition during sweeps can be fierce, because market ranking can determine advertising rates.

When authorities discovered that the trio had used footage of staged dogfights and dog training scenes for their series, not only did the reporter and videographers lose their jobs, but a grand jury probe also led to Bergen being charged with multiple counts of perjury. Because they attended the staged dogfights in order to film them, Stair and Wright also faced additional charges of dog fighting and conspiracy.

Wright and Stair both pled guilty to being an accessory to dog fighting and got probation. KCNC news director Marv Rockford was reprimanded for not adequately supervising his staff. Bergen was convicted of staging a dogfight, being an accessory to a dogfight, and conspiring

to commit dog fighting. She was fined $20,000 from a maximum sentence of 10 years in prison and $300,000 in fines.

Bergen's ethical decision-making process was corrupted by the competition and pressure of sweeps week and by the pressure to maintain her award-winning reputation in a highly competitive TV market like Denver. "It was just one small, bad decision after another," Bergen told the *American Journalism Review*. "I knew it was wrong, but no one ever believed it would escalate to this level."

In hindsight, which is always 20/20, many ethical minefields can be seen clearly, but only after great damage has been done to journalism's reputation and careers ruined. Because of the "star" system embraced by many television network news operations, and this particular reporter's award-winning track record, at first her dog fighting stories, footage, and sources went largely unchallenged.

Also, had videojournalists researched their own legal standing, they would have learned that merely attending a dogfight was illegal and was not an activity protected by any First Amendment exemption. And the pressure-packed work environment of television news, which Bergen later characterized as a "two-minute review" of news stories by a line producer just before they air, certainly contributed to the ease of getting the fabricated package into the station's story lineup.

The Briefcase Hand-Off

A famous example of an attempt at using a reenactment that turned out badly occurred in 1989 when ABC News on the *World News Tonight* broadcast featured ABC employees acting out a scene that depicted suspected spy and State Department employee Felix S. Bloch exchanging a briefcase with a Soviet diplomat. The constructed scene was based on words from an FBI document that said Bloch had been seen passing luggage to a known Soviet agent. In editing, the ABC film was treated to look like an FBI undercover tape, the original color video was turned into black-and-white footage, and the quality was decreased to make it look more grainy. Crosshairs were superimposed on the screen to make it look like surveillance film. During the East Coast broadcast at 6:30 p.m., the label "SIMULATION" was inadvertently dropped. "SIMULATION" was added to the 7:00 p.m. feed, but most of the country saw the first telecast, not the second.

HBO° | Movies

HBO Films
Too Big to Fail

In 2008, the fate of the world's
economy was decided in a
matter of weeks

Synopsis
Cast & Crew
Inside

Join the Conversation
Share your thoughts about 'Too Big To Fail' in the Talk section
now.

Become a Fan of HBO on Facebook
Join the community, get the latest news and show y
appreciation for HBO on Facebook.

Trailer Photos Opening the Vault. The Buzz: Premie. C

◄ **Too Big to Fail.** This
docudrama was based on
real events. Don't confuse
docudramas that use actors
with videojournalism, which
records and presents the
"real thing." (Directed
and Produced by Curtis
Hanson, HBO)

Bloch was never charged with any crime. There was no trial, but he lost his government job. Although ABC News executives were split over whether they'd ever use the technique again, ABC News correspondent Sam Donaldson had no question in his mind that the technique was wrong and unethical.

"It's important not to mix straight reporting with things that are not factual," Donaldson told the *New York Times.* "People who saw that story are liable to say: 'I know Bloch's guilty. I saw him pass the briefcase.' Of course, they didn't see that at all."

Most journalists now consider "simulations," even those labeled as "simulation" or "reenactment," to be unethical because any simulation—labeled or not—can mislead viewers. The danger, of course, in acting out a story is that doing so can lead viewers to conclude that something probably happened, and happened the way it was portrayed because, after all, "seeing is believing."

Videojournalism versus Docudramas

Many producers select reenacts of an historical event as the method of choice. Actors dress up, for instance, as 19th-century historic figures like Abraham Lincoln or Ulysses S. Grant and play parts and speak lines that the author thinks might have taken place 150 years ago. With actors in wigs and costumes, viewers will not mistake the scenes as the real thing. The result, a **docudrama**, is an amalgam of a documentary based on facts and a drama that adds fictional elements.

Movies, of course, often show reenacts of historical events—even some very recent news events. HBO, for instance, created a docudrama of the monetary crisis that almost brought a second Great Depression to the United States. The producers used famous actors playing living personalities. Based on the book by Andrew Ross Sorkin titled *Too Big to Fail,* the movie purported to show what happened in a series of closed meetings that took place in New York and Washington when the future of the U.S. economy was on the line. The movie made clear that although it was based on fact, the docudrama was fiction played by actors including Paul Giamatti, William Hurt, Ed Asner, and others.

There is a vast difference between videojournalism (which records reality) and other forms of entertainment such as docudramas and "Hollywood" movies. The bottom line is that videojournalism rests on the ethical foundation that viewers can have absolute confidence that what they are watching took place. The videojournalist was there, on the scene, to record the moment as it is presented to the audience. Videojournalists don't invent anything. Viewers hear the actual voices of real characters. The people they are seeing are not scripted actors.

A videojournalism story is not a docudrama.

Journalism, photojournalism, and videojournalism get their power from showing the unmanipulated, raw, candid truth. If videojournalists cross the ethical line, viewers will question whether what they are seeing really happened—and may one day turn away from the medium altogether. ∎

▲ **Covering the Police in Action.** Police use pepper spray to keep protesters from crossing a line at California State University, Northridge, during a demonstration against the appearance of former Ku Klux Klan Grand Wizard David Duke. In the United States you can legally film the police or anyone else, even when they are making an arrest, as long as you are in a public place such as sidewalk, street, or park. (Pete Erickson, *Golden Gater*, San Francisco State University)

The Law

David Weintraub

Instructor, Visual Communications Sequence, School of Journalism and Mass Communications, University of South Carolina

Videojournalists enjoy the same rights and face the same restrictions as their still-photography colleagues. All the major legal issues remain the same, no matter what type of camera is in your hand: Where can I shoot? What can I shoot? And what can I do with my video after I've shot it? In legal terms, these questions concern the laws of trespass, privacy, defamation, and copyright. If you've taken some basic journalism courses, you are probably familiar with these laws. But videojournalists do have some special concerns. For example, can adding a particular sound track alter or distort the meaning of a video? What effect does combining clips shot at

This symbol indicates when to go to the *Videojournalism* website for either links to more information or to a story cited in the text. Each reference will be listed according to chapter and page number. Links to stories will include their titles and, when available, images corresponding to those in the book. Bookmark the following URL, and you're all set to go: http://www.kobreguide.com/content/videojournalism.

different times and in different locations have on the "truthfulness" of a video? This chapter will explore some of the special legal issues that concern videojournalists.

The chapter applies to laws in the United States only. Some other countries have very different regulations that cover photography and videography.

TRESPASS: WHERE CAN I LEGALLY MAKE IMAGES?

The First Amendment affords us extremely wide latitude as to what we can say and what we can publish. In terms of journalism, the amendment's protections extend from today's giant media conglomerates all the way to the lone videojournalist with his or her own website. And these protections don't apply to just journalists. Anyone living in the United States enjoys the five freedoms guaranteed by the First Amendment's 45 words: freedom of religion, speech, press, assembly, and petition. The First Amendment, of course, does not

▶ You can legally shoot video on **public streets and sidewalks.** (Photo by Ken Kobré)

exempt journalists from the laws that apply to everyone else. Journalists cannot be prevented from doing something that ordinary folks are allowed to do. So videojournalists cannot be prevented from taking photographs and video in most public places.

Shooting Video in Public Places

What is a public place? From Wall Street to Main Street, streets, plazas, parks, bridges, and city-owned transit systems are all fair game. And these are not limited to the physical structures themselves. You are legally free to video any person in a public place—be they a politician, a celebrity, a member of law enforcement or the military, or just an ordinary citizen. They may be central to your shot, or just a small figure included for scale or human interest. By appearing in public, they have relinquished what lawyers call "a reasonable expectation of privacy," and are thus suitable subjects for your lens. Although you have almost unlimited freedom as to whom you can video in public, there are restrictions on what you can do with the footage. These restrictions are discussed in the sections on privacy and defamation. Also keep in mind some common-sense cautions. If a private individual says he or she doesn't want to be videoed, stop shooting and assure them that you won't use the footage. And be wary of filming children without notifying their parents, lest you seem like a predator.

▶ **Street versus Private Property.** If you witness a scene like this future NBA champion practicing in his driveway, you can shoot from the street, but you need at least verbal permission to go onto private property. (Photo by Andrew Craft, *Fayetteville Observer*)

If you are in a public place or on publicly owned property, you can generally shoot video to your heart's content. But many local jurisdictions, such as cities and counties, have ordinances to prevent obstructions to the safe flow of pedestrians and traffic. If people have to navigate around your equipment to move safely down the sidewalk, possibly stepping into the street, that could be a problem and you may need a permit. However, if it is just you and your video camera, you have the same rights as everyone else to film and photograph freely in a public place.

May I see your permit? If you are packing a lot of equipment, however, you may be asked for your permit and certificate of insurance. Shooting permits are usually required for commercial shoots or film productions that involve significant use of public property—blocking a street to film a sequence for a television show is one example. A certificate of insurance shows that you are covered for liability in case someone is injured as a consequence of your shoot, say by tripping over your light stands or microphone cable.

I'm just trying to do my job. Sometimes members of law enforcement agencies, other officials, and even bystanders interfere with journalists who are simply trying to do their job. According to attorney Bert Krages, author of *Legal Handbook for Photographers*, the trauma of 9/11 may help account for the fact that officials have tried to block photographers from photographing at airports, train stations, and subway

terminals—even though few of these public places have rules prohibiting photography. In July 2010, the online edition of the *Washington Post* reported on ten incidents in the D.C. area between 2008 and 2010 in which photographers were asked to stop taking pictures, even though they were on public property and had the legal right to photograph.

At Washington's Union Station, for instance, a station security guard interrupted filming by a Fox 5 news crew. The guard demanded the crew produce a permit. Guards at federal buildings do have the right to question photographers but cannot prevent photography of a federal building from a public place.

Authority and control. "The police may believe they are protecting the property or privacy of people involved in a newsworthy situation. Or, they simply may wish to exert their authority and control the situation," says Jay Bender, the Reid H. Montgomery Freedom of Information Chair at the University of South Carolina's School of Journalism and Mass Communications and a lecturer at the university's law school. Bender, who is also an attorney for the South Carolina Press Association and the South Carolina Broadcasters Association, says a photographer working for the *State* newspaper in Columbia, South Carolina, was arrested for trying to find out what was going on at a car lot containing automobiles ticketed and towed by the police. The photographer was with friends whose cars had been towed from a popular Columbia entertainment neighborhood.

▲ **At Washington's Union Station,** a station guard interrupted a Fox 5 news crew even though they had the legal right to photograph there.

◄ **Police Don't Have the Right to Block You.** A Florida state trooper illegally tried to block the cameras of two *Palm Beach Post* photographers who were covering the arrest of an armed robbery suspect. The incident resulted in an apology from the highway patrol. (J. C. Walker, *Palm Beach Post*)

The police told the car owners they could enter the lot, but prevented the news photographer from doing so. When the photographer identified himself as a journalist and asked who was in charge, he was arrested. "Of course, the arrest was invalid and the charges were ultimately dismissed, because fortunately he had a videotape of the police acting in excess of their authority," Bender says. "But it's generally better to avoid the confrontation if you can."

► **Metro Station.** Police and security guards often try to ban cameras even when videojournalist have the right to shoot. A security guard warned that "it was against the law to take pictures in the parking lot of the Douglas Road Metro Station in Miami," reported Carlos Miller, from the website Pixiq. A security guard, however, has no authority to ban you from public property without a court order. (Photo by Carlos Miller)

In Oakland, California, retired KGO-TV videographer Doug Laughlin was outside Highland Hospital on March 21, 2009, to cover the aftermath of the single deadliest day for the Oakland police department. A total of four Oakland police officers had been shot to death in two separate incidents. When he tried to film the arrival of an ambulance at the hospital, Laughlin says several officers attacked him and broke his camera's viewfinder when they knocked him against a parked car. Laughlin filed a federal civil rights lawsuit against the Oakland Police Department in U.S. District Court in San Francisco.

The police are shown on Laughlin's videotape cursing at him, shoving him away from the hospital, and threatening to arrest him, despite the fact that the videographer was on a public street filming a newsworthy event. Finally, the police put up yellow crime-scene tape to keep Laughlin away from the hospital. Laughlin's lawsuit asks for unspecified damages and an injunction to prevent the police from violating the First Amendment rights of journalists.

"The public has a right to be informed and for its journalists to report the news," said Charles Bourdon, one of Laughlin's attorneys.

◄ **Outside Hospital.** KGO-TV videographer Doug Laughlin was outside Highland Hospital in Oakland, California, when he was shoved away from the hospital and threatened with arrest, despite the fact that he was on a public street filming a newsworthy event.

"Mr. Laughlin was doing his job to present a newsworthy event to the public and was not at any time interfering with the legitimate actions of the police." Watch the confrontation and judge for yourself. What would you have done as a videographer? As a member of the police whose comrades had been killed?

Of course, law enforcement and emergency services personnel have the right to make sure their work can go on without interference. In normal situations, newsgathering activities such as making images and asking questions are not seen as interference. But if newsgathering hinders the work being carried out or threatens to compromise an investigation, officials are allowed to restrict it.

Once you have been ordered to stop shooting or to move back, and you refuse, you can be arrested for disorderly conduct or for interfering with a police officer's performance of duty—possible felony charges. In all cases, says Bender, don't try to argue your case with the police officer or other official. Take a step back, he says, call the organization you are working for, if any, and above all, do not physically interfere with any law enforcement or emergency services personnel. Try not to let adrenaline and your independent spirit interfere with your good judgment.

Public Buildings

Although the First Amendment guarantees freedom of the press, freedom of access for photojournalists is not protected. Federal, state, and local governments have rules about where you can shoot and where you cannot—even in what are clearly public buildings. If you are planning to shoot in a public building—including government buildings, schools, courtrooms, hospitals, and jails—make sure you check with someone in authority first so that you know the rules.

Privately Owned Places

Trespass law prevents you or anyone else from going uninvited into a person's private property, which generally includes a person's house, apartment, yard, car, and any of their possessions. There is no First Amendment defense to a charge of trespass, says Bender. And it doesn't matter whether you are a videojournalist, professional still photographer, or newspaper reporter. If the owner asks you to leave private property, you must comply. A person can ask you to leave even if a news event like a fire or accident is occurring on his or her property.

WHERE AND WHEN A VIDEOJOURNALIST CAN SHOOT				
	ANYTIME	IF NO ONE OBJECTS	WITH RESTRICTIONS	ONLY WITH PERMISSION
PUBLIC AREA				
Street	X			
Sidewalk	X			
Airport			X	
Beach	X			
Park	X			
Zoo	X			
Train Station	X			
Bus Station	X			
IN PUBLIC SCHOOL				
Preschool			X	
Grade School			X	
High School			X	
University Campus	X			
Class in Session				X
IN PUBLIC AREA—WITH RESTRICTIONS				
Police Headquarters			X	
Government Buildings			X	
Courtroom				X
Prisons				X
Military Bases				X
Legislative Chambers				X
IN MEDICAL FACILITIES				
Hospital				X
Rehab Center				X
Emergency Van				X
Mental Health Center				X
Doctor's Office				X
Clinic				X
PRIVATE BUT OPEN TO THE PUBLIC				
Movie Theater Lobby		X		
Business Office		X		
Hotel Lobby		X		
Restaurant		X		
Casino				X
Museum			X	
Shopping Mall				X
Store in Mall				X
PRIVATE AREAS VISIBLE TO THE PUBLIC				
Window of Home	X			
Porch	X			
Lawn	X			
IN PRIVATE				
Home		X		
Porch		X		
Lawn		X		
Apartment		X		
Hotel Room		X		
Car		X		

However, as long as you remain on public property, such as a sidewalk, you can train your camera lens on anything in plain view, including people on private property. This includes people standing in the yard of their home, sitting on their porch, or even standing inside behind a picture window. As long as they are in "plain view"—that is, visible from the street or sidewalk—they are fair game as subjects for your camera. By putting themselves in places where they can be seen by the public, these people have given up what the U.S. Supreme Court in *Katz v. United States* (1967) considered a "reasonable" expectation of privacy.

Reporters go undercover. Two ABC reporters committed trespass in a case involving the grocery chain Food Lion. In the spring of 1992, the reporters went undercover and got jobs at two Food Lion stores—one in South Carolina, the other in North Carolina—to secretly videotape with miniature cameras unwholesome food-handling practices. Some of the shocking, newsworthy footage was broadcast, airing on the ABC program *PrimeTime Live.* Food Lion sued, but instead of alleging defamation—that is, that the footage was unfairly embarrassing—the company said ABC had committed fraud, breach of duty of loyalty, trespass, and unfair trade practices in gathering the video footage. Food Lion said the reporters had lied to get their jobs working at the grocery stores.

The U.S. Court of Appeals ruled that the ABC reporters were guilty of trespass and breach of duty of loyalty. How could they be convicted of trespass? As Food Lion employees, weren't they authorized to enter the company's premises? The court found that in secretly videotaping while on the premises, the reporters committed "a wrongful act." In other words, Food Lion had hired the two to work in the grocery store, not to take surreptitious videos. The court brushed aside ABC's First Amendment claim, saying, "We are convinced that the media can do its important job effectively without resort to the commission of run-of-the-mill torts."

At the invitation of police or fire officials. Can police or fire officials invite a journalist onto private property as part of the routine conduct of their duties?

In the aftermath of a house fire in Jacksonville, Florida, that killed 17-year-old Cindy Fletcher, members of the press were invited to enter the Fletcher home by a police sergeant and the fire marshal. *Jacksonville Times-Union* newspaper photographer Bill Cranford was asked to help by taking pictures that could be used to investigate the fire—the fire marshal had apparently run out of film. Cindy's mother, Klenna Ann Fletcher, was away at the time, but when she opened the next day's edition of the *Times-Union,* she saw a gruesome photograph showing the silhouette of her daughter's body,

burned into the scorched floor of her home. Fletcher sued the Florida Publishing Company, which owned the *Times-Union.*

Among the legal issues at trial were these:

- Can members of the press enter private property during a newsworthy situation?
- Do police and emergency services personnel have the right to invite a journalist onto private property?
- Which is more important, the public's right to know, or a private individual's right to be free from trespass and intrusion?

The Florida Supreme Court ruled in favor of the Florida Publishing Company, saying that it was customary for photographers to accompany police and firefighters onto private property to cover newsworthy events. In addition, the homeowner was away, and no one asked the press to leave. Finally, the journalists did not force their way onto the property and caused no damage. In 1977, the U.S. Supreme Court let the ruling stand when it refused to review the case.

However, according to the *Legal Handbook for Photographers* by Bert Krages, the Florida case seems to be the exception rather than the rule. Most courts have ruled that government officials do not have the right to invite members of the news media onto private property without

◀ **Invited by the Authorities into a Private Home.** In the aftermath of a house fire that killed a young girl, a *Jacksonville Times-Union* news photographer was invited to enter the home by a police sergeant and the fire marshal. After the picture was published, the girl's mother sued, raising a number of legal issues. (Photo by Bill Cranford, *Jacksonville Times-Union*)

the owner's permission. And in 1999, the U.S. Supreme Court took a dim view of so-called "ride-alongs," saying that law enforcement agents who invite journalists to accompany them when they enter private property in the line of duty run afoul of the Fourth Amendment's protection against illegal search and seizure. The court finding suggests that inviting a journalist to accompany a cop could nullify an otherwise legal arrest.

Private Property Open to the Public

What about filming on private property that is normally open to the public, such as a restaurant or a shopping mall? The rules in this situation are not clear. Does the management need to post a sign saying that photography and videography are prohibited? Can you legally shoot unless someone in authority tells you to stop? In a 1978 case from New York, *Le Mistral Inc. v. CBS*, a television news team entered Le Mistral restaurant, cameras rolling, to film an investigative piece on health code violations by a number of restaurants. The Supreme Court of New York ruled that the journalists and CBS were guilty of trespass. Why?

First, the manager of the restaurant ordered the news team to leave, and they did not comply. Second, the news team had no intention of dining at the restaurant, which was the purpose of its being open to the public. Third, the news team was disruptive to the ordinary business of the restaurant, particularly by using bright lights for filming purposes. And finally, patrons of the restaurant had no obligation to be on television. In fact, many left the restaurant, hid their faces behind napkins and tablecloths, or ducked under a table. The court rejected the network's First Amendment defense and said the First Amendment's guarantees do not override all other rights.

Large shopping malls often serve the function of a traditional Main Street or town square where people meet, converse, window shop, and even exercise. These malls often have special events such as art shows, plant exhibits, concerts, and holiday celebrations. Thus it would seem that photography and videography in a mall's walkways and courtyards should not be a problem. However, in some states, you still must obtain permission from the mall's owners

► **Rights of a Paparazzi.** Paparazzi Ron Galella continued to photograph actor Marlon Brando even after Brando broke the photographer's jaw. Galella had the legal right to photograph Brando when the screen star was in public. (Photo by Paul Schmulbach)

or management to film on the premises. And you may also need permission from the people involved in the event you wish to photograph. Generally, the owner of the mall or their representative, such as the security police, can ask you to stop filming and you must obey their request.

They can't take that away from you. Despite the fact that you may be asked to leave a particular location or to stop filming, all of the footage you shot prior to that moment is protected by the First Amendment's prohibition against prior restraint—perhaps the amendment's highest protection ensuring press freedom. In other words, no one can demand your camera, video camera, your MiniDV tape, or your memory card. In fact, anyone touching your camera or your person may have committed the crime of battery. You are free to publish and otherwise distribute the images you made while on private property. But bear in mind that you can be punished if the images are found to violate other laws—such as those involving privacy, defamation, or copyright.

PRIVACY: THE RIGHT TO BE LEFT ALONE

The right to privacy is not mentioned in the Constitution, yet it is a fundamental right enjoyed by everyone in the United States. How did this come to be? Many legal scholars point to an article in the December 1890 *Harvard Law Review* (Vol 4, No 5) written by two alumnae of the law school, Louis D. Brandeis, who went on to become a renowned U.S. Supreme Court justice, and Samuel D. Warren. In what amounts to a tirade against the press and modern technology—such as half-tone reproduction of photographs at that time—the two lawyers proposed a right to be let alone—free from "the evil of invasion of privacy by the newspapers," whether by news reporting, photography, or "any other modern device for recording or reproducing scenes or sounds." The two were particularly peeved by gossip columns that exposed the sex lives of the rich and famous—material apparently as irresistible in the Victorian era as today.

Thus the "right to be let alone"—expressed in Brandeis's 1928 dissent in *Olmstead v. United States*—began to make its way into the legal framework of our country, culminating in the 1973 U.S. Supreme Court decision in *Roe v. Wade*, which found a "right of privacy" in the Fourteenth Amendment's concept of personal liberty and restrictions upon state action. But what about the public's right to know, and the right of the press to be free from all but the most necessary restraints? These rights are often at odds, as Brandeis and Warren knew when they wrote their seminal law review article.

What Do Privacy Laws Protect?

Privacy law has four main branches: intrusion, revelation of private facts, placing someone in a false light, and misappropriation of a person's name or likeness. You can run afoul of privacy laws whether you are a still photographer or videojournalist. However, not every state recognizes all four branches of privacy law. Additionally, some states have enacted statutes regarding privacy to supplement the laws already recognized. The best guide to privacy law is the *Photographers' Guide to Privacy,* an online publication of the Reporters Committee for Freedom of the Press. The guide contains a primer on invasion of privacy, a state-by-state guide to case law, and nine ways to avoid invasion of privacy lawsuits.

▲ **A Home (or a Hospital Room) is a Person's Castle.** You can film legally in a person's home or a hospital room only with the permission of the homeowner or the patient. A hospice patient who was dying of lung cancer gave the photographer permission to shoot as the hospice nurse and the doctor were stopping by to check on her in her own home. (Photo by Andrew Craft, *Fayetteville Observer*)

Intrusion

You may be liable for invasion of privacy if you intentionally take pictures or film people in a place where they could reasonably expect to be free from media scrutiny, such as on private property and out of view of passersby. Thus if you try to sneak into their home and photograph them inside without their knowledge or consent, you may have invaded their privacy.

Privacy from the media? So private property is clearly off limits. But what about recording in other circumstances, where people might have an expectation, if not of complete privacy, at least of having their images and conversations shielded from the media?

Ruth and Wayne Shulman, mother and son, were injured when their car veered off Interstate 10 in Riverside, California, flipped over into a drainage ditch, and trapped them inside. Two other family members were with them in the car. A rescue helicopter from Mercy Air was dispatched to the scene. On board was a videographer employed by Group W Productions, Inc. The flight nurse working on the helicopter was wearing a wireless microphone. The videographer filmed the couple's rescue from their car, the first aid they received at the scene, and the medical attention given during the helicopter ride back to the hospital. A few months later, the rescue footage, combined with the audio, appeared as a nine-minute segment of the television documentary *On Scene: Emergency Response.* The Shulmans sued for invasion of privacy—claiming both intrusion and unwanted publication of private facts.

The trial court ruled in favor of Group W Productions, Inc., citing the First Amendment. The appeals court, however, reversed, and the case went to the California Supreme Court. In its ruling, the state's highest court agreed with the couple's intrusion claim. It had merit, the court said, because a rescue helicopter, like an ambulance or a hospital room, is a place where accident victims and patients have a reasonable expectation of privacy. The court found "no law or custom" allowing the press to ride in ambulances or enter hospital rooms without the patient's consent. Also, the audio recording itself may have constituted intrusion, because it transmitted conversations that the parties may reasonably have thought were private.

Was recording aboard the helicopter and the recording of conversations "highly offensive to a reasonable person"? The court said a jury might well conclude it was:

> *Arguably, the last thing an injured accident victim should have to worry about while being pried from her wrecked car is that a television producer may be recording everything she says to medical personnel for the possible edification and entertainment of casual television viewers.*

▼ **No Permission Needed.** A fire captain comforts a woman trapped beneath a pickup truck in which she had been riding. The photographer had the right to shoot this scene without asking permission because he was shooting while on public property.
(Photo by Rick Roach, editor, *Vacaville Reporter*)

Note that nothing in this ruling prevents you from filming at an accident scene, as long as you are on public property. You may also film in a rescue helicopter, ambulance, or hospital room—provided you have the patient's consent. It is always best to get consent prior to shooting, because the very act of filming and recording audio in these types of locations may be considered intrusive.

Privacy of employees in the workplace. Do employees in the workplace have a valid intrusion claim against an undercover reporter who secretly records them on both video and audio? In 1999, the California Supreme Court ruled in favor of workers at a "telepsychic" hotline who were the subjects of an investigative report. Even though they knew their conversations could be overheard by their coworkers, the court ruled the employees had an "expectation of limited privacy" when it came to scrutiny by the press. Thus, in California, at least, privacy is not black and white, but tinged with shades of gray, according to Justice Kathryn Mickle Werdegar, who wrote the court's opinion in *Sanders v. American Broadcasting Cos., Inc.*: "There are degrees and nuances to societal recognition of our expectations of privacy: the fact the privacy one expects in a given setting is not complete or absolute does not render the expectation unreasonable as a matter of law."

The judge was careful to state that the use of hidden cameras and microphones does not automatically violate the law. However, investigative journalists need to be wary, lest they find themselves and the organizations that employ them sued for invasion of privacy. To protect yourself, make sure you understand the privacy laws in the state where you work.

Video voyeurism statutes. According to an article in the Winter 2007 *Penn State Law Review* by Timothy J. Horstmann, 26 states have anti-voyeurism statutes designed to restrict photography and videography in certain places and under certain circumstances. What Horstmann calls "Peeping Tom" statutes target people who trespass onto private property or loiter nearby for the purpose of spying on, secretly filming, or audio recording the inhabitants. "Circumstances" statutes make it a crime to secretly film or photograph any part of a person's body—clothed or unclothed—regarding which the person had a reasonable expectation of privacy, and in a circumstance in which they would have a reasonable expectation of privacy.

"Place" statutes criminalize secretly photographing and filming people—in full or partial nudity—in places accessible to the general public, such as restrooms, tanning salons, and changing rooms, in which a person would have a reasonable expectation of privacy.

Horstmann's article, "Protecting Traditional Privacy Rights in a Brave New Digital World: The Threat Posed by Cellular Phone-Cameras and What States Should Do To Stop It," is specifically about a repugnant practice called "upskirting," in which voyeurs use cell-phone cameras to peak under the skirts of unsuspecting women in public places and then post the images to pornographic websites. For the purposes of his article, Horstmann used the term upskirting to include another obnoxious practice, known as "downblousing," which requires a high vantage point. Not surprisingly, many states have found that their privacy laws are outdated when it comes to this sort of digital skullduggery, and some are scrambling to catch up. The federal government has also taken steps to curb this disturbing practice, with the Video Voyeurism Prevention Act of 2004. This act makes it a crime to photograph, film, or broadcast "a private area of an individual" without consent, provided the individual has a reasonable expectation of privacy.

Private Facts

If you publicly disclose information concerning the private life of another person, you may be liable for invasion of privacy. The information would have to be highly offensive to a reasonable person and not be of legitimate concern to the public. Photographers and videographers who film newsworthy people and events from public property are generally shielded from a private-facts claim of invasion of privacy. If you somehow gained access to private property and filmed a politician having sex with his mistress, broadcasting the video on YouTube would be a private-facts invasion of privacy, says Jay Bender, an attorney and journalism professor. Also, you need to be very careful when photographing crime victims—especially victims of sexual crimes—and witnesses in court cases. Some courts have held, for example, that although a rape may be newsworthy, the identity of the victim is not.

False Light

Disclosing to the public information about a person that places them in a false light may make you liable for invasion of privacy. The false light

would have to be highly offensive to a reasonable person. Also, you would have to have known the information was untrue and would place the other person in a false light, or have known of the falsity but disclosed the information anyway. According to the Reporters Committee for Freedom of the Press, a condensed or fictionalized story could expose a videojournalist to a claim of false light invasion of privacy, as could the use of generic stock footage that includes recognizable people.

It's usually not the photograph or video footage, however, that puts someone in a false light. But when you add words, either as captions, text, or voice-over narration, you may run into trouble. Not all states recognize an invasion of privacy claim for false light. In states that do, you can be liable even if you had the right to film your subject—and even if your depiction of the person was not defamatory. How can this be? The tort of false light takes into account psychological damage and considers the subject's emotional state—did your depiction clash with a subject's view of himself and cause him mental anguish? Defamation, as we shall see later, concerns injury to reputation.

A famous false light invasion of privacy case involved major league baseball player Warren Spahn. A flattering biography portrayed him as a hero during World War II, largely through made-up dialog and fabricated incidents. In Spahn's view, however, he was not a hero, just an ordinary soldier. Being called a hero in a book certainly did not damage Spahn's reputation. But the portrayal was inconsistent with his view of himself and what had occurred to him during the war. So he sued in New York State for false light invasion of privacy and won. Although Spahn was a well-known personality, he could recover damages when his personality was fictionalized and then exploited for private gain.

Misappropriation

Using someone else's name or likeness for personal gain makes you liable for misappropriation invasion of privacy. What's the logic behind this liability? First, how would you feel if your name or your image appeared in an advertisement for a product or service without your permission? And what if the ad were for something you detested? Second, if you are a famous person, you have probably invested a lot of time, energy, and perhaps money to create your unique identity. You own it—your identity is your property. No one can "borrow" it without your permission.

So, if a video clip you shot is used to sell or endorse a product or service, you can be liable for damages—unless you have consent in the form of a model release. The purpose of a model release is to protect you against liability for misappropriation invasion of privacy. If the use is primarily educational or informational, there is no misappropriation, so a model release is generally not needed.

Safety education in schools has reduced child accidents measurably, but unpredictable darting through traffic still takes a sobering toll.

They Ask to Be Killed

By DAVID G. WITTELS

Do you invite massacre by your own carelessness? Here's how thousands have committed suicide by scorning laws that were passed to keep them alive.

▲ **Words Added to Pictures Can Cause Legal Problems.** The *Saturday Evening Post* magazine was sued and lost because it used a file photo and added the headline "They Ask to Be Killed." The combination of words and pictures showed the subjects in a false light.

Advertising or editorial use? A shorthand way of referring to this distinction is to contrast "advertising" with "editorial" use. Advertising use would be a video segment that appears in a paid advertisement, such as you might see on the Internet or on television. Editorial use would be journalistic videos and multimedia pieces whose purpose is to inform or educate, such as you will find on KobreGuide.com.

▲ Candid footage of an art class shot for journalistic purposes cannot be used to advertise a workshop in Italy without the explicit and signed permission of the subjects. (Photo by Ken Kobré)

Note that the legal test is *not* whether you have been paid for your work or whether your employer is out to make a profit. Some people mistakenly think that what matters is whether the use of the images is commercial or non-commercial. Newspapers, magazines, books, and journalistic websites are all commercial ventures—they need to be profitable in order to stay in business. But the editorial content of these publications is designed to provide news and information to the public. Paid advertisements contained within these publications, however, have a different goal—to sell a product or service.

Releases needed or not? Consider the following hypothetical scenario. You are covering an environmental demonstration on a public street outside the corporate headquarters of British Petroleum, the company responsible for the oil spill in the Gulf of Mexico. Do you need model releases for the people pictured in your shots if you want to post the video to a news organization's website? Because this was a newsworthy event occurring on public property, and the use is for news and informational purposes, no releases are needed.

During the filming, though, say you happened to capture images of several people talking on their iPhones. The marketing director for Apple Inc. sees the video, sends you an email, and offers you a hefty chunk of change to use the footage in one of its upcoming ads in order to stress the company's commitment to the environment. Do you need a model release? You bet. Same footage, same images, but now the purpose is to advertise a particular product. Because people have the right to control their name and likeness for trade or advertising purposes, you and Apple Inc. could be sued for misappropriation invasion of privacy if the footage is used without model releases.

DEFAMATION: DAMAGE TO REPUTATION

At its most basic, defamation means harming the reputation of another person. Defamation is a tort, meaning if you defame someone, you may be liable for damages. Defamation that is printed or broadcast is called **libel**. Defamation that is spoken is called **slander**.

The conflict between defamation and the First Amendment—holding someone liable for something they have said or written, despite the guarantees of freedom of speech and freedom of the press—is what makes this area of media law so challenging. Suits for defamation give people a way to protect their reputations and clear their good names in situations where they may have no other recourse. But the threat of defamation suits can have a chilling effect on the news media, hindering their ability to act as the people's watchdog and to protect our democracy.

Is the Person a Public or Private Figure?

The first thing a court has to decide in a defamation case is the status of the plaintiff, that is, the person making the claim. If the person is deemed legally to be a "public official" or a "public figure," there is almost no chance he or she will succeed in winning the case. Why?

The answer comes from the *New York Times v. Sullivan* (1964) case, in which the U.S. Supreme Court made it difficult for public officials to win a libel suit. When the case first went to trial in Alabama, the jury decided that L. B. Sullivan, an elected official in Montgomery, had been defamed by an ad placed in the *Times* by a civil rights group and awarded him $500,000, a huge amount in the 1960s. The Alabama Supreme Court upheld the verdict. However, in a historic decision, the U.S. Supreme Court said in *New York Times Co. v. Sullivan* that if the person is a

"public official," that person cannot be awarded damages for false and defamatory statements relating to official conduct unless the public official proves "actual malice."

What is actual malice? A public official has to prove that the defamatory statement by the journalist was made "with knowledge of its falsity or with reckless disregard of whether it was true or false," according to the court finding. Although the ad contained factual errors, and the *New York Times* may have been negligent in not checking the facts, its conduct did not rise to the level of actual malice.

Later U.S. Supreme Court rulings extended the actual malice test to defamation cases involving people deemed "public figures." Who is a public figure? The Court gave the following guidelines: someone can become a public figure by playing a powerful or influential role in society. Being caught up in newsworthy events can transform a private individual into a "limited-purpose" public figure. Similarly, a person can thrust himself into a controversial issue for the purpose of influencing its outcome, thus also becoming a limited-purpose public figure.

In these cases, the Court said, people suing for defamation have the same almost insurmountable hurdle faced by public officials—proving that the defamatory statement published about them was a knowing or reckless falsity, and not just the result of careless reporting or sloppy journalism.

Defenses to a Defamation Claim

Truth is an absolute defense to a claim of defamation. If what you present in your video or multimedia piece is a truthful representation of what your subject said or did, then you cannot be successfully prosecuted for defamation. And in many jurisdictions, as long as your reporting captures the essence of the story truthfully, you will be forgiven minor, inconsequential errors of fact. This is called the "substantial truth doctrine."

Be an excellent journalist. To protect yourself, be an excellent journalist and adhere to the highest standards of truthful, unbiased reporting. Be extremely careful with identifications. Are you absolutely sure you've gotten the correct name, spelled correctly, with the correct middle initial (to help avoid confusion with another person with the same name)? Be especially scrupulous when your reporting involves people accused of a crime or other form of misconduct. Check and recheck your voice-over script to avoid any legal hassles later.

Take nothing for granted. Take nothing for granted, especially from "official" sources. How do you know the person giving you the information has gotten it right? Is your source reliable? Confirm the information you've obtained with your subject, or at least make an attempt to do so. Avoid making unsubstantiated conclusions. Let the facts speak for themselves. You are responsible for the accuracy of not just your own words spoken on camera or in a voice-over narration, but also for the words of anyone you have interviewed.

Other common defenses. Additionally, there are other common defenses to defamation. Statements made in judicial, legislative, and administrative proceedings are privileged, which means they are defamation-proof. Similarly, your coverage of public bodies, such as the county board of supervisors, is generally protected. And anyone with an already damaged reputation will have a hard time claiming defamation.

If your video is an opinion-based piece—a condemnation of a particular environmental abuse, for example—you may be forgiven if you use extra emphasis in your voice-over narration, because most people will interpret it in context. Finally, if you are threatened with a libel suit, most states have laws allowing you to publish a retraction—and this may end the legal proceeding against you.

Defamation Issues with Text, Narration, and Music

Defamation concerns can certainly arise once you marry images with text, voice-over narration, music, and other audio tracks. Let's say you are doing a video documentary on the club scene in your hometown. You prowl the streets after dark, getting colorful footage of people hanging out in front of bars and restaurants, strolling arm in arm, enjoying themselves. You get permission to film a few bands on stage and people dancing to the music. Edited, titled, and mixed with some interviews and natural sound, you've got yourself a nice little slice-of-life feature story.

Jazzing it up. Now let's take the same video footage, but we'll jazz it up a bit for more impact. "Cruising Main Street, U.S.A." will be our title. A voice-over narration will introduce the story. We see a shot of couples strolling down the street, while the narrator says, "Prostitution is on the rise in small-town America, and police are helpless to stop it." Cut to a shot of several

young women hanging out in front of a bar. Fade up music: Roy Orbison singing "Pretty Woman." Next shot: a group of guys walking by. Music changes to the theme from *Jaws*. Suddenly your nice little feature becomes an ominous undercover exposé of a crime-ridden section of town.

Changing the meaning. Clearly, text, narration, music, and other audio can completely change the meaning of images. They can push your truthful documentary over the line and make it potentially defamatory. Not that you ever said the women in the shot were prostitutes and the men were johns—but taken as a whole, that was the implication. Your only defense? That these implications are actually true. You would have needed solid evidence that the guys and gals were exchanging sex for money. Admittedly this is an exaggerated example. But when you consider how easy it is to edit video and mix in various audio tracks, you can appreciate the caution needed to make sure that you are presenting a truthful picture, not one that could be interpreted as defamatory.

Defamation Issues with Editing

Are there defamation issues that can arise when you set up shots or combine scenes shot at different times? Yes, says attorney and journalism professor Jay Bender. If you combine footage shot at different times and in different places to give the impression that the action was happening at the same time in a single location, the resulting falsehood could be defamatory if it injures someone's reputation.

But I was just on vacation. Bender uses the hypothetical example of someone filmed in front of a hotel in the Bahamas—stock footage that later shows up in a documentary on the Mafia's control of gambling in the Caribbean. The person has no connection to the story, yet the documentary makes it look as though he is involved with the Mafia or with gambling. Clearly, that falsehood could be injurious to his reputation.

Let's just move a few things around to get a better shot. What about setting up a shot to illustrate your story? Bender describes a libel case involving a newspaper photographer who was assigned to illustrate a story about drinking alcohol in public parks. The photographer found a group of young people in a public park and asked them to sit on a picnic table. The photographer had collected beer cans from around the park and put them in front of the picnic table.

Bender says the photographer had envisioned a photo illustration in which the young people would not be identifiable.

Unfortunately, the newspaper ran the photograph without any modification, and everyone pictured was clearly recognizable. What's worse, says Bender, is that the young people were part of a Sunday school class having a picnic in the park. Were the photographer and his newspaper at fault? Certainly, Bender says. "Where you juxtapose different images and different scenes and sounds to create an impression that's not the reality, you're exposed to a libel claim." To avoid the problem of combining elements that seem to show someone in an unflattering light, avoid setting up situations under any circumstances. This principle will protect you from both the legal and the ethical quagmire of staging shots (See Chapter 14, "Ethics," for more on staging).

Model Release: No Protection Against Defamation

Would model releases from the Sunday school picnickers have protected the photographer and his newspaper? No. A model release protects you against a claim of misappropriation invasion of privacy. Having releases won't help if you broadcast footage that contains falsehoods damaging to any of your subjects' reputations.

COPYRIGHT: WHO OWNS YOUR WORK?

There are many misconceptions about copyright—about what it does and does not protect. Creative professionals who are in business for themselves depend on copyright law for protection. Without it, they could be stripped of the ownership of their intellectual property, have no ongoing income from their work, and almost certainly face a dismal economic future. Protecting the creative work of individuals was seen by the framers of the Constitution as so important that they enshrined it in Article I, Section 8, of the Constitution, which details the powers of Congress: "To promote the progress of science and useful arts, by securing for limited times to authors and inventors the exclusive right to their respective writings and discoveries."

What Work Is Eligible for Copyright Protection?

In order to be eligible for copyright protection, a work has to be fixed in an original, tangible form of expression. In other words, a photograph or a video is eligible for copyright protection, but

your *idea* for a video documentary project is not—at least not until you write the script or prepare a storyboard. The moment you hit the "record" button on your video camera and film a scene, you have created a work that is copyrighted. You own the copyright of the work; it is a form of property called "intellectual property." You don't have to do anything to copyright the work. When it's created, it's copyrighted. (But there are things you have to do to reap the full benefits of the law if your copyright is infringed, or violated, as you will learn later.)

The Benefits of Copyright Ownership

So what does owning copyright of a work allow you to do? Let's use the example of a short video documentary. You have the right to reproduce the work. You can distribute the documentary to the public, either by sale, transfer of ownership, or some form of licensing; you can also give it away for free or broadcast it on cable TV. You can broadcast your documentary on the Internet or show it at a film festival. You can create what is known legally as a "derivative work" based on your documentary, such as a magazine article or blog using the material you gathered through researching and interviewing.

No restrictions on your rights. Notice that copyright law places almost no restrictions on what you can do with your work. You can sell it, give it away, lock it up in a vault, or make it available to anyone who wants it. You can leave the copyright to your work to your heirs, just as with other forms of personal property. About the only restriction is that if you transfer exclusive rights to your work to someone, the transfer must be in writing.

Employee or Independent Contractor?

If you are an employee, and your regular duties of employment include photography or videography, your employer owns the copyright to everything you shoot. This is called "a work made for hire." But let's be clear—this has to be regular, full-time employment for which you receive a paycheck with deductions for Social Security, Medicare, and other benefits. And photography or videography must be in your

▼ **Aftermath of a Tsunami.** This photo was taken after a tsunami hit Banda Aceh, Indonesia. The tsunami killed 230,000 people worldwide. If the photographer had been working for a newspaper or magazine when he took the picture, the publication would own the copyright to the image. In this situation, the photojournalist was a freelancer and therefore owns the copyright. (Photo by Ken Kobré)

job description. If you are a newspaper staff photographer, the paper owns all your images—still and video. But if you are a newspaper reporter, and photography is not one of your regular duties, the pictures you shoot are yours, not the newspaper's.

If you are an independent contractor, which is the status most freelance creative professionals fall under, you own the copyright to all your work—even if your client pays all your expenses or provides you with equipment. The only exception is if you sign a "work for hire" agreement, giving up your copyright. The distinction between employee and independent contractor is crucial in determining who owns the copyright. A great resource for learning more about employment status can be found on the Internal Revenue Service website.

Other Examples of Work for Hire

Even as an independent contractor, you can be stripped of your copyright if you sign a work for hire agreement. The key word here is "sign." A work for hire agreement is a contract signed by both you and your client, before the work starts. Remember, you don't have to sign the contract as it was handed to you. You can ask the client to change the contract with language that gives the buyer the right to use the footage in specified situations but lets you keep the copyright.

Publication

Copyright law defines "publication" as distributing or offering to distribute your work to the public. In other words, when you finish burning the DVD of your documentary and send it to your client, for the purposes of copyright law, you have "published" the work. Also, if you show your images or videos in a class, the copyright law considers this action the equivalent of publishing. Note that this is different from what we ordinarily think of as publication, which usually means the production of printed copies. Publication is an extremely important concept in copyright law, because it starts the clock ticking in terms of certain legal remedies available to you if someone uses your work without your permission.

▼ **Passover Preparation.** Ultraorthodox Jews in Jerusalem receive food before Passover. If you shot the scene as a freelancer, you own the copyright. You can sell the video, post it on the Internet, show it at film festivals, or do nothing with it. If you were working as an employee and shot the scene as part of your regular work, your employer would own the copyright. (© 2010 Ken Kobré)

Copyright Notice

Although no longer required by law to secure your copyright, it is still recommended that all works you create and distribute contain a copyright notice. A proper copyright notice contains three elements: the symbol ©, or the word "Copyright," or the abbreviation "Copr."; the year of first publication of the work, using the copyright law's definition of "publication"; and your name. Thus, a proper copyright notice looks like this: © 2011 David Weintraub.

How Long Does Copyright Protection Last?

In most cases, your work is protected from the moment it is created until 70 years after your death. This means that you never have to worry about seeing your work fall into the public domain, where anyone can do whatever they want with it. Also, the life-plus-70-years formula ensures that you and a few generations of your heirs are entitled to any income produced by the work. In the case of work for hire, the copyright lasts for 95 years from publication or 120 years from creation, whichever is shorter. Because corporations typically own the copyright in work for hire situations, they receive protection longer than actual creators.

Copyright Registration

Copyright registration involves filling out some simple paperwork, depositing a copy of your work with the U.S. Copyright Office, and paying a small fee. There are several ways to register, including online registration. You can register multiple unpublished works at the same time for a single fee. Although not necessary to secure a copyright in your work, registration has several advantages, including establishing a public record of your copyright. The most important advantage, however, involves what happens if your copyright is infringed—meaning someone has used your work without your permission—and you wind up in court.

If you have registered your work in a timely manner and win your case, you are entitled to what the law calls "statutory damages" and attorney's fees. Statutory damages for willful infringement can be as high as $150,000 per infringement, although this certainly doesn't mean every award will be that much. If you didn't bother to register, or missed the deadline, all you can recover are "actual damages" and profits of the infringer, which might not even pay your legal fees. Remember, although your work is copyrighted from the moment it is created, registration is what puts the real teeth in the copyright law and protects intellectual property.

Creative Commons License

The Creative Commons copyright license gives you a way to share your work inside the traditional "all rights reserved" standard that copyright law creates. The Creative Commons tools give everyone from individual creators to large companies and institutions a simple, standardized way to grant copyright permissions to their creative work. There is a vast and growing digital commons, a pool of content that can be copied, distributed, edited, remixed, and built upon, all within the boundaries of copyright law. Check it out.

Fair Use

What about looking at copyright law from the point of view of the user, rather than the creator—do you always need copyright owners' permission to reproduce their work? Surprisingly, the answer is no. The copyright law has carved out a narrow limitation to protect certain kinds of activities that otherwise could not flourish. The Fair Use provision of the Copyright Act allows limited use of copyrighted material without permission for very specific purposes. Among these are criticism, comment, news reporting, teaching, scholarship, research, and parody. People engaged in these activities often need to use someone else's work without their permission, in order to do their work fairly and impartially.

► **Original** *Vanity Fair* **Cover.** The copyrighted Annie Leibovitz cover image is used here for informational and educational purposes only. The image is iconic as a magazine cover featuring a notable actress in the nude while pregnant, and it engendered fame for both the actress and the magazine. (Photo by Annie Leibovitz, *Vanity Fair*)

◄ **Movie Poster Parody.** Moore's appearance nude on the cover of *Vanity Fair* magazine while seven months pregnant spawned imitators such as this poster for the movie *Naked Gun 33 ⅓: The Final Insult* with Leslie Nielsen in a parody of the Moore cover.

The image used on the *Vanity Fair* cover, although copyrighted, could be recreated because no alternative to it could possibly exist to create the parody, which is a form of comment and criticism. Leibovitz, the creator of the original Demi Moore portrait, sued Paramount Pictures Corporation and lost.

Let's say you have a blog that comments on the current state of videojournalism as displayed on the Internet. Clearly, you need to be able to show examples of what you consider excellent videojournalism and poor videojournalism. What would happen to your blog if you needed to get permission from each copyright owner? Some might deny you permission to use any of their videos. Others might say, "Sure, why not?" And some might say, "You can only use the ones you consider excellent." So much for your ability to be a fair and impartial media critic.

Four tests for fair use. Copyright law has four tests to determine whether a particular use is fair:

1. The purpose and character of the use, including whether such use is of commercial nature or is for nonprofit educational purposes.

2. The nature of the copyrighted work.

3. The amount and substantiality of the portion used in relation to the copyrighted work as a whole.

4. The effect of the use upon the potential market for, or value of, the copyrighted work.

Note that there is nothing here about number of words, lines, video frames, bars of music, or pixels, so forget everything you've ever heard about how much or how little you are allowed to copy. Here's all that matters: is the type of activity you are engaged in primarily educational or commercial? Is the nature of work you are copying mainly factual, or is it a creative, imaginative work of art for which the creator expects a financial return? Have you grabbed the entire work or its most important part, or have you merely taken a small slice to use as an example? Has your use caused a drain on the copyright owner's present or potential future income? If you take someone's entire video and post it on your blog without an analysis or critique, that's probably not fair use. If you use a sequence to illustrate a particular critique, you have a better chance of claiming fair use.

Respecting the Copyrights of Others

Clearly, copyright is one of the most valuable rights enjoyed by creators of original work. So it is essential that you respect the copyrights of others, just as you expect other people to respect your copyright. This means no pirated software or music, no appropriation of other people's work to include in your own, and no copying of other people's words, graphics, pictures, or video.

But hasn't everything been shot before by someone else? Now this doesn't mean that your video of a cable car climbing Hyde Street in San Francisco with Alcatraz in the background constitutes infringement, just because someone else (probably thousands of other people, in fact) have shot the same scene. What matters is whether you willfully set out to copy another person's creative work, as pop artist Jeff Koons did when he made a life-sized wood sculpture based on a photograph taken by Art Rogers called "Puppies." Koons, a famous artist, thought he could get away with appropriating another person's work, but he lost in court. His sculpture was supposed to be art, not parody or comment. When in doubt, either get permission from the copyright owner or don't copy. It's as simple as that.

What about stuff in the background? Sometimes copyrighted work forms part of the background for the scene you are shooting. If you are filming a news interview in someone's office, and there is a copyrighted photograph on the wall, do you need to get the photographer's permission to include that part of the wall in your shot?

The artwork behind an interview subject is called "incidental and fortuitous reproduction" of a copyrighted work, and it is allowed under the Fair Use limitation for news and other informational purposes. If you were filming an advertisement or a feature film, you would be wise to get the photographer's permission or replace the photograph with one of your own. Similarly, if the photograph or other copyrighted work were the main element of your video, you might have a hard time claiming fair use.

Unauthorized use of someone else's work. Attorney and journalism professor Jay Bender says his biggest concern about copyright is the unauthorized use of someone else's work. "The taking of someone else's image and downloading it and using it as part of your work might ultimately be a derivative work for which a separate copyright could be obtained. But if you don't have the license to use that work, you're infringing the original copyright holder's rights."

The most famous recent example of this is the Obama *Hope* poster. "The artist who created the poster has finally acknowledged that he used an AP photograph as the basis for the poster," Bender says. "That's an infringement of AP's copyright, and there's been litigation over it."

The Associated Press and Shepard Fairey, the artist, eventually settled. "In settling the lawsuit, the AP and Mr. Fairey have agreed that neither

▲ **Copyright Infringement.** Designed by Shepard Fairey, a Los Angeles–based street artist, this image has become so much in demand that copies signed by Fairey have been purchased for thousands of dollars on eBay. Only when confronted with a lawsuit did the artist acknowledge that he had used an AP photograph as the basis for the poster. (Photo by Mannie Garcia for the AP; design by Shepard Fairey)

side surrenders its view of the law," says a statement on the AP website. "Mr. Fairey has agreed that he will not use another AP photo in his work without obtaining a license from the AP. The two sides have also agreed to work together going forward with the Hope image and share the rights to make the posters and merchandise bearing the Hope image and to collaborate on a series of images that Fairey will create based on AP photographs."

Not all infringement suits are likely to be settled as amicably. Bender says he is worried because many young people have grown up with the ability to download files from the Internet and use them however they please, and they don't see anything wrong with that. "Unfortunately, we're training a generation of people to use technology to steal," he says.

SUBPOENAS, WARRANTS, AND PROMISES OF CONFIDENTIALITY

As a videojournalist, you may film an event that is of interest to law enforcement. For example, you may be shooting a peaceful political protest when a small group of demonstrators decides to block traffic or destroy property. The police move in and make arrests and you capture all the action with your camera and post your video online. The next day, you receive a subpoena asking for all the footage you shot during the protest, not just the segment you made public.

If you are subpoenaed or served with a search warrant, what should you do? First, consult with an attorney. If you are working for a news organization, make sure you discuss the subpoena or warrant with your editor. Above all, do not destroy any of the footage you shot. This may expose you to a citation for contempt of court or other serious legal problems. Also, be very careful when promising a subject that you will not reveal his or her identity. You should be prepared for a legal battle and possible jail time if you don't keep your promise.

Why Journalists Object to Subpoenas

Some videojournalists find promising confidentiality to subjects necessary to get the story. The First Amendment protects freedom of the press, and many journalists say the press cannot truly be free if reporters, photographers, and videographers are constantly under scrutiny by the government. Investigative reporting, which upholds the role of the press as the public's watchdog, would be severely hampered without

the ability to promise confidentiality to sources, some journalists claim. Also, trust in the press would be seriously eroded if the public believed that journalists worked hand in hand with law enforcement, routinely turning over unpublished material to further police investigations.

We'd like to see all your photographs. Photojournalist David Morse works for the San Francisco Bay Area Independent Media Center, or Indybay. On December 11, 2009, Morse covered a protest at the home of Robert J. Birgeneau, chancellor of the University of California, Berkeley. Dozens of people converged on Birgeneau's home to protest budget cuts and a fee increase. They broke windows and lights and overturned planters; eight people were arrested by University of California police, including Morse, who was carrying an expired press pass but repeatedly identified himself as a journalist.

The police then obtained a search warrant to view all of Morse's photographs of the demonstration, never telling the judge who signed the warrant that Morse was a journalist. California has a shield law that prevents police from subpoenaing a journalist's unpublished information, including photographs obtained in the course of newsgathering. In June 2010, an Alameda County Superior Court Judge said that the campus police had obtained Morse's photographs illegally and ordered them returned.

We'd like to see all your film. Documentary filmmaker Joe Berlinger made a film in 2009 called *Crude: The Real Price of Oil*, alleging Chevron played a role in polluting the Ecuadorian rainforests. Chevron and two of its executives subpoenaed all of Berlinger's unused footage, claiming they needed the material to help with criminal and civil lawsuits in Ecuador and with an international treaty arbitration. Under U.S. law, federal courts can order the production of evidence needed for foreign cases. Berlinger claimed a First Amendment privilege not to provide Chevron with his unused footage—more than 600 hours. He also said he had promised some of his sources confidentiality and that turning over the unused footage would break that promise.

In May 2010, Judge Lewis A. Kaplan of the District Court for the Southern District of New York agreed that filmmakers were indeed eligible for the qualified privilege available to journalists under state law. But the judge also held that Chevron had a compelling need for the unused

footage, and that Berlinger had not proved his confidentiality argument. Judge Kaplan briefly stayed his order to allow for an appeal. In July 2010, the U.S. Court of Appeals for the Second Circuit ruled that Berlinger had to turn over those parts of the unused footage that might help Chevron win its cases.

No first amendment privilege. The U.S. Supreme Court in *Branzburg v. Hayes* (1972) refused to recognize a First Amendment privilege for journalists that would release them from the requirement—shared by all other citizens—to answer subpoenas and testify in court. The Court did add that Congress could enact a federal shield law—as narrow or as broad as necessary—to protect journalists from having to disclose the identity of sources or to testify when subpoenaed. However, efforts to pass such a law have repeatedly failed so far. Many states have shield laws of one form or another to protect journalists. For a state-by-state rundown of journalist shield laws, visit the Citizen Media Law Project. ■

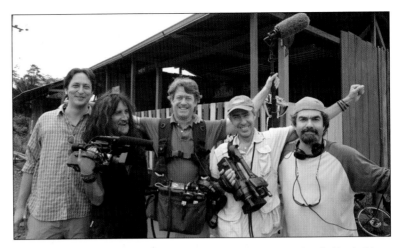

▲ **Crude: The Real Price of Oil.** Images from documentary filmmaker Joe Berlinger's video. In July 2010, the U.S. Court of Appeals for the Second Circuit ruled that Berlinger must turn over those parts of the unused footage that might help Chevron, the oil company featured in the video, fight its cases. (Joe Berlinger, producer)

▲ Emergildo Criollo, a leader from the Cofán indigenous community, testifies at the trial against Chevron in the Amazon rainforest of Ecuador. From the film *Crude*, directed and produced by Joe Berlinger. (Photo by David Gilbert)

▲ Cancer victim Maria Garofalo reflected in the stream behind her home in the Ecuadorean Amazon. From the film *Crude*, directed and produced by Joe Berlinger. (Photo by Juan Diego Pérez)

▲ **Waiting Topless.** Yes, sex sells. A popular video about a café with topless waitresses resulted in increased traffic to the website for Salt Institute for Documentary Studies. The story went viral. (Produced by Briget Ganske)

Marketing a Story

Mary Thorsby

Independent business writer, Thorsby and Associates

You've done it! You've taken the initiative to create a videojournalism or multimedia masterpiece! You've got drama! You've got intrigue! You may even have a little sex appeal thrown in for good measure.

Now where's that lucky website that's eager to buy it?

Well, my friend, step away from your Final Cut Pro. We've got the old good news and bad news story to tell you.

THE GOOD NEWS

Shaul Schwarz creates and sells videos and multimedia pieces, most notably selling to *Time.com* his self-initiated video "Breach of Faith," which he shot immediately following the 2010 Haiti earthquake.

This symbol indicates when to go to the *Videojournalism* website for either links to more information or to a story cited in the text. Each reference will be listed according to chapter and page number. Links to stories will include their titles and, when available, images corresponding to those in the book. Bookmark the following URL, and you're all set to go: http://www.kobreguide.com/content/videojournalism.

▲ **A Breach of Faith in Haiti.**
In the harrowing days after the Haiti earthquake, documentary makers Shaul Schwarz and Julie Platner witnessed families mourning loved ones and youths whose injuries meant tragic choices of life over limb. They sold the story to *Time.com*.
(Photographed by Shaul Schwarz, *Time.com*)

Schwarz was among the first on the scene, flying to the Dominican Republic on his own dime without knowing for sure that he had an assignment. His agent at Getty brokered a deal for his still shots for a combined *Time* and CNN assignment while Schwarz was en route.

Get the Story, Fast

"I didn't know how big the story was going to be, but I'd been to Haiti twice before," Schwarz says. "The biggest thing to my advantage was I was quick and decisive. I was going to be on the ground that next morning. So if an outlet wanted stills, I was going to be there to get them."

Schwarz spent eight intensive and emotional days shooting, often hearing those devastated by the earthquake talk about how their faith in God had been tested to its core. His photos ran in a ten-page spread in *Time*. CNN ran his images frequently during the first few days after the earthquake—mainly as transitions between stories and commercial breaks.

After completing his *Time* and CNN assignments, Schwarz took a day off to rest, but couldn't get the conversations he'd overheard out of his head. "People were talking about their shattered beliefs, and I thought that was an important story to tell," he says. "But I didn't know how to photograph it. It needed a different media."

Shoot First, Sell Later

The next day, Schwarz decided to use his same Canon camera to shoot video interviews, with no particular buyer in mind.

When he returned to his home in Brooklyn, Schwarz showed some rough footage to Kira Pollack, his photo editor at *Time*. She encouraged him to edit the piece a bit—he got it down to 11 minutes, still long, based on today's standards—and she then showed it to her *Time* colleagues, all of whom gave it an enthusiastic thumbs-up.

"She said, 'I love this,'" Schwarz recalls. "She said, 'We can't do this all the time—we have our own people who shoot video. But your product is special, unique, and different. I'm not sure that we'll get enough clicks or that people have 11-minute attention spans, but I want a few of these a year.'"

"Breach of Faith" originally ran on *Time*'s paid subscription iPad app, and then on *Time.com*'s home page as a companion piece to a *Time* editorial several months after the earthquake. And although *Time* doesn't release site traffic numbers—not even to the

videojournalists themselves—*Time* multimedia director Craig Duff says the staff was very pleased with the result.

Solid Journalism, Audience Interest

"It did very well on the site," Duff says. "It's true that people are more likely to watch shorter videos, but Shaul gave us a solid piece of journalism that kept people interested all the way through—even while they were at work."

Time paid Schwarz an additional fee for the video—part of which he shared with Bryan Chang, a freelance editor who had spent a month helping edit the piece. But even better than the relatively small sum of money—Schwarz estimates the video required 100 hours of work to make—*Time* has hired Schwarz to do more videos.

"That piece has led to longer, better assignments," he says. "It's nice to see intelligent clients who really respect and want higher-end pieces and recognize that it's going to take a lot of time and energy."

THE BAD NEWS

When it comes to getting the attention of editors, not everyone has the credentials of *Robert Capa Gold Medal*–winning Shaul Schwarz. But at one time, neither did Schwarz.

"This is new, even for me," Schwarz says. "It's all in the product. If you come up with a good product and you're good at what you do, you know when to knock on the door and not waste people's time. If you show things too early, you'll burn yourself for the future."

MEDIA OUTLETS

Although some journalistic websites have their own paid video staff, many are open to using independent videojournalists. Here's a look at eight that use freelancers.

The *New York Times*

From New York, U.S., and world news to business, technology, the environment, science, health, travel, the arts, and more, the *New York Times* is the number-one newspaper site based on traffic, with a print/online audience of 22.4 million. Founded and continuously published since 1851, the *New York Times* print edition is the largest local metropolitan paper in the United States.

The *New York Times*' Video and Television Editorial Director Ann Derry manages a video department of 18 people, easily matching staff

videojournalists to stories that reporters and editors suggest could benefit from some visual storytelling. She also buys video stories from independent videojournalists for the site.

The further away the story is—say something interesting is happening in Beijing—the more likely Derry will turn to her roster of freelance videojournalists all over the world rather than pay travel expenses to dispatch a staffer from New York. Plus, local videojournalists tend to be more familiar with and often speak the language of the country where the story is based.

Derry finds most freelance videojournalists through word of mouth, and some of the freelance still photographers she uses shoot video, too. The main qualifications: videojournalists must produce the highest-quality work and be able to work collaboratively with reporters and editors.

"We closely supervise our video stories," Derry says. "We have a discussion before the videojournalist goes out, he or she then collaborates with the reporter, we have another discussion after the story is shot, there's a script—it's quite a long process."

Derry usually has five to ten freelance-based videos in the works at any given time, and although she's open to pitches, she's more likely to make assignments based on what the newspaper is covering.

"If you see a topic that we're reporting on intensively and you have exclusive access to particular characters associated with that topic, yes, we'd be very interested in seeing what you have," Derry says. "If you have something amazing that nobody else has, we're interested."

Derry says that videojournalists she works with regularly usually receive a bit more than newcomers.

"If I were a videojournalist, I'd specialize in anything foreign or anything lifestyle-related," Derry says. "There's a huge amount of opportunity there."

MSNBC.com

NBC has a broadcast channel with a nightly news program, an all-news cable channel, and a website. The website, called *MSNBC.com*, is owned by both NBC Universal and Microsoft, the software company.

From entertainment, business, and politics to what's happening across the globe and on your block, *MSNBC.com* delivers a comprehensive and diverse perspective, attracting close to 40 million visitors each month.

The *MSNBC.com* website has its own staff, which includes photojournalists who shoot both stills and videos as well as video-only specialists. The site highlights many multimedia experiences on its home page.

PhotoBlog: Sacrificing for the Stars and Stripes in Afghanistan

Is *MSNBC.com* open to hearing from independent videojournalists? "Absolutely, says *MSNBC.com* senior multimedia producer Meredith Birkett. "My job here is basically to do exactly that. To understand who's doing what work out there, and the quality of their work. We're happy to hear from videojournalists from a still, TV, or film background." In fact, the website has a special section where professionals can submit project and assignment ideas along with videos.

And Birkett especially likes meeting potential shooters at conferences and other networking events. She is also open to calls and emails. "I think there are a lot of folks who assume that we don't take cold calls or cold submissions," she says. "But I'm always happy to hear from people."

When Birkett assigns a multimedia story, she needs the story shot, reported, and produced. She's open to people who work solo or as part of a team. The day rate averages about $700–$800. She typically licenses or assigns about two pieces a month to freelancers. For already finished videos, Birkett comes up with a project-specific licensing fee.

Birkett champions the thought that videojournalists deserve fair pay. And, she warns those trying to freelance that revisions can be a time suck, so make sure you work out overrun details—say your client has saddled you with eight hours of revisions—beforehand.

Birkett paid around $2,500 for Bob Sacha's first sellable piece, "5 Years Later—A Soldier's Legacy," a two-minute video about a father who lost his son in the Iraq war. Sacha connected with Birkett via friends he made at an Eddie Adams Barnstorm Workshop. The piece was timely, as the 2,000th casualty was approaching at that time.

Sacha and Sokol spent two days recording the audio interviews and shooting the piece, with Sacha spending another two days editing and producing it—which comes to $500 per day. The two split the fee in half.

Birkett doesn't have a large amount of work to give out because most of the site's stills and video come from wire services and *NBC News* broadcast channel. That leaves a small amount of resources for original reports from staffers and freelancers.

"I say no more than I say yes," Birkett says in terms of responding to pitches. "Assigning videos is not a huge piece of our pie."

The *Olympian*

Kathy Strauss was an occasional freelance photographer for the Olympia, Washington–based *Olympian* when she took several multimedia immersion courses. She approached the news outlet's editors about doing unpaid videos for its website to gain more experience, including one story about nine-year-old fiddler Maggie Neatherlin.

The *Olympian* managed to offer Strauss a little money. "It wasn't much—just $100 per story, which is nothing considering how much time goes into each video," Strauss says. "But I was a beginner and learning, and I wanted a place to publish my work so that I could improve my skills."

She published six pieces until the *Olympian* entirely eliminated its freelance budget. But by then, Strauss was getting better paying video gigs from viewers who'd seen her work on the site. In fact, one events planner hired Strauss to videotape a conference. The payoff: $1,200. While there, several attendees asked Strauss for her business card. She now produces several videos at a time for different clients.

Time

Time magazine, established in 1923, excels at summarizing the news of the week. *Time.com*, its website, offers reliable, up-to-the-minute reporting, photography, video, and in-depth analysis on the people, places and issues currently in the news. From the economy to technology and health care to international features, entertainment, and sports, it's one of the fastest-growing national news sites in the United States, with more than 7 million unique viewers per month.

In addition to the glossy weekly magazine and the website, *Time* has a separate outlet for its material on its iPad and tablet applications.

Time.com multimedia director Craig Duff posts eight multimedia pieces weekly for the magazine's iPad issue, with a few of those posted to *Time.com* as well. Most of what he publishes is produced

▲ **The Soldier.** An American contemplates the thousands of soldiers killed in Iraq. The story features one family's reflections on the life and lost legacy of their loved one.
(Produced by independent videojournalists Bob Sacha and Brian Sokol)

▶ **Fiddle Phenom Maggie Neatherlin.** Meet nine-year-old Maggie Neatherlin of Olympia, Washington, lead fiddle player for the Grizzle Grazzle Tune Snugglers.
(Produced by Kathy Strauss)

by an in-house staff of two videojournalists, an iPad producer/editor, a part-time editor, and two interns. Plus, Duff himself reports, shoots, writes, and edits.

Some *Time.com* reporters also shoot video, and Duff is working on getting cameras in more reporters' hands, including those who report and produce for the website and the "Briefing" section of *Time* magazine. Duff conducts video workshops designed to help reporters learn to file their own video pieces. "But that requires quite a bit of work for us and a learning curve for them, and we just haven't had the time and resources to make it work as well as I would like," Duff notes.

Along with paid staff, Duff also regularly works with independent videojournalists. Duff welcomes pitches—he receives about a half dozen unsolicited emails a week from independent videojournalists, usually containing story pitches and suggestions—but rarely finished videos. Keep 'em coming, he says. Even if he doesn't choose your pitch, he may consider hiring you for an assignment.

"I'll often get flurries of pitches from the same location or on the same subject," Duff says. "Recently, there were three different VJs [videojournalists] in Haiti all pitching similar pieces. But we had just run a number of stories from Haiti after the earthquake and, as important as it is to keep a spotlight on the country in the aftermath of tragedy, our budget only allows a certain amount and we need to balance our global coverage.

"Similarly, I've gotten several pieces from VJs embedded with troops in Afghanistan with similar themes," Duff adds.

But what most often keeps him from green-lighting a story is when it doesn't fit the requirements of videojournalism. "We need a compelling character or characters, in the act of doing something," Duff explains. "Video is visual. If there's no way to see and show what's going on, no matter how important the subject, then it's probably a better print piece."

Duff has also rejected folks because they clearly aren't ready to work at the level he requires. "I look closely at work reels and ask a lot of questions before I'll agree to work with someone," he notes.

However, he remains open to hearing from freelancers, especially those in geographically desirable locations. "That's what I tell students," Duff says. "The last thing you want to do is move to New York—plenty of videojournalists are there already. If you go someplace where news is

happening but is not widely covered, then there isn't as much competition and you can make yourself valuable. Establish yourself as the go-to person, and you'll get more work."

The pay? It's on a piece-by-piece basis, with videojournalists he's worked with for quite some time earning a bit more than newcomers. Duff covers expenses when he knows about them in advance and when the story requires them.

Multimedia journalist and *Time.com* freelancer Jason Motlagh, a native of Virginia, settled in Istanbul—he wanted to get to Middle East assignments on short notice. "I can be in Kabul as quickly as Khartoum," he says.

Time.com's Craig Duff emails Motlagh with assignments, and Motlagh, also a freelance writer, emails Duff with his own ideas for pieces that complement stories he writes for *Time*'s website or print edition.

"Video allows you to do more humanistic stories," Motlagh says, pointing to his 2008 story on the world of underground wrestling in Mumbai he shot for *Time.com.* Titled "In Mumbai, Wrestling to Be a Cop," the 4:26-minute piece features young men who practice an old form of wrestling popular among India's lower classes as a way to build their strength and confidence in order to apply for jobs as police officers.

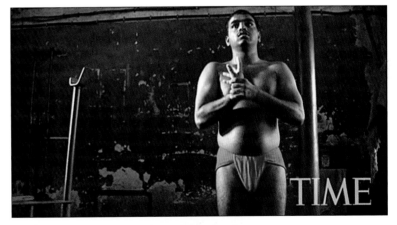

▲ **In Mumbai, Wrestling to Be a Cop.** In a mega city of 18 million people, some men do everything they can to boost their job prospects, including practicing an ancient form of wrestling. With its color action sequences, this story was better suited to *Time*'s Internet site than to the magazine itself.

▲ **In Mumbai, Wrestling to Be a Cop.** Young men, many of whom want to be police officers, get in shape by practicing an old form of wrestling popular among India's lower classes.
(Produced by Jason Motlagh)

"The subject wasn't so well suited to a *Time* magazine print story, but it was great for video on their website," he says. "I spent two days following the men who come in from the countryside to train. I spent a few more days editing the piece before sending it to Craig."

FRONTLINE

Since 1983, *FRONTLINE* has served as PBS's flagship public affairs television series and features incisive documentaries. Although segments are produced for the *FRONTLINE* TV show, they run in their entirety on the website, as well—many as long as an hour.

Filmmaker/journalist Travis Fox is busier these days than he was as a *Washington Post* staffer, when he was one of the first to experiment with the new form of multimedia storytelling on the Internet. In 2006, his distinctive style earned the first Emmy Award given to a web video producer for his coverage of Hurricane Katrina.

Fox had great connections with colleagues at *FRONTLINE* while employed by the *Post*. Those connections led to his first assignment soon after he left the paper on January 1, 2010. Only twelve days later, the Haiti earthquake occurred and *FRONTLINE* hired him to cover the aftermath.

Fox says *FRONTLINE* pays a standard industry rate—$2,000–$3,000 per week for producers and $800–$1,000 per day for camera people.

► **The Economy of a Tent City.** Ten weeks after the earthquake, the temporary settlements where Haitians congregated developed into rich, complex communities. (Produced by Travis Fox)

Because Fox produces, shoots, and edits his pieces, he works out a special financial arrangement with *FRONTLINE*. "In terms of payment, it's the Wild West," he says. "We're all trying to figure it out."

Al Jazeera

Al Jazeera is an international news network headquartered in Doha, Qatar. Initially launched as an Arabic news and current affairs satellite TV channel with the same name, Al Jazeera has since expanded to include the Web and specialty TV channels in multiple languages that are accessible in several world regions.

▲ **Return of the Warlords.** What does the return of Afghanistan's most notorious warlord mean for Afghan democracy? (Produced by Jason Motlagh and Rick Rowley)

The original Al Jazeera's willingness to broadcast dissenting views, including those presented on call-in shows, created controversies in the Arab states of the Persian Gulf. The station gained worldwide attention following the 9/11 attacks when it was the only channel to cover the war in Afghanistan live.

Along with freelancing for *Time.com,* Jason Motlagh shoots for Al Jazeera. It pays far better than most outlets—as much as $1,000 per minute for a finished, broadcast-ready program, Motlagh says. He's able to nab three or four assignments for 20- to 30-minute pieces each year for Al Jazeera's English channel.

For "Return of the Warlords," he and his partner, filmmaker Rick Rowley, zeroed in on Afghanistan's most notorious warlord, Rashid Dostum.

Motlagh typically spends about two to four weeks reporting on a subject. The projects usually take about three weeks to edit.

The *Smithsonian*

Smithsonian is a monthly print magazine published by the Smithsonian Institution in Washington, D.C. It features in-depth coverage of history, science, nature, the arts, travel, world culture, and technology. *Smithsonian.com* expands on magazine content and includes videos, blogs, and a reader forum.

Long-time magazine writer Laird Harrison has turned to video to accompany some of his written stories. Writing about California's Ohlone Indians for *Smithsonian* magazine prompted Harrison to pitch the idea of an accompanying video about their lost language. The video editor gave an enthusiastic nod.

▲ **Reviving the Ohlone Language.** Using archived ethnographic research, Linda Yamane is bringing back the language of the Ohlone, a Northern California tribe of American Indians. (Video by Laird Harrison)

Harrison spent more than 20 hours on "Reviving the Ohlone Language" and received a few hundred dollars for the video. *Smithsonian* paid him from a separate budget for the text story.

National Geographic

National Geographic has inspired people to care about the planet since 1888. The magazine contains articles about geography, popular science, world history, culture, current events, and photography of places and things all over the world and the universe.

National Geographic's e-publishing division gathers targeted material for mobile devices like Apple's iPad and iPhone. With *National Geographic*'s strong heritage and core strength in still photography, David Griffin, former director of photography at *National Geographic* magazine and then executive editor of e-publishing before moving to the *Washington Post*, was careful to apply *National Geographic*'s same high-quality standards to multimedia storytelling.

"We're teaching our print journalists how to think digitally—to expand telling of their stories with video, audio, graphics, 3D mapping, and interactivity," Griffin says. "These are all new forms that add to the storytelling process. It's like having another set of lenses in a photographer's bag."

Griffin usually made one or two video assignments per month for *National Geographic*'s e-publishing projects. Though most of the videos are shot and edited by *National Geographic* staff members and regularly contributing freelance photographers, Griffin was open to hearing from independent videojournalists by email. In fact, he was hoping to build a stable of VJs to call on, especially to create multimedia for *National Geographic*'s iPhone and iPad apps.

Although Griffin has moved on to the *Washington Post*, *National Geographic* is still looking for new video stories.

WHERE ELSE CAN YOU SELL VIDEOS?

Probably the best potential market for freelance videojournalists is not cash-starved newspaper and magazine websites, but organizations and associations whose sites are designed to communicate to their membership. The videos many of these groups produce are honest documentaries and not public relations puff pieces.

American Association of Retired Persons

Among those who have hired outside videojournalists is the gargantuan 40-million member American Association of Retired Persons (AARP). The good news for video-journalists is that AARP.org represents a viable freelance market.

AARP multimedia producer Nicole Shea, whose background includes stints at *National Geographic* and Getty Images, regularly uses freelancers. Shea is interested in videos that capture how AARP members live their lives and reflect what they think and feel about the issues they face.

"Because our audience (and thus our subject matter) is defined by age rather than geography, and because we are a multimedia staff of two, we use freelance videojournalists for almost all of our feature pieces," Shea wrote for the April 2009 issue of the *Digital Journalist*. "This enables us to work with some of the best people in this emerging field. It also challenges us to constantly recruit talented new freelancers, and it forces us to be disciplined in communicating the unique parameters of creating features for a specialized organization such as ours."

► **Marathon Woman.** Margaret Hagerty—at 64 years old—traded smoking for running. She ran a marathon within a year and is a Guinness World Record holder as the oldest person to run a marathon on all seven continents. (Kat Keene Hogue, videojournalist and editor; Nicole Shea, multimedia producer, AARP)

Marathon Woman *AARP*Bulletin

For short documentaries, Shea strives for "exceptional storytelling, real characters who inspire others to action and a theme that speaks directly to the AARP demographic of those ages 50 and older.

"I approach these features as the videojournalism equivalent of environmental portraiture," Shea told the *Digital Journalist*, pointing to "World of Words," a story about 70-year-old Alfred Williams learning to read in Ms. Hamilton's first-grade class.

Shea also tries to introduce issues central to members through compelling characters and stories. "What Will Happen to Andy?" presents an increasingly common issue faced by older parents of adult children with special needs: how do these parents plan for their children, both financially and in terms of lifestyle, when they themselves will be gone? To provide useful information rather than simply raising questions, Shea also assigned a companion piece featuring resources and advice on planning for the future needs of adult children with special needs.

VJ Movement

UK videojournalist Adam Westbrook often contributes pitches to VJ Movement, a Holland-based website. Each Sunday, the site invites its international viewers to vote on proposals for videojournalism projects. VJ Movement pays to have those projects produced and published on the VJ Movement website. The VJ Movement site is one example of "crowd sourcing" to pay for multimedia and videojournalism. See "Raise Funds on the Internet," page 252.

So far, two of Westbrook's pitches have won the most Sunday votes, including "Contesting an Election: From Lawbreaker to Lawmaker." This multimedia piece features former prisoner John Hirst, who, while in jail, taught himself to become a lawyer, and upon his release fought for prisoners' right to vote.

Contesting an Election: From Lawbreaker to Lawmaker

Story by: Adam Westbrook
United Kingdom 04 May 2010
Summary
More than 80,000 prisoners won't be able to vote in the UK general election, May 6th, because of a blanket ban by the British government.

▲ **Contesting an Election.** John Hirst works for prisoners' rights. Adam Westbrook's story about him appeared on VJ Movement and sold as a radio and print piece. (By Adam Westbrook, *VJMovement.com*)

Hirst hasn't yet won his fight, but Westbrook's piece appeared on VJ Movement, and he also sold the story to Radio Netherlands Worldwide and to print magazines, receiving around 600 euros ($400) for his work.

Institutions, Foundations, and Other Organizations

"Institutions, foundations, NGOs, universities—these are great multimedia clients," says *MSNBC.com*'s Meredith Birkett. "I think having these kinds of clients is critical in trying to make a living as an Internet videojournalist. You have to have a diversified portfolio of clients."

Foundations and institutions are big buyers of multimedia, according to Brian Storm. Storm's staff at MediaStorm.org has worked closely with the Soros Foundation, the Bill and Melinda Gates Foundation, the Council on Foreign Relations, and more.

"These organizations have a mission and they have money to fund important work," says Storm, noting that Soros spent a million dollars sending 31 teams into the field to cover Hurricane Katrina. MediaStorm developed and published the teams' material for its site.

Videojournalist Bob Sacha concentrates his efforts on companies and foundations. "Papers and magazines have no budget, "Sacha says. Both Sacha and fellow multimedia producer Mike Schmidt keep busy creating videos for Open Society Institute (OSI), a part of the Soros Foundation that focuses on building vibrant and tolerant democracies.

▶ **Right to Relief: Palliative Care in India.** Doctors in India say it's time for the Indian government to integrate palliative care into routine health care. (Photography and video by Brent Foster for Human Rights Watch)

When Human Rights Watch, an independent organization dedicated to protecting and defending human rights, hired independent videojournalist Brent Foster to shoot a piece about access to pain relief through palliative care in India, the organization paid his travel expenses—he was already living in New Delhi at the time—and gave him about 15 days to cover doctors throughout the country. The organization wanted stills for a print report and multimedia for the web to explain the issue.

A lot of people die in pain, but this piece shows how care can be given to relieve or eliminate that pain, Foster says. "It's rare for publications these days to pay you properly for that amount of time."

WHAT KINDS OF STORIES ARE WEBSITES BUYING?

From the servers at the Grand View Topless Coffee shop in Vassalboro, Maine, to fetish and bondage gear manufactured in Karachi, Pakistan—can you guess the topic that tops the charts (including *KobreGuide.com*) when it comes to website traffic?

"Sex sells," says videojournalist Kathy Strauss, freelance producer for the *Olympian* newspaper. "Doom and gloom stories are big, but the highest hits are for anything having to do with sex."

That wasn't surprising to videojournalist Briget Ganske. The Grand View Topless Coffee Shop in Vassalboro, Maine, was already getting a lot of buzz when she shot and edited her story as a student at the Salt Institute for Documentary Studies in Portland, Maine, in 2009. (Sadly, the coffee shop burned down not long after—a suspected arsonist was later arrested.)

Ganske's piece ran on The Sunday Best, a crowd-funded multimedia site based in Portland, Maine. "That's how it got traffic," Ganske says. "It was pretty crazy, and then all sorts of other sites began linking to it. Things can really spread fast on the Internet."

For photo- and videojournalist Ed Kashi, reality is a bit hard to digest. "People want celebrity-oriented stuff," he says. "They're burned out on Iraq and Afghanistan. I'm constantly in conflict with what I want to do that's important and what the public thinks is important."

Still, for most websites, a key measure of a story's success comes down to what's featured on a home page and how many people click "play."

Aim for a Wide Audience

Birkett of *MSNBC.com* is interested primarily in stories that resonate with a national news audience. "We want someone in New York City to care about the story as much as someone in a small town in Kansas," she says. "We're looking for stories that follow national trends as well as big news stories that go on for a few days. We also like interesting cultural phenomena—things that are unique and quirky that set us apart from the competition."

And because of limited staff travel budgets, Birkett is also interested in international pieces. "Freelancers are a huge help to us—they're our

eyes and ears in terms of interesting stories from around the world," she says.

But, she warns, international stories for *MSNBC.com* still need to resonate with an American audience, the site's primary viewers. "If you're doing a story on Iraq, Afghanistan, North Korea, or Russia, those countries are quite top of mind and easy to sell," she says. "Ghana? That's tougher. We still publish stories on Africa, but we don't get to do it quite as often as we'd like."

Pieces that Birkett passes on? "Anything too local," she says. "Something that's interesting to people in Ft. Lauderdale just might not be interesting to a national audience."

Which Websites to Target?

So which websites do you target with your great idea or newly polished piece?

"I'll pitch a story I believe is right for a particular website. I won't pitch a one-hour story— you have to be reasonable about who your client is," says Shaul Schwarz, freelancer for *Time.com* and other websites. "And for every 'yes' I get, I get a lot more 'nos.' That's just life. You have to knock on doors and listen to feedback."

The key here is to know the website, the audience, and the kinds of stories they've run in the past. The best predictor of what they will buy in the future is what they have published before.

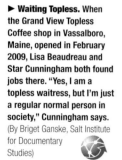

► **Waiting Topless.** When the Grand View Topless Coffee shop in Vassalboro, Maine, opened in February 2009, Lisa Beaudreau and Star Cunningham both found jobs there. "Yes, I am a topless waitress, but I'm just a regular normal person in society," Cunningham says. (By Briget Ganske, Salt Institute for Documentary Studies)

DOES LENGTH MATTER?

Two minutes? Four minutes? How about fourteen?

Turns out that three minutes seems to be the magic number when it comes to optimal video length. That's according to Brightcove and Tube-Mogul, two companies that team up to measure viewer engagement, behavior, and similar web video analytics.

"A documentary that's two to three minutes is fine—if you go over that, the number of people who drop off is much more severe," says David Burch, TubeMogul communications director. "For what it's worth, I think audiences are watching longer in certain categories like TV shows. They'll watch music videos for around two minutes and videos on news sites for less than that."

In short: the longer the video, the more likely viewers will watch a bit and then click away to something else.

Micro or Mini?

Ann Derry of *nytimes.com* likes to keep videos to three to five minutes, but she also publishes longer mini-documentaries with substantial, in-depth reporting, usually about stories that her team has followed over a long period of time. These can be seven, eight, and even up to fifteen minutes long.

Time.com's Craig Duff runs a mix of short and longer videos. "A good video will retain half the viewers at the end as it did at the start," Duff says. "A lot of people watched Shaul Schwarz's entire 11-minute piece on the Haiti earthquake—even while they were at work."

When at *National Geographic*'s e-publishing division, David Griffin almost always edited pieces down to two minutes. "That's my max," he says. "If something comes along that's really engrossing, I might make an exception."

Divide and Conquer

Talking Eyes Media's story "India's Fast Lane to the Future" was one of Griffin's exceptions. Shot by Ed Kashi and edited by Julie Winokur, the documentary on India's new expressway and its effects on the country weighed in at 30 minutes.

But instead of posting it as one video, Winokur divided the piece into five easy-to-digest chapters. "People may not be willing to watch a 30-minute video, but they will watch five six-minute segments," Winokur says.

Or perhaps people are simply more willing to watch when they're especially interested in the subject matter—and when the quality of the video and, of course, the journalism itself is exceptional.

"If people are interested in what you're doing, they'll watch," Winokur says, referring

▼ **India's Fast Lane to the Future.** The Golden Quadrilateral Highway project is one of India's largest and most ambitious infrastructure projects ever. In fact, it's a metaphor for how India is entering the 21st century and modernizing itself to be a dominant player in the global economy. (Photo by Ed Kashi)

to two successful pieces she produced. "'The Sandwich Generation' was 13 minutes long, and people seemed willing to go there. 'Denied' is 10 minutes long and it was the hottest thing on *MSNBC.com* the day it went live."

Attention, Please

In fact, *MSNBC.com*'s Meredith Birkett says she doesn't have a preferred video length. "We've published pieces as long as 20 minutes," she notes. "Not everyone watches the entire piece, but some do.

"Our biggest constraint is people's attention," Birkett says. "The second that a video's storyline moves too slowly, people will click away. It's critical to capture them in the first 15 to 20 seconds. The beginning is the most important piece that you'll edit."

That means putting all the important information early in the video.

▼ **The Real Slum of** *Slumdog Millionaire.* Dharavi in Mumbai India is Asia's largest slum and the location for the movie *Slumdog Millionaire.* (Photo by Brent Foster)

Too Short?

Ah, but Brightcove and TubeMogul warn against videos that are too short, too! Their studies show that if your video is under a minute, people are more inclined to click away, as well.

"We can't prove why—it just seems that if people see something extremely short, they'll fast forward to get to the punch line," Burch says.

PREFERRED FORMAT: RAW, ROUGH, OR POLISHED PIECES?

In general, producers are interested in reviewing and licensing projects in a variety of states—raw material, rough cuts, and finished pieces.

"I'm really open," *MSNBC.com*'s Birkett says. "I like looking at raw video because I can pay for that and have our in-house team do all the production," she says.

"What's great about finished projects is that you know what you're going to get in the end," Birkett continues. "But often people have spent more time putting the piece together than what we can pay for. I spoke to one photographer recently who spent two months on a piece—nobody can pay you for two months of work. The more production time you put into something, the harder it is to find someone with a budget to pay for it. The most we've ever given was a six-week assignment after Hurricane Katrina."

Independent Canadian videojournalist Brent Foster, formerly of the *Los Angeles Times*, warns against producing pieces and selling them later. "It's the toughest way to do it," he says. "You'll spend hour after hour shooting and editing. I hate to work on a project like that and not be able to get it out anywhere."

That's why before he spent a year living and working in New Delhi, Foster alerted several editors about his travel pans. His timing was right. The movie *Slumdog Millionaire* had just been nominated for multiple Oscar awards. Foster pitched the idea for a video documenting what life is really like in Dharavi, the slum where part of the movie was filmed. He ended up selling *The Real Slum of Slumdog* to *Time.com*.

SHOOT FIRST, SELL LATER? A CASE STUDY

It's not impossible to create your own projects first and find nicely paying homes for them afterward—or at least homes that lead to other homes.

Julie Winokur and Ed Kashi did exactly that early on. The husband and wife duo collaborates on a daily basis and as complementary colleagues in their careers—Kashi is a photojournalist and Winokur a print journalist and documentary filmmaker.

Together they run Talking Eyes Media, an organization that creates and distributes visual materials advocating for positive change.

Articles Caught Their Attention

A series of articles noting that Americans over 55 will outnumber those under 18 by midcentury caught their attention in 1995. So the two began pursuing magazine stories—at their own expense—as part of what became their "Aging in America: The Years Ahead" project.

They sold their first piece, on geriatric prison wards, to the *New York Times Magazine*. It was so well received that the two spent the next seven years traveling to nearly 30 states, turning out yet more magazine stories about aging Americans. "We were aiming toward a book and traveling exhibition," Winokur says. "We were supporting the project through a couple of foundation grants we had received."

Going Back to School

Toward the middle of the project, Kashi signed up for Dirck Halstead's six-day Platypus video immersion course.

"It was a logical career move," Winokur wrote in a piece for the *Digital Journalist*.

"In the age of multimedia, photographers who can shoot video have a distinct advantage. I fully supported Ed's decision to invest the time and money into Platypus." But when Kashi proceeded to outfit himself with the best equipment to shift his career, the price tag was nearly $10,000; Winokur blanched at the cost and tried to dissuade him.

"Trust me on this one," Kashi said to his wife.

Early Adopters of Multimedia

Today, Winokur happily admits that Kashi was right on target, and the two became early adopters of multimedia. "It made sense," Winokur says. "Here we were audio recording our interviews with people—we might as well be videotaping them, too."

▼ **Aging in America.** The Senior Olympics in Baton Rouge, Louisiana. In 15 years, the Senior Olympics has grown from a modest experiment to a national phenomenon drawing more than 12,000 athletes in dozens of events. (Photo by Ed Kashi)

A year later they met Brian Storm, who was with *MSNBC.com* at the time. *MSNBC.com* was the only website then paying for and publishing videojournalism.

"We approached Brian with our treasure trove of stills and hours of audio interviews," Winokur recalls. "He said, 'This is great. Send me everything.'"

But Storm's budget was limited to $3,000—a small sum for seven years of work.

MSNBC Comes Through

Winokur and Kashi ended up sending Storm four multimedia pieces and worked with Storm and producer Meredith Birkett to edit the pieces for the site. The collection, called "Aging in America: The New World of Growing Older," remains on *MSNBC.com* today.

Although $3,000 isn't a huge sum for four multimedia pieces, Winokur is quick to note that MSNBC provided at least $10,000 worth of post-production services, which enabled their project to be widely viewed on the Web.

Along with the web series, Winokur and Kashi did indeed turn their work into a book, documentary film, and traveling exhibition and won numerous awards as well.

One Success Leads to Another

After collaborating with the two on several MSNBC stories, Storm asked Winokur and Kashi to shoot "The Sandwich Generation" about the challenges, responsibilities, and unexpected joys of caring for aging parents. Coincidentally, Winokur and Kashi were doing exactly that— caring for Winokur's father, Herbie, who was suffering from dementia.

They followed up a year later with *Part 2: Living with Herbie,* funded by AARP for $10,000 and later licensed by *MSNBC.com.* They also sold various excerpts to PBS and Mutual of Omaha. "In the grand scheme of things, the piece has done well," Winokur says.

These days, though, Winokur and Kashi are more likely to shoot projects for which they're hired. "It's much harder to sell finished pieces than ideas," she says. "Most clients have their own agenda about what they're doing. It's hard as an outsider to come in with something pre-packaged that's perfect for them."

HOW DO SITES KNOW THAT THEIR INVESTMENT IS WORTHWHILE?
Time on Site

"It's a combination of things," says *MSNBC.com*'s Meredith Birkett. "You look at traffic, at how many people clicked the link, and how many stayed to watch the video. Time on site is a very important metric. We want to make sure people stick around. We're also interested in how many recommend our videos on Facebook and Twitter. Reader feedback is really helpful."

And though Birkett and team weigh numerous tangible metrics as a way to measure success, they also take into account this important question: was it the right story to tell?

"A video may not be popular, but if it's an important story to get out there, we want to do that," Birkett says.

Video Completes the Story

David Griffin, formerly of *National Geographic,* considers a video investment worthwhile when a piece completes a story.

"Wildlife photojournalist Tim Laman did this great piece on bowerbirds in New Guinea," he recalls. "The male birds build these elaborate homes to attract females, and they do a very interesting dance, as well. We have the written story and beautiful still photographs, of course. But capturing 30 seconds of the dance in our 'Build It (And They Will Come)' video is worth its weight. It expands the story and makes the story more complete."

Brilliant Video versus Justin Bieber

At *Time.com,* Craig Duff certainly pays attention to the statistics, but he doesn't discuss them— not even with the videojournalists themselves.

"I don't want people to be so concerned about numbers," he says. "I don't want to

▼ **The Sandwich Generation.** Herbert Winokur, 83, suffers from dementia and has recently moved into his daughter's house in Montclair, New Jersey. Isabel Kashi (foreground), with Herb Winokur and Julie Winokur (standing), in their kitchen. (Photo by Ed Kashi)

▲ **Build It (And They Will Come).** A male bowerbird builds decorated homes to attract females.
(Photo by Tim Laman)

compare how many people watched a heavy, moving, and brilliant video with how many watched something on Justin Bieber."

According to TubeMogul, by the way, viewers have plenty of opportunity to watch videos of the young superstar celebrity. There are more than 12,382 videos of, or that mention, Justin Bieber on the Web. Viewers have watched them more than an astounding 2.5 million times.

IT'S OK TO GIVE IT AWAY . . . SOMETIMES

We're all eager to earn money for our multimedia masterpieces, but several videojournalists have learned that by giving away a little, they can get a lot more in return.

Volunteering Opens Doors

In 2000, Mike Schmidt and his then-college-girlfriend-now-wife volunteered to create short videos for Zoom Culture, a Chapel Hill, North Carolina–based site for which college students created and uploaded video content for free.

"We shot and submitted two short documentaries each week on local bands, cool places to go like tattoo parlors—anything we could think of," Schmidt recalls. "Our stuff sucked so terribly. We were learning on the fly and reading all the books. It was really fun. We were up on the whole possibility of what it could be."

That whole possibility led Schmidt to Zoom Culture's headquarters, where he was hired as an in-house editor. Zoom Culture morphed into a TV show production company that created a show called Hip Hop Nation, which was picked up in five NBC markets. Before Schmidt knew it, he'd gone from the guy who posts free three-minute videos to being named Hip Hop Nation's senior producer.

"That was a great six months before investors decided to cut their losses," Schmidt says, laughing.

These days, Schmidt is busy creating multimedia pieces for nonprofits including the Open Society Institute, as well as for the University of North Carolina–Chapel Hill. He also provides graphics services and builds websites for clients.

WHAT'S THE FUTURE OF VIDEOJOURNALISM, ECONOMICALLY SPEAKING?

It's hard work just getting work these days, but videojournalists who can spot and tell a story, and who can prove themselves dependable—and good—will likely have a steady stream of assignments up their video camera sleeves.

The key, as most successful videojournalists agree, is to remain open and market your work in a variety of venues.

Starting Out

How to break into the market? For journalism students and beginning journalists, that may mean using Transom, CNN's iReport and other citizen journalism/semi-self-publishing vehicles. You might contribute to these websites even if they don't pay. Getting published by your school or local media is critical to those that want a leg up on the career ladder. Try to persuade your school or hometown newspaper to put your multimedia

RAISE FUNDS ON THE INTERNET

The Internet is a rich resource for video-journalists in ways other than showing and sharing video and multimedia stories. It also has opened a new avenue for independent videojournalists to raise funds for reporting those stories. *VJMovement.com*, where the site's visitors voted to fund Adam Westbrook's proposal about an advocate for prisoners' rights, is one example.

Emphas.is, Kickstart.com, and Indiegogo.com are sites that provide platforms for individuals to seek funds for their projects.

Say you have a good project under way but you need more funds to move forward. You will want to review the sites and the kinds of projects that have been funded successfully. Sign up on one that befits what you're doing and describe the project. On Emphas.is, Kickstart, and Indiegogo list your fundraising goals, and outline what contributors to your project will receive in addition to feeling good about supporting your idea. If your project is featured on these sites, visitors will have the option to contribute directly to it.

Typically, a board of reviewers will judge the quality of the project and provide feedback, whether accepted or rejected.

Contributions from donors can range anywhere from ten dollars to three thousand or even more targeted specifically for your project. Depending on the site, a proposal may have a certain number of days to reach its stated funding goal—60, for example. If the proposed project does not meet the goal in the time allotted, the funders get their money back. If the effort is successful, the project receives whatever funds come in.

However, your fundraising effort has only just begun.

Tomas van Houtryve, for example, a well-respected photographer in the agency VII Network, and a 2010 Photographer of the Year, proposed on Emphas.is returning to Laos to finish his project about countries that still adhere to communism. He had completed a large portion of the project already, having shot in Russia, Vietnam, Cuba, and North Korea, etc. Still, he needed to return to Laos for more in-depth coverage. He offered his on-line contributors different rewards depending on their contribution levels. For $10, contributors received access to his blog, where they could follow the project "behind-the-scenes." In addition to this access, contributors of $125 or more received a collector's edition of a mini book about the project. Those contributing $1,000 or more also received a 24"×20" art print of one of van Houtryve's images from the project. The photographer also sent signed postcards to every contributor. "Contributors want something tangible," he says, in exchange for supporting a project.

What was the key to van Houtryve's success? Of course, his was a solid project, and he was already a widely acclaimed photographer. But he also wisely exploited the Internet and social networking. He began by contacting everyone on his own email list and worked out from there. He asked each person, in turn, to contact their friends to support the project and to then ask their friends to do the same—and thus the circle spread wider. As you can see, this approach to funding is not for the shy and retiring. Ultimately, contributions to van Houtryve's project exceeded his goal of $8000—a function of staying in close contact with his contributors through his blog and searching for more and more contacts.

Van Houtryve turned to Emphas.is because of its sole emphasis on photojournalism. KickStart helps people fund a variety of documentaries as well as fictional film projects. Indiegogo, another fundraising site, provides a platform for a whole host of creative proposals ranging from technological innovations to music concerts to film and video documentaries. ∎

▶ **Laos—Communism Continues.** A girl on inline skates glides past a Communist poster showing an image of the first Communist leader of Laos, Kaysone Phomvihane, in Vientiane, Laos. (Tomas van Houtryve, VII Network)

and video stories online. Once they are up, you can link to them from your social media accounts at Facebook and LinkedIn. Future employers will be impressed that you have brought your work to the public. *Transom.org, ireport.cnn.com*, and *alternativenewsreport.net* are other sites you want to check out.

Mix and Combine

"Get still assignments and video assignments, sell your audio to radio stations, sell your video to TV, and be able to teach workshops or classes," suggests Brent Foster. "If you can mix and combine all those things together, you can make a living. It's very tough to make it just as a multimedia videojournalist. It's really touch and go. If you can live from a backpack on a shoestring budget, it can be done. But it's a tough thing to do."

Have Enough Projects in the Pipeline

Even successful longtime videojournalists like Bob Sacha are always looking for their next projects.

"You want to always have enough things in the pipeline," Sacha says. "You always want to be working on multiple pieces and, if things go right, you'll be starting something just as you're finishing something else—and, in between, you're planning, writing budgets and so on. You have to have a lot of balls in the air. And you have to create a portfolio of powerful work and that becomes your calling card. That hasn't changed."

And will that lead to a road of riches? Not necessarily. "I got into journalism because I really enjoy it, and the idea of getting paid for it comes secondarily," Sacha says. "I wish I could say you can get wealthy. I don't have a secret. I do it because I like to do it."

Desire and Initiative

You must have desire and initiative, as Shaul Schwarz can attest with his "Breach of Faith" video, highlighted at the beginning of this chapter. Arriving in Haiti the day after the January 2010 earthquake, Schwarz knew he could shoot plenty of compelling still photographs to suit the needs of his clients, CNN, and *Time* magazine. But, several days into the shoot, he also knew he had stumbled upon another story that needed to be told—that of how the highly religious Haitians were now questioning their faith following the earthquake's devastation.

It was an emotional story best told through video. So Schwarz took the initiative to switch his Canon settings from still photography to video and got busy doing what he does best—telling people's stories. His *Time* editors loved what he did and bought the video, as well.

Be Better and Different

Just remember to set yourself apart from your videojournalist colleagues. How? "It's just like freelance writers versus staff writers," says Michael Rosenblum, a videojournalism pioneer and publisher of Rosenblum TV. "You have to be better and different."

A Very Bright Future

So whether you're hoping to strike bank-account gold with your multimedia masterpieces or you simply want to lead a full life by sharing stories about the lives of others, the future for videojournalists, says the *New York Times*'s Ann Derry, is very bright. In fact, she used those very words—"very bright!" ∎

Page numbers followed by *i* indicates image and *t* indicates table.